D1537704

End-to-End Game Development

End-to-End Game Development

Creating Independent Serious Games
and Simulations from Start to Finish

Nick Iuppa
and
Terry Borst

Focal Press
Taylor & Francis Group

NEW YORK AND LONDON

First published 2010
by Focal Press

Published 2015
by Focal Press
70 Blanchard Road, Suite 402, Burlington, MA 01803

Published in the UK
by Focal Press
2 Park Square, Milton Park, Abingdon, Oxon OX14 4RN

Focal Press is an imprint of the Taylor & Francis Group, an informa business

Copyright © 2010 Taylor & Francis.

All rights reserved. No part of this publication may be reproduced, stored in a retrieval system or transmitted in
any form or by any means electronic, mechanical, photocopying, recording or otherwise without the prior
written permission of the publisher.

Notices

To the fullest extent of the law, neither the Publisher nor the authors, contributors, or editors, assume any
liability for any injury and/or damage to persons or property as a matter of products liability, negligence or
otherwise, or from any use or operation of any methods, products, instructions, or ideas contained in the
material herein.

Libraryof Congress Cataloging-in-Publication Data
Iuppa, Nicholas V.
End-to-end game development: creating independent serious games and simulations from start to finish /
 Nicholas Iuppa. Terry Borst.
 p.cm.
Includes bibliographical references and index.
ISBN 978-0-240-81179-6 (pbk : alk. paper) 1. Computer games—Design. 2. Computer games—Programming.
 3. Video games—Design. I. Borst Terry, II. Title.
QA76.76.C672.L87 2010
794.8 1536–dc22

BritishLibrary Cataloguing-in-Publication Data
A catalogue record for this book is available from the British Library.

ISBN: 978-0-240-81179-6

To Tony Iuppa, one of the most talented and dedicated game producers.
To Carolyn Miller, a constant light.

CONTENTS

ACKNOWLEDGMENTS

We owe a huge debt of gratitude to our technical adviser, Martin van Velsen, senior research engineer at Carnegie Mellon University.

We'd like to acknowledge these major contributors of content, ideas, and graphics: Dr. Andrew Gordon of the Institute for Creative Technologies, University of Southern California; Phil Campbell of Phil Campbell Design; Michelle Harden of Compelling Technologies; Bill Groux of Retention Education; George Lang, The Big Picture Film and Video; Independent Art Director Lance Alameda; Carolyn Scott of Virtual MindWorks; Ina Tabibian for her editorial work on some of our fables; and Joe Harless for the strong grounding in educational technology.

We'd also like to acknowledge the following for generously sharing their experiences and insights: Adrian Wright of MaxGaming Technologies; Justin Mette of 21-6 Productions; Kam Star of Playgen Ltd.; Eitan Glinert of Fire Hose Games; Luke Nihlen of 10th Artist; and David Rejeski of the Woodrow Wilson Center for International Scholars. In addition, we'd like to thank the Singapore-MIT Gambit Game Lab for permission to use our cover image from the game *AudiOdyssey;* and all the rights owners, artists, and designers responsible for the images used throughout the book.

Introduction

New Tools Replace Old Tools

In the award-winning AMC television series *Mad Men*, set in the early 1960s, a mysterious and massive machine shows up one day in the offices of the advertising agency Stirling Cooper. The machine is a Xerox photocopier, and the workplace is about to change forever. Previously, document duplication was done with a mimeograph, a hand-cranked drum machine that would ink a stenciled original to create up to a hundred ever more slightly muddy copies. Almost overnight, photocopying solved the problem of massive document distribution, accelerating the flow of information in every workplace, improving customer outreach, and becoming a standard tool for almost every employer and employee.

For most of the 20th century, financial analysis and financial modeling was the domain of a small "priesthood" of in-house or contracted analysts who would laboriously build models that frequently had to be rebuilt in order to revise a parameter or a formula.

But as the 1980s dawned, personal computers like Apple IIs and Radio Shack TRS-80s—previously considered little more than toys—began to appear in offices, running an electronic spreadsheet called VisiCalc. The mechanics of financial modeling were now vastly simplified, placing an extraordinarily powerful tool in the hands of millions. Customer targeting and business planning improved exponentially, and few of us can imagine working today without the aid of a spreadsheet. It would be like a carpenter working without a hammer.

With the advent of the photocopier, the slide projector, and expensive and bulky graphics printers and design tools, the in-house "graphics department" ruled the roost any time you wished to create a sophisticated 35-mm slide show or hard-copy presentation that included handouts, charts, and illustrations. If you had an important presentation to make to your boss or an important client, you'd have to get your materials over to the graphics gurus days or weeks in advance of the event—and you'd better have a good relationship with the department if you expected your deadline to be met. Good luck if the graphics department made an error!

A DIY (do-it-yourself) alternative was to photocopy some bullet charts and graphs onto overhead transparency acetates, and veteran professionals still remember the

interrogation-like glare of overhead projections and stark black-and-white images that hurt the eyes. (If you wanted to make last-minute changes, you needed to use a Sharpie to make your edits directly on the acetate.)

However, in 1990, Microsoft rolled out PowerPoint at the same time it introduced Windows 3.0. Almost overnight, the all-powerful graphics department vanished as an institution: anyone using PowerPoint became his or her own graphics department, and new ideas and data could be incorporated into a complex presentation in a matter of minutes. As a bonus, those overhead projectors soon became obsolete.

As these examples illustrate, workplace technological developments have placed even greater amounts of power and precision in the hands of professionals. Put another way, new tools evolve and replace old tools in the communication toolbelt. And the trend continues.

Would You Like to Make a Game?

Now, as we close out the first decade of the 21st century, a new wave of evolution has struck the shores of the modern workplace. And because you're looking at this book, chances are you've heard the crash of that wave.

You may be working in any number of capacities:

- For an oil company, training workers to operate on offshore oil platforms, and concerned about new security issues in this environment

- As a producer on a university website, where you've been asked to create fresh and engaging content that attracts new traffic while highlighting the university's "brand"

- For a nongovernmental organization that provides relief services and aid to over-seas populations

- As a principal of an independent or startup game company, trying to figure out how to keep paying the bills while you produce (on spec) the entertainment product you're passionate about

- For a financial services company, training employees to move into management responsibilities

- As a real estate partner, looking to attract younger home buyers

- For a state or county entity that wishes to promote social change (hands-free cell phone use while driving, entrepreneurialism in blighted communities, etc.)

In any of these situations and hundreds of similar scenarios, you may be involved in some form or manner with a variety of challenges:

- The transfer of training, educational, or pedagogical material to employees or volunteers

- The task of motivating social change or changing social behavior

- The challenge of attracting new business or new customers

You know how your job has been done in the past. For example, traditional professional training has taken place in several ways:

- On-the-job training, which is (1) costly because it requires the time of other personnel (who may or may not be good at training) and (2) risky when failure is not an option (surgery, firefighting, military command, and so on)
- Classroom mentoring and role-playing, which obviously lowers the real-world risk but falls short of on-the-job training in simulating the pressures of the job, while still being labor, facilities, and time intensive
- Pencil-and-paper training, which does little to test the transfer of knowledge in the context of stress, human interaction, and changeable situations (pencil and paper have now been transferred to the computer screen, but the methodology remains identical)
- Some combination of the above approaches, which usually shorts them all (while the limitations of each remain in place)

As a second example, traditional workplace or social persuasion and behavior modification (this would include commercial advertising, marketing, and recruiting) has typically been advocated in these ways:

- One-way media: flyers, pamphlets, public service announcements, print advertisements, radio and television commercials, and other attention-getters that lay out the case for the argument or behavior (or purchase decision). The problem in the 21st century is that we're so inundated by these methods that we largely tune them out.
- Two-way interaction via training classes, focus groups, or one-to-one meetings. These methods are not only time and labor intensive, but they battle a natural resistance from the audience.

But a new generation—the Millennials (sometimes known as the Net generation)—has been immersed in interactive media since childhood (see Figure 1.1). Digital social networking has been available for a substantial part of their lives. They're visually intuitive and respond better to experiential and collaborative learning methodologies than traditional "skill-and-drill" and text-based learning. They multitask well, but are often prone to "grasshopper mind."[1]

In short, the old ways of training and persuading are going to be even less successful for them. However, growing evidence exists that applying entertainment videogame mechanics and techniques to learning and communication objectives can pay dividends. In an interview with the website Gamezone, noted education expert Professor James Paul Gee recounted his epiphany on this point: "It dawned on me that good games were learning machines. Built into their very designs were

[1] Jonas-Dwyer, D., and Pospisil, R. *Millennials Rising: The Next Great Generation.* New York: Vintage Books, 2004.

FIGURE
1.1

The Millennial generation has been immersed in interactive media since childhood. Photo courtesy of iStockphoto. © The New Dawn Singers, Inc., Image # 6945908.

good learning principles, principles supported, in fact, by cutting-edge research in cognitive science."

Similarly, advertisers have realized that 30-second linear television spots are having increasingly little impact on Millennials. But engage a potential customer interactively, and you're more likely to engender a sale and create brand loyalty.

As these appraisals have percolated through the workplace landscape, your boss now may be wondering if your organization should be undertaking a videogame, a "serious game" (which we'll define more thoroughly in Chapter 2), to introduce new procedures or job tasks. Or you may be aware of colleagues who are launching serious games to better promote their products and begin thinking you should do the same. Alternatively, you may be looking to secure a government grant for a serious game that will motivate social change, such as more conservation or more nutritional meals. Or you may be in charge of training personnel for hazardous duties and wondering if a virtual world *simulation* (which we'll also define more thoroughly in Chapter 2) could improve preparation and confidence before personnel go into the field.

You may be a PowerPoint master or Webmaster, a project manager, or web producer (highly experienced or new on the job). You may be a Java or AJAX programmer, the administrator of a content management system, or the director of human resources. Or you may be a young entrepreneur trying to launch an independent game company (we'll be defining independent games in Chapter 2).

But as you begin to think about *all* the necessary components needed to develop and produce a serious game or simulation, the task seems daunting. Developing and producing *any* kind of videogame is hard enough. The challenges are enormous. But how do you also develop the teaching points and meld the desired knowledge base to the gameplay and narrative elements contained in any serious game or simulation?

You're also aware of the budget and time limitations you have: creating media is always expensive, and efficient asset management is critical. Distribution, product assessment, and return-on-investment measurements also must be planned for.

This is more than just building a complex interactive PowerPoint presentation, or a new corporate blog, or the backend on a retail website.

The chances for failure seem very high, while the chances for success seem slim. In fact, the chances for failure *are* high.

Too often, one element of the process winds up running roughshod over the other elements. The teaching points become subservient to gameplay or narrative; or the teaching points throttle engaging gameplay and compelling immersion. Too often, the development and production lack coordination, resulting in a serious game or simulation that fails on one or more levels.

What This Book Is About

This book will offer a time-tested, systematic approach to the conceptualization, development, production, and rollout of a serious game or simulation. In a sense, we're going to take a look at game development and production from end to end, from starting point to finish line, on an independent ("Indie") game budget.

The authors wouldn't be so arrogant as to proclaim our approach the *only* approach to end-to-end game development. But we've spent our careers writing and producing media and between us have accumulated 40+ years collaborating on the creation and production of commercial videogames, serious games, and virtual world simulations (find a full overview of our backgrounds at **www .endtoendgamedevelopment.com**, and see Figure 1.2 and Figure 1.3 for examples of our work). In addition, we've talked to dozens of colleagues to further refine the approach presented within this book.

At its best, the conceptualization and completion of any serious game or simulation will still make you feel like you're flying by the seat of your pants. But you'll see that even in this exciting new arena of communication and education, we'll be discussing proven methods and processes. We're going to show you our approach in detail and use many examples from real-world cases to illustrate its effectiveness. Our goal here is to improve your chances for successfully making the leap to creating a serious game or simulation. This will be true even if you're already an independent game developer, because serious games and simulations are different animals than entertainment-oriented games.

Once you undertake the building of a serious game or simulation, you become an independent game developer yourself, regardless of whether you're entrepreneurial or working under the umbrella of a corporate, nonprofit, or government organization.

After defining our terms and goals in Chapter 2 and giving you a more detailed overview of the book's organization in Chapter 3, we'll begin to discuss setting up game development and the acquisition and management of clients (whether the

FIGURE
1.2

Image from *Leaders*, the advanced leadership simulation training project that we wrote and produced in collaboration with Paramount Pictures, the Institute for Creative Technologies (ICT), and the U.S. Army. ©2004, University of Southern California Institute for Creative Technologies. Used with permission.

FIGURE
1.3

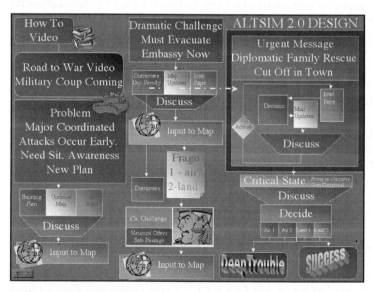

Master presentation flowchart for an early version of ALTSIM, another leadership training simulation, which we developed with Paramount Pictures, the Institute for Creative Technologies (ICT), and the U.S. Army. ©2004, University of Southern California Institute for Creative Technologies. Used with permission.

clients are in-house superiors or outside organizations you're trying to secure funding from).

We'll move from the initial determination of the project's goals to seeing how we can begin to integrate teaching/persuasion material, gameplay, and game narrative into a seamless and scalable design.

We'll look at selecting platforms and tools, building and managing development and production teams, and getting the most bang for the buck with limited budgets.

We'll then walk through the production and authoring phases and take a look at distribution and assessments, which may, in turn, spur development of future versions or follow-up projects (just as good box office or television ratings will trigger sequels or spin-offs).

Although we believe the central concepts and approaches in this book will apply to almost any game development project, we do not aim to cover well-funded commercial projects. The Microsofts and Electronic Arts of the world routinely spend $10 million to $60 million to develop game properties, and these projects are more comparable to studio film productions in scope and size.

Since the late 1990s, however, the democratization of video production equipment and tools has made it possible for almost anyone to make a film, and the Internet has now made it possible to easily distribute it.

Similarly, this book exists because the democratization of game production and authoring tools has made it possible for small entrepreneurial and in-house teams to create games for teaching, persuasion, and motivational purposes. If your budget is $10,000 or $500,000, we're here to tell you that making a game is possible. And with a logical, methodical approach, making a *good game* becomes possible too.

endtoendgamedevelopment.com

The companion website to this book contains these features:

- Additional chapters and expanded versions of some chapters, with updated information
- Access to serious games, advergames, and simulations you can try out for yourself
- Samples of documents, budgets, code, concept art, and other assets and artifacts
- News of latest developments in the field

The book's website is a great resource for helping you succeed in creating an exciting and innovative serious game or simulation, and we hope you'll check back with it on multiple occasions.

CHAPTER TWO

Defining Independent Games, Serious Games, and Simulations

The Minefield of Terminology

We'll need to define a few terms before we get going, and none of these terms is easy to pin down. Indeed, even the most trusted media definitions are losing their meanings as technology advances.

For example, what does a term like *television* mean when episodic television is now delivered on iTunes, via broadband, and on DVD? Similarly, the term *video-game* becomes increasingly quaint as we create and play digital games using cell phones and handheld digital "pens" and as we merge the virtual world with the real world via alternate reality games (ARGs).[1]

Nevertheless, we have to work with industry-standard terms even when their boundaries are a little blurry, and we'll find enough general agreement to make these terms meaningful as you navigate these evolving industries.

Independent Games

The term *independent games* borrows from the term *independent film*. In the film industry, independent films refer to films not made under the auspices of major studios (Fox, Paramount, Sony, etc.) or "mini-major" studios (Lionsgate, NuImage, etc.). Funded outside the studio system, independent films are, by definition, low-budget films, with the trade-off being that independent filmmakers usually enjoy

[1] ARGs take place in the physical world, combining the use of staged events, physical clues, faxes, mailings, emails, websites, phone calls, and other delivery media to create an "alternate reality" narrative. Examples include Audi's *The Art of the Heist*, ABC's *Lost Experience*, and Nine Inch Nails' *Year Zero*.

more creative freedom than their studio brethren. (In recent years, studios have created their own independent film distribution arms, blurring the line between studio and independent product. But true independent films are still made on very limited budgets, with no studio interference or input.)

Similarly, independent games refer to either entertainment game or serious game titles created by independent companies with limited resources, operating outside the mainstream game publishing industry (Electronic Arts, Microsoft, Sony, Activision, etc.).

As independent game developer Jonathan Blow has noted, "The mainstream industry does not spend much effort exploring the expressive power of games; that's where the Indies come in." Fellow independent game developer Derek Yu has said that independent games are "where the passion is."[2]

Independent games (aka *Indie games* or *garage games*) could only arise when game distribution moved beyond retail shelf space and onto the Internet, thanks to ever-increasing bandwidth and broadband penetration in countries around the world. Often, Indie games are offered as shareware or freeware and sometimes are also "open source," allowing anyone to modify the underlying game code or assets.

Some of the most successful independent games produced as of the writing of this book include the following:

- *Portal,* now distributed by Valve Steam (who also distributed *Half-Life*); *Portal* began as an independent game called *Narbacular Drop,* created by students at the DigiPen Institute of Technology, who entered it into the Independent Games Festival and Slamdance to great acclaim

- *World of Goo,* developed by 2D Boy, an independent game startup

- *Braid,* developed by Jonathan Blow and now distributed via the Xbox Live Arcade service and by Valve Steam

The titles above are the exception that proves the rule about independent games: in general, they have a tough time making "real money." Although the Internet is a tremendous distribution platform, it's also an environment whose users are often reluctant to pay money for a product.

Thus, independent games frequently serve more as calling cards for their creators: they become launch pads for careers and opportunities in the bigger world of mainstream game production and publishing. In this way, independent games are much like independent films: gifted independent filmmakers will almost always "graduate" to studio filmmaking in order to pay the rent as well as to have adequate budgets to fully realize their creative visions.

But while working on its labor of love or seeking licensing on its intellectual property, what can an independent game company do to generate revenue?

[2] "The Indie Game Movement." Indiegames.com, showcasing the best in independent games. 08 Sept. 1008. 5 Mar. 2009, www.indiegames.com/what.htm.

Just as some independent filmmakers pay the bills by making commercials or client videos, so can independent game companies now look to producing serious games or simulations for corporate and nonprofit clients. Fittingly (according to Indie game developer Andy Schatz), independent games "spurred the growth of technology that has allowed serious games and persuasive games to be created,"[3] bringing us full circle.

The serious games/simulations market isn't easy to break into, clients aren't easy to find, and budgets aren't normally large. But success in this arena can partially or wholly foot the bill for the creation of independent entertainment titles. In addition, the skills and creativity needed to make an engaging serious game or simulation will inevitably be applicable to creating engaging entertainment.

Serious Games

Early this decade, public policy scholars began to promote a Serious Games Initiative to propel simulation and game development addressing policy and management issues. Gradually, the phrase *serious games* has gained widespread adoption, even though disagreement exists on what they include and exclude.

In general, serious games are designed to act as conduits for each of the following:

1. The transfer and reinforcement of knowledge and skills

2. Persuasive techniques and content aimed at changing social or personal behavior (this would include games that promote, market, and recruit)

Marketing and technology research company Forrester Research broadly defines serious games as "the use of games and gaming dynamics for non-entertainment purposes."[4] (See Figure 2.1.)

As noted in Chapter 1, using "gaming dynamics" for nonentertainment purposes makes a lot of sense in the 21st century. According to University of Wisconsin researchers, videogames are "powerful contexts for learning because they make it possible to create virtual worlds, and because acting in such worlds makes it possible to develop the situated understandings, effective social practices, powerful identities, shared values, and ways of thinking of important communities of practice."[5]

[3] Ibid.

[4] Keitt, T. J. *It's Time to Take Games Seriously.* Cambridge, MA: Forrester Research, 2008, 1-25, p.1

[5] Shaffer, D., Halverson, R., Squire, K., and Gee, J. *Video Games and the Future of Learning.* WCER Working Paper No. 2005-4, University of Wisconsin, June 1, 2005. Accessed March 5, 2009, www.wcer .wisc.edu/publications/workingPapers/Working_Paper_No_2005_4.pdf.

FIGURE
2.1

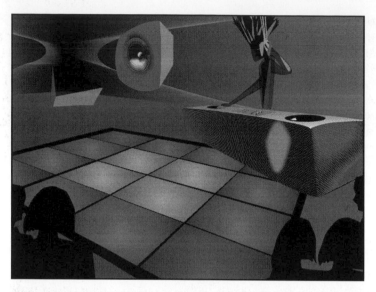

Screenshot of *AudioOdyssey*, a serious research game designed for both the mainstream audience and the visually impaired. Used with permission of the Singapore-MIT GAMBIT Game Lab. ©2007 MIT and MDA. All rights reserved.

We might look at serious games as the successors to commercial *edutainment* games of the 1980s and 1990s (*Jump Start*, *Reader Rabbit*, and many others), which were aimed strictly at children. Now, with vastly improved videogame technology and more platforms to deliver it on, serious games can be aimed at either children or adults. And we should remember that most adults under 40 are comfortable and accepting of the videogame format.

Consequently, serious games have become increasingly popular in education, industrial and emergency training, efforts for social betterment, and marketing. Applications for serious games include occupational training, disaster and emergency preparation, leadership and crisis management, primary and secondary education across the liberal arts and sciences, behavioral and social change, and advertising, recruiting, and activist persuasion.

Because they're built for low-budget development using small teams, independent game companies are ideally situated to develop and produce serious games, which in turn can keep the lights on while an innovative "calling card" entertainment game is under development. But serious games can also be produced by in-house teams, who may outsource some or most of the development and production to small game companies and independent contractors. We'll be looking at these various approaches throughout the book.

Although the two worlds of independent games and serious games are very different, we'll see what independent game developers need to do to win serious game business and succeed in the production of serious games.

Serious Games versus E-Learning Applications

The line between serious games and e-learning applications is becoming increasingly blurry. As learning content began to migrate to digital and online distributions, *e-learning* became the designation for virtual delivery of classroom experiences (lecturing, discussions, assignments, and testing). But simply transferring real-world, real-time classroom pedagogy to the virtual realm has seemed simplistic and sometimes wrong-headed, often ignoring the strengths of each venue while amplifying the weaknesses.

As a result, some e-learning applications have been adopting gamelike features (e.g., quiz show formats, leveling up, lock-and-key mechanisms) to better adapt to the digital realm and better engage the Millennials primarily using the apps.

We have seen e-learning applications labeled as serious games (when they really aren't), and we've seen serious games labeled as e-learning applications (which was sometimes true, but sometimes not).

We continue to separate serious games and e-learning applications, defining serious games as learning, persuasive, or promotional applications that adopt game formats, structure, functionality, and interactions and attempt to be fun to at least some degree. Clearly, a tipping point exists where an e-learning application will adopt so many game tools that it evolves into a serious game.

For instructional designers and application developers who may be building (or considering building) e-learning applications, we believe that much of this book can be applied to e-learning development. As time goes on, the line between serious games and e-learning applications is likely to further blur, and we wouldn't be surprised if both designations are completely obsolete in another 10 or 20 years.

Simulations

In one sense, all games are simulations. But in this book, we'll define a *simulation* as a virtual environment that attempts to accurately replicate (i.e., model) a task or experience for specific training or educational purposes. (Put another way: simulations are models of physical reality combined with models of human behaviors.)

While simulations often use screen-based, three-dimensional, computer-generated environments (such as we see in *Unreal* or *Grand Theft Auto*), simulations may also be delivered through media such as web pages, cell phone text messages, and faxes, or they may be delivered through virtual reality or other physical environments or

devices. The question is what exactly we're modeling: navigation, decision-making processes, physical or human interactions, and so on.

We are often asked whether simulations are games. Here's our best answer. Some simulations are extremely open-ended, with little in the way of *game* elements, a game being a closed environment with (1) clearly stated rules, (2) clearly understood goals, and (3) measurements of success or failure in achieving goals.

Other simulations ask users to move through levels, score users for performance, and even offer a winning path through the simulation experience, clearly meeting the test of a serious game.

For the most part, this book includes simulations when they have at least some game elements. However, some simulations are being built to act as activist/ persuasive or promotional/marketing tools, especially in Second Life (*Gone Gitmo* and *Mexico Ruta Maya* are two such examples). Much of this book's discussion applies to these types of projects (see Figure 2.2 for an example).

In the more restricted definition we've offered, simulations with game elements are always serious games, but serious games do not need to be simulations to succeed, and in fact, the vast majority aren't simulations.

As we might guess, simulations are particularly useful for modeling risky job situations. The airline industry, of course, has used flight simulators for decades,

FIGURE
2.2

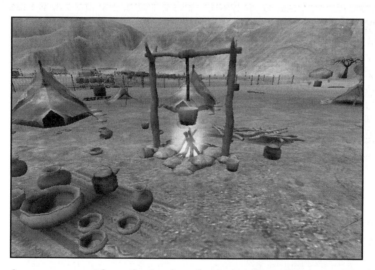

An encampment from the *Leaders* simulation. Part of the vast virtual world is set in the desert of Afghanistan. The world included a military compound, the distribution site itself, various checkpoints in and out of the valley where the site was located, a command post, heights around the valley where a warlord and his men camped, and a small abandoned building called the chapel where the American commanding officer (C.O.) met with a local tribal warlord. ©2004, University of Southern California Institute for Creative Technologies. Used with permission.

because crashing a virtual airplane is acceptable, while crashing a real one is not. Professional flight simulators cost millions of dollars, but the rapid development of consumer equipment and software means we can now deliver a simulation on a shoestring budget, relatively speaking.

The military, first responders, and industries with potentially dangerous aspects (energy, construction, shipping, etc.) have all begun exploring simulations to better train their personnel. These simulations not only model some of the physical dangers in these endeavors, they often model the leadership and decision-making processes that can either increase or lessen potential dangers.

Simulations of business and financial decision making may not be so life and death, yet the deep 2008-2009 recession demonstrates the high stakes of these realms and the value of simulating these arenas before entering them in reality.

The Book's Shorthand

A large percentage of the time, we'll be using the phrase *serious games and simulations* to try to incorporate the widest application of our processes and experiences.

However, because we consider simulations (and advergames, persuasive games, recruiting games, social change games, etc.) to be a kind of serious game, we are not excluding them when we don't always mention the term.

Although this book's emphasis will tend to be on training and teaching applications, we believe a large percentage of what we write about pertains to simulations and other serious game apps. In a larger sense, an advergame—or a game trying to persuade teenagers to avoid drinking and driving—is a type of training. All serious games are united by the desire to *change* the user's way of thinking and view of the world, whether focused narrowly on a job task or consumer habits or trained on larger social and cultural issues.

Summary

- *Independent games* are low-budget entertainment or serious games developed by small companies outside the mainstream game studio and game publishing industries.

- *Serious games* (with rare exceptions) are developed outside the mainstream game studio and game publishing industries with the intent to teach, persuade, or promote using established videogame dynamics.

- Various categories and subsets of serious games have emerged, including *simulations*, which create virtual world environments that model actions and decision-making processes, often in risky or dangerous situations and occupations.

- *Serious games* and e-*learning applications* are two terms that are sometimes used interchangeably because the line between the two has begun to blur. This book focuses on serious games, rather than e-learning, but many of the principles and common-sense advice offered in this book apply to both realms.

- Examples of independently developed serious games and simulations are discussed throughout the book, but you'll find many more examples of these applications at **endtoendgamedevelopment.com**.

CHAPTER THREE

From Start to Finish:
A Walkthrough

Introduction

Having defined our terms, let's look at how the book is organized. Some of you may have developed games but never managed a team and never worked on a serious game or simulation application. Some of you may have prior management experience but have never been involved in a game project.

Our approach is to walk through the game development process, from conception to distribution and marketing. We've divided the book into sections that roughly correspond to phases of the project. Naturally, real life doesn't line up into boxes quite so neatly, so phases often overlap, and actions and approaches are often iterated throughout the project's timeline.

But the division into sections will help you quickly find the information you need. Some of you may be able to skim the section focused on team building and project management and jump to the chapters about platforms and game engines. Others will know about game engines but not about instructional design and user assessments.

As much as possible, we look at situations both from the viewpoint of a reader who might be part of a large organization and from the viewpoint of a reader who is part of a small team, game dev shop, or "garage" startup. In either situation, we assume you are—or may become—at least peripherally involved with the oversight, management, guidance, or funding of a serious game or simulation. However, we're confident that the general-interest reader will also find the process of independent serious game development to be of interest.

Let's look at our six sections.

Section 1: Setting up Game Development

You've got a germ of an idea for a serious game that might solve a problem within your organization. Or you've just started up a tiny game shop, only you've never managed a development team before.

This section discusses the process of setting up game development: from the initial entrepreneurial or leadership itch to client acquisition and management, legal issues, staff hiring and team building, and project planning and management.

Several tongue-in-cheek fables will illustrate some key pitfalls of the setup phase, and solid nuts-and-bolts advice (rather than rigid adherence to development approaches) will offer you some guidance when you encounter challenges and obstacles.

Section 2: Determining Project Goals

Serious games and simulations should address specific problems or issues or promote specific causes or products. Instructional design (whether used in a training game or a promotional game) can nail down a client's or user's needs, set goals that answer those needs, and develop scoring and testing mechanisms to give both the user and the client immediate feedback on user progress. Without thorough analysis of the issues, the game is likely to lack focus or completely miss the target it's aiming at.

Section 3: Game Design—The Creative

With an instructional design in hand, simulation activities can now be designed, evaluated, and then translated into effective gameplay and game mechanics. You've got a game concept. If you haven't developed one already, now is the time to create a concept document (or preliminary design document), which will capture the essence of your game—both for your team and for potential investors or organizational higher-ups.

The concept document, and any storyboards or demos or miniprototypes you've created, should be tested to find out what's working and what isn't.

Section 4: Game Design—The Technical

Your concept may have made a delivery platform and selection of development tools obvious. But often, concepts may work on several platforms, and a plethora of software tools can help build the application. What should you be thinking about in selecting a delivery platform? What tools are affordable for your development shop?

With the winning concept tested and platform and tools in place, the creation of a design document, a bible for your development, is essential for production success. Think of it as a blueprint as you begin production.

Section 5: Production and Authoring

With a design document in place (which will continue to evolve), your artists, programmers, and other creatives can get to work producing the game. We'll look at graphics production; audio and video production; and how programmers and game designers produce core gameplay, user interfaces, and stable builds of the application.

Finally, a beta version of the game is tested and tested—but as we'll find out, testing should be done throughout production.

Section 6: The Finish Line

Once a golden master is produced, the serious game or simulation needs packaging (either physical or digital), distribution, and marketing. What are some of the deciding factors for choosing packaging and distribution? How can marketing be done when there isn't an obvious commercial channel for your application?

We'll answer these questions and also discuss user assessment methodology so we can begin to evaluate the success of our application (whether in terms of improved performance by the game player, an increase in fundraising, an increase in market share, or some other metric). We'll see if we can earn any kind of return on investment.

Summary

- This book is divided into six sections that roughly track the conceptualization, development, production, and distribution of an independent serious game or simulation.
- Let's go make a game!

SECTION ONE

SETTING UP GAME DEVELOPMENT

The Business Side

You can begin building games for yourself in your home office. You can amaze your friends with your ideas and skills. But while the term *serious games* refers to a certain kind of game, it also refers to games that are serious in their intent to make money (or at least, make your organization money by better branding or training) and serve a purpose. For that reason, the process of independent serious game development as we define it starts by talking about the things you have to do to bring in the game business and prepare for a development effort that has deadlines, legal contracts, and client approval.

You'll need to put together a team to do the work, and you'll have to have a plan for getting the project done on time and within the budget. Having a plan is critical; being prepared to manage the project as it progresses is something more. You can't manage a project well unless you have certain skills and practices that will allow you to do it. We'll tell you how to identify and acquire those skills.

We'll talk about these issues from the point of view of different kinds of game development groups: from those setting up a sort of independent game team within a larger corporate or organizational umbrella, to independent startups seeking venture capital before they approach potential clients.

This may not be where you want to begin your study of end-to-end game development. If that's the case, please jump ahead to the next section. But we suggest that you come back here later and consider this phase of development, because you'll need to set up your game development effort correctly if you want to succeed.

CHAPTER FOUR

Getting Started

Introduction

When we asked the readers of our previous books about ideas for this work, they almost all requested a strong emphasis on the business aspects of game development, including business development, client management, and project planning. The recommendations reminded us of our experiences in several startup companies, especially one where we were developing a series of sword-and-sorcery games. The efforts involved in starting up the company seemed to parallel the elements of the games we were designing. It felt like we were trying to build a corporate kingdom while slaying a high-tech dragon. As a result, we started creating tongue-in-cheek fables that illustrated some of the insights we were gaining as we went through the difficult process. Throughout Section 1, we'll present some of those fables as we look at the business side of game development.

What It Takes to Get Started

There are four ways you can become involved in setting up a game development effort:

1. You can contract with a game development company to build a game for you.

2. You can start a game development group within a non gaming business.

3. You can take on a game development project or projects within an Indie company.

4. You can start your own Indie game company.

We will look at each of those situations, especially the fourth, which is the most demanding, most rewarding, and most dangerous. But let's consider the others first.

Let's say you've just received a small grant to develop some instructional material for a government agency. What's next? Well, the grant may have specified that the product should be a serious game, or it may have been so open that it was

left up to you to decide the best approach to follow. In the case of Compelling Technologies (CTI), a group that specializes in developing training materials for the U.S. Fire Service, the grant specified a serious game. CTI's next step was to take its well-developed and already approved proposal and find someone who could design the game the company was proposing and then build it. The situation puts CTI clearly in category 1 on our list.

CTI felt that a strong instructional design was imperative with the lives of firefighters on the line, so the group came to us, people who know both instructional and game design. While the grant was approved and funding was on the way, CTI was able to use its own resources to sponsor the initial meetings needed to get the preliminary research and analysis done. At the same time, the company was able to identify and bring aboard a small game development house that would partner with us on the game design and then would build the final game. In sum, four groups came together to create the game: a client (the U.S. Fire Service), a management team (CTI), an analysis and design team (our group), and a game development team (which actually bridged two small companies). Figure 4.1 shows a concept sketch for the serious game CTI developed as the result of this effort.

FIGURE
4.1

Concept art for Compelling Technologies' firefighter safety training system, *Fully Involved*. ©2007, Compelling Technologies, all rights reserved. Used with permission.

If you were to create a getting started "To Do" list for Compelling Technologies, the company's tasks would be as follows:

1. Find the client.

2. Get the funding.

3. Build the management team.

4. Find the necessary design and development players.

Because CTI had its own limited funds, the company did not have to seek angel money or venture capital to tide it over while personnel wrote grant proposals and waited for those proposals to be approved and for the money to come in. In fact, the CTI team included a former fire chief who was well versed in the politics of identifying and creating promising grant proposals and who made that job go more smoothly.

Interestingly enough, the tasks listed here can be juggled to fit other situations. You may want to put together the management team and then find the client, or put the team together and then get some funding before finding the client. The important thing is to keep the management team small until it is time to get into the actual design and development, and to avoid any major staffing until you reach that point.

The general process is similar when working within a corporation or other large organization. Say you want to start a serious game development group within a high-tech manufacturing organization. You and a few ambitious and talented colleagues get together and start planning the creation of a game group. Again, the route will be as follows:

1. Find the client.

2. Get the funding.

3. Build the management team.

4. Find the necessary design and development players.

To find the client, ask yourself, Are there groups within the company who could use a serious game to help meet their business objectives, and do they have the budgets to make it happen? More specifically, is there a marketing group with a reasonable training or promotional budget that would buy the idea of a serious game to help sell its product or train its sales staff? How about your company's training or personnel department? Training departments have myriad needs that serious games can address. Personnel departments need help explaining payroll policies, equal employment opportunity practices, and open enrollment issues. Can you convince any of those groups to fund the creation of a serious game? Will the management of your own group let you do it? Will management help you set up the meetings with these other groups and join you in your presentations? And will management support the overhead you will need (legal, accounting, human resources, etc.)?

At the Hewlett-Packard Television Network (HPTV), we were very interested in the creation of an interactive game development group. (Even though the term *serious games* was not in widespread use at the time, that's what it was, so we'll use that term here.) The manager of HPTV helped us identify prospects within our umbrella department (corporate training); we found that the head of the management training group was especially willing and able to sponsor a series of learning games that

were effective for its group and brought needed revenue into our department. HPTV had a unique business model at the time that required that it show internal income to offset its overhead expenses. This made our boss's effort very pragmatic. It also helped because it meant that we had several people in HPTV whose specific task was business development. These salespeople were dedicated to bringing internal business into HPTV.

Consequently, they began to seek various other departments within HP training (and later, some divisional marketing groups) who might have a need for serious game projects. Throughout all of this, our department head played an active role. She helped make finding serious game business one of the top priorities for the sales group. She was present in all the initial meetings, adding the prestige of her office to those meetings. As a result, she enabled us to create what today would be called a serious game group within the corporate HPTV Network.

Because we had a group of graphic artists on staff and had media production people, what we needed were software development engineers. We were able to bring in these people as freelance contractors, and we mixed and matched them to the individual projects. At the time, adding headcount for such services was difficult, but as the projects piled up, we were able to add staff with these skills. In sum, we followed the model we described earlier. The head of HPTV worked with us to form a management team. The HPTV business development group found us clients and funding, and our internal staff was supplemented with the freelancers we needed to build the games we sold. We were lucky. We had the infrastructure already in place. But even without such a setup, you should be able to develop a serious game group within your corporate department if you can show (as we did) that the creation of a the group can help your department reach its goals, and help client groups within your organization achieve their objectives. In our case, we brought in a lot of projects and related revenues to HPTV and helped it survive and succeed.

If you're part of a company that creates games as a business and you find yourself in charge of a serious game development effort, the situation is clearly different. In this case, you're the game producer, and a lot of the work we just described in finding clients may already be done. If the company you work for also publishes games (as a lot of small, CD-ROM serious game developers do), your client will end up being the marketing group or the brand managers within the publishing group. Funding will be available, the management team will be in place, and key staff will exist as well.

If that is the case, then the challenges are these:

- Getting the project done on time
- Planning and running the project so that the workers produce quality work
- Managing the budget
- Keeping the client (product managers and marketing people) happy
- Getting along with the management team

Individual chapters on each of these subjects make up the rest of this section of the book.

But what if the project you are asked to work on is some kind of a trial balloon, an effort to see if serious games can be profitable within your Indie game company? Your job then is not just to produce the game. It is more entrepreneurial and more like the other efforts described on our getting started list. You'll have to make sure that your managers clearly understand the new serious game effort and its goals and that they will continue to appreciate the value of the effort as time goes by. You'll also have to see to it that they continue to provide ongoing support. You'll have to be an explainer and maybe even something of a performer. Depending on the seriousness of management's commitment, politics may enter the picture. You may have to fight to keep your key staff so that they are not siphoned off onto other projects that are more in keeping with the short-term needs of the company. You may also have to fight to maintain your budget if and when things get tight. Again, you'll have to be more than a producer; you'll have to start acting more like an entrepreneur.

The entrepreneur is the person in the fourth and most challenging of all the categories we listed at the top of this chapter, the person whose goal is to build an independent serious game company from the ground up. But all the other people seeking to become involved in serious games must at some time or another practice many of the skills needed by the entrepreneur. So let's discuss that role, and as we do, consider how the skills we are describing can be beneficial to you regardless of how you are involved in setting up a serious game development effort. What does it take to be an entrepreneur and build an Indie or serious game company from the ground up? Lots of things, but let's start with the most valuable and critical of all skills.

The Role of the Entrepreneur

The skill set required to be an entrepreneur includes a large number of intangibles, and that has led to a certain mystique about the leader or entrepreneur. Although it would be wrong to say that there is a single game company entrepreneurial type, it is true that certain requirements of the job attract a specific kind of person.

For example, you have to have presentation skills if you're going to impress venture capitalists or corporate higher-ups and clients. If you're charismatic and can convey a sense of excitement, if you can explain your ideas clearly (even your most abstract ones), and if you can create a vision in the minds of your employees, clients, and investors, then you have a chance to succeed.

Having a great interest in the game world and some interesting and original game concepts helps too. But those qualifications aren't enough. There is at least one more requirement. All venture capitalists and corporate leaders will tell you that you must have desire, a "fire in your belly." In fact, if you aren't insanely dedicated to your goal, you may not be able to make it through the difficult and discouraging times that are always a part of getting a game company off the ground.

Now, problems do sometimes arise because there are people with a fire in their belly who are charismatic, good at presenting concepts, and even good at coming up with unique and original ideas, but who aren't necessarily good at planning, day-to-day management, or delegating. And to make matters worse, the person who starts the company almost always feels that he or she is entitled to run it and reap the rewards of the Herculean effort needed to bring it into existence. When the person has those weaknesses, the weaknesses become magnified as the company grows. This is the dark side of entrepreneurs, and it's best to know about it from the get-go, whether you're interested in becoming part of the new startup or are the entrepreneur yourself. Thus, a cautionary fable, which focuses on the entrepreneur or, as the person should rightly be called in the game development industry, the Wizard!

FIGURE
4.2

A Corporate Wizard contemplating his serious game company.
Photo courtesy of iStockphoto. © David Earl Crooks, Image # 8386001.

The Wizard's IMP

Roland the Tall was a great and powerful wizard. He had fiery eyes, boundless energy, and the unswerving curiosity of a child. One night, he discovered the

(Continued)

thing he loved to do most in all the world: by casting a simple spell, he could create game companies.

Roland's spell contained one innovative idea, two parts luck, three parts enthusiasm, ten parts venture capital, and an IMP (a small, wiggly creature that he pulled from a bottle on the topmost shelf of his apothecary).

Then, *poof!* A bright, new game company began "tooling up" for great enterprise.

The place hummed with activity and gleamed with chrome fixtures, digital displays, *Star Wars* prints, and cappuccino machines.

The next morning, a prince arrived at Roland's doorstep with countless bags of gold. He was determined to purchase the company and its brilliant future. So Roland the Tall reluctantly parted with his toy.

But in a flash, Roland created a second game company, and it was also ready for business. It was created with the same spell: one innovative idea, two parts luck, three parts enthusiasm, ten parts venture capital, and a wiggly creature from a bottle on the wizard's topmost shelf.

This time an emissary from a triumvirate of princes was at Roland's doorstep ready to buy. Roland made the sale with relish, for he was fast becoming a wealthy wizard doing the thing he loved best in all the world.

Roland banged out a few more game companies, joined the lecture circuit, appeared on television, and was interviewed by Jon Stewart. He was even asked to pose nude on the cover of *Vanity Fair*, a proposition that he modestly accepted.

But out in the real world, something wasn't quite right. Those hot new game companies were beginning to turn a funny shade of green. Then, whole buildings imploded, and workers lost their jobs. It seemed that those companies made games that taught people nothing at all and that nobody wanted to play.

The princes who had purchased Roland's handiwork formed an angry mob. They cornered the wizard and demanded that he fix things.

Roland the Tall postponed his television interview, returned to his apothecary, and checked into his formula. Perhaps he had left out an essential ingredient. He inspected the bottle labeled "IMP" from which he had pulled that nasty little wiggly creature, and he found these words:

(*Continued*)

Imp:
100% pure extract of impulse and whim
An artificial substitute for planning
Yields impressive results quickly
But deterioration sets in at once.

Roland the Tall laughed out loud. So a successful game company took *planning* of all things! Roland would never waste his time on anything like that.

Instead, he attacked his princely purchasers for bad management and poor follow-through. And Roland the Tall kept right on building game companies on impulse and whim. And he kept right on selling them to the unsuspecting buyers who, in turn, continued to pay handsomely for the privilege…

of going bankrupt.

The Moral of the Fable

The problem with wizardry in our world is that it really does exist. All the seductive powers of Roland the Tall are at play in the magical world of game building. We know. We've worked for Roland. You have to understand those seductive practices before you sign on.

But maybe you aren't signing on. Maybe, you realize one day that *you* are the wizard, which means that you are required to perform all the tasks needed to set up a game development company or department.

The Role of the Wizard

Let's look at the role you have to play in simply getting your game company or serious game department off the ground. As we write this, we have to confess that we're recalling several would-be entrepreneurs who came close to starting great companies yet couldn't make it happen.

1. Get Your Ideas Squared Away

Just write them down, diagram them, do a PowerPoint about them (only for yourself), or build a little mockup. But figure out what they are. Think them through. Make sure your ideas are in the nature of solutions, not merely a new game mechanic! Create an "elevator pitch" (the whole concept presented in a few well-chosen words), something that you will later be able to lay on an important decision maker when he or she is trapped in an elevator with you for a few moments. It will give you the essence of your concept and your goal. Then run the pitch by a few

really close friends and get their input. Revise it. Improve it. Get more input. Do they like your ideas? Are they enthusiastic, or are they just being nice? Consider their judgment and be honest with yourself. Is this idea really worth the effort and suffering it will take to get it off the ground?

2. Set up Your Team

Remember that common weakness of Roland the Tall and other entrepreneurs and wizards? They may have lots of presentation skills and good ideas, but they often do not know how to manage the details. The answer to this problem is to put together a team of experienced people who get along with each other, whom you'll trust, and who can keep the company running. This "management team" is just what venture capitalists, corporate executives, clients, and sponsors look for in any new venture. You have to show them you have people who can find the business, cultivate the client relationships, and deal with the legal and financial issues, as well as come up with the ideas for the games and then build them. The management team needs to be small, but its presence and competence will be critical. How do you get team members on board? That's what wizardry is all about—sharing your vision and excitement. Paint that picture of your wonderful future company.

As you're putting your team together, identify some champions, those who know the business, understand how to succeed in your particular area, and can offer guidance and support. For the purposes of this discussion, let's say you want to start your own Indie game company, but you think you need some funding and a small staff to get it off the ground. Find someone who has succeeded in the area, maybe someone who writes about it or has funded companies that work in the area or has marketed to it. Go to the Independent Games Festival, the Game Developers Conference (GDC), and other game conferences where experienced hands share their experiences. They know a lot. Offer one of them an advisory role in your operation. Look for someone who has good chemistry, whom you enjoy being with, but also look for someone who can help with a funding strategy and can recommend venture capitalists (VCs) or clients with enough funds to help you do serious game development for them while they provide the overhead support to allow you to follow the rest of your vision.

If you're in a large organization (public or private) and hope to start your serious game effort there, find a mentor, someone who likes you and understands your goals. If he or she also understands the company, you will be able to ask about the politics and processes needed to make things happen in that environment. That mentor can also open doors with future clients.

3. Plan

This does not mean make a business plan. That comes later. The planning that has to happen at the start of your enterprise is based on your idea. What would it take

to make the concept understandable to clients and VCs? For example, maybe you have a unique approach to a serious game, and it has features that are clearly superior and valuable. How can you present it to potential serious game customers in such a way that they'll want to hire you to develop a game using your idea? (If they hire you to use your idea, they'll not only be paying for the implementation of the idea, they'll be hiring you to build a product that you can use as a prototype when seeking future customers.)

If you feel you need funding right away and decide to present to VCs, you have to ask yourself, are the features of your idea so unique that they are patentable? Is this legitimate intellectual property? Intellectual property (IP) is the real Holy Grail of corporate kingdoms, not to mention VCs. Once you've found your Holy Grail, funding just might come pouring in. In your planning, work with your champions to figure out just how real and valuable your intellectual property is. Then decide how you will illustrate or demonstrate it to investors.

Do you need a demo? (Sometimes a paper-and-pencil mockup will do the trick.) You have to be realistic about the question, because building demos may require the hiring of people with specific expertise. If you're trying to start a company, it may take you out of the garage and into an office space big enough to house a team of developers. And it may mean that you will need some initial funding (seed money) to get started. If you're with an organization, it may mean hundreds of extra hours doing something that the organization will probably feel it owns just because you developed it on the organization's premises. If you are doing it for the organization, that's okay, but you'll have to surrender it to the organization in any case. At this point you may want to reconsider finding a client to fund an actual project that will allow you to create your serious game and implement your idea without the help of VC funding or seed money.

There is no doubt that time will be of the essence—and if the market conditions are right, if there are clients available, and if you're running out of money, that will surely be the case. But consider successive approximations:

1. Do a one-page write-up, and try it out on your key champion and other advisers and friends.

2. Then create a PowerPoint presentation, and try it out again on a fuller circle of champions, mentors, and colleagues you're comfortable with. You might even show your presentation to a few associates or friends-of-friends who know something about the business or your prospects. If they *get* your concept and your capabilities, this may be enough to give you something to shop around. If not, go on to step 4.

4. Build a Demo or Prototype

The big difference between a demo and a prototype is whether or not you're actually showing the capabilities and features of your concept at work (in which

case, it's a prototype) or if you're only pretending to show them (clearly a demo). We discuss the values of each in the upcoming chapters.

Briefly, the general belief is that prospects and even "angels" (folks who will give you seed money to get started) will accept a demo. VCs will need to see a prototype. In either case, you are now faced with an interesting dilemma. Where do you find the people you need to build the demo or prototype? The answer is you try to find someone who will work on the speculation that the individual or group will have a role in the future company. Now that you're the wizard, you have to do whatever it takes to work your magic on these prospective employees who will really be working for nothing. Remember all the things that Roland the Tall did? You have to do them too: you have to conjure, you have to sell a vision, you have to bribe, seduce, and everything else.

5. Create a Business Plan

This has to be a document and a presentation. If you're pitching to VCs, you'll need about 60 pages plus a 15-slide PowerPoint summary version of the plan. You'll need to pack the plan full of content. Who are the customers for your product? What is their greatest need, and how do you answer it? You have to have statistics to back it all up. What is unique about what you have to offer? In what way are you better than your competitors? And in the end, what will this do for your customers' bottom line? If you're in a corporate environment, the same kind of plan will be needed, but in that case you'll have to have some sense that the prospective decision makers will be willing to hear your plan and give it serious consideration.

We'll go into this in greater detail in Chapter 5 on client acquisition, but realize you may have to find someone to help create the plan, and that will probably need to be a marketing person. (Professional writers, of course, can write almost anything, even on subjects they know nothing about. So as an alternative, an experienced writer could research and create a viable marketing plan, but he or she won't have the perspective and is unlikely to have the contacts.) Does a startup serious game company need a marketing person or even a writer? Maybe not, but you may need the services of such a person for a short time, and you'll have to conjure and seduce to convince the person to work for free.

6. Create a Budget

We'll dig deep into the subject of budgeting in Chapter 10. But for openers, if you're working within a large organization, you need to work some magic on a few of the brighter folks in the finance group and ask them to help you put some numbers together. In a corporate effort, you'll at least need to budget for a project. But if you're thinking of creating a whole department, you'll need someone who knows salaries and benefits packages, overhead and equipment costs, taxes, and the like. It gets complicated. Begin by determining just what your management will require

and expect. It has to be a serious and respectable effort. You'll probably also have to project income from successful projects to offset your costs, and you'll have to cite sources for your data.

At Paramount Pictures, we had to put together a plan for the simulation group we set up and ran. We had to show the cost of staffing, benefits, and office space on the studio lot for our people as well as the income we projected from the sales of the serious games we intended to create.

If you're trying to start your own company, your initial advisers will likely be able to help you determine just how much money you'll need to allocate to each element of your project. But before you're through, you'll need a finance person to create the spreadsheets, verify the costs, and figure in the overhead and taxes. Experienced finance folks know how much square footage you'll need to house your staff when the company gets rolling. They'll know how to figure the cost and amortization of the kinds of hardware and software you'll require. (In Chapter 20, we'll be discussing some of your software needs and costs.) If you think everyone can work out of their own homes and provide their own hardware and software tools, the finance folks will still be smart enough to ask about telephone charges, Internet access, health care benefits, overtime, and similar issues. Bring on the finance man, woman, or team, and see how they get along with you and the rest of your advisers. Make it a trial affair, because the director or vice president (VP) of finance will sit in one of the most influential positions in your would-be little company, and you'll want to see how you and everyone else gets along with this critical player.

7. Prepare Your Pitch

With the demo, the business plan, and the budget in hand you're ready to pursue corporate higher-ups, clients, VCs, angels, and anyone who'll talk to you. This is where you have to stand in front of the mirror and work your magic. Are you really a wizard? Can you really conjure up a believable image of your wonderful new serious game division, company, or empire? Can you seduce millionaires to invest in your dreams? Try your darnedest. Practice. Then make a critical judgment. If you're not able to be the wizard, then you need to find someone else who can do it. But before you give up, go to wizard training school. Take some courses in public speaking, hire a coach, or join Toastmasters. Give it your best shot. Because the alternative to doing it yourself is to find a person who can be your wizard, and that person will want to be CEO of the company and run things. So either learn some magic or get ready to step back and let someone else take charge and get all the glory.

The Road Ahead

The chapters that follow will take a closer look at the processes of finding clients, getting their business, managing the relationship, building your team, and planning the first project. Future sections will then take you through the whole game development

process. But in this chapter, we've tried to focus on the job of getting started and the role you will have to play if you want to be the person who makes it happen. We've looked at the mystique of the entrepreneur, and we've asked you to face the critical question, have you got what it takes to be a wizard?

Summary

- There are four ways that you can set up a serious game development operation:
 - You can contract with a game development company to build a game for you.
 - You can start a game development group within a nongaming business.
 - You can take on serious game development projects within an Indie game company.
 - You can start your own serious game company.

- The getting started "To Do" list for the first three of those groups (and in some cases all of them) boils down to these tasks:
 - Find the client.
 - Get the funding.
 - Build the management team.
 - Find the necessary design and development players.

- Starting and running a serious game development company or establishing such an operation within a much larger corporation requires a certain amount of wizardry. We've described those magical skills and painted a picture of a successful wizard who also, unfortunately, had a dark side. We've suggested that this dark side is prevalent in the high-tech and game industries. We have also outlined the steps you have to follow if you want to be the wizard, overcome the dark side, and start your own serious game company or department:
 - Get your ideas squared away.
 - Put your team together.
 - Plan.
 - Create a demo or prototype.
 - Create a business plan.
 - Create a budget.
 - Prepare your pitch.

- Finally, we've asked you to make sure that you have the skills and talent needed to be a wizard. If not, we've suggested that you either learn them fast or find someone else to do the job (in which case you'll have to move to the back of the room).

CHAPTER FIVE

Client Acquisition

Introduction

Whether you're starting up an independent game company intent on producing serious games or are trying to launch a serious game effort within some other kind of business, the task of getting and keeping clients is critical. In the previous chapter, we suggested that part of the process is to establish mechanisms for finding clients as you set up your operation. If you're trying to create a game development group within another kind of organization, you need to start by convincing your department head to help you find clients and use the clout of your existing department to gain entry to prospective customers. We also encouraged you to look for champions within other parts of the organization who would have connections with prospective clients. We mentioned the training, personnel, and marketing departments as prime target areas for a corporate in-house serious game business.

When we spoke of Indie startup companies we mentioned that angels, venture capitalists (VCs), and advisers all might be sources of referrals to prospective clients, and we even went so far as to suggest that, as you search for members of your management team, you try to find people who have access to potential clients, either from their previous business experience or through other kinds of personal contacts. All of that was intended to stack the deck in favor of having a good base of potential customers when your operation is ready to get under way.

But there is more to client acquisition than just lining up people who can help you identify clients. Someone has to go out and meet them, ask them for their business, and maintain and cultivate the relationship. How do you systematically find and develop clients? How do you assure a continued flow of work and income for your operation? Can you do it all by yourself, or do you need to work with other people who are dedicated to that effort? That's what this chapter is all about.

Marketing versus Sales

Let's say you're starting up a new company to make serious games and entertainment games, and you decide that serious games are a way to get the capital needed to get your company off the ground.

You've identified the members of your team and have them on board. A few of them know people who might be interested in serious games, but even though they've tried, none of them has really been able to come up with an actual paying customer. What do you do next? You probably decide that you need someone to focus on getting you those customers. So you go out and find a person to be vice president (VP) of marketing (when you're a startup, everyone is a VP).

The VP of marketing comes in and starts talking about your marketing message, market research, a marketing plan, pricing, advertising, and things like that. You say, "Find someone who will pay us to build a serious game," and the VP says, "That's not what I do. I'm in marketing. You're talking about sales."

In a sense, your new VP is right. Marketing and sales are not the same thing. But there are plenty of marketing people who have sold and salespeople who have been in marketing. What's the difference?

Here is what the marketing person is going to do:

1. Figure out the best way to describe your product so that your customers will understand it and see its value.

2. Come up with a whole strategy on how to position your product among the other products that are just like it out there.

3. Decide which parts of your product you need to focus on and which you shouldn't waste your time with because no one will care.

4. Set the price for your service based on what it's worth to the customer while still providing optimum profit to you.

5. Look at industry trends and make sure that the industry climate is right for your product.

What the marketing person will *not* do as part of his or her job is start making phone calls and knocking on doors to ask for business.

In the previous chapter, we suggested that it is important for you to decide early on who you are (your identity, your image), what your product is, and what kinds of customers are out there. Depending on what kind of team you have, you may be able to answer those questions in a way that will satisfy a potential customer.

But if you decide that you need to tap into some venture capital or other kinds of funding to get your operation off the ground, then you'll absolutely need a marketing person and a business plan. The VP of marketing may want to hold focus groups about your company, its image, and your product. He or she may want to make presentations to several sets of select people and see what they think. He or she may insist that you go to market research groups and buy the latest demographic data on the potential future of the serious game business and new technologies that may enhance or destroy it. You may need money for that kind of market research too. In the end, your marketing person will want to prove to potential investors and clients that you have done the "due diligence" necessary to run a business.

FIGURE
5.1

> **Creating Your Business Plan**
> - Establish Your Mission Statement
> - Determine Your Product Strategy
> - Define Your Product
> - Define the Customer Advantage
> - Define the Marketplace
> - Define the Competition
> - Identify Your Competitive Advantage
> - Determine Your Revenue Model

Tasks required for the creation of a business plan and, incidentally, a good outline for a PowerPoint pitch to potential investors.

All this collected data has to be put together into a business plan that can be presented to investors or corporate higher-ups, and, if done well, it will surely help you acquire the funding you need to get your operation off the ground. Figure 5.1 shows the typical tasks you have to complete to create a business plan.

Establishing your mission statement will help you come to grips with your purpose, your long-term goals, and, as a result, who you are. It may help you choose a name for your organization and even set the tone for the creation of a logo. And it may be the one topic that you and your team can do without any additional help.

This is not a book on writing business plans, but even if your marketing person knows the subject well, you could still benefit from reading one of the many publications on the subject. The Small Business Administration offers a guide to business plan writing and even templates you can use to create them. The Small Business Planner web page is shown in Figure 5.2.

Sales

Let's face it, sales is the worst job in the world. It takes a tough skin to face up to a lot of people who won't be interested in your product unless you sell, sell, sell. Sales folks are tough. The rest of the world doesn't like them and has become very good at slamming doors in their faces. Salespeople routinely go to seminars that get them charged up enough to keep doing their jobs. They have to do that, because the act of selling something to people who don't want it is painful. That's why the salary curve for salespeople within companies is detached from everyone else's. There is often no ceiling to the amount of money they can make. It's all tied to a commission on the business they bring in. If you are lucky enough to find a dedicated sales professional who is willing to develop business for you, it might be worth it to bring that person on board.

But if you can't, there is an alternative. You, as the head of the company, should take on the sales role. This isn't a bad idea at first, because the head of the company

FIGURE
5.2

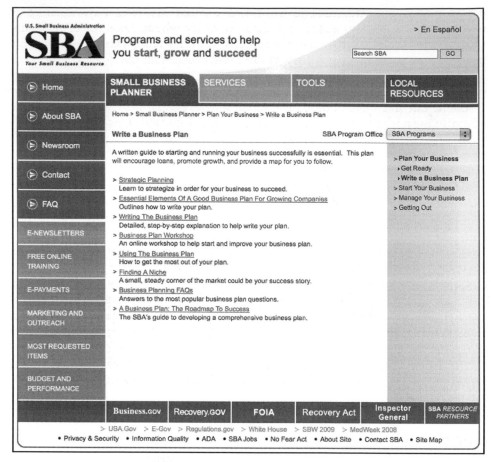

U.S. Small Business Administration Small Business Planner homepage, offering advice on how to create a business plan.

always knows more about the product and is more passionate about it than anyone else. That passion is contagious; that passion is what lights up your eyes when you describe your product. That passion is what *sells*.

Prospecting

The first step in the sales process is to put together a list of people who could use your service. If you're an independent, look for organizations in your area that need the kind of serious games you can build. Start with the Internet. Visit corporate websites. Find the names of the department heads of those companies. List those

people. Rank them according to the likelihood that they will buy. Then go to developer websites. Find out who is doing what for whom. Look for connections. Go to game development online publications. Look for ads posted by clients who need work. Check out Craigslist; jobs are posted there that could lead to projects. Then look through print media; read the want ads and the advertisements for local organizations who could be clients.

Check out trade magazines in your area of expertise (sometimes companies advertise there for developers). Look at the articles; search for people who are doing what you want to be doing and see who they're building projects for. Get ideas about kinds of clients who could use your services. Again, use the information to build your prospect list.

Use LinkedIn. It'll open the door to contacts and referrals; discussions on practically any business topic, which can lead to greater market awareness; potential business opportunities; and even venues for speaking (to raise your industry profile). (See LinkedIn's blog for further tips on its usage.)

Check out all the conferences on serious games or in the subject areas that you think will best show off your work (medicine, finance, engineering, programming). Find out where those conferences are and when they are. Then determine if you can afford to attend any of them. If so, add the conferences in a separate area of your prospect list. Try to become a speaker at one or more of those conferences. Check out the other speakers. Determine if there is any chance for a preconference discussion that will help shape your presentation.

Use all these resources to build your prospect list and, in every case, try to get the name of a person or at least a department to contact in a company that can use your product.

Gather Referrals

Expand your prospect list through referrals. Join several business networking websites. Talk to everyone you know, including your own staff. Ask if anyone knows of any companies or individuals who could use your product. Add those names to your prospect list. Ask those people who do have contacts to make a call on your behalf, and see if you can involve them in promoting your service. You're looking for an appointment. You want to get in the door. You want to talk to someone who can be a client.

Make the Appointment

Make a call list of all your prospects and referrals, starting with the most promising, and then just go down the list. Call yourself. Have members of your team call. If you have an assistant with a great voice and personality, have him or her make some of the calls to try to set up appointments for you. (If you go this route, make sure that what the assistant says is well scripted so that the message is perfectly on

target. Actually write out a little speech of you need to.) Keep calling until you have some meetings set up.

Chances are that the referrals will be better received than the "cold calls" (calls made on people you don't know and who had no idea you were going to call them). But big organizations are often receptive to service providers and have procedures set up to at least hear your pitch. Eventually you'll get a chance to tell your story. Ideally you'll get several chances, and if you're smart, you won't schedule the more promising pitch first. In the beginning, find a low-threat, low-risk prospect to listen to your message so that you are able to practice your presentation in a less critical part of the real world.

Demonstration versus Prototype

We mentioned both demos and prototypes briefly in Chapter 4. A *prototype* is a working model of your product; a *demonstration* is a *pretend* working model. To create a demonstration of the features of your serious game, you could make a PowerPoint or a Flash demo that shows off the talent of your staff, the quality of your writing and instructional and game design, and any neat features that are unique to your system.

If you build a prototype, you do much the same thing, except that it has to work on the platform that you're proposing, and the client has to be able to use it (play some part of the game). The buttons have to work, the links all have to be there; the feedback, the audio, the video, or the animation has to be real. You can mock up a little demo on late rainy afternoons in a few days. It takes a couple of dedicated programmers weeks to build a prototype. If you're going to build your game in *Unreal Tournament* or in any of the other game engines available, then you'll have to purchase or license the software and have people trained to use it. (We'll discuss the acquisition of game engines in Chapter 20, and we'll examine prototyping in several upcoming chapters.)

Conventional wisdom is that clients and VCs are less impressed with demos than they are with prototypes, because if you can make a prototype you have pretty much proven that you can make a finished product.

The answer to the demo versus prototype question is really one of time and money. If you have the time and money, build the prototype. If you don't, make the demo, launch the sales effort, and start working on the prototype in the background.

Prepare the Pitch

Ideally, you've already thought of what you're going to say when you get in to see a client. You've got your demo. You know the answers to those marketing questions. You may also want to prepare a handout or leave-behind sheet that has all

the pertinent information and describes your product's features and benefits (see Figure 5.3). Make sure it has your contact information and is attractive, because it will say something about who you are and the kind of work you do long after you are gone.

The exercise of forcing yourself to think of your product in terms of customer benefits may have its own rewards. Often developers become enamored with some novel piece of technology that is cool in itself but raises the cost of the product and makes no difference to the customer in the end. When you follow the formula in Figure 5.3, you learn that if you say something like "When you use our game's new X feature you'll be able to …" and there really is nothing tangible that the user will be able to gain because of the feature, maybe that feature (maybe even your product) isn't that marketable after all.

You need to be able to say, "When you use our game's new X feature, you will increase your ability to make decisions under stress!" Or to offer yet more detail, you can say, "You will increase your ability to make decisions under stress when you use our new simulation with our patented stress inoculation system."

You also need to create a PowerPoint presentation that introduces you and your company and can help you through the presentation (it should include 15 slides maximum). Make sure it looks good. If you don't have graphic skills, use one of the templates that come with PowerPoint, or download a free one to be a little more original. If you want to add pictures (and they always help), download some appropriate images from a free image website. Figure 5.4 shows a PowerPoint slide from a pitch for an advanced advergaming service. A complete feature benefit statement might say, "You get a tremendous cost savings: no fees for test marketing, primary placement for regional expansion, and the rest, because you participate in the pilot of our service."

Tailor the pitch to the particular client. Add a specific slide to the PowerPoint presentation that addresses the company and its needs. Then rehearse in front of

FIGURE
5.3

Feature Benefit Writing

- Customers want to hear about what a
- product will do for them.
- These are called "benefits"

 To write feature/benefit statements
 complete this sentence:

 – *You will get - (this benefit)*
 – *Because our product has - (this feature)*

- *EG:*
 – *You will get improved employee skills*
 – *Because our serious game has a solid instructional design*

The formula for describing product benefits. Sit down with your partners and figure out what your application's features and benefits are, using this formula. Then add it to your pitch.

FIGURE
5.4

Sample slide from a PowerPoint pitch.

members of your staff and your friends. Invite a second person along with you to take on part of the presentation. Depending on the character of your product, take along the person who knows the areas you don't (the chief engineer, your lead creative, your instructional designer)—whichever role helps differentiate your service. Then you're ready to pitch.

Make the Pitch

You need to make a good impression and fast. Look around the prospect's office or the conference room. Look for anything there that can spark a conversation: pictures of kids, boxes of software, anything that you can use to break the ice. Begin with that conversation, and then, as soon as you can, get into the actual show. For a demo, bring your own computer or make sure that the prospect has a system that can show it from a flash drive. But bring your computer as a backup anyway. In fact, have members of the team bring their systems as backups to your backup. Arrive early enough to set up before the key decision makers are gathered. If you do need equipment, you have to talk to an administrative assistant early on so that he or she will have things ready for you. It's that person's job, and the assistants are

usually happy to help. Plus, if you treat them with respect and appreciation, you'll have developed an inside contact at the company.

If this is a prospect (as opposed to a venture capitalist), don't leave the meeting without determining the next steps in developing the business. Set up a follow-up meeting. Get another contact who can get the ball rolling. Find out who that person is and, if possible, have someone agree to make the referral. You need a way back into the organization if you're ever going to succeed.

Don't Get Discouraged

You only need one client to get started, right? So you can have a hundred failures as long as there is a success in the end. Immediately after the meeting, have a post-mortem with your team. Decide what worked and what didn't work. Fix missteps based on the input you get. Then keep trying. If you realize that you were never meant to be a salesperson and you blow it every time, then get a pro to do the job. Yes, hire a salesperson. Use commissions, company equity, or any other means of inducement you can think of. And all the time you are working to find a client, keep revising and improving your prospect list and your demo.

Serious Game Contract Development as a Revenue Stream

Making money as a development contractor in the serious games or simulation arena is no slam dunk. But Justin Mette, founder of small game development company 21-6 Productions, believes it's possible.

"Serious game contracts have been paying over half of our bills each year for as long as we've been in business. They started out as just contract gigs to pay the bills but have evolved into a very rewarding experience. Helping kids learn math or giving firefighters some confidence for when they're facing life-threatening situations result in a lot of pride from our work."

Mette recommends that small startups do the spade work to expand into the serious game arena. "There is a lot of money through grants and investors available to build products that help our society. Also, a lot of people are trying to build companies in that space without the knowledge of how to build the game itself. Whether you're looking to supplement income or to focus on them specifically, there are a lot of opportunities available."

(Continued)

Adrian Wright, founder of Max Gaming Technologies, concurs. "We've paid the bills for the last four years working in the serious games arena, and with the growing realization that interactive learning works, I see that continuing."

One bonus Wright has found is that "it's actually a great way for an independent development company to build its talent pool, as large game development firms normally shy away from this area of the industry."

Networking

Conferences are a tremendous resource for education about an industry and its applications, and can be a good venue for cultivating potential clients and referrals.

A number of trade conferences focus specifically on serious games and simulations, and most of these conferences are held annually:

- The Game Developers Conference contains a track devoted to serious games.
- Games for Health and Games for Change conferences are dedicated to specific flavors of serious games.
- The simulation arena is represented by MODSIM World (modeling and simulation), ITSEC (Industry Training, Simulation and Education), and MMVR (Medicine Meets Virtual Reality).
- Numerous professional education conferences have tracks devoted to digital forms of learning, including serious games and simulations.
- Advergames have had various conferences and forums devoted to them.

Summary

- These are the nuts and bolts of client acquisition:
 1. Answer some basic marketing questions about yourself.
 2. Develop a business plan.
 3. Create a demo or a prototype, depending on time and money available.
 4. Identify prospects.
 5. Gather referrals.
 6. Go out and sell.

- Another way to gain projects and funding has to do with acquiring money from grants: government grants, military projects, and educational programs. Securing grant funding takes special expertise (grant proposal writing, political networking skills, and sometimes even security clearances). Organizations that specialize in these areas often make it their sole focus.

- If you're an independent game developer, your job will probably be to work as a subcontractor for one of those companies. To get the company on your prospect list, check the Internet to discover grants that have been awarded in various areas, and then use the steps presented in this chapter to call on those companies. Attend trade conferences to stay up-to-date on issues, and cultivate client and referral contacts. Links to conferences and further information about client acquisition can be found at **endtoendgamedevelopment.com**.

CHAPTER SIX

Client Management

Introduction

Who is your customer? In the serious game business, it may be the firefighters who are playing your game to learn safety techniques. It may be the soldiers who use your simulation to acquire leadership skills. It may be the kids learning how to prevent fires in their community or who play your games just for fun. All of those groups could be considered your customers. But in this chapter, those are not the customer groups we're discussing. Instead, we'll focus on the representatives of the game publisher or organization that has commissioned your serious game, the entities you work with day in and day out during game development—in other words, the client.

In the 1960s and 1970s, the slogan for good client management was "The customer is always right!" In the 1980s and 1990s, client managers got a little more honest about it. The new expression became "The customers may not always be right, but they are always *the customers*." Translated: the customer is the one bringing in the business and paying the bills. The customer (at this point) is the one who can take the business away and stop the influx of income, which will eventually lead to your company's demise.

Many game companies survive based on one or two customers alone. But they may really want additional customers and want to build their business. Interestingly enough, if they think about it, they will realize that the key to getting *new* customers is actually keeping their *current* customers happy. Word of mouth is the key to finding new customers and growing new business. The first thing a new prospect may ask for is a referral from one of your existing customers. Old and new customers may be colleagues. The old customer may be able to refer you to associates who can become new prospects and customers. The current customer is still the person whose word means the most, far more than the word of your best salesperson. So in the end, there is no getting around it—the current customer has to be treated with care and managed carefully.

Today's slogan should probably be "The customer is always *the customer*, right or wrong." Customers can be demanding, they can be unreasonable, they can be impossible—but at the end of the day, if you figure out how to work with them, treat them with respect, and keep them happy, you can go a long way toward guaranteeing your company's success.

We're going to outline the steps you can take to help assure customer satisfaction in the game development business. There will be times when the demands of the customer and the demands of your development team are at odds. You have to build goodwill during the good times in order to be prepared for those bad times. Here's an example we encountered about a year ago.

We were producing a game for a major commercial game publisher. Our game was pushing up against a deadline set to assure that the game would be out in time for the holiday season. The problem was that after months of beta testing, one small bug continued to be elusive and was still being reported by the quality assurance department. We might have tried to talk the customer into living with a bug that only occurred if 75 wrong things were done in a specific wrong order by the game players, making the chances of its occurring somewhere around a million to one.

But because we had developed a trusting relationship with the customer and had been straightforward along the way, we were able to talk the publisher into supplying the extra funding needed for express delivery of the golden master to the Asian production house. This bought us the extra time we needed to find the bug and fix it. If we had been working in an adversarial relationship, it never would have happened. Everyone would have started blaming everyone else; the game would have missed the target date and probably would never have seen the light of day. Everything got easier because we had a positive relationship with the client.

How do you build positive relationships with clients? We'll tell you how to do it in this chapter, starting with the must fundamental method of all—recognizing their authority.

FIGURE
6.1

Classic tools for asserting authority.
Image courtesy of iStockphoto. © David Earl Crooks, Image # 7865140.

The Authority Dance

The first thing people learn when they are given authority is that being *given* authority doesn't mean that you *have* it. The Constitution of the United States of America says that the people in charge have to *derive* their authority from the *consent* of the governed. Now that's in a constitutional government, but even royalty like kings, queens, and corporate customers have to assert themselves enough to make sure that everyone knows they are in charge.

The governed sometimes need a little *shaking up* before they finally get with the program.

Moreover, in addition to the initial effort needed to gain the consent of the governed, considerable energy is expended every time the ruler brings someone new under his or her control. All that shaking soon takes on the aspects of a royal ball or authority dance in which Her Royal Customership, for example, has to put on a show of authority to convince vendors and project managers that they have to give their consent to being governed.

In light of all this, you can see that you can really ingratiate yourself to any ruler, new boss, or customer by shortcutting the authority dance and giving immediate consent to being governed. You don't have to do it in so many words, of course, but as it turns out, that isn't a bad way to go. For example, you could begin any recommendation or proposal with the phrase:

"Of course, you will have the last word on this."

Or you could say, "Of course, we will do it any way you want, but I suggest...."

Does that make you a "yes-man" or "yes-woman"? Not if you play your cards right. The fact is, once you have given the corporate customer the proper nod, you will then be able to do just about anything you want. Let's face it, in this busy world, kings, queens, and corporate customers have their hands full shaking things up and going to authority dances. There really isn't time to figure out which of the people who have already given their consent are reneging. Most royalty say to themselves, "I've got their consent. That's good enough for me!" And they are usually right.

Once you've paid your respects, the only thing left to do is to allow kings, queens, and corporate customers to check in periodically so that they can make sure you continue to give your consent while they go about completing the commitments on their authority dance card.

In the meantime, you may have bought yourself the freedom to do most things just the way you want.

Let's return to our example relating to the million-to-one-shot bug fix. We had built our level of trust with the publisher (our customer) by starting with an acknowledgment that the publisher was our customer, and we would give our customer what the customer wanted. From that point on, we were all on the same team, and that is when we could ask for the added funding for the express shipping that would buy the time needed to fix that last, most illusive bug.

Making Friends with the Customer?

One of the cardinal rules of management is that you can't be friends with your employees or you'll never be able to make the demands you have to make to be in charge. It may be that most of the time you really can't be friends with your customers either. But if you get a chance, you should try.

In developing sales and interpersonal training over the years, we've studied the performance of many expert salespeople and client managers. They all have different styles. Some are push, push, push; others are folksy. They take their time. They get to know people.

One good model was a salesperson who sold products for a media equipment and supply company. He wouldn't ask for the order when he walked in the door; instead, he'd talk about everything but that. He'd hint at some piece of business news that related to why and how the customer should place an order. But he still wouldn't ask for the order; instead, he'd shoot the breeze until he was about ready to leave. Then he'd end with a phrase such as "So what do you say? Should I put you down for a few dozen boxes of those?"

Client managers can work the same way. They need to get to know their customers and develop a sense of mutual understanding that helps build a sense of trust. Find things to talk about; look for common bonds. Then, when the tough stuff comes along, the groundwork has been laid for working through it together. When the customer and the client manager meet, even over the bad stuff, they can fall back on a good positive relationship. It helps.

On one of our most recent efforts, we heard about a serious game company that was bidding on an important contract. We also learned that the company was interested in subcontracting with a game designer when it got approval for a contract it was bidding on. After an initial and very positive phone meeting, we flew to the company's location and had lunch with the principals. We spent a lot of time getting to know each of them by talking about films we liked and our experience in the movie business, about novels that appealed to us, as well as our favorite European travel destinations.

It was only after we had gotten to know each other through most of the lunch that we began to talk shop. We explored their projects and the needs they expected to have. We tried to focus on the know-how within our little organization, and when the time was right we asked for a chance to put a development plan in front of them. They asked for a nondisclosure agreement, we agreed, and even though

our operations were thousands of miles from theirs, we were soon exchanging proposals, signing contracts, and heading off on a long and fruitful collaboration. Eventually a few complications arose, but because we had established a friendly relationship, a strong element of trust existed, and we were able to talk openly about our mutual problems and solve them amiably. Are these people personal friends of ours now? We think so.

Dealing with International Customers

If you're working with an international client, especially in his or her country, protocols exist that you'll have to follow to establish a client-provider relationship. It's not really about friendship then, but it is about respect, and in many ways that's close to the same thing. International clients will want you to demonstrate that you're eager to know them and to know their culture.

In the complex dealings we had with Japanese companies when we were developing an interactive adverbusiness application several years ago, we worked with them every day of the week side by side (in Tokyo), and that working relationship started the minute we got off the plane after a 15-hour flight at three in the afternoon on a Sunday. They expected us to hit the ground running, so that's just what we did.

A Japanese executive was assigned to us. His job was to make sure that we understood the protocol, but we soon learned that there was even protocol to be followed in dealing with him. What made that initial contact work was an open and respectful attitude on our part. We wanted to like the guy on his terms, and he could see that. That made him more comfortable, and he did a great job coaching us and seeing to it that we participated in the traditional Japanese corporate activities the way we should.

We ended up doing everything right. It helped that we were enthusiastic about the culture and the people we were working with. It's possible to go too far with enthusiasm, of course, but if you're respectful and interested in learning, the experience can be amazingly rewarding in every way.

Work Your Tail Off!

This may seem like an unusual piece of advice in a chapter about client management, but the truth is that when clients see how hard you are working, they can't help but notice and respect it.

We know that the game industry is run, pretty much, as a suicide pact of the young. Enthusiastic young men and women get together, dedicate themselves to a project, and then work night and day for months and sometimes even years until the game is done. When someone over the age of 35 steps into the mix, he or she

can wash out in a matter of days. So you may wonder, how do you impress the client with your work ethic in an industry whose work ethic is the highest in the world? The answer is the well-worn Nike slogan: *Just do it!* The other members of your team will notice, and so will the client, and it'll help. If you can't stand the pace, better start looking for a job in some less suicidal but probably equally less rewarding field—like sales, for instance.

Manage Client Expectations

This is one of the great keys to client management. It assumes you've done the previous things we've talked about to win a level of trust from the client. It continues in the actual written project proposal. Don't propose something you can't deliver. Don't propose a timetable you can't meet. Don't propose a budget you can't afford. Be realistic. Lowballing and then looking for ways to make back the money that should have been in the bid to begin with is no way to build a positive working relationship.

As the project rolls along, make every client update extremely honest. Let the client know exactly where you are (when you are ahead and when you are behind). Give all the good news all the time. But don't hide the negatives. That doesn't mean presenting the situation in the worst possible light. Doing that is a manifestation of a personality flaw (negative thinking). Don't be negative; be honest! That means presenting the positive and the negative in every situation as well as describing all the areas of gray in between.

If things start to go bad, indicate the downward trend as soon as it is clear. Again, be honest with the client and with yourself. Don't paint the most negative picture, just tell the truth. The truth must be carefully crafted, of course, not because you're trying to "spin" the truth but because the truth is usually complicated and you will want the client to understand all the nuances. Those nuances have to be worded accurately, and that takes crafting.

In our example of the bug fix, part of the truth was that quality assurance could stop the release of the product unless the highest officers of the company agreed to release the product with a known bug. It also included the fact that the Asian manufacturing company had a window of production. Our estimates had set our target date at the early end of the window, so it was possible that the game could be finished on time, even if the shipment of the golden master occurred after our hard deadline. The truth also included a realization that the game would barely sell at all if the product arrived on the shelves less than two weeks before Christmas. Only if the client fully understood all of these truths could everyone decide on the best course of action.

Starting with an honest proposal, keeping the client informed, and pointing out the full truth of any negative situation are keys to managing client expectations.

Take Responsibility

There are going to be times when things don't measure up to client expectations no matter how well you set them. If you're the client manager, you have to face up to problems and be willing to admit when you're wrong, even when the client's point of view seems unjust. You can't admit to your organization's shortcomings, of course, without the agreement and consent of your own management. It's a little easier to do if you're running the place, but if you're not, then you have to act as a go-between. You must fight to represent the customer's point of view to your boss as much as you have to fight to represent your boss's viewpoint to your client.

We were involved in a big project for the Army that was subsequently killed. The demise of the project had more to do with certain research considerations than with the design and style of the game or even the instructional intent. It would have been easy to try to place blame with everyone (including with the Army). But the responsible thing to do was to analyze the client's concerns, admit whatever failings occurred, identify steps that could be taken to find an alternative approach, then do everything to work in that new direction. In the case of this project, we did that—and we were able to negotiate a new project and a new direction that was more suited to the Army's needs.

It's hard to know where the buck stops in the area of responsibility. As we just pointed out, someone acting as client manager or client interface may not have the authority to promise a "make good" or a redo on something the client is unhappy with, but he or she can act as a negotiator with the client on one hand and company management on the other. That is a rough spot to be in, of course, requiring lots of hand-holding and listening. But if you handle the situation correctly, it is a chance to have everyone win, and you'll get credit for standing up to one of your organization's biggest challenges.

Egos, Personalities, and Politics

If you're given the job of client manager (often that job is rolled into the responsibilities of the producer), one of your biggest challenges will be handling your counterpart on the other side. Most of those relationships are positive and helpful, especially if you're doing the things we've just talked about. But it's instructive to look at a worst-case scenario when your counterpart becomes a problem.

Imagine that you're working for a company that is designing a sales training simulation for the training department of a large computer corporation. The company assigns a sparkly young new college grad named Laura to oversee the game development from the client side. The company trusts Laura and wants to give her a lot of room to succeed. The problem, it turns out, is that Laura has set ideas about the way things should be done, not just operationally but creatively as well. She also has ideas

about instructional tactics and everything else. On top of that, she has little experience, and, to the eyes of you and your team at least, her ideas are not that good. She doesn't really care about the well-crafted design your team has put together. She wants to be *the* producer, and she sees you as the competition. It's a struggle for control.

Laura begins talking directly to the programmers and developers. She starts giving them directions that contradict the plans you've already presented and her company has approved. Maybe she goes out on analysis missions, tries to take over the meetings, and dominates the conversation by asking questions that aren't even relevant to the analysis process. She wants to run the casting sessions too. She insists on her ideas for the look and feel of the product and tries to cut you out of the loop on every play. Ever have to work with someone like that? What do you do?

We think there are three ways you can go:

1. Try to partner with her. Have meetings about your roles and try to define the territory.

2. Slug it out on a daily basis, always asserting yourself when she gets out of line.

3. Go over her head and try to have her replaced or at least counseled.

The truth is that you may have to do all three, but do them in that order. First, try to discuss roles and responsibilities. Make sure she knows that you have a certain role to play and there are reasons for it. There are agreements in place too. Even contracts. During the conversation, however, find out her take on things. Listen. Be ready to bargain. Try to find out the roles she wants to play and try to find a specific area you can steer her into. Help her play those roles when she can. Also, get Laura to agree to support you in your areas of responsibility. Even if this whole effort fails, it will at least make it easier for you carry out approach number 2, putting her in her place the 25 or 30 times a day she steps out of line. You can remind her of what she agreed to and what she is now failing to carry out.

If the first two strategies in the process don't succeed, you may have to move to the third step. Document what is going on. Write down her quotes if you can. Get comments from members of your team who agree with you. Look for specific areas where her behavior is threatening specific terms of your contract. Then search your soul and make sure that this isn't just about personalities. If you can honestly say that it is more than that, then go after her. But have your boss talk to her boss, or maybe the four of you can talk. In doing so, you risk intensifying your personality clash, and it could hurt the whole project. But if, in fact, Laura's behavior is damaging the project, the client needs to know it.

During the kind of nightmare we're describing, it's important to keep your management apprised of the situation as soon as the problems become clear. You may not want to do it at first because you feel it will reflect badly on your ability to manage your clients. But if Laura sends a letter to your boss condemning you, it may show up in your performance review and cost you the next promotion. Still, this is a book about getting projects done, not about your own personal career path. If there is a difficult project manager on the other side who is threatening the

project, you owe it to the organization to let it be known so that your company can take whatever steps are necessary to keep things moving smoothly. Unfortunately, that may mean that you are taken off the project as well. But that may not be so bad after all, right?

Just for learning purposes, let's make the situation even worse. What if you go to your boss to talk about Laura and it turns out that your boss has terrible interpersonal skills, doesn't want to go to management, and may be looking for a way to get you out of the picture because he or she feels threatened by you? Now what?

Talk to the head of the company yourself, lay it on the line, and see what happens. If you don't dare do that because your boss and the organization head are close buddies, at least ask them to send you to some courses on interpersonal relations, and then keep on doing your best, applying the principles you learn in the courses. You'll be living a clinic on the subject, right? You'll get better, and you may be applauded for seeking to better yourself. Also, console yourself with this thought: one of the good elements of the game business is that people move around a lot. The situation will change soon enough if you can just hang tough.

A Few More Client Management Tips

We talked to a few experienced developers, and here are some additional tips they had for managing clients:

- "Test frequently, and use the testing feedback as justification for changes you want to make. It may be easy for the client to argue with you about what to implement next, but it is much harder to argue when you have hard testing data backing up what you're saying."

- "We plan for a lot of interaction with our clients throughout a project. Often those clients are remote, so we also budget for a few onsite visits either at their location or ours. Lack of communication is the number one way to derail a project, because the client expectations are the most important aspect to manage. Also, because game development is so much more fluid and dynamic than other types of software, it's important to engage the client often so they can experience and respect that process."

- "We often make sure that our deliverables are worded in fairly vague terms as to not to get pinned down on something that can't be delivered. A lot of the time the client's expectations change because they see something related and think that's what they now want. So being flexible up front saves a lot of hassle later on."

Summary

We've looked at client management from a couple of different viewpoints here: (1) as though you were the head of a small independent company on your own

trying to find a way to maintain clients who will continue to give you business and refer you to their friends and (2) as though you were part of a small independent unit inside a bigger organization with all the layers of management and all the corporate politics that go with it.

In some ways the situations are the same, except when you work for a small independent there are fewer layers of management. On a project last year, we couldn't go talk to the president of a state university when a health care serious game project (shepherded by a single academic department) ran into complications. But the head of an Indie game company is probably within reach of the producer of one of its biggest projects.

Despite this difference, best practices of good client management are the same for both types of organizations:

- Recognize that the customer is always *the customer* and is central to success of your company.

- Let it be known right away that your goal is to take direction from the customer.

- Get to know the customer, and be friendly.

- Show respect for the customs and practices of international clients.

- Work like crazy so the customer will respect your work ethic.

- Manage the customer's expectations by being honest and giving fair warning of difficulties on the horizon.

- Take responsibility for issues that arise with the client, the performance of your team, and the overall project.

- Learn how to handle difficult personalities, especially those that are set up as your counterpart on the client side:

 - Talk to your counterpart about your mutual roles.

 - Get your counterpart's support.

 - Steer your counterpart into areas where he or she can exert total domination if that's what the individual wants.

 - Assert yourself if necessary when he or she tries to take over your role.

 - Go over your counterpart's head if necessary.

 - If all else fails, get extra training in interpersonal relations and consider the situation a fabulous learning experience.

CHAPTER SEVEN

Legal Issues

Introduction

If you're trying to start an Indie game company or intraorganizational game group, you're almost immediately going to find that legal issues will be staring you in the face.

If you are starting up an Indie game company on your own, here are the questions you need to answer:

- How do you protect your ideas if you need to present them to potential employees or investors?
- Should you create a nondisclosure agreement for them to sign?
- Should you be willing to sign a nondisclosure agreement if they ask you to?
- What kinds of contracts or agreements do you need to have with the members of your team?
- What kinds of contracts or agreements do you need to have with subcontractors?
- If you are planning to offer stock options to your potential employees, what kind of an agreement do you need to create?
- What are you allowed to keep after the project is done?

If you're trying to start a serious game group within a larger corporation, university, or part of the military, here are the questions you need to answer:

- Does your employment contract (if you have one) require that everything you do and every idea you have while you are working there belongs to that company?
- Are there incentives within the company that encourage and promote the sort of entrepreneurial effort you are undertaking?
- What kinds of legal review and approvals will the company want to have before management allows you to pursue your ideas?
- What kinds of legal issues are there relating to discussions of your ideas with members of other departments?

- What kinds of legal issues are there relating to discussions of your ideas with the company's vendors or suppliers?

- What kinds of contracts or agreements do you need to have with subcontractors?

- Has the company already built software that is reusable? If so, what rights do clients have to that code? (Do they get the source? Are they allowed to change it?)

In light of these questions and others like them, we have some observations, but first we want to add our own disclaimers:

1. We're not lawyers.

2. We're not qualified to give legal advice.

3. Everything we say here reflects our opinions and experience.

4. We take no responsibility for any complications that arise if you follow our advice and run into trouble.

5. The only way to be safe in all these areas is to get your own lawyer (or at least a lawyer within your company if you are operating in-house).

That last disclaimer is our first and most important recommendation.

All about Lawyers

Like so many other inhabitants of the mysterious world of games (serious and otherwise), lawyers have great value—and also a downside. The value is that they can help you see the dangers and advantages in any agreement you need to make. They will set things up so that when everything goes to hell, you still have a fighting chance. The downside? They cost a lot of money, and they usually take a lot of time. If you are part of an organization that already has its own lawyers, they may not cost you anything (although they could be charged against your department or project), but they may take even longer.

A colleague of ours (Sue) entered into a partnership with one of her closest friends (Greg) to develop and promote an entertainment game together. Sue was working for an entertainment company at the time, so she had to offer the game to her company first, and the company had to turn it down before she could legally try to sell it anywhere else, which they did.

Because they were friends, Sue and Greg decided that they did not need a contract between the two of them. Sue would design the game and write the script. Greg would promote it and find a customer. He would then become the producer of the game and manage its development. Sue built a quick prototype, and they found the customer together. It was a major game publisher who had big plans for the project. While Sue then developed the game and wrote the entire script and design document, Greg hired a lawyer and incorporated so that his company would be in position to build the game.

The legal wrangling involved in Greg's effort took up the good part of the following year, during which time the customer lost interest in the game and decided to shelve it. Sue and Greg were paid a nice sum of money for the concept and the script anyway. But Greg felt that because he incurred the legal cost of setting up his company, he was entitled to the lion's share of the payment. It had been expensive. Sue, on the other hand, had no real out-of-pocket costs, just her time. But she did create the intellectual property that the company bought, didn't she? And it was Greg's desire to incorporate that delayed meetings with the client until they eventually lost interest. Things got nasty between Sue and Greg, ending in more legal wrangling and a broken friendship.

Did the involvement of lawyers doom the project? Well, they slowed down the process, and eventually that slowdown was what got the project shelved. But in retrospect, there should have been a contract between the parties up front. Relying on friendship alone meant that Sue and Greg did not take the time to think through the sets of issues that could arise during the design, sales, and development of the game. They also had no common agreement on how to share profits or anything else.

We can say with great certainty that business deals between friends without legal contracts are an invitation to disaster. This is especially true when you are talking about starting departments or companies and developing intellectual property. As for why legal processes cost so much and take so much time, perhaps only a cautionary fable can answer that question.

FIGURE
7.1

"EMERGENCY! EMERGENCY!!" Image courtesy of iStockphoto. © David Earl Crooks, Image # 7361566.

The Birth of the Legal Profession

In the days of the cave folks, people settled their differences in a simple way. The two grieving parties squared off and tried to bash each other's heads in. The person who was the best head-basher won. The loser was lucky to escape alive. And so, it wasn't long before the weaker people realized that they didn't have a chance in these encounters. That was the time when a few wiser souls decided to hire big, strong head-bashers to do their bashing for them. The idea soon caught on with the opposite side, and for the next few thousand years, whenever two people disagreed, they would send two other people out to bash and decide who was in the right.

The legal profession was probably born the day a pair of head-bashers suddenly realized that there might be a far less painful way to settle other people's grievances.

"Why don't we just decide what we think is right?" said one. "Then we'll tell everyone, and if they don't agree, we'll bash *their* heads in."

The plan worked, and soon clients were offering large sums of money to the bashers who could hammer out the best terms (so to speak).

The legal profession was born! And by the Age of Mystery, legal head-bashing had spread to every nook and cranny of daily life. Furthermore, lawyers had convinced those in charge that everything needed the strictest legal review.

The result was a bottleneck the likes of which no one had ever seen. Furious throngs began storming the legal departments of the world. Solemnly, the lawyers gathered to resolve this latest and gravest dispute. And the finest legal minds of the age did come up with a solution.

With everyone clamoring, "Emergency! Emergency!" the lawyers simply decreed, "There is no such thing as an emergency. You'll simply have to wait your turn."

"All in due time" became the slogan of the legal world. And we have been living with it ever since.

Ignorance Does Not Excuse

What are the facts you need to be aware of as you and your Indie game company (or your new corporate internal serious game department) decide how to relate to the legal profession?

1. There is no such thing as an emergency (to lawyers), so allow lots of time.

2. Not all lawyers are qualified to work in the complex areas that surround game companies. Games always involve intellectual property (IP), the stuff that silicon

dreams are made of. To work in this area, you'll need a lawyer with knowledge of IP law. You'll also need someone who understands corporate law and the workings of business relationships. If you're starting a game group within an organization, the company's lawyers will be available to help you. They'll know the ins and outs of corporate law, and they'll at least have connections to good IP lawyers as well. That'll save you a lot of money, though time, of course, will continue to be an issue.

If you're starting out on your own, you'll need to track down a lawyer who has the expertise. Where do you find one? A LinkedIn interest group may give you a worthwhile referral. But ask your friends in the industry, members of your team, your accountant, or your banker—someone whose judgment you trust. If one of them can offer a referral, he or she can also appraise the working relationship: Did the lawyer answer calls, and was her or his office good in handling legal documents? If you get a solid referral, that lawyer will tell you if he or she can handle your business. If not, you should be able to secure a useful referral to a competent IP attorney who can help you.

But remember this caution: even if you find a good IP attorney, make sure that attorney isn't also handling IP matters for a competitor or client. The overlap can create conflict of interest issues down the road.

What will you need a lawyer for? We consider this question next.

Nondisclosure Agreements

If you're going to present ideas to potential clients or investors or if you need to explain your business to would-be employees, you will need to prepare a nondisclosure agreement (NDA). Typically, such agreements contain the following points:

The signer of the agreement agrees to do the following:

1. Hold in confidence and not disclose to any third party proprietary information (usually that means any information marked confidential or identified as confidential during the disclosure)
2. Not use the proprietary information to serve his or her own purpose or the purposes of any third party
3. Not copy the proprietary information
4. Take care to avoid the publication or dissemination of the proprietary information
5. Not disclose the substance of discussions about the proprietary information

These conditions may not apply to information that becomes public through no fault (wrongful act) of the person who signs the nondisclosure or that the person is legally compelled to disclose.

Our purpose in listing these five items is *not* to provide a template that you can use to make your own nondisclosure agreement. Subsets of information need to be

included in such a formal agreement. So have one drawn up that includes all the details. Do you need a nondisclosure if you are setting up an in-house group? Check with the corporate lawyers. They may say that such conditions are covered by the company's employment agreement. But we would argue that unless they discourage it, do obtain a nondisclosure agreement. People actually take nondisclosures seriously; take advantage of that.

NDAs can sometimes seem threatening, especially to people unused to dealing with IP matters. One solution is to use a mutual nondisclosure agreement (MNDA). An MNDA will seem like a good exchange of value and may even add an extra layer of protection on IP matters.

Subcontracts with Your Vendors

Whether you run a serious game development group within a corporation, a university, or some other organization or if you have your own Indie game company, you're probably going to need to subcontract with writers, graphic artists, programmers, and other vendors, and you'll need to create contracts with those parties. The part of the contract that does not deal with the specifics of the job is usually called the *boilerplate* because it's the part that never changes. Get a lawyer to create the boilerplate of your contract. Lots of subcontractors will ask that your agreement be drawn up without lawyers. We discourage that, at least on your side.

Anticipate issues. We'll discuss how ownership (of IP, etc.) works in the next section. But even the use of open source software can create complications, as several types of licenses exist for its use. If a subcontractor is building on your open source framework, you should also make sure everyone has the same understanding of what those licenses allow (which probably means it should enter the contract). Is there a possibility your subcontractor will outsource some work overseas? This could be a problem if you have a government contract.

The best way to understand the ins and outs of these kinds of contracts is to think about them as though you were the subcontractor. (Have some empathy.) We suggest that even those of you working inside a corporation, university, or other entity read through the following section with that point of view in mind. No matter how big the organization that surrounds you, when your vendors have issues with their contracts, the first person they are going to call is *you*.

Contracts with Clients

The Boilerplate

Let's think about this as though you are the vendor who has just received a contract for a serious game. The boilerplate is the longest and most complex part of that contract. It will include additional nondisclosure requirements, statements about use of equipment and materials, and some scary statements relating to rights of ownership. To paraphrase:

All developments created by YOU *while contracted by* ME *are the exclusive property of* ME. YOU *hereby agree to assign to* ME *all rights, title, and interest* YOU *may have to developments, now and in the future.*

That's just the way it is. You're working for the clients, and they own the stuff you create or extend: IP, source code, assets, and the like. You may also see clauses that limit your ability to work for competitors for a given period of time. There will be a clause on termination, which tells you how the client (or, if the client is generous, you and the client) can end the project if need be.

You need to review these issues carefully and decide whether you want to call in a lawyer who'll advise you on the details (probably), make some changes, and then send it to the client's lawyer—who will (probably) make changes to those changes and so on. Is it worth the time and expense?

When you read the contract in detail, the wording of some of those clauses will make your hair stand on end:

YOU *agree to inform* ME *of all inventions that* YOU *are developing even if such inventions are not covered by this agreement.*

Those are words from our contracts with our vendors, and we're nice guys. You have to decide for yourself if you want to get a lawyer to help address those details, but we recommend it.

The Statement of Work

Attached to the general body of the contract will be an appendix or two that describes the work you are to deliver, the delivery schedule, and the payment timetable. Often the clients will ask you to write up a *statement of work* that they will use as a basis for this document. This appendix and others that are attached can also be sent to a lawyer for review and clarification. Whether or not you do that, we have some advice on issues you should address in the statement of work, as you will be the one drawing up that document.

1. Be as complete as possible in describing the kinds of work you will do for the client. If you're designing the game, producing the game, hiring all the talent, and so on, spell it out.

2. If there are things you are not doing, spell them out too. Make the exclusions clear.

3. Address the issue of "change of scope." That is, make sure that the project is defined well enough that if the client makes major changes (like additional scenes or added levels or characters), you can get extra money for dealing with those items, because the client has changed the scope of the project. Use the words "change of scope" and address the issue.

65

4. Specify work the client has to do upon which your work is contingent. For example, if the client is to provide subject matter experts, make sure that this is stated in the contract, or you could be left without the information you need to get the job done and with no recourse about the matter. Sometimes access to confidential source materials or classified government information is necessary; make sure this is specified.

5. Look out for work schedules that specify minimums (you will work a minimum of 3 hours a month), but don't specify maximums (but you might also have to work 600+ hours a month).

6. Don't lowball—that's the practice of bidding low and then adding "extra charges" that let you recoup the charges that you should have included in the first place. Ask for what you want and need to get the job done and what you think you are worth. In a long project, people tend to become bitter if they think they are being underpaid. If you have to cut back your costs to meet a client's budget, do it by eliminating items that contribute to the cost so that you can honestly present a number that won't leave you having to finance half the job out of your own pocket.

7. Set realistic deadlines. Don't go along with an impossible timetable if you know you can't meet it. It's better to lose the job than be forced into bankruptcy by having to hire extra people who are not in the budget.

8. Make sure that the payment schedule gives you a fairly even cash flow. Don't agree to payments that all come in at the end of the project. Make sure that you receive reasonable payments at the key milestones so that you can pay your bills and your workers as you go along. Especially important: start with some upfront money upon contract signing, and if the client can't agree to that (some government agencies won't allow it), then set a very early milestone, like a preliminary document that will get you a very early payment.

New Contracts and Contract Extensions

Let's say you've done a great job, and the client loves your work and wants you to do more. Maybe it's a little more of the same, another module to the existing project, even a prototype of the next version of the project. This kind of work may call for a new contract. However, many developers find it easier to extend work, or even start new versions of projects by extending the current contract. That limits their legal review process (*all in good time*) to a review of a new contract addendum, and it may get around certain internal limitations and policies that their company has relating to vendors and their use. Generally, this is a well-established practice and nothing to be concerned about. Again, the advice about the statement of work applies. It's important that the statement of work for the contract extension be realistic and deal with the issues we've talked about.

Let us add that if you are a client and reading this to understand the vendor's point of view, it's good to note that this is a way that you, as the head of a corporate or university serious game group, can keep a project going as the contract is about to run out. Ask your corporate lawyers how to extend the existing contract.

Patents

Obtaining a patent on a piece of intellectual property is a complex and time-consuming process. Software patents are usually recommended if there is a mathematical algorithm that is the basis of the software. In that situation, you patent the algorithm. The MP3 encoding algorithm is a good example.

If you think your idea is strong enough, you'll need to hire a patent attorney to look at it, investigate the patents that already exist in the subject area, and then (if there are no clear competitive patents already in place) draw up and submit a patent application. There are fees for submitting the patent, but they pale in comparison with the fees your attorney will charge.

While the wheels of the patent office grind ever so slowly as the office reviews your patent application, you'll want to keep your IP under wraps. Once someone can prove that your IP is published somewhere, it is no longer patentable. So over the course of the next year or so, the person in the patent office will review your claim and accept or reject all or part of it. Any part that is not rejected can form the basis of a revised patent application. It may take several years before you are through with the process. But if your idea is good enough, you'll get a patent—and a letter from a company that offers to mount your patent on a nice plaque that you can hang on your office wall.

From that point on, you'll want everyone to see your patented product. Here is what you're hoping for:

1. That your IP will be so unique and wonderful that it will give you a competitive advantage in the game market

2. That someone will approach you for the rights to use your patented IP

3. That people will use it without telling you, and then you can sue them for patent infringement

Most of the time the goal is to get the famous label "patent pending." That's enough to scare away most competitors. That's why a lot of companies that build game engines go through the patent process until they have enough software developed that it's easier for a competitor to buy their product than to develop the software themselves. From this point on, then, it seems to them to be a lot more fruitful to focus on the finer details of licensing than to continue to spend the time, money, and energy to have the patent approved.

If your serious game group is within a larger organization, the organization may try to get the patent. If it does, the organization will own it, but you may be listed

as a co-holder of the patent, or a co-inventor. If your game group is lucky enough to prosper and spin out from under the company, you can then buy the patent from the organization. This may turn out to be tricky, however, because large companies with good lawyers can structure the agreement in such a way that the resulting source code you get is virtually useless. Unless you get a worldwide, non-context-specific exclusive with reselling rights at the source level, you will most likely lose money on the deal.

If your group is in a university, you'll have pretty strong legal support, but you may not get as much cooperation from your coworkers. Idealistic university types are sometimes more interested in the flow and expansion of knowledge that come from the free exchange of ideas than the exclusivity that a patent will bring. Also they'll want to start publishing papers about it long before the patenting process is complete. (Just turn to them and say, "All in good time!")

If you're in a startup, you had better hope you have enough money to fund the patent search. It may be worth it if you succeed. Venture capitalists value patents and consider the patenting process part of the business, so they will help fund it. But the two patents we have on serious game technology cost tens of thousands of dollars each, and that was in 2004. It's expensive.

Spec Work

Spec work refers to work you do on speculation, and the differentiating characteristic is that you don't get paid for the work. As a result, often no legal agreements are in place, and that can be a disaster. There are two basic kinds of speculative work: self-promotion and startup client work. Let's look briefly at each of them.

Self-Promotion Spec Work

Writers usually don't get jobs unless they've created samples of—or "calling cards" for—their work. They may spec screenplays or novels. Either form may land them an agent and possibly writer-for-hire work (such as adapting a novel for the screen or novelizing a film).

Graphic artists will also do spec work, thereby building a portfolio that may land them a staff position or freelance assignments.

In sum, using spec work to promote yourself is a tried and true practice in the creative world, and that applies to the worlds of serious games and independent games as well.

You should build prototypes of your ideas whenever you have the time to do so. It always helps to have samples of your dreams, or "vision pieces," as they're sometimes called.

And if you have a specific product idea, prototyping it can move your vision forward. It helps to have a dream and to be working toward it. Some employers

look for those kinds of things when they are considering employees or contractors. And when companies—in this case serious game companies—have dreams, these dreams help to promote them too.

The question is, how do you protect that spec work? How do you keep other people from stealing it? Nondisclosures can help, and if you are sincere in explaining why you think your idea is so valuable that you want people to sign a nondisclosure agreement, you're only enhancing the product, aren't you?

If you can write up or sketch out your idea, you can begin to create a legal paper trail by registering the material with the Writer's Guild of America (wga.org). For decades, the WGA has registered media project outlines, treatments, scripts, and other documents, even for non-Guild members (the fee is $20). Any kind of serious game or simulation would be a media project, and the WGA's service offers legal evidence of creation date and intellectual property content. Other online services, like protectrite.com and protect-it-online.com, provide similar services. Although registering won't prevent IP theft, it may prove critical if a legal dispute about ownership ever arises.

Startup Spec Work

Many companies, especially startups, have gotten very good at getting people to work for them for nothing. They may offer you stock options, a future position in the company, or other incentives if you'll agree to do work that will help them get funding. But they want you to perform the work at no charge. If you are starting an independent or serious game company, you may find yourself doing the same thing.

A good friend of ours recently performed the ultimate act of spec work. He runs a video production company and has complete production and editing facilities and a full-time crew on staff. When asked by a startup company to provide a 10-minute video piece to be used as part of the prototype for the company's new serious game service, he agreed, and his entire company did a spec project (i.e., his company did all the casting, video recording, and editing on spec).

Unfortunately, in spite of the quality of his work, the company's presentation did not succeed—and this time around, the spec investment got him nothing.

Many lawyers look askance at such spec relationships, feeling that most startups never get off the ground, and even if they do, they may find ways to avoid paying the party that has been working on spec. In the end, if you have the time, the situation boils down to a simple choice: Do you want to spend your free energy doing work for someone else or doing it for yourself? If you like the company and the people and have the time, you might consider doing the work. If so, you'll probably want to have a contract that spells out just what you have to do and what you'll get in exchange for all your efforts. The contract should be governed by the same parameters we set out in talking about how to structure a statement of work.

Summary

- If you're a single-person shop or a start up Indie game company, you will almost certainly need a lawyer to help you through the miasma of corporate contractual relationships you'll be facing. If you are starting a group within a company, a university, or the military, you will probably have legal advisers in place who can help you. Lawyers aren't likely to make your job easier, but they will provide protection in the case of work- or IP-related disputes.

- Business relationships centered on media projects normally involve several important documents, such as nondisclosure agreements, contracts, and contract extensions. We recommend consulting a lawyer before signing most contracts and extensions.

- A *statement of work* is a document you draw up for a client. It should contain clear-cut specifications about the scope of work, because the client will typically refer to the statement in drawing up critical parts of its contract with you.

- A thorough understanding of your contract will help you do a better job in dealing with your contractors when your Indie game company or corporate game department is the client.

- Patents are a valuable goal of Indie game companies or intraorganizational game groups, but time and cost problems are associated with seeking them.

- Spec work is nonpaid work undertaken to launch a future project or showcase talent. Even here, lawyers can play a role in clarifying the relationship between you and your nonpaying client.

Team Building

Introduction

When you take on the job of developing a serious game or simulation, either you'll have to have a team in place or you'll have to put one together—fast! Although it's true that the individual members of the team start at different stages of the project, you still need to know that you can get the right people before you commit to doing the project.

Team building, when understood in these terms, can mean assembling the members of the team. We'll walk you through several ways of getting it done.

But team building, at least in the business world, also means molding the workers you have assembled into a cohesive unit that works together. Consequently, we'll also need to discuss that process. Let's start by talking about how you will find the skilled workers you need to create the project in the first place.

Assembling the Team

If you've ever been part of a startup company and had to go to venture capitalists (VCs) to obtain development funds, you already know that one of the most important things that VCs look for in a prospective company is whether or not it has assembled a team with the right makeup to work together. So your team will have to impress the VCs, and it will also need to convey the same sense to your prospects and clients. Do you have the right people, and can they perform the tasks needed to create the game you are promising? Inside a corporate environment it's the same thing; having the right mix of people will help assure that the management of your overall department or division will support your effort, and in all cases it will help you to get the job done.

What game development tasks are needed to create the game, and who needs to perform them? It depends on the project, of course. Let's take a simple project like the one we did a few years ago. We were building an interactive version of Sudoku.

For those of you who don't play Sudoku, a typical Sudoku puzzle is shown in Figure 8.1. Sudoku is a mind-training puzzle game requiring players to put the right

FIGURE
8.1

		4		9			6	5
	8		6	3		7	4	1
2		1		4	7			3
					4			
9				8				6
			9					
4			2	6		9		7
8	9	7		5	1		3	
3	2			7		5		

A classic Sudoku puzzle.

numbers—from 1 to 9—in the right boxes on a grid. Most of the boxes are empty, but just enough numbers are present to allow the player to figure out the rest, if that player is persistent and logical.

In our version of the game, the interactive system recognized where the players clicked on the Sudoku puzzle grid and then used that information to provide audio advice. The system actually knew the answer for each box in the puzzle. It could then tell players the answer, or hint at it, or suggest strategies that players could use to figure out the right answer for themselves.

Before we developed the game, we had to assure the game publisher that we had access to programmers who knew how to program their system. We needed to assure them that we had audio engineers, because this particular system relies heavily on audio, including sound effects, a music track, and original instructional narrative. That meant we would be using actors, musicians, and writers.

We needed graphic artists to design the game puzzles, as well as someone who knew all the secrets of Sudoku and how to explain them. We needed game, interface, and instructional designers to figure out the hints and other instructional strategies, the game play, and the best way to present the mechanics of the game. In addition to all that, we needed people with expertise in package design to present the product in the best possible way. And, of course, we needed a producer to lead the team and deal with the budget, deadlines, clients, management, and the other complexities of the project.

Figure 8.2 shows an expanded version of a project team that starts with the kinds of people we had on the Sudoku game and then adds those we would need if we were building a virtual reality game that has the kinds of workers needed to perform the tasks that we detail in Chapter 22 on graphics creation.

We should note that on the Sudoku game project, there was a layer of management above our small game development group within the company that had subcontracted with us. The layer of management included a company CEO, lawyers, finance people, and a support staff. But let's face it; this company would not have

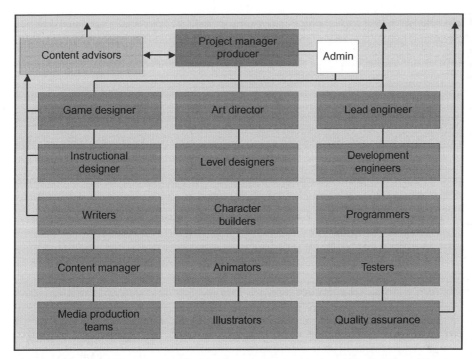

FIGURE
8.2

Organization of a typical project team. Note that the arrows pointing off the picture indicate reporting relationships to other departments within the company or other group managers outside our own.

obtained the business if it couldn't show that it had the workers to get the job done. And that brings us to the first big question in all team-building activities: Where do you get those guys? Well, the answer was easy for our client. They hired us. But that didn't do the job entirely, because we didn't have all the people we needed either.

Whenever you have a project such as the one we just described, often a small group of people is already in place. Sometimes you have only a producer, or an engineer, or a programmer. Regardless, if they've been in the business for any length of time, they know other people who can fill some of the specialized roles you need to fill.

In addition, you should review the people you know and match them up against your list of required jobs. Then ask for referrals from those people. They might realize that they fit the job requirements and go after the positions themselves. But here is an important caveat for this part of the process. You have to be brutally honest in assessing their skills.

Who are you looking for? People who have specific talents:

1. Know how to do the job
2. Do quality work

3. Can meet deadlines

4. Can work fast

5. Have stamina (because in a game company, the time pressures are incredible)

6. Are responsible

7. Are flexible and can accommodate changes in direction

8. Know how to finish (because some people just don't and won't)

9. Can take direction

10. Respect you and will follow your lead

11. Can get along with their coworkers

12. Are even tempered

13. Have a positive attitude

14. Present well (can tell others about the product and do it intelligently without turning them off)

15. Like the company and its products

Do you know what's important about that list? It's in order of importance. People who get along with everyone but don't do quality work have no business being on your team. People who love the company but never finish anything don't belong. People who look and talk great but make everyone else angry are poison.

You may have noticed that two qualities often used to select employees are *not* on that list:

- People who are friends
- People who are benefactors

Those attributes are nowhere on the list, because the quickest way to lose friends is to hire them and then try to protect that friendship when they can't do the job and are taking the project down. Do you want to lose friends? Try having to fire them. As for benefactors, you may owe someone a lot for the great things he or she has done for you in the past, but you don't owe him or her your career. You have to be brutally honest and use our list as a guideline.

In sum, find people you know or who are referred to you by people you know and who can do the job. Then hire them. Unfortunately, you probably won't know enough people to fill all the job requirements.

What's your next source of staffing? Other people in the industry who have experience with the kinds of skilled professionals you're looking for. Ask for recommendations from business associates, vendors, and customers, and then make contacts and interview them. College professors are a great source of input, and they can often recommend candidates for internship positions.

At the University of Southern California's Institute for Creative Technologies, we staffed an entire graphics and animation department with interns. They were

great. In addition to their indomitable energy, endless optimism, and state-of-the-art technical knowledge, they also worked for relatively low salaries. Of course, if you're going to build a staff of interns, then you need intermediate managers who can handle them, relate to them, enjoy them, teach them, and be patient with their limited experience.

If you're staffing with interns, then the need for a special kind of group manager becomes critical. Add that function to your list of people to hire. In other words, instead of one or two experienced animators who can work together with limited supervision, you may need five or six interns and an experienced manager.

Job boards and job posting sites (monster.com, dice.com, craigslist.com, etc.) are also a great source of employees. Similarly, LinkedIn has become the dominant professional social networking site, where skilled people can be located quickly. The way you describe the job and the way the prospects describe themselves becomes especially vital. Make sure, in describing the job you need to fill, to include all the special requirements.

If you've committed to a certain software development package, note that into job requirements and be wary of people who say, "I've never used it, but after all, how hard can it be to learn?" or "Don't worry; I'm a quick learner." Some professionals have learned Director and Flash and haven't been able to learn anything else since. Also be just as wary of people who claim to use a piece of software but really haven't. Being able to recognize these "outliers" is a critical skill. We've met many people who claimed to know Maya and had never touched the product. Once you've got some good candidates, interview them.

The Job Interview

There are those who say that the job interview is an art rather than a science, on both sides. Interviewees are often nervous or at least too distracted to present themselves as they really are. Although a job interview may be a test of their presentation skills, it is seldom a good test of their personality or job performance. As the interviewer, here are a few of the most important things you should do in a job interview:

- Ask for and look at the candidates' work samples. Discuss the samples and how they illustrate the skills you need.

- Some programmers and artists claim they know a package, when they really don't. Ideally, either you or a co-interviewer can do a little discovery on this issue. Tell the candidates about a hypothetical problem in your startup phase, and ask their expert opinion. The candidates who know what they're doing will give you a high-level answer, with the details being couched in the terms of the software package. The candidates who just boned up on a user manual are not likely to be able to fake it.

- Check out your candidates' résumés and explore their job experiences. Ask them what they thought of any previous jobs and what they liked or did not like about the work environment. Ask why they left their previous employer.

- Look for major gaps in work time, and consider long periods of time with any single employer as a good sign. (Even in a business like the game industry, being willing to stay put for a while shows perseverance.)

- Look to see if there is a build to their career. Can you see that they have been given increasing responsibility as they move from job to job?

- Ask how they feel about management: Do they like doing it, or would they prefer to continue to be an individual contributor doing the basic job rather than getting others to do it? (Unless you actually need to groom managers, this kind of person may be perfect for the day-to-day development tasks you need. Some experienced producers go out of their way *not* to hire people who want to be managers because these individuals often start looking for a management position as soon as they become part of the company. Or worse yet, they start trying to evolve their position into management when they are supposed to be cranking out code or art.)

- Talk about their education and the skills they developed, especially as they apply to the job in question.

- Ask how they feel about gaming and the game development business. Do they like to play games, which are their favorite, how good are they? Are there some kinds of games they dislike?

- Talk about the hours and the demands that might be made as you reach crunch time at the end of the project. Can they live with them? This is a tricky area, and something of a discrimination minefield. Questions about a person's family life could imply that you are discriminating against them because they have children or family commitments. How do you avoid it? Focus on hours and demands and never talk about reasons why a person might not be willing to work four 100-hour weeks during the last month of a project (as we all have).

- Talk about their priorities and where this job fits in their plans. Is this a stepping-stone in their career plans? Or have they avoided considering any career plans? Maybe they just live to hack and will go from job to job doing it for the rest of their careers. That's fine.

- If the position involves designing or working on serious games, ask them about their understanding of teaching strategies and instructional design, but be willing to accept the fact that you don't usually find this orientation in game development professionals.

- Explore their interests and hobbies, looking for clues that might describe their work ethic or even give you common ground for an interpersonal relationship.

- Ask them about their strengths and weaknesses. Don't be surprised if they actually come right out and tell you their limitations. But be aware of the old tactic of presenting strengths as weaknesses with the idea that it might be a way to get around the question. For example, a candidate might say, "My biggest weakness is that I just feel so dedicated to the gaming business that I'm willing to work around the clock, day and night to get the job done." That is not an indication of any weakness but may be a symptom of some kind of mental illness.

- Embrace diversity, which can bring a unique style, point of view, and distinction to your product.

Salaries

Once you've found the right people, you have to make each of them a job offer. Although conventional wisdom suggests that you should pay the lowest possible wage for the largest amount of work, that turns out to be a bad operating principle. We've found that paying employees what they want or as close as we can come to it (or even, if possible, slightly more) makes them work harder, eliminates any residual resentment they may feel as the project wears on, and encourages extra effort. It's important to be fair in salary negotiations. Find out what the employee's demands are, not only in terms of salary but in terms of hours and bonuses as well. You will almost certainly be handcuffed by the budget, but be as generous as you can.

Of course, if you're running a serious game department within a corporation or university, you may be operating under a strong organizational salary structure. That makes negotiating easier for you. You can't give people everything they want because the organization's guidelines are limiting your options. Then, unfortunately, your job is to defend the structure, which may not be easy to do, so learn as much as you can about it so that you can explain it to your employees.

You may be required to operate within salary ranges which demand that you start employees low within a given salary range and then give them periodic raises so that they have a feeling of progress. This turns out to be a good principle because even when you start someone at a high fixed salary, he or she will eventually want more—say, when the employee enters his or her third year without a raise. So the request to "start me high within the range and you won't ever have to give me a raise," probably won't work. Still, if the person is critical to your operation, you may have to do just that.

After workers reach a certain salary level, we have found that recognition is often a greater motivator than salary itself, and salary is often looked upon as an indicator of recognition. This means that you should assume that workers will want to know how their salaries compare to those of fellow workers, and they will probably compare notes on who makes what if only as a way to determine who is more highly valued.

Don't announce salaries. Discourage people from disclosing their salaries, but assume that all of the employees will talk about them. Be ready to talk about comparative salaries if workers bring it up. You should not disclose salaries or comparable values of employees during these conversations, but there has to be a reason why one person makes so much, and if you're confronted with evidence that an employee knows everyone's salary, be prepared to say why one person or another receives a high salary:

- "Marc is the best 3D animator on the West Coast."

- "Janet can record and edit audio and deliver perfect sound packages in half the time that it takes anyone else on the staff."

- "We couldn't exist without Assad. The authoring tools he develops makes everyone's job easier."

Other Incentives

Game companies are unique in that they require extremely demanding hours, but they also have a lot of ways to reward good employees. They can give comp time when things are slow; they usually have stock option plans and bonuses as well. Comp time may be under your control; stock options will be determined by a board of directors; bonuses usually come out of a pool of money that is accumulated through sales. The accountants in your organization will give you the guidelines, and you have to follow them.

Most important, you have to fight for the people who are doing a good job for you. You have to keep your good workers, and you have to go to the mat for them whenever there are debates about who gets what. Your employees will learn that *you* are their champion. *You* are the person who helps them get the things they need to do their job and feel good about it. And they'll do better work for you because of it.

Things are different, of course, when you are running a game operation within a corporation, university, or government agency. You'll have to live by the rules of that entity. But you may be able to convince your managers that they have to recognize the rules of the business you are trying to run. If you have a great game designer and your management recognizes it, you may be able to offer incentives that are like those in game companies, even though they are outside the general guidelines that your organization follows.

Screen credits for games and other media-based products are a benefit that means a lot to employees, costs nothing, but may be highly regulated by the company. When you can, give credit, somewhere in the game, to the people who built it. The ranking and titles of the people within the credits may be an issue (see the following section), but if you can work it out, it is worth doing. Such recognition is often considered as valuable as major financial reward.

Credits

Credits have historically been thought of as a reward for helping to create a project. This stems from the Hollywood movie credit model and the desire of many workers to see their name in lights. Hollywood, of course, is a highly unionized industry, and industries that are unionized have sets of rules for job titles and credits; within those industries, there is little room for getting around the rules. For this reason, screen credits in the motion picture and television industries are largely governed by what the various unions allow. The rules that govern "union shoots," as they are called, do not apply to nonunion productions, but the conventions are so strong that independent movie and television production companies usually follow them anyway.

Individual talent within those industries can negotiate specific kinds of screen credits as part of their deals, and the positioning of names on a movie marquee is a good example of how actors, directors, and even writers vie for recognition. Remember, recognition is the single biggest motivator there is.

Within the game industry, the International Game Developers Association (IGDA) recognizes the reward perception of credits but also acknowledges that credits are increasingly being used to verify past employment and skill level. The IGDA therefore recommends that everyone who has made some impact on the building of a piece of software should be credited. The association has created a paper on crediting guidelines for the gaming industry (see Figure 8.3).

Many game publishers have strict rules for the kinds of credits they allow, and game companies often follow the dictates of their publishers. As in other arms of the entertainment and media worlds, individual talent can sometimes dictate the kind of credit one gets and where it is displayed (Wil Wright, creator of *The Sims*, is a prime example—as his name alone is a selling point for the product.)

Indie game companies can often provide credit in any way they choose, and both the titles and the placement of those titles are negotiable. Corporate, university, and government agency credits are sometimes at the whim of the organization, but one of the jobs of a good leader (remember the Wizard from Chapter 4) is to convince management of the low-cost but highly prized value of credits. We were able to convince Bank of America to use the same credit guidelines for our corporate videos as were used by the Hollywood television industry and achieved strong motivational results because of it. Our feeling is that good managers can use credits and even job titles to recognize and motivate good employees, and, as the IGDA pointed out, credits can help verify employment and skill level. Following are some specifics about credits within the game industry.

Many games avoid displaying any individual credits; instead, a short leader is displayed as the game loads, listing the publisher and developer (and sometimes engine licensors).

Game credits, when given, are typically presented as a scrolling list of names— like scrolling credits at the end of a movie—accompanied by music and sometimes

FIGURE
8.3

**Game Crediting Guide
Draft 8-5 Beta**

April 2007

This work is licensed under the Creative Commons Attribution-
NonCommercial-ShareAlike License. To view a copy of this license, visit
http://creativecommons.org/licenses/by-nc-sa/2.5/

Title page of the IGDA's credit guidelines.

visuals, animation, and outtakes. In some cases, players have to beat the game to
view the credits, but just as often, game credits are hidden in a game "Easter egg"
that most players will never see.

Some points of contention relating to credits are as follows:

- The order of credits is typically hierarchical. But the publisher is usually listed
 first.

- The title is almost always the person's official job title, but it can be changed to
 match the duties that the person actually performed. For example, people can

ask for titles above their current title if they did the advanced job on the game but have not yet been officially promoted.

- People who have left the company are frequently included in an area called "Special Thanks." They rarely get full credit, and the credit they do get is based on their length of time with the project, their "shippable" contribution, and their relationship with the company at the time of departure.

- The production team typically collates the credits, but these usually need to be approved by the executive staff of the development company, the publisher, and the legal department.

IGDA Credit Guidelines

The following sections from the IGDA Credit Guidelines present a more specific set of rules for the use of credits:

1 – Any person, contractor or employee, who has contributed to the production of the game for at least 30 days of a 12-month or greater project, must be credited. For projects shorter than 12 months, any person who has contributed during 10% of the project's total time in development must also be credited.

 1-1. Time on project is to be counted in days the position is held, not hours worked.

 1-2. For Leads, it is permissible to omit the "Lead" designation from the credit if the person spent less than 50% of the project's total workdays in development in a Lead role.

 1-3. For non-Leads, if the contribution consists of less than 40% or 8 months (whichever is least) of the project's total workdays in development, then the credit may be listed in a lower tier, e.g., "Additional Programming."

 a. While credits have been just as controversial for who is included as much as who was not included, the more manageable solution is to adopt an inclusive philosophy. Given the nature of intermittent activity in the development process, a simple threshold may not be so unreasonable. Special consideration should not be provided for "crunch days" when determining the number of days for an employee's contribution to a project. If there are rewards for "crunch," there is no incentive to reduce it, and there are other ways to reward crunch without affecting crediting practices.

(Continued)

2 – Credit is retained by any person who leaves the company or project prior to the project's completion, provided they pass Rule 1.

 b. Typically, there is no resistance to this idea until a person with a solitary credit, usually a Lead, realizes he or she must share billing with an ex-contributor.

3 – Credit is retained by any person who is fired or who has engaged in illegal activity not related to their contribution to the project, provided they pass Rule INCL.1.

 c. Getting fired is a human resources issue that should have nothing to do with crediting projects. For example, while a few U.S. Representatives have been convicted of criminal activity and removed from office, all of them are still acknowledged as having been U.S. Representatives.

 d. Past service should always be acknowledged for the record to avoid the possibility of blacklisting.

4 – "Legacy credit" should be provided in the following circumstances:

 4-1. For re-releases or acquired properties that include a previous original work in whole or in part, all of the original developers should be credited above any new credit related to the re-release or adaptation, since the work being purchased by the consumer is fundamentally the original content for all intents and purposes.

 4-2. For ported games, credits should show the whole original team at the top, followed by the whole team of the ported version at the bottom, since the work being purchased by the consumer is fundamentally the original content for all intents and purposes.

 4-3. For expansion packs, credits should show the whole expansion team at the top, followed by the whole team of the original game at the bottom, since the work being purchased by the consumer is specifically the expanded content.

 4-4. For sequels or franchise installments, credit should be provided to the person responsible for creating the original concept, idea, or design known as the "intellectual property."

 Example 1: A North American company acquires a 15-year-old Japanese game and upgrades the graphic style from 8-bit to 16-bit; the original 8-bit Japanese developers should receive credit, including

(Continued)

> the artists. This credit may be supplemented with new credit for new work (e.g., for added dungeons etc.). Example 2: In Ubisoft's Rayman Raving Rabbids, a credit states that the game is based on the characters of Michel Ancel.
>
> 5 – [Optional] Credit may be provided to those who have contributed to the original creation of tools, art, programming, sound effects or other assets that are continually used within an ongoing game franchise.
>
> 6 – [Optional] Any person who has contributed to the production of the game for less than 30 days or 10% of the project's total time in development, whichever is least, may be provided with credit in a "Special Thanks" section, which may be tiered with an "Additional Special Thanks" section.

We should add that there is a tendency among some executives in large organizations that have internal serious game development groups, or even in some start-up Indie game companies, to avoid using credits because they are difficult to administer fairly. But the advantage of giving credit seems to outweigh the difficulty. Our advice is to give credits to worthy people on every game you produce if the publisher or your corporate overlords allow it.

Place the credits in as conspicuous a position as possible, on the box if you're distributing this way, or inside the accompanying literature.

If you are distributing online, then production credits can be accessed from an options menu within the game itself or, as the major companies do, as a scrolling list at the end of the game as described earlier. But put the credits *somewhere*, in an Easter egg if you have to, so that your workers gain personal recognition for their efforts.

For example, in the Sudoku game we described, there was a policy against giving credit for productions. However, the game had an accompanying comic book, and the very last page of the book had a drawing of a huge temple. Part of the game was to learn a certain cuneiform code to identify letters within the game puzzle, and the initials of every developer who worked on the game were present in that illustration.

Job Titles

Table 8.1 shows a list of titles provided by the IGDA. The association recommends that these same titles should also be used as the basis for game credits.

TABLE **8.1** IGDA's categorization of game development job titles.

Programming	Design	Production	Art	Audio	Writers	QA
Chief Technical Officer	Creative Director	President	Art Director	Audio Director	Story Writer	Tester
Technical Director	Director	Executive Producer	Senior Art Director	Audio Manager	Scenario Writer	Tester Lead
System Programmer	Assistant Director	Line Producer	Graphic Design	Sound Producer	Script Writer	Test Manager
				Sound Design Mgr		
Engine Programmer	Design Manager	Director Of Development	Lead Artist	Sound Producer	Text Writer	
Physics Engine Programmer	Lead Designer	Senior Producer	Lead Technical Artist	Sound Engineer	Dialogue Writer	
Software Engineer	Senior Designer	Producer	Senior Artist	Sound Programmer	Copy Editor	
Software Tools Programming	Designer	Associate Producer	Artist	Sound Mixer		
Program Manager	Lead Level Designer	Assistant Producer	Production Artist	Sound Editor		
Lead Programmer	Level Designer	Project Coordinator	Background Artist	Sound Mixer/Editor		
Senior Programmer	Lead Scenario Designer	Project Director/Leader	Background Modeler	Sound Effects (Electronic)		
Programmer	Scenario Designer		Background Texture Artist	Foley Artist		
Rendering Leads	Scenario Director		Texture Maps Map Artists	Foley Supervisor		
Camera Programming	Planner			Foley Mixer		
Artificial Intelligence Programmer	Concept Authors		Concept Artist	Foley Recordist		

Programming	Design	Production	Art	Audio	Writers	QA
Audio Coder	Conceptual Design		Character Modeler	Musician/Composer		
Script Programmer	Interface Designer		Character Designer	Singer/Vocalist		
Event Programmer	Camera Designer/ Planner/ Programmer		Cinematics Director	Lyricist/Songwriter		
Battle Programmer	Battle Designer/ Planner/ Programmer		Cinematic Lead Animator	Orchestration		
Combat Programmer	Combat Designer/Planner/ Programmer		Lead Animator	Score Engineer		
Gameplay Programmer			Animator	Recordist		
Lead Scripter			Animation Supervisor	Score Copyist		
Scripter			Interface Artist	Orchestra Contractor		
System Optimization				Choir Contractor		
Graphic Optimization				Concertmaster		
Data Optimization				Score Assistant		
				Sound Assistant		
				ADR		
				Voice Director		
				Recording Engineer		
				Voice Talent		

Managing the Team

Once you've hired the people needed to produce your game, it's important to get them working together as a unit. This brings us to our second definition of team building, forging the individuals into an effective unit. There are some unique challenges facing team leaders within the game industry. But let's refer you to this chapter's fable before we deal with what it takes to manage a group of creative people.

FIGURE
8.4

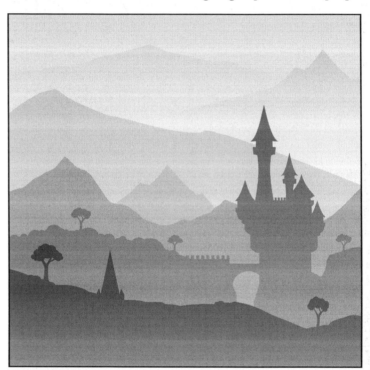

The Domain of Creativity. Image courtesy of iStockphoto. © David Earl Crooks, Image # 6773321.

The Contessa and the Gardener

Carrie, the Contessa of Creativity, ruled a small but profitable domain on the edge of a vast empire. Her subjects were all creative and hardworking, and each turned out wonderful products.

But alas, Carrie soon found her charges were given to bouts of petty bickering, low morale, and missed deadlines. So Carrie involved herself deeply in

(Continued)

everyone's work by stepping in to make key decisions any time she thought she was right. Even when Carrie's decisions led to great success, the workers resented her actions and missed even more deadlines. Carrie became more confused and frustrated than ever, and her workers grew very angry.

One morning, as a disheartened Contessa set off to walk around her domain, a group of subjects suddenly gave chase. Carrie realized her life might be in danger, so she dove through a small doorway and the crowd surged past.

"Excuse me, Your Ladyship," a voice said suddenly. Carrie jumped and turned. It was only the gardener, a jolly, round-faced man with muddy hands and quite a few missing teeth.

"I've been watching, Your Highness," the gardener whistled, "Seen you struggling with your management job. And I felt that maybe you were facing the same kinds of problems as me."

Carrie realized that the garden was the safest place she could be, so she sat down on a bench and began to listen.

"You see," the gardener continued, "the first thing we gardeners have to do is to find a climate where our plants and flowers can grow. More often than not, that means building greenhouses to keep in the warmth and moisture and keep out the cold. You hafta do that too, mum. Create a climate where your folks can grow. Make sure there's plenty of warmth for everyone, and you have to keep out the cold as well."

The Contessa remembered the chill that shot through her domain when a group of lords threatened a political takeover. The distraction brought work to a complete halt.

"So, I should build greenhouses to protect my people from political intrigue," said Carrie.

"That's right," said the gardener, "Course, you have to give them sunlight too."

"Sunlight?"

"Your attention, Contessa," the gardener answered. "You have to ask about their projects and their work, and then you have to listen. That's the kind of sunlight I'm talking about."

"But I held one-on-one sessions with every person in my domain," Carrie said, "and it didn't do any good."

(Continued)

"I'll bet you got into plenty of arguments during those one-on-ones," came the reply. "Bet you were saying, 'My ideas are better than yours,' and things like that. Ain't no sunlight in that."

"But I did weed out the troublemakers," Carrie added.

"Heard you had them thrown off the top of the castle. We have better ways to deal with troublemakers here in the garden. See, a lot of rare and exotic flowers that come into this place turn out to be weeds. Dealing with weeds is written up in our Gardener's Manual. Too bad there isn't some book like that you can follow?"

"There is, actually," the Contessa answered, because there was sort of a Magna Carta that documented what leaders could and could not do in the treatment of their subjects.

"Don't you see," the gardener said with a chuckle. "If you start following those procedures as soon as you think you spot a weed, the weeds will see what you're doing and get scared right out of the place."

Carrie was amazed. Scare the troublemakers away, just by showing them that she was serious about getting rid of them!

"There's one more idea I want to give you," the gardener added. "But it may be the most important of them all. Once I've planted the seed for some new flowers, and watered them and kept the greenhouse set just right and kept the weeds back, then I walk away. I back off into a corner of the garden, and I watch them grow."

"You just watch?" asked Carrie.

"I watch," the gardener said with a smile. "But what I'm really doing is *leaving them alone*! It's hard not to step in and twist them this way and that or push my ideas on them when I'm feeling clever. But you don't get great flowers that way, do you?"

"No," Carrie sighed, "I guess not."

"Give them room to grow, mum, even if you don't completely agree with the way they're doing things. And the toughest call in the garden is when to step in. Sometimes you have to do it. But rarely!"

"Amazing!" said Carrie, shaking her head in wonder.

"Build greenhouses to keep the good climate in and the politics out.
"Provide the sunlight of attention.

(Continued)

> "Follow procedures to scare troublemakers away.
> "Give your people room to grow."
>
> Contessa Carrie reflected on all that she had heard. Then she stood, thanked the gardener, and left the garden vowing to follow his precepts. And she did follow them, and she became world renowned for her successful and nurturing management. Carrie returned frequently to the garden where she and the old man spent many long hours together talking of so many things: of management and strategy and policies and organization, and, of course, they also talked about flowers.

Goals and Commitments

As sound as the corporate gardener's advice was, he did leave out one important ingredient to good team building. It has to do with goal setting and performance planning, and as unpleasant as those subjects sound, they're vital. That's why we'll dedicate the next chapter to them.

Summary

- Team building comprises two critical actions: the first is actually putting the members of the team together; the second is forging the members into a cohesive unit.

- Finding good team members is a matter of establishing necessary criteria, using every avenue possible to recruit, and then using the interview process to pick the best candidates.

- As our fable suggests, the job of the team leader is to create an environment that encourages teamwork. Build an environment that keeps out distractions (especially the political kind) and provides the nurturing power of positive attention. Get rid of the people who are unwilling to work as part of the team. Then stand back and give the members of your team room to operate.

- Project planning is a crucial aspect of team building, to be discussed in the next chapter.

CHAPTER NINE

Project Planning

Introduction

In our chapter on team building, we mentioned that you should use the project planning process to help create a more cohesive team. In this review of the process, we will talk about how you should do that. Specifically, we'll look for ways that you can use the project plan to set goals and gain commitments from various team members. We'll also explore how to put together a budget that will help assure success. Along the way, we will identify ways that you can adjust the project timeline and the budget for purposes of risk management. That way, you can anticipate problems that occur as the project evolves.

Creating the Project Timeline

It is critical that you sit down with your team and discuss the schedule and the tasks involved in the development of the game. We like to start out projects with a kick-off meeting where we introduce all the team members, and possibly bring in some key clients and executives at the start of the meeting. If there are contractors to whom we will outsource large parts of the work, we make sure that they attend the meeting as well. Once the introductions, blessings, and formalities are out of the way, we get down to the serious business of project planning: setting goals and assigning deliverables.

A group planning session that starts by setting an overall deadline and then works backward to create an entire timeline will help the team see exactly what has to be done. Getting input from the team members on how long it will take to perform each step will help them feel that they have some say in their destiny over the course of the project. Then, as you work backward, you'll begin to see where the difficulties lie. If you reach the start date for the project and find that the project should have started two months ago, you'll know that you are in trouble. You'll have to find ways to compress time. The key here is to work together on the issues. In fact, even if you prefer to make up the project plan on your own, it is important that you get input from experts in each subject area and then still walk the whole team through the plan together.

To begin the project planning process, you need to determine the final delivery date and then work backward from that date through each of the milestones your team will face. For the sake of discussion, let's say that, in a game development project, the key deadline is the certification of the golden master. (In many organizations there are steps after that, of course. See the discussion of final testing and refinement in Chapter 25 for details.) In any case, big companies have well-established processes and even an entire quality assurance (QA) department whose job is to certify that the game has reached golden master. That is, they say that the software has been tested, was found to be flawless, and is ready for replication. What precedes that moment is usually months of QA testing, bug checking, and bug fixing. So you have to go back to the point before the certification of golden master and set that date as your preceding step.

As you'll see in Figure 9.1, we said that the previous step occurred when we created a version of the game that was good enough to be used for beta testing. To get to beta, there had to be an alpha version of the game that was complete (though probably very buggy). At the time that the alpha version was being refined, all other media that was to be part of the game had to be completed. In small shops or Indie game companies, of course, you will certainly have different processes for getting things done. You probably won't have an entire QA department or formal QA procedures spelled out. So you will have to set up your own internal, ad hoc QA. You'll have to conduct the quality assurance testing yourself and determine when in your estimation the game has passed through each of these phases. (We'll discuss the production flow in more detail in Chapter 24.)

Figure 9.1 shows the start of the project planning process. Working backward from the deadline, it appears that you have a reasonable amount of time to finalize the beta version. But then the programmers announce that they will need three months to build the first alpha version of the game. That puts the timeline back to January 1. Then the game designers say that it will take two months at least to complete the design and the design document. Now you are back before the date

FIGURE
9.1

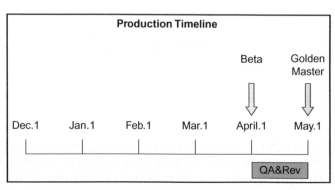

A production planning timeline starting with the end date and working backward.

FIGURE
9.2

Production timeline completed. The problem is that today's date in the example is 12/1, and the project needed to start (we find out in the planning session) on 11/1.

of your meeting. Sounds like a good time for give and take on what each group requires and how they can adjust things to help you meet your deadline.

Figure 9.2 shows a project in which the issue becomes how to compress a six- or seven-month development process into five months. Having been in that situation, we can tell you, "It ain't easy."

We'll discuss some of the more creative ways to solve this time problem in a moment, but first, let's consider it from a team-building perspective. You ask your teams how they can help compress the development time. Maybe they can think of ways to shave time off certain processes. You get the team to agree to a set of solutions, and then you ask them to commit to meeting that goal.

This is definitely the time to have people voice concerns so that those issues are out on the table and won't be raised behind your back. Address the concerns as well as you can and in the end, take the leadership position of committing to the plan. Tell the team,

"This is a plan I can work with."

The goal in the project-planning meeting is for the team to achieve a consensus for solving the problem (in this case, the scheduling problem), and then each group within the team should commit to the solution.

Accurate Estimates

Determining the length of time it takes to create a serious game requires input from people who have done the job before. So they must attend your meeting. If your team is inexperienced, you might go so far as to bring in people from outside the team to serve as experts when you discuss the time frame. Your team members will

appreciate it. Ask folks in related departments to attend the meeting. Work with everyone to reach a consensus on the length of time it will take to perform each step. Consider all the possibilities, and err whenever you can on the side of allowing too much time.

Game development has so many variables that you'll want to allow as much time as possible for every step. The first step in the game development process that we use is called concept development. It includes research, analysis, and game design as well as the writing and approval of the design document. It may also include prototype iterations of the application.

We know from experience that this part of the process has the most volatile time frame of all. Sometimes a prototype may need to be built and then completely scratched. We tell all potential clients that concept development can take anywhere from a week to a year. If clients are unable to decide on the concept and the game design they want, then we can't do much in the way of real game development, so we can't deliver the product on time. When clients come face to face with that fact, they often become more willing to make decisions and approve the concept in a timely manner.

Feature Creep

Mention the term *feature creep* to experienced game developers, and you'll always get a shudder. "Feature creep is a big problem in software development and can be the number one reason for delayed deadlines," Adrian Wright (founder of Max Gaming Technologies) notes.

Feature creep is when features keep getting added to a project during production. According to Wright, "If you start a sentence with 'Wouldn't it be cool...?' then you should probably stop right there. If it's not in the initial design specs, it probably isn't that cool."

Although much of this problem is a project management issue, Wright says that "The first safeguard against feature creep is a thorough design process." Solid project planning is a key component of this process.

Worst-Case Scenarios and Risk Management

You may be staring at a worst-case scenario as soon as you complete your timeline. In our example, we said that after we created the timeline, we found that we should have started the project months earlier. On short-term serious game projects, that is often the case. It's a worst-case scenario right out of the box! But what if everything looks perfect when you lay out your timeline during your planning session? Then take a longer, harder look at the situation and work with your advisers to figure out

just what could go wrong. Begin with what is most likely to go wrong, and then figure out what would happen if you had no luck at all and everything went wrong. (See the fable in Chapter 10 on luck versus skill.) Make a straw case for as many worst-case scenarios as you can think of, and then start finding solutions that you can anticipate and plan for.

Solutions to Timeline Problems and Worst-Case Scenarios

Fortunately, there are some tried and true methods for handling timeline problems and worst-case scenarios. Take a good course in project management if you want to know them all, but here are a few of the most effective ones.

Turn Linear Activities into Parallel Activities

You should do this as you're constructing the initial timeline, but you can refine your plan and do more of it as the job progresses and new problems arise. For example, while you're getting the concept approved and starting a research and gameflow-structuring effort that leads to a design document and final design approval, maybe you can jumpstart your graphics and animation team who would otherwise be waiting around for the design document to be completed. If you have some handle on the initial design, why not start preliminary character development?

In our sample timeline, you can see we started media production during the final stage of developmental testing. In the case of the project referred to in previous chapters, the media was audio. We worked with scratch audio for the alpha version of the game and then began producing final audio as soon as the product moved toward beta. We had full final audio halfway through the alpha stage so that programmers didn't have to reprogram the audio just before we submitted our beta version. We were still open to last-minute audio changes, but most of the work had already been done.

You may not agree with these particular practices, but you should get the general point. Look creatively at the tasks that have to be performed, and if there are any that can be set up in parallel to other tasks, do it. Overlap activities, even scripting and programming, even testing and development, even scratch media design and production during the creation of the design document. Any time you can set processes in parallel motion instead of waiting for one to be finished before the next one begins, you're saving time, even if you have to repeat some of the steps.

Figure 9.3 shows a different kind of timeline that forces the exploration of parallel development tasks. It's called the project evaluation and review technique (PERT). It was developed by General Dynamics and the U.S. Navy and focuses on the time it takes to complete milestone tasks.

FIGURE
9.3

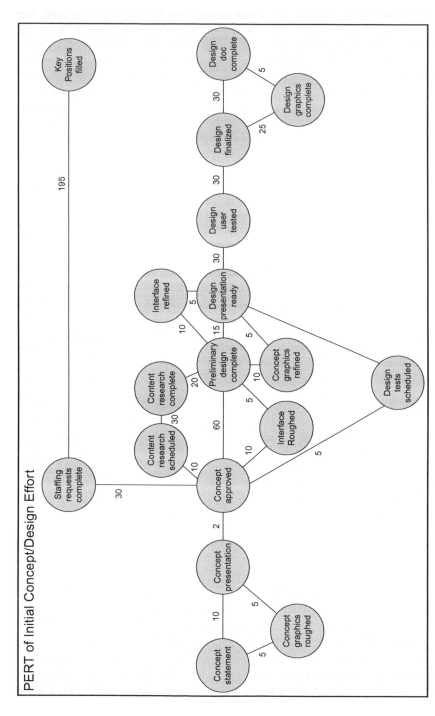

PERT chart of a concept design effort.

Note that in the chart, several tasks are pulled out in parallel to others. For example, any research needed to create the preliminary design can go on at the same time that preliminary interface sketches and concept graphics are being roughed and refined for concept testing. Note too the way the chart is constructed, with every task being stated as a completed event (e.g., "Design user-tested," meaning that users have already tested the design). Every task completion event is placed in a circle after the event that must be accomplished before the new task can be begun. The line between the circles represents the length of time between completed events. The number beside the lines indicates that actual time in weeks.

Techniques such as PERT allow you to identify bottlenecks in workflow and show tasks that do not need to be performed immediately because the tasks that are prerequisite to them and those that must follow are dependent on other things being done. For example, in the PERT chart, it may take five days to schedule all the design tests that are required for the product, and the scheduling may have to be done two days before the testing starts, but 75 days are allowed for all the other tasks that must be performed between the concept approval and the complete design presentation; so a lot of slack time is available for the person scheduling the design tests.

A common risk is the "single person" bottleneck, where one person is responsible for integrating work product coming from several directions (this could be an artist or programmer). Look for this particular kind of bottleneck, and aim for as much parallelism as possible in your workflow (this gets harder with small staffs).

PERT allows you to find the critical path, the one path that shows the longest time it will really take to get the job done if you consider the earliest and latest times that each task can start without delaying the project. The tasks on the critical path are those on which other tasks are dependent. They have the most important timelines. Trace the PERT timeline, and look at those tasks that have to be done before others can begin. The line of all the tasks that have these dependencies is called the critical path. You and your team need to focus on that path and adjust other activities so that the critical path can be managed successfully and risks can be reduced. PERT and critical path management (CPM) are disciplines in their own right, and you can take courses in them online. But they are also basic sciences that have been rolled into newer and larger management programs.

Staffing and Overtime

Our point about the critical path brings us to the next most important technique for managing the risk of timeline problems. It *is* the obvious technique. When you don't have enough days to complete all the work, get more people working on the project. Adding staff is the clear solution to most timeline problems and worst-case scenarios, but it's also the hardest to implement, between the budgetary issues (you probably can't afford the extra people to do the work) and the availability issues (you just can't find the right people). There are a couple of solutions to these challenges:

- *Anticipate the need whenever you can.* Build a contingency in the budget to bring in added staff during crunch time. Use interns if the task is right. Bring in college kids with endless energy and limited skills, but allow the time to teach them. Some game professionals say that this approach limits the output of your more experienced workers because they end up trying to teach and supervise as well as do their own work. We discussed this issue in Chapter 8, and the advice we gave there still stands. If you bring in interns to do large parts of the job, you must have a manager they can relate to, one who has the skills to show them what to do and the ability to hold their confidence.

- *Make people work longer hours.* This solution is commonly practiced in the industry, and in many ways it's both the most effective and the most destructive. In the game business, long hours are a given, and when the staff is working overtime, the manager better be working overtime too—if you don't want a rebellion. The previous chapter on team building identified several techniques to motivate people when they are working endless overtime hours. Use every one of them, then invent a few more of your own. But obey the law! State labor laws, such as those in California, have been amended to cap overtime hours. Know what those laws are and follow them. They were meant to keep you from killing your workers or getting murdered by one of them yourself.

Focus

PERT allows you to figure out the critical path, and it also shows the noncritical paths. The noncritical paths are where you may find workers who can perform tasks that need to be carried out on the critical path. Sure, the art director on the project may not be able to perform the programming tasks required of the software engineer. But there may be times when she can step into the critical path and help you solve an acute graphics problem. By focusing the energies of the entire team on some of the critical tasks that must be completed first, you may alleviate some of the timeline problems that you'll uncover as you move forward.

Gaining Consensus

Early in this chapter, we talked about a group planning session where all the members of the team get together and create the timeline. In a sense, the timeline may not actually need to be created during that meeting. It may be enough to simply verify the timeline that you have already worked out with key members of your team. At the kick-off meeting, you can pass out the timeline you've already created and gather support for it. But if you really want to build consensus, set your own timeline aside and have the entire team build it as a group. Pray that the one the group comes up with matches the one you've already developed, but also be willing, when group input tells you that you need to correct something, to adjust your original timeline.

The people in this meeting are the ones who are going to have to work the long hours it'll take to get the job done. So the more they can say about the process, the better they'll feel. In the end, you, as the team leader or project manager, will have the final say, but you need to get them to buy into the plan as much as you can before you override them and say, for example, "Okay, but in spite of that we have to do all the software development in two months." This forum is also a good place to look for creative solutions to some of the problems you have identified in your planning phase. Some of your less experienced or just lesser known workers may have some great ideas that will make the project go a lot smoother. Look for them.

What Do Serious Games Cost to Make?

No easy answer exists for this basic question, of course, and the broader answer of "anywhere from $50K to $10 million" doesn't help much.

Budget Hero (discussed more fully in later chapters), a 2D browser-based game built in Flash, cost around $250,000 to develop, but project director David Rejeski acknowledges plenty of volunteer contributions to the application, especially on the back end (which otherwise would have required much more substantial research-and-development costs).

Fully Involved, a 3D game built in Torque and deliverable via CD-ROM, cost less than $1 million to develop; this included all instructional design activities.

Clearly, staff size and development time will drive your costs. A simple game that requires short development time and a three- to four-person staff can be made for $50,000 to $100,000. A highly realistic 3D simulation requiring substantial modeling, animating, coding, and content development would be difficult to achieve without budgeting a million dollars or more.

Budgeting

There is good news and bad news about the budgeting system you'll have to follow if you're a game project manager, producer, or sometimes even the head of the Indie game company. Someone else usually sets up the budget you'll be following, or at least creates the rules you'll have to apply when preparing your own budget. That's good, because at least you don't have to do it all by yourself. But it's also bad because the budgeting system will probably have all kinds of complications built into it that you certainly would rather live without.

Let's look at budgets, and we'll try to offer some advice about coping with them. We'll start with the easy stuff first.

Overhead

If you're part of a larger organization, your project overhead and maybe even some of your organizational overhead may be built into your budget. The overhead number will probably be assigned to you and can include the cost of office space, equipment, and even executive salaries. The good news is that you don't have to worry because you probably won't have a thing to say about the size of the overhead costs or how they're charged. The bad news is that overhead costs could force up the price of the application you're building and potentially drive it right out of the ballpark.

How do you handle overhead costs? Most important, know what they are and if you have to charge for them so that you don't negotiate prices without taking them into consideration. These expenses will be added to your client's bill whether the client likes it or not.

If you've got your own company, make sure your accounting people (if you have any) consider overhead, so that you can at least cover your costs if you get a contract. If you're operating out of your own garage, consider what your operating expenses are. If your project is the only source of income, make sure those expenses are represented in the project budget. Here we're talking about rent, furniture, electricity, and the like. The same applies to supplies and equipment. Include those costs in your budget. You can use a percentage of the overall budget costs if you want to. But the supplies and equipment category should be addressed. It should not be left out, because, if nothing else, it may give you a little bit of a contingency that you can draw from later. Maybe, if things get tough, you can live without that three-terabyte hard drive that you put into the original budget.

Travel

Try to negotiate the budget so that it excludes travel so that the client covers it separately. Then, if a great deal of travel is involved, it won't blow your contract out of the water. Is this a way of hiding costs? Sort of, but the amount of travel involved can be negotiated as the project goes along and can be minimized if things are going well. Also, many large client organizations have their own travel departments that have deals with airlines and hotel chains. They can arrange for corporate rates that you can't get if you are an Indie company and are making the arrangements yourself. In these cases, it's in the best interest of the clients to arrange your travel themselves.

We've been able to enter into contracts where the class of travel can be negotiated. If you've worked in a big organization, you may feel that because you were once a VP somewhere that you are always entitled to a first-class ticket. The days when anyone could negotiate a first-class airline ticket as part of an employment contract are just about gone. The best you can hope to do these days is arrange to pay for the ticket yourself, then have the contractor reimburse you. That way, you may at least be able to keep the frequent flier miles.

Licensing Agreements

Many manufacturers of development software require licensing fees for the distribution of products made with their software. Make sure you know if there are licensing fees that apply to the software you intend to use in your product development, and include those fees in your budget. In addition, make sure your developers know what the budget limits are. If you anticipate someday selling the code your team develops, you need to make sure that the code isn't dependent on other licensed (non-open-source) software. (We'll discuss these more in Chapter 20.)

Salary Charges

In small companies, the number of employees may be so few that you just need to add their known salaries for the duration of the project and that will be the number that you put into your project budget. For larger groups, especially game groups operating within corporations, universities, or government agencies, you need to find out if your operation uses a single number for all employees with the same skill. In other words, is the same fee charged for all programmers regardless of individual salaries? If that is the case, look at the number of employees you have built into the development estimate, multiply the number of each kind of employee by the time they will spend on the project, find out the salary number for that kind of employee, and then use that information to determine salary charges.

If it is possible that your operation will be granting raises during the course of a long project, then you will have to estimate the size of those raises and plug them into the budget for successive years. In large companies, your financial advisers may be able to give you an inflation multiplier number or a salary raise multiplier that you apply to project various costs on a project to determine the total project budget. For example, if your artists are making $6000 a month and your adviser suggests that there may be 4% raises given over the next year, do the math and determine salaries for the upcoming year ($6240).

If you are contracting with freelance workers, their salaries will have been negotiated in their contracts. You can add these salary numbers from the contracts into your budget or show the contractors as line items that will include all their charges in a single functional category. For example, we often use a freelance art house to develop storyboards and presentation boards on our bigger projects. Rather than showing salary totals for theses contract artists under the salary budget category, we include the total cost of their work (including any travel or supply charges) as storyboard costs.

Benefits and Overtime Charges

Using in-house employees (in corporations, academia, or in game development shops, both large and small) means that you have to add benefits into salary costs.

You can break the benefit charges out if you want. The benefits costs are usually figured as a percentage of the salary (in some organizations it's now around 26% of the salary). So if the salary figure you use for all junior programmers is $50,000, you can either show their salaries as $63,000 each (including the 26% charge), or you can show salary totals and benefit totals separately. You can get the official number for benefits or a benefits multiplier number from your financial advisers.

When dealing with contractors, you will probably not have to compute benefit costs unless they are listed in the contract. Some union members require that benefit charges be paid to their union, and in some cases it is the employer's responsibility to make the payment directly to the union. The terms of these agreements will be (must be) spelled out in the agreements with your contractors. So use the numbers from the contract when entering salary and benefit numbers into your budget for contractors.

Overtime is a more difficult number to figure. Look at the crunch time periods (such as bug fixing days just before big presentations), look at the workers you think you'll need, and add in time-and-a-half for their salaries during those periods of time. Remember that you will have to pay double time for some holiday work and for work completed after so many overtime hours. Check the latest state labor laws relating to overtime pay, and follow those guidelines. You may be able to show overtime as a single lump-sum allocation. In that case, enter a single number that represents a careful estimate of how much overtime you think you will need. *Then double it!*

Payments

You may need to hire unionized creative talent. Voice actors, scriptwriters, video directors, and other professionals often belong to unions. The creative talent you use may require union contracts and special payment procedures. These may be different and more complicated than ordinary pay requirements. For example, union actors require that you pay them on the spot after their performance. That means you'll have to bring a checkbook with you to the recording session. Find out how union workers need to be paid and factor that into your budget. You may have to explain those special requirements to your client as well.

Media Production

The best way to handle video or audio asset production may be to hire an outside producer who can deal with the dozens of elements that make up a video shoot or an audio record session. There are talent and equipment fees, facilities, personnel, possibly even costumes and craft services (food). We'll talk more about this in upcoming chapters. For now, be aware that you'll need to get some numbers from a reputable source and include them in your budget.

Business Development and Meetings

Is it necessary or even possible to charge your client for the cost of meetings to get the project off the ground? Yes and no. It's possible to charge for meetings once the project is going, and as you can tell from the timeline, there will be lots of meetings. Try and add funding for some meetings and the meals that go with them. In addition, projector and other equipment rentals and media distribution costs (handout and report printing, CD-ROMs, etc.) should also be included.

Contingencies

Many clients refuse to consider or allow funds for contingencies, but these are real risk management tools if you can get them. You might ask before you submit a budget if your client allows for a contingency category in your budget. If so, add it immediately. If not, go back through the various parts of the budget and add 10% or 15% to the most volatile categories to make sure you're covered.

Production Fees and Profit

In the corporate film and video business, companies show the charge for profit as a production fee. You can spell out profit, of course, or you can use the production fee category. You can also create an overhead category that includes profit along with your overhead charges. Another common practice is to mark up every other cost. Profit is often figured as a percentage of the overall cost of the project and varies by company. Find out what your company profit margin is. Although 10% was once a common figure, there have always been companies that charge much, much more.

Solutions to Budgeting Problems

There are ways to manage the risk of budget problems. Generally these problems occur when the project bogs down, you don't have all the skilled workers you need, or your clients start changing their minds. Here are a few solutions:

- *Limit the amount of changes the client is able to make.* This issue is called *change of scope,* and we discussed it at some length in Chapter 7. Make sure your contract says that the client cannot send the project off in an entirely new direction after you are well into development.

- *Build buyoff points into your agreement.* That way, you will be able to bail if it looks like you either can't get the job done or the client doesn't like the job you're doing.

- *Track your project budget daily.* If you aren't good at that sort of thing, ask someone on the team who is great at it to keep you apprised of problem areas.

- *Be creative.* Build in optional elements to the project that you can drop if you start running into budget problems. For example, you budget for original music created by Green Day, but as the project moves along you realize you need to spend that allotment on programmers. Is that unethical? Well, if you sold the concept based on the Green Day music, then it's a little dicey. But once budgets are approved, they are not usually reduced. You may not be able to get more money, but you can adjust costs and product features to make sure that you don't run over budget. Dropping features as projects begin to run into budget difficulties is standard practice. Creative budgeting is what small game development organizations use to stay in the black. And that's very ethical!

Summary

- This chapter explored two critical project planning processes: (1) creating an accurate project timeline and (2) creating an effective project budget.

- Creating an accurate timeline requires input from knowledgeable workers in each of the tasks that make up the project. They have to help you estimate the length of time each task will take and how many workers are needed to get the overall job done. Other techniques for solving timeline problems include turning linear tasks into parallel tasks, adding staff, and allowing overtime. Keeping a strong project focus is critical to assuring successful completion.

- When assembling major budget categories, the emphasis must be on making sure each category has the funds needed to get the job done. Certain parts of the budget offer opportunities to create a cushion in case there are budget difficulties in other areas.

- Risk can be managed in different ways. Plan for challenges and worst-cast scenarios, and have layers of contingencies. These will give you options and a road map when difficult decisions have to be made during project management.

CHAPTER TEN

Project Management

Introduction

In the previous chapter, we outlined the procedures needed to plan and budget for the development of a serious game. If you follow those procedures and the ones in the chapter on team building, you can enter your project with a great chance of success. Then all you have to do is manage the project effectively, and you can't fail, right?

Okay, a little luck wouldn't hurt either, and maybe you've always been extremely lucky, so much so that you start to factor luck into the equation. Maybe people have always had such high hopes for you, and you for yourself, that you start to figure that you can't fail. Those last two perceptions are not elements in the formula for success.

In this chapter, we'll talk about following up on your initial team-building and planning efforts, and then we'll add some procedures that are unique to the management process. But before we do that, we'll present a fable to offer a little advice about relying too much on luck and great expectations.

FIGURE
10.1

Armed with a new suit of armor and some remarkable luck, George heads off to do battle with a dragon.

Luck versus Management Skill

There was once a lad named George who was the son of a fine and noble knight. His parents doted on him, and so he grew up believing that he could do almost anything.

"I'll be great," he would say, "and marry the most talented maiden in the land."

Few doubted the youth's aspirations, but as the years went by, it became clear that George was far more inclined to talk about his goals than to plan for their accomplishment. However, on his 17th birthday, a great and terrible dragon named Magnus Fabulorum emerged from one hundred years of hibernation and began to wreak havoc on the countryside. The king immediately offered a great reward to anyone who could slay the beast. And, to the horror of his parents, his neighbors, and Old Asthmas the village elder, George proclaimed that this was the very opportunity he'd been waiting for.

Magnus Fabulorum had enjoyed a rewarding morning. He had terrorized several travelers and feasted on a small village. Now he was dozing in the noonday sun. Out of the corner of his eye, he watched a rider ascending the rugged mountain slopes that lead to his lair.

Magnus expected warriors would be coming after him. They always did, and he always gobbled them up. Then armies attacked, battles raged, Magnus would conquer all and then strike a terrible bargain with the king: one hundred years of peace for the regular sacrifice of a talented young maiden. Finally, after a generation of feasting, Magnus would settle back to sleep for another hundred years. It was a most pleasant life for a dragon. In fact, the more Magnus thought about it, the more contented he felt, and the more satisfied he was with his own intelligence.

All was blackness then inside the dragon's cave. The air was full of sulfur and other nasty smells. George beamed with foolish pride as he plunged into the abyss. And that is when Magnus Fabulorum, Magnus Draconus Horriblius, lifted his hideous head. George, hearing a crackly, scaly sound behind him, turned to see a great, fiery monster as large as the cave itself, and he cried out with an epithet of horror and surprise:

"Mango and ginger chutney!"

An odd expletive, but quite a stroke of luck! For the monster was feeling amazingly intelligent that day, and the hallmark of intelligence is curiosity.

(Continued)

Old Asthmas had led a posse to the very edge of the dragon's domain. They had seen George enter the dragon's lair and heard his desperate cry. Suddenly, a great quake began rumbling through the earth around them. Then the whole side of the mountain ruptured, and the mighty Magnus launched himself into the sky.

He paused in midflight, sending Asthmas and his posse running for cover. They expected the usual blast of fiery breath, but instead, the dragon made a polite dip in their direction and zipped off toward the East. And at that very moment, a dusty but undaunted George staggered out of the gaping hole, a wide grin still on his lips.

"What a fine fellow Magnus is," said George, "and powerfully interested in chutney, which I said was as sweet as honey but hot as fire."

"So that's why the dragon left in such a hurry," Asthmas replied, "to find some chutney. You sent him off to India, which is half way round the world!"

When the king heard about it all, he immediately showered George with a fortune, and he gave George the hand of his talented young daughter. George was also made the head of the kingdom's greatest corporation, one that was so successful that the king was sure it needed little more than a leader with great enthusiasm and luck.

The king was wrong.

Within a year, George had the corporation floundering under the weight of arbitrary decision making and confused priorities. In two years, the best workers had fled. In three, the corporation was gone and so was George, sent off to achieve his true potential in some barren, distant land.

And that, unfortunately, is the same pattern seen in the careers of many of today's young game producers and project managers. For it is still possible to attain a leadership role through little more than luck. But to keep it, you need to know something about MANAGEMENT!

Knowing priorities, being realistic, and making good decisions—these were the qualities George lacked in our fable, but they are the traits you'll need to be a good project manager of serious game development (or a good manager of anything, for that matter).

Let's build on the previous chapter and talk about a project that was already in progress when it needed some very effective management. As complex and difficult as it was, the experience can serve as a model.

Management Challenges

We were developing a project for the Army. The project required that we turn a proven training film into a serious game. We had designed the game, written the first part of the script, and contracted a local game development group to create the game for us. The sample work that the group did was not at all satisfactory to the Army or to us. The military liked the story we created, they liked the game design, but they did not like the look of the simulation or the quality of our vendor's animation.

That's when we decided to take a big gamble and build our own team of in-house animators. Following the processes we talked about in Chapter 8 on team building, we brought in a strong art director and gave him the time and support he needed to assemble a talented group. Some of our new employees were interns, so it was important to make sure that the group had strong senior people and a strong leader.

With input from the art director, we then adjusted our schedule to accommodate our new artists' learning curve and made sure that we had enough time for client reviews so that we could be assured that, this time, the look and feel would be exactly right. In the same way, we were able to revise our initial budget so that it would accommodate the move from a major game development company to a group of in-house developers. This freed up some money, which we decided to hold as a contingency in case there were additional staffing requirements or other needs that we could not foresee. On October 1 we began the development effort with a deadline of September 1 of that following year. This was almost certainly a suicidal schedule given the scope of the project.

The initial development plan for the game called for five levels of play, and after two months of character and virtual world modeling, we were ready to dig in and start building those levels. By the end of the first month, it became clear that we were never going to be able to build all levels of the game in the allotted time. In response, the heads of the various project groups got together and decided to scale down the design and combine objectives so that we could cover the required material in three levels rather than five.

This, of course, required new scripting and game design and needed the approval of our clients. The negotiations for approval went on in parallel with the creative development of the scenes and gameplay. In this interim time before approval, we redirected our artists to focus on the parts of the game that would not be changed when we moved to the new direction.

The client approved, and we redesigned the game and continued game development, which successfully met our next major review milestone. At this meeting, the client determined that the most important level of the game needed greater visual impact. We determined the best way to do that was to give our cut scenes a more filmic look by bringing in a film director who knew something about game development. That meant that we needed to draw on the contingency funding we had set aside earlier in the project.

Fortunately, we found a young video director who was also a gamer with an unbelievable work ethic and a bright creative mind. He was personable enough to enter the project and start giving detailed direction to the art director and programmers without creating any ill will. However, to follow his direction, we needed to adjust our workflow, such as moving animators from one particular character to another.

Our challenges were still not over. Only a month before the final completion date, a higher-priority project suddenly appeared in the shop, and the managers of that project were able to pull away our best programmer. That resulted in additional adjusting of personnel and workflow to finish the project and get final client approval, which we did, right on time and on budget. Phew!

Management Skills

Let's step through the project in chronological order and look at the management challenges that we had to face. You'll see that we had to exercise certain management skills over and over again in different situations:

- *Client relations*. Responding to client concerns about the quality of the original art.
- *Decision making*. Replacing a vendor who was not performing adequately in providing that original art.
- *Team building*. Finding a new art director and then hiring an entire team of artists to support him.
- *Budget planning*. Adjusting the budget to the new staffing situation.
- *Risk management*. Setting aside the funds from the new staffing situation as a contingency for later use.
- *Decision making*. Recognizing that the five-level design could not be done in time and switching to a new three-level design.
- *Managing workflow*. Adjusting the schedules to accommodate the new design.
- *Client relations*. Responding to client concerns about visual impact late in the project.
- *Decision making*. Bringing in a video director to direct the cut scenes.
- *Budget management*. Using the budget contingency to fund the video director.
- *Team building*. Replacing the lead programmer when he was taken off the project.

Quite a set of tasks, made easier because of the careful project planning and risk management that we did before the project started. Was there luck involved? Of

course! The art staff, after all, came on and did a great job. We could have ended up with a group that couldn't work together at all. But we certainly had our difficulties, and they could just as easily have been attributed to bad luck. The loss of our lead game engine programmer during the final month of the project made our success almost impossible. But we were able to get an extraordinary push from the rest of the team and that got us through that crisis. We've talked a lot about client relations, team building, project planning, and risk management up to this point. So even though those tasks do carry through the entire project, let's focus now on the tasks that we haven't talked about yet: decision making, managing workflow, and sharing the vision.

Sharing the Vision

In Chapter 9 we talked about a kick-off meeting that presented the project to all the members of the team. We said that it was important to hold regular follow-up meetings where groups reported on their progress so that you, as the project manager, could track the progress of the project and team members could gain a sense of accomplishment.

This approach gives the project a sense of direction and purpose, which the team needs to maintain its commitment. The more team members can see the big picture and see the importance of their role in it, the more willing they will be to make the extra effort needed for your project to succeed. Success, after all, is always about extra effort. Great games don't come from everyone doing the minimum job; all of the team members have to be doing their best.

To accomplish this goal, the project manager has to be able to portray a vision of the project that makes it worthy of everyone's best. He or she has to be able to describe it in ways that the team members understand and appreciate. It's a real talent to be able to talk about a game (or any other project) and convey a true sense of excitement about it. But that's your job.

We feel that the key to that talent is understanding and believing in the project yourself. It doesn't hurt to practice by sharing your vision with your spouse, partner, friends or even your coworkers. It doesn't hurt to stand in front of the bedroom mirror and pitch the vision to yourself. It doesn't hurt to pitch the vision as you're driving down the freeway on your way to work or when you wake up at 3 a.m. and can't go back to sleep. Answer these questions: What is this game about? Who's it for? What's the story? You're going to have to pitch to customers, management, and everyone else anyway, so why not practice on yourself?

One danger of selling your staff and even yourself on the project and its capabilities has to do with focus and project scope. The enthusiasm you generate in your team meeting might start everyone—you and everyone else—thinking about better ways to do things, about ways to change the product before it is already built, about other side projects that relate to it. The effort to make things better

is a good thing; side projects are not. It becomes a self-generated feature creep, your worst nightmare in a client, and one you should not tolerate in your staff or yourself. When it happens you'll have to turn everyone's effort back to the main task, expressing admiration for any idea that comes along without allowing it to sidetrack one or many members of the team onto an extraneous and unproductive effort. From personal experience, we know that the first job of a hatchet man (that's the person who comes in to save a floundering company) is to fire people who are not focusing on the clear goals of the company. Do yourself and everyone else a favor by continuing to make people focus on the goals of the project, not away from them.

In reviewing these ideas with some colleagues in the world of consumer game development, we asked for the single issue that was most important in getting the game produced. The answer we got was that consumer game production is all about delivering the highest possible quality *on time*. The most important function they listed for accomplishing that goal was to maintain the integrity of the scope of the project. Make sure that the goals and the extent of the project are defined clearly and are not allowed to creep or grow out of control.

We talked about identifying changes in scope that can kill projects. The most painful example we know of involved an interactive video shopping system that we developed in the late 1980s. The president of the company had been a major player in one of the world's biggest game companies, and as soon as he saw a way to introduce games into the sales system, he turned everyone's attention to that effort. Guess who the hatchet man got rid of first when the project began to falter? The president, right. Unfortunately, as part of his management team, we were next to go.

To prevent project-killing changes in scope, you have to make sure everyone knows what the project *is*. When people start stretching it, adding new things, and so on, you have to say, "Great, but that's outside the scope of this project."

Managing Workflow

Managing workflow contains three key actions:

1. *Make sure you understand your project's priorities.* Know what has to be done and in what order, whether it is about dependencies (beginning with work that has other work dependent upon it) or meeting key milestones set up by the client. We talked about project planning and making project timelines in Chapter 9. You need a good project plan as a road map to making sure you know who is supposed to be accomplishing what and by when.

2. *Get today's work out today.* The second part of workflow management is to realize that the job of a manager is to get today's work out today. So you have to know what everyone is doing every day, what their goals are, and

you have to keep track of their progress toward those goals. In some way, your job is to bug the hell out of everyone all the time to make sure that they are as painfully aware of the deadlines as you are. Of course we use the term "bug the hell out of people" loosely, because pestering people is only one of the vast arsenal of tactics that good managers use. Just having workers know that you're paying attention goes a long way to making sure that they get the job done. Constant checking is good (you can only expect what you inspect). Team meetings, as noted, where everyone has to stand up and report their progress is another. Rewards, recognition, competitions, and incentives are all tools that you can use to motivate employees. The big wrap party at the end of the project motivates some people. T-shirts are a nice incentive, but in the end bugging the hell out of them may be the most dependable tactic of all.

3. *Hire deadline-oriented staff.* "Meeting deadlines" should be a critical criterion item for hiring people. You have to ask people about their ability to meet deadlines in their job interviews (and ask their references about this, to get a better perspective). When someone wants to transfer onto your project, find out about the person's ability to meet deadlines. Then continue to check for deadline awareness after people are hired and begin to do their work. If they continually let deadlines slide, get rid of them. Some people realize that deadlines are real, that if you miss the Christmas launch of a big consumer game, for example, you might as well not even bring out the product. The same goes for any kind of serious game that is tied to a product or service. If you don't complete the sales training by the time of the product launch, the service will not succeed. If you don't complete the new instructional system by the end of the fiscal year, the money will run out and you won't get the funding you need to keep the company running next year. People have to believe in their souls that it's true. Then they'll be willing to put in the extra effort or hours or whatever it takes to meet the deadlines and assure completion of the project. They won't blithely stop work half an hour before the end of the day, clear their desk, and watch the clock as it winds down. They won't say no when you tell them everyone has to put in overtime to get the product out.

But what happens when an unexpected situation zings you, the way it did when we suddenly learned that our ace programmer on the Army project was being pulled away to work on something else? What do you do then? As surprising as it is, the answer is that you should have anticipated it somehow.

Risk management is what we're talking about. You have to anticipate challenges and worst-case scenarios. You should have layers of contingencies set up, as we did when we set aside funding from the reduction in the cost of our graphics staff for possible difficulties down the road. Anticipate unexpected zingers as best you can, and then when you haven't anticipated something, you have to be flexible, agile, pragmatic, and creative. Those qualities lead us to our next topic.

Making Decisions

Decision making during the development of a gaming product isn't a crapshoot. If it were, all that business about luck at the beginning of this chapter would have been irrelevant. The point is that you can't rely on luck. You have to plan. And because it is inherently incredibly difficult to predict and plan the development of a game, your planning has to take on added complexity. You have to put contingencies in place so that when you have to make tough decisions because the unexpected happens, there is a fairly clear path for what to do. You know what your fallback positions are.

In his book *The Last Lecture*, Randy Pausch defined luck as anticipation meeting preparation. In other words, your management skill will translate into "luck."

We talked about being flexible, pragmatic, and creative in our decision making. What does that mean?

- *Pragmatism.* When the unexpected happens, assess the situation realistically; assess the options and the contingencies you have laid out. Consider the downside of every possibility. Then be realistic. Choose the alternative that will most realistically lead to your goal. Eliminate emotion, and just consider where you are, where you want to go, and the best way to get there. If politics or personality issues are involved, set those aside for a moment and just consider the clearest way to reach your goal. We call it *harsh reality time*. Take the most cold-blooded look at the way things are and what you can do to make them right. Then add in the emotional and political parts of the equation and see what you actually *can* do.

- *Flexibility.* Don't be bound by the traditional ways of doing things. If you have years of experience to rely on, great. But don't be bound by it. Consider all the options; talk to people who can give you clear and original advice. Be willing to face up to new ways of doing things just as we considered dropping (and eventually did drop) our traditional graphics house in favor of an in-house development team made up mostly of interns. Look for courses of action that you never thought of before. Weigh them. If they seem the best way to go, follow them.

- *Creativity.* Don't be afraid to take long walks just to sort things out. Be willing to sleep on things. Pray. Get away for as long as you can, an afternoon, a day, a week; don't think about the problem so that you can clear your mind and then see what pops into your head. Let the computer in your head do some unmonitored processing, and see if it doesn't kick out a solution that you didn't even know was there. It might even be a strong affirmation of things you knew were there all along but were not excited about before. Open up to new connections between some of the elements in the problem. There may be two pieces of the puzzle that never seemed to fit together before and yet suddenly, they do. There may be helpful bridges between disparate elements that suddenly appear out of nowhere. Connect all the dots, then break all the connections and reconnect them. Look at the biggest picture and then smallest. Do something brand new!

But don't let this go on forever. Give yourself your own deadline for making that decision and then bite the bullet and make it. Once you have found a solution, you may be so excited by it that you don't have to wonder if it is the right decision. On the other hand, you may be afraid of the risk and the unknown. It doesn't matter. The bottom line is that when the time comes to make the decision, make it, commit to it, and from that point on don't look back. As the commercials say, "Just do it."

The same principle that applies to these big decisions also applies to the small ones. The worst thing managers can do is *not* make decisions. Gather as much data and information as you can, but when the time comes to make the decision, *just do it*.

Of course, there are tools that can help you through all of this, through decision making, planning, and predicting, and now that we've talked about the process, let's consider those tools and what they can do for you.

Philosophies of Project Management

We've managed to write almost a full chapter on project management without reference to philosophies or styles like Agile, Scrum, and Waterfall. This isn't an accident.

Since the formulation of the Agile Manifesto in 2001, it's become fashionable to proclaim allegiance to Agile software development and Agile project management methodologies, in contrast to the more traditional Waterfall approach (emphasizing a structured process and deliverable artifacts).

In fact, the Agile Manifesto dictates the following:

- Individuals and interactions over processes and tools
- Working software over comprehensive documentation
- Customer collaboration over contract negotiation
- Responding to change over following a plan

Unfortunately, the simplicity of the manifesto sometimes results in a misreading of its intent. Naturally, everyone values working software over comprehensive documentation—but this shouldn't be interpreted as meaning that documenting design and processes is unimportant. Responding to change is important, but without a plan in place, teams devolve into chaos or inertia very quickly.

We've come on board projects that downplayed the importance of plans, processes, and documentation, and they were always projects headed for oblivion (unless new plans, processes, and documentation were put into place). The goal of "responding to change over following a plan" winds up getting translated into "put it in production and fix it as you go," which rarely ends well.

Agility, as a philosophy, is particularly wonderful in pure software development. But serious games and simulations are communication media projects, as

well as software projects—in addition, they include pedagogical development and educational/communication/marketing content development. Consequently, we shouldn't look for a 100% correlation between software development principles and serious game/simulation development principles.

More emphasis should be placed on Agile methodologies than manifesto. Here are just a few:

- Build self-organizing teams, whenever possible.

- Empower teams and avoid micromanaging.

- Delay crucial decisions until the client is sure of direction, then deliver iterations as rapidly as possible.

- Aim for software craftsmanship (thinking about coders as part of a craft guild is particularly useful in the marriage between coding and media that games offer; in the film/TV world, creative principles are also members of guilds).

- Produce fully developed and tested features every few weeks, as opposed to slowly nudging along dozens of features, hoping they'll all be completed around the same time and then finding out that many don't work as planned.

The processes discussed throughout this book are probably more Prince2 or Waterfall than Agile. But in reality, we're wedded to no particular philosophy of project management. When Agile methodologies work, be agile. When Waterfall approaches solve problems, go with the Waterfall. There is no reason both methodologies—and the many other approaches that exist, such as Scrum, Lean Software Development, and Feature Driven Development—can't be used for the same project. Each project is composed of smaller workflows and larger workflows, and different approaches may be more appropriate in different instances. Agile versus Waterfall is a false dichotomy, overly simplifying a more complex world.

As we talked to game developers in the course of writing this book, we found our lack of adherence to management philosophy was reflected in the day-to-day practices of many game developers. Justin Mette, founder of 21-6 Productions, says, "we've rolled our own project management philosophy based on software development practices from our IT backgrounds and real world game development needs, which are much more fluid in nature than business software."

It is probably true that an overall Agile philosophy will be more effective with small teams who have worked together before and are contained in the same building (and better yet, in the same open-flow room). But as teams grow, philosophy needs to make way for practicality. Eitan Glinert, founder of Fire Hose Games, believes the company's approach has changed as it has expanded, moving from a more Agile approach to more of a Scrum approach (though "we prefer not to call it that," he said). "Way too many people talk about Scrum or Agile like it is religion, and will somehow magically solve all your management problems. This is not the case. Ultimately, each team needs to decide what works for them and act appropriately."

"You can't just design as you go," says Kam Star, CEO of England's PlayGen. "You do have to set out what it is you need to be delivering in the game, because feature creep is the biggest killer of profit. And once a client gets to see something, suddenly they're committed. And if you're trying to define stuff as you go along, and didn't define from the outset, or draw boundaries, the client comes up with ever more elaborate ways of expressing their subject area through the game."

In our own experience, virtual teams that rarely interact face to face and have not previously worked together are often better served by a more structured management approach. But as the game developers cited here suggest, there is never a one-size-fits-all approach.

Your mileage may vary, of course!

Ironically, the Agile Manifesto pledges to value individuals over processes. Yet a blind allegiance to a philosophy of agility simply substitutes a different sort of process and ignores the individuals involved. The best project management mixes and matches methodologies throughout while keeping all eyes on the prize: the best possible project, delivered on time, with personnel ready and eager to tackle the next project.

Tools of the Trade

Microsoft Project is probably the standard for project management software. In our chapter on selecting development tools, we'll mention some other tools for project management and collaboration. Project management software resources are plentiful, and if you're new to project management, we encourage you to download some demo applications and see what fits your project. If you've already got your own project management toolbox, then go with it.

Summary

- Luck is no substitute for careful project management, no matter how lucky you may have been in the past. In spite of the fact that game production is inherently difficult to plan for (because of the deadlines, the personalities involved, and the fact that you don't know whether your product is good until it is almost done), there are techniques you can employ.

- Consider these techniques management skills. This chapter's project example showed how the skills discussed in previous chapters (client relations, team building, project planning, and risk management) played a big role in meeting the project's challenges. Additional actions are critical to successful project management:

 - *Share the vision.* Make sure everyone knows what those goals are. This will ensure you are managing the project's *scope* by clearly defining the goal and extent of the project so that the project doesn't creep and grow out of control.

- *Prioritize,* so that your people do the right things in the right order, whether because there are dependencies or because you need to hit the key goals first.

- *Manage workflow.* Hire people who know how to meet deadlines, then monitor their progress and do everything you can think of to keep them on track. That especially means you may need to bug the hell out of them.

- *Make decisions.* Whenever you need to make them, just do it. The worst thing a manager can do is not make decisions in a timely manner. When especially challenging issues arise, be pragmatic, flexible, agile, and creative.

- Studying project management and software development philosophies and approaches is enormously useful, but real-world experience argues against blind allegiance to a single approach. The best project management sizes up the situation and the individuals involved and then finds approaches to move the project forward.

DETERMINING PROJECT GOALS

The Argument for Instructional Design

Chances are good that the first serious game you oversee or make will be instructional in nature. Whether it's for business, the military, or the health, safety, or service professions—or whether it's designed to provide basic elementary or high school curriculum material—you'll have to know about the content you're going to present and you'll have to know the best way to present it.

Instructional design is a process that is not always popular within the game development industry. In the rush to get going and make a game (often with funding ticd to delivery deadlines), dissatisfaction with the need to analyze the content and study the makeup of the target population before game development begins often arises. This is true not only of serious games created for learning purposes but for promotional and persuasive serious games as well.

This section discusses the following processes:

- Determining project goals
- Gathering content to put into your game
- Organizing that content so that it is instructionally effective (whether from the perspective of training, political persuasion, or marketing)
- Qualifying your target audience

The section suggests quicker, more effective methods for carrying out this process and gives examples of how we applied these methods to the design of some of our games. Our purpose is to increase the effectiveness of serious games by returning to some of the fundamental instructional design techniques that have been lacking in most serious games.

CHAPTER ELEVEN

Game Design and Instructional Design

Introduction

In the following chapters, we're going to talk at length about instructional design and then about game design. So why have a chapter that compares the two? Well, good instructional design will tell you that when you have two concepts that people continually confuse, they should be presented together so that the similarities and the differences can be compared and people come to understand the distinction.

The truth is that, in many people's minds, game design and instructional design are the same thing. In other people's minds, they're at odds. Some of our game designer friends have told us that talking about instructional design in a book about serious game development will muddy the waters greatly and even mislead fledgling game developers into including instructional designers as part of their team. They tell us that instructional design really competes with and detracts from much of what game designers want to do.

Confusion! Let's clear it up. Let's look at how the two disciplines are different and how they can complement each other.

A study carried out by the U.S. Navy in 2005 reports that "empirical research does not make a compelling case for games as the preferred instructional method."[1] In other words (at least according to the findings of this report) instructional games aren't any more effective than any other methods of instruction.

Although this situation (according to the report) has something to do with the lack of rigorous data collection and analysis on the part of the researchers in the field, it's not the whole story. That same report compelled the Army Research Institute to launch a further study designed to evaluate the value of including instructional design in the game development process. The underlying premise for the study was that instructional games are largely devoid of instructional design

[1] Hays, R. *The Effectiveness of Instructional Games: A Literature Review and Discussion.* Orlando, FL: 1995. Naval Air Warfare Center Training Systems Division.

and, as a result, serious games are rarely as effective as they should be. That study is currently in progress.

Keeping in mind the conflicting views of game builders and major serious game clients (the U.S. Navy, the Army Research Institute), let's do a quick comparison of instructional design and game design, see if there is a way to understand them better, and in the process find a way to have them complement and enhance each other so that we can create better serious games.

The Horrors of Instructional Design

Let's start by acknowledging that there are valid reasons for the negative feeling that many game designers have about instructional design. There was a moment in the 1960s and 1970s when instructional design, performance problem solving, and various kinds of analyses were all the rage in the training community. The theories and practice came from the application of principles of behavioral psychology and especially from the work of B. F. Skinner. Advocates of this approach were convinced that if you could define a behavior well enough and reward it in the right way, you could teach that behavior or set of behaviors to just about anyone. It was like teaching rats how to find their ways through mazes, as Skinner had done in his famous experiments. The Skinnerian box (a modified version of a rat maze) became the logo of more than one large and prosperous instructional design firm.

This moment of notoriety had a nasty effect on some of the finest minds in the profession. So confident in their ways were these designers that they launched into an era of performance contracting that offered this bold promise: they could teach whatever they were asked to teach to a predefined level of satisfaction, or they would not have to be paid for their services. In other words, they would develop instruction that taught exactly what it said it would teach, or they wouldn't have to be paid at all. There were a few notable successes, but soon, of course, most of these companies went out of business.

This is too bad, because the underlying principles of behavioral psychology do apply to learning. Fortunately, they were not totally abandoned; others in the profession did pick them up, and some of the older gurus of the craft became consultants and spread the word. Consider that instructional design and development really consists of three parts:

1. Analysis of what the learning problem is

2. Design of a solution to the problem

3. Development of that solution

Training departments, intrigued by the new technology, began setting up instructional design groups to take advantage of it. The problem was that many of these departments were staffed with disciples who had limited knowledge of the craft. What actually happened in many cases was that instructional designers forgot all

about design and development and focused only on the first part of the process: *analysis.*

The phrase *paralysis by analysis* may have been coined in reference to early instructional designers and the levels of analysis that they indulged in. Corporate clients who had limited time and limited budgets were shocked when they got the results of highly touted analysis projects and found, for example, a 200-page list of everything that someone had to do to perform a specific job, but little else. The content in these lists seemed fairly obvious to the clients; nevertheless, the analysts implied that to go forward with the project, another kind of analysis would be needed, and then another and another. That really turned off the clients. The corporate honchos soon either shut down their instructional design departments or brought in people who were more oriented toward development than analysis.

Unfortunately, in turning their backs on what many considered to be a time-consuming and wasteful process, these corporate training leaders turned their backs on the important function that instructional design provides. After all, if you don't identify all the steps in something you are trying to teach someone, if you don't specify criteria for performing those skills correctly, how do you figure out *what* to teach and *how* to teach it? How do you determine the content of your serious game or simulation? The answer, unfortunately, for too long, has always been somebody's best guess. And as educated as those guesses might be, they remain guesses. What the analysis phase of instructional design did was provide a rigorous framework for collecting data and an organized way of providing research material. The rigor seemed excessive, but it was dependable and accurate.

The strange evolution of instructional design then saw a polarization of the process. Some companies were able to crossbreed (as it were) analysts and designers and developers and actually turn out amazingly effective products. Others, however, maintained the more old-fashioned instructional design staffs who conducted their analyses ad infinitum—and helped convince the rest of the world that their profession was useless. It was from this low point in the history of instructional design that many game designers, especially designers of serious games, got their opinion that instructional design means endless, unproductive analysis. Almost as a group, they decided to keep instructional designers out of the serious game development process at all cost.

The Need for Instructional Design

If you could walk into a client's office and have the client hand you a set of specifications for your application—one that spelled out exactly what each player had to learn, the details of the tasks each person had to perform in the game, and how well the players had to perform each task in order to succeed—you would feel very secure in your ability to deliver an effective serious game. The challenge would be to find interesting gameplay to make the game fun enough to play over and over again while all that learning was happening.

What if your client then gave you a document that showed you each of the steps that the player would have to go through in playing the game, the order in which the steps had to be taken, the worst-case scenarios for failure, as well as the best-case scenarios for success? If the information was correct, again you would feel that you were well on your way to having a successful game.

That largely defines what you should expect to get from an instructional designer. If the client can't give you those specifications to the degree that you need them, then you need an instructional designer to do it for you. The result of the analysis will tell you exactly *what* you have to teach or, if it is a simulation, the tasks the player has to complete successfully to simulate the experience and learn the correct behavior. The results of the instructional design will tell you how to present the information in a way that will help the learner understand.

The Process

When you know what you're going to teach and how you're going to teach it, then you're at the point where you can begin the creative design process or, as you may prefer to call it, game design. We spent years designing educational material for Walt Disney and other world-class educational media companies, and when we walked in the door to start an educational project, the client would often hand us a well-prepared document that said, this is what you are going to teach and how you are going to teach it. Then it was up to us to figure out the creative way to do it.

Retention Education is another designer and developer of innovative educational materials. The company focuses on educational programs for cross-cultural training, especially aimed at Hispanic Americans or Hispanics who have come to America to live and work. Retention Education's classic series *Sed de Saber* uses LeapFrog interactive game technology to teach new arrivals in this country how to work in the U.S. Food Service Industry. Figure 11.1 shows a sample of the interactive game book from *Sed de Saber*.

Retention Education asked us to do the game design for a program that would enable qualifying Spanish-speaking people to pass the U.S. citizenship test. Retention's educational specialists gathered and organized the basic content material and passed it on to us. We went through it carefully and then turned our attention to the game design itself.

We chose to follow the basic game design used by Retention Education in *Sed de Saber*. That is, we designed a learning game featuring a combination of reading, engaging with the narrative, and then responding through the LeapFrog pen and book interface. The simple interaction (selecting choices on a screen) required the strong narrative story to keep adults engaged. To build a story, we started with a story premise.

FIGURE
11.1

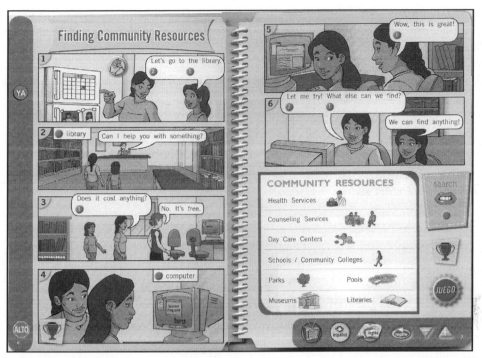

Interactive "pages" from the *Sed de Saber* learning game. This section deals with finding community resources. ©2007 Retention Education, all rights reserved. Used with permission.

The Premise

The premise of the game is really the first creative element designers usually try to deal with in developing gameplay. They have to figure out the story of the game, and since we are classic storytellers, we follow the traditional formula: hero, goal, and obstacle.

To help our learners (adult Hispanics now living in America) gain some comfort in what they may consider difficult and new surroundings, we created a family to serve as models for the behavior we wanted to teach. We then developed different characters to represent the various, conflicting points of view that our audience might be feeling. Our hero was the person in the family most interested in obtaining citizenship. In our case it was the mother, Lilia. But we also needed a parallel hero, someone with whom the male population could identify. So we developed Lilia's husband, Juan, a hard worker who put in long hours.

The goal for Lilia and Juan, then, was to gain U.S. citizenship, and the obstacle was lack of knowledge of the information needed to pass the citizenship test. But

almost as important, we gave them a lack of knowledge of the advantages of being a citizen. We also addressed another obstacle: misinformation and fear about the cultural disadvantages of U.S. citizenship (e.g., losing a sense of Hispanic identity or never being fully accepted as an American).

To review, we had:

- Heroes—Lilia and Juan

- A goal—citizenship

- An obstacle—lack of knowledge and misinformation

Other Characters

We decided to give Lilia and Juan a preteen daughter, Theresa, who went to a local school, who was savvy about all things American, and who could be their guide and mentor along their path to citizenship. We also added another character, Grandpa (Papa), who started out voicing all the natural concerns and negative ideas about becoming an American but who in the end turned around and became anxious to gain citizenship himself.

Business

The mechanism we chose to introduce Lilia and Juan to the information they needed to learn about citizenship (the information on the citizenship test) was a tour of Washington, D.C. In the process of the tour, Theresa would show them various landmarks and explain the different branches of government and their operation. Sometimes the narrative of the characters would initiate gameplay activities that would provide some of the content information. Other times, the various tools that were part of the creative design of the game would disclose it.

For example, in the capital map game suggested in Figure 11.2, players would be asked to tap on one of the buildings in the map of the Capital Mall, and then indicate whether that building was part of the legislative, executive, or judicial part of the government. Note also the tool icons in the lower-right-hand corner box and their purpose:

- The hand-to-ear icon played all narration in order.

- The microphone icon played and recorded oral quizzes.

- The dictionary icon played definitions of key words.

- The videogame icon played learning games.

- The music note icon played related music or spoken words.

- The cartoon balloon icon played cartoon dialog.

FIGURE
11.2

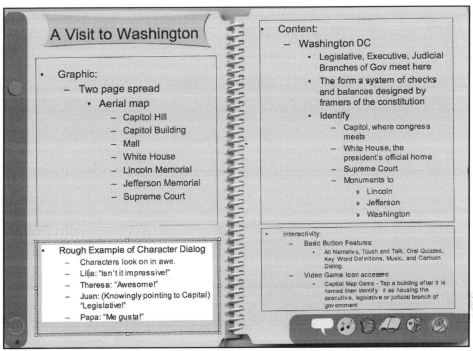

Sample interactive pages from our "Citizenship" creative design. ©2007 Retention Education, all rights reserved. Used with permission.

There was a great deal of creative gameplay designed for this game: all of it initiated in response to the objectives of the course, which were identified in the instructional design. We won't go into the details of the instructional design or creative development of this particular game in this overview, but we'll discuss this topic extensively in Chapter 15 (on determining simulation activities) and Chapter 16 (on designing gameplay).

The Pay-off

All good stories have an ending, and in our case the ending provided reinforcement and encouragement to the players. We displayed comic-book style art that portrayed Juan passing the test successfully, receiving the news that he and Lilia have qualified for citizenship, taking the oath, and then participating in a family party, where, to everyone's surprise and amusement, Papa announces that he is going to apply for citizenship.

Making the U.S. Federal Budget Fun for the Checkbook Challenged

The learning content for the Woodrow Wilson International Center for Scholars' *Budget Hero* couldn't be more formidable: a deep understanding of the U.S. federal budget; its budget categories, priorities, and built-in commitments to Medicare and Social Security; and how forecasting, projections, and politics shape policy.

The complexities of the learning content had a paradoxical effect on the game design. David Rejeski, then director of the Foresight and Governance Project for the Center and creator of the game, says, "One of the major challenges for the game was making federal budget prioritizing approachable. Most people have trouble balancing their personal checkbooks—what would make them want to tackle the nation's checkbook given its complexities?"

He and his team realized that "the game would need to be completely unintimidating to invite engagement and get people into the experience."

This resulted in using the metaphor of a Pokemon-style card game to interact with the material and the development of an "incredibly disarming" user interface: a cartoony city landscape that echoed styles from old children's board games, storybooks, and Saturday morning animated series.

The resulting game design succeeded in pulling in both children and adults (who might like to play in this "cartoon" world a bit), even while dealing with budget numbers that would make anyone's head hurt.

The dialectic between instructional design and game design can sometimes lead to surprising new and creative directions, as the experience of *Budget Hero* suggests.

The Comparison

You can see that the instructional design process—or rather, the analysis and design process—is really a rigorous way of gathering the information needed to create the game or other piece of instructional media. The better the analysis, the better the data that the game designers have to work with. And the instructional design does more than clarify the topic. It identifies certain instructional principles that can be used to help make decisions during creative development. What is the best order to present information? Yes, there is a *story* order, but there is also an instructional order, and a good solid instructional design can present information about

the instructional order as well as much, much more, so that the creative designers can be informed when they are hashing out the elements of premise, business, and gameplay.

One rule we have in doing analysis and instructional design is that we never allow ourselves or anyone else working on that part of the project to think about creative solutions, story or gameplay, or anything else until we have the content and the instructional principles fully defined. That way we don't start shaping the content to fit some story idea we have. We don't start looking for skills and practices to justify an activity or a piece of gameplay we want to create. The instructional design has to be pure if is going to yield the best gameplay.

In the next two chapters, we'll look even more closely at examples of instructional analysis and design and principles of good game design based on some of our most recent work.

Summary

- Serious game designers often find themselves at odds with instructional designers. Although history may underlie this conflict, the fact is that each designer needs the other to effectively develop serious games and simulations.

- Make no mistake: instructional design and game design *are* different. In one way, instructional design is the pure research that someone has to do before the creative elements of the game are hammered out. If gameplay precedes instructional design, it is likely to do a poor job delivering the necessary teaching points.

- But in another way, instructional design identifies principles of good instruction that can be added to the game to make it more effective. Some of these principles, while not interfering with the creative design, do provide the key to elements of gameplay that can be compelling as well as instructional.

Determining Project Goals through Analysis

Introduction

You have a client who is really looking for results, who wants you to be more rigorous, more thorough, and more effective about the "serious" part of your serious game. How do you incorporate instructional design into your design process while sidestepping the game-design-versus-instructional-design conflicts described in the previous chapter?

The answer is twofold:

- Find instructional design specialists who are sensitive to deadlines and understand that their job is to uncover relevant data to inform the overall game design.

- Employ simpler, more streamlined kinds of analyses (as we will describe later in this chapter).

This will result in a game design (well grounded in the reality of the learning problems because of the analysis) that will lead to the development of a superior final product.

Let's walk through a step-by-step breakdown of classic instructional design analyses.

Needs Analysis

This step could also be called *research* or *data collection*, and it can be argued that the process should be completed before a game development team becomes involved in the project. But if you *are* a game development team, there is good

reason to want an instructional designer (or I.D. specialist) on your team. If a needs analysis has not been done, this person can quiet any skeptics among clients who may have doubts that a serious game is an appropriate solution to the particular learning problem they're trying to solve.

You'll be able to say, "We have an instructional designer who will make sure that the game is instructionally sound and will do exactly what you expect it to. And, of course, we'll document the expectations, solutions, plans, and designs."

A complicating factor can be that part of the mission of a needs analysis is to determine the best solution to the performance problem—even if that solution is *not* the serious game you are proposing. Why would you want to have a member of your team who might tell the client that your product is not what the client needs?

- If there is a person who should say that, better that he or she be on your team and on your side than somewhere else.

- The ability to point to a resource that will look objectively at the learning problem and identify appropriate solutions seems like a strong benefit to offer the client and is an assurance of credibility for your team or outfit.

But here's some good news: the answer will almost never be that a learning game is a completely inappropriate solution for the performance problem. At worst, it will have to be part of the solution. Organizational and motivational issues may be impacting the problem, and you might as well point them out because if they operate against the effectiveness of your game, it's in your best interest to know what they are and be able to explain them.

For example, in a learning game we developed to teach firefighter safety, we identified a strong motivational problem fire captains have with sending sick firefighters home. Sometimes the sick firefighters in question stand to lose part of their salaries, benefits, or even their pension if they have to miss a day of work. Consequently, they come to work and ask to go out on the job even if they are in poor health.

Think about it. A sick firefighter is out there on the lines. It's dangerous for the sick firefighter, dangerous for the other firefighters, and dangerous for any victims who may be involved in the incident. We could address this issue in a number of ways in the serious game, but more important, we could point it out to the fire service and suggest that it address this issue from an organizational point of view. We did that, and it greatly added to the credibility of our analysis and our final product.

The needs analysis has to address the following questions:

- What problem is stopping people from doing what they are supposed to be doing?

- What are the causes of that problem?

- Within the training domain, what general skills and knowledge do we need to impart to make the problem go away?

- Can we simulate the performance of those skills?

FIGURE
12.1

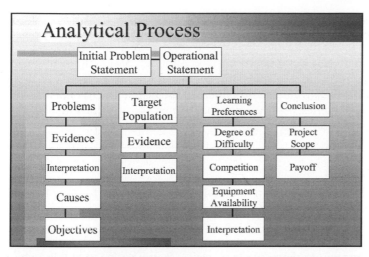

The analytical process shows the subject areas that must be addressed in a needs analysis, along with the activities that must be performed in conjunction with each topic area that must be followed in a needs analysis. Data must be collected and analyzed. This will lead to objectives and recommendations. ©2007, Compelling Technologies, all rights reserved. Used with permission.

Figure 12.1 outlines these issues and other kinds of information that can be gathered as part of the needs analysis.

The needs analysis requires that the analyst get up to speed on the subject fast. What better way to start than by reading the literature available on the subject? The Internet is a great source of information, and the client will almost always be willing to supply you with mountains more. But for training and education, and even many persuasive/social change applications, there is no substitute for subject matter experts (SMEs).

Subject Matter Experts

Subject matter experts are people with hands-on expertise in the field of application you've entered into (we'll discuss different categories of SMEs in a moment). You should anticipate that once your needs analysis has begun, SMEs will want to question you on *your* knowledge of the subject. A careful reading of all the literature you can get your hands on may seem difficult and time consuming, but undertaking it will make you something of an armchair expert on the subject who is ready to talk to SMEs and understand and maybe even use their terminology and frame of reference. Eventually, these SMEs may need to sign off on analyses, documents, or finalized gameplay sequences or simulation environments, so they're worth getting on the same wavelength early.

Types of SMEs

SMEs, however, come in many flavors, and it is a good idea to know that, so you can identify the role that each is supposed to play. Although SMEs are most prevalent in the development of training games and simulations (and we'll look at them from this vantage point), their value is also critical to the development of persuasive games and social change games. As we'll see in Chapter 14, they have their counterparts in the promotional game arena too.

Curriculum Authorities

These are experts on the subject who are probably not currently performing the job. They are more likely serving from an administration chair now; they may have written books about the topic, and they may have even retired.

It's not unusual that the senior person at the client's organization is a curriculum authority. This is the person of whom everyone says, "You really need to talk to him or her." Including the advice of this level of authority adds credibility to the analysis and gives a great theoretical underpinning.

Curriculum authorities may have critical insights, which help unravel a problem. They may also have prejudices that you will probably be able to debunk in your analysis. This will make you a hero to those who can see through the boss's limited thinking. On the other hand, these same curriculum authorities also have pet theories or ideas that you'd better pay attention to and verify with your analysis. After all, it's better to include a creative idea that may be a little limiting than a belief about how something is done that could be outdated or just plain wrong.

When we developed a game to teach fire safety to eight- and nine-year-old Alaskan Natives (eventually called *Spark Island*), we talked to tribal elders who had valuable insights into why Alaskan Native kids are so fascinated by fire, why they are unafraid of it and see it as a plaything. Our senior client was taken with the idea of using a raven (a major figure in Alaskan Native mythology) as the voice of reason in this wild environment. Many of the elders liked the idea, so in the end we incorporated the idea of the raven as an intelligent tutor into the final design.

Experienced Practitioners

At the opposite end of the spectrum from curriculum authorities, experienced practitioners are people who perform the skill well and do it almost every day. In some cases, these people are difficult to take advantage of because they have built up a great store of tacit knowledge, which can be hard for them to put into words. In other cases, they are overflowing with information and your only job may be to keep them on track.

In working with the fire service, we were introduced to model fire stations with model programs and firefighters who were experts at the very job we were

analyzing. These people gave us an initial review of the problem and outlined some of the solutions. They played an even greater role in the task analysis that was to follow.

The Target Population

These are representatives of the people who will play the game. Get to know them. Learn what they're like, how they spend their days, how they feel about interactive applications such as games and simulations, and how proficient they are as gamers. In the end, their attitudes and opinions will determine whether or not your game is a success. Therefore, consider their demographics and tastes. But remember that they may not have yet discovered the secrets that the experienced practitioners know. You can't just talk to the target population and expect to be able to describe the performance you are trying to teach.

Job Trainers

These people may have great insights into the target population and the skills to be taught, or they could be bureaucrats who are hanging on until retirement. In either case, they probably hold important information. They can describe the kinds of training that your audience is already getting. They can show you the kinds of learning facilities that are used. They know the kinds of computers available to your target audience.

Job trainers will also have opinions about serious games, and they may be in a position to endorse or kill the game you are planning to develop. Get them on your side. Point out that games can be played individually or in groups with the facilitation of a leader (like them). With this understanding, the trainers will become allies, encourage the purchase of your game, help to get it installed, and build it into their curricula. You need them on your side.

Conducting the Needs Analysis

The following steps outline the process of conducting a needs analysis.

Step 1: Sell the Analysis

Since analysis and instructional design will add a little more time and money to the project and the budget, you will probably have to convince the client that the activity is worth doing. The client will certainly have a preset notion about what kind of serious game is needed. But the client will also know that you have to expand your knowledge, talk to the important parties involved in the project, and get some added details from subject matter experts. In many ways, what you are asking for is time to do research, but in fact it is highly organized research that

will provide a more detailed understanding of the skills the serious game needs to teach. If the word *analysis* sets off alarms with the client, call it *research* or *data collection* or even *content gathering*. Who can argue with that? Also note that there are several parts to the analysis phase of the project. Make sure the client knows that. Suggesting that those parts can be combined (as we will explain at the end of this chapter) can help.

Step 2: Schedule Interviews

Have a kickoff meeting that gets the key players from your team together with the key decision makers on the client's side. Begin the analysis *during* that kickoff meeting. Ask the clients to define the purpose of the serious game right then and there: What are they trying to accomplish? (But be prepared for the client to be completely off target.) Then ask the clients to set up meetings with the kinds of SMEs mentioned earlier: senior experts and authorities on the subject (curriculum authorities), people doing the job right now (experienced practitioners), people the game will be aimed at (the target population), and job trainers.

Step 3: Formulate a Hypothesis

We said that people in your client's organization will have a gut feel for the solution to any learning problem. They'll also have a strong opinion about the problem itself (though maybe not the solution). At your kickoff meeting, your clients will present you with these opinions. Encourage them to be as specific as they can be, then turn these opinions into the hypotheses of your analysis. Your research will then be to verify the hypothesis; this is Scientific Method 101.

Step 4: Create an Operational Statement

The first interview or two in your analysis will help you clarify the client's hypothesis enough so that you will be able to restate it in terms that will more easily lead to behavioral objectives. It will then become your description of the problem: your *operational statement*. (Note that the operational statement can also become part of the statement of work in your own contract, as we discussed in Chapter 7.)

In the needs analysis for *Fully Involved,* the *hypothesis* was stated this way: Deficiencies in the performance of some company officers put their firefighters at risk. Major deficiencies include the following:

- Poor decision making

- Inadequate size-ups

- Inattention to the condition of their team

- Inability to maintain personal accountability

- Letting adrenaline take over and weaken their judgment

A restatement of this hypothesis that focused more on specific behaviors resulted in an *operational statement.* Major incident command risk factors include the following:

- Not following proper procedures in a firefight
- Not establishing authority and control in a fire situation
- Not doing a good size-up of fires in single-family dwellings
- Not being able to recognize key firefighter safety hazards
- Not maintaining situational awareness
- Not making correct decisions under stress
- Not maintaining clear communications with firefighting crews
- Not controlling and limiting "freelancing"
- Not managing the physical fitness of the crew

Although the initial problem statement we received from our client in our first meeting was good, there were some things missing, and it didn't take more than two meetings to begin to identify what those things were. How did we find them out? By asking.

Step 5: Collect Data

This is where interviews begin in earnest, as many as you can cram into a one- or two-week period. If possible, try to duplicate the geographic diversity of the target population. Travel to locations that are typical of the places they'll be. The job is to gather evidence about the truth of the operational statement. Interviews with SMEs are the key. Some SMEs may dispute parts of the operational statement, but most will contribute examples that build out the statement and allow you to divide it into subtopics.

Look for exceptions; follow procedures through at a top level, and also ask about motivational and environmental issues, as illustrated in Figure 12.2. Are there issues in the environment that make it impossible to perform the task correctly? Are there motivational problems that make performers not want to do so? Immersion is also important. You can't live their lives, but you can at least get into the field with your potential users. Go with them when they do their job. Gather firsthand evidence of correct and incorrect performance. Additionally, there is nothing like recorded video and audio. You can use this material for many purposes and the firsthand material helps in case you have to show evidence of a certain design decision.

As mentioned earlier, while you're in the field, take the opportunity to ask about existing training, the learning environment, preferences for computers or game consoles as a learning device, favorite videogames, and so on. Get to know your audience.

FIGURE
12.2

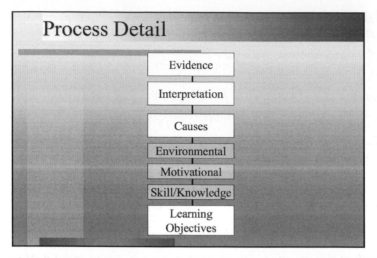

This slide shows the step in which the instructional analyst considers environmental and motivational causes of the performance problem. Maybe the performers don't want to execute the procedure the right way or something is stopping them from executing it correctly. (This is different from not knowing *how* to execute the procedure.) ©2007, Compelling Technologies, all rights reserved. Used with permission.

Step 6: Analyze and Compare

Now it's time to sit down with all the notes you've taken and any recordings you have made of your interviews and look at the data. Where do people agree and disagree? What explanations exist that address one or another of the most common discrepancies?

Pull out quotes that prove the point, and make sure you know the authors of the quotes. If you have to present a PowerPoint of your analysis, quotes always help sell it. Perform a diligent online search (and use print publications when they fill in the gaps, as many trade, professional, and research journals still resist making everything available online). When possible, use real cases. Once you've digested all your research, taped your flipchart pages to your walls, and divided hastily written index cards (or the digital equivalent) into piles pro and con, it's time to draw conclusions about each of the points in the operational statement. Figure 12.3 displays an interpretation slide from the first objective in *Fully Involved*.

Step 7: Report

The completed needs analysis—with its newly defined set of objectives, its conclusions, and its recommendations—needs to be presented to and agreed upon by the client.

FIGURE
12.3

1 - Following Procedures

- Definition
 - Deficient Company Officers don't know basic procedures especially those relating to the safety of firefighters.
- Evidence
 - Problem cited in
 - 4/4 SME interviews
 - 4/4 fire fighter interviews
 - Research Data

A presentation slide about "Following Procedures"—an interpretation of the information gathered in the needs analysis. ©2007, Compelling Technologies, all rights reserved. Used with permission.

Though we can probably agree that we've all seen too many PowerPoint slideshows, a presentation tool (whether PowerPoint, OpenOffice Impress, or Google Presentations) remains the best method of presenting the report to an assemblage (physical or virtual) of client representatives. Who attends the meeting will tell you a lot about the importance of the project in the eyes of the client. (If you're in Los Angeles, for example, and people come in from as far away as Alaska, you know that it counts!)

Naturally, photos or video captured during the analysis phase can brighten up the presentation by putting a face on the voice of those interviewed and illustrating training locations, tools, and equipment that may play a part in the results of your analysis.

The PowerPoint version of your needs analysis, of course, should be accompanied by a fully detailed report so that those unable to attend the presentation will not have to read between the bullet points of your slide show. The client needs to sign off on this report—literally. Then if there is anything wrong with the materials or analysis, you should be able to avoid liability for the consequences.

Here is a simple outline of the content that should be presented in your report:

- The definition of each of the problems and subproblems identified

- Evidence to support the problem statements

- A commentary on the validity of the evidence

- Causes of the problem (according to the three major types of causes)

- Appropriate behavioral objectives that, when met, will alleviate the performance problem

Task Analysis

If the purpose of the needs analysis is to identify the problem and its causes and turn those problem/cause statements into behavioral objectives, then the next step—the task analysis—is to identify and describe the details of the tasks that make up the behavioral objectives.

Some instructional designers also differentiate between a task analysis and a cognitive task analysis (CTA). According to this distinction, the task analysis looks at overt behavior, which can be considered performance skills, and the CTA tries to define and verify the kinds of deep thinking required for many covert activities.

Returning to our illustration using *Fully Involved*, a major problem with firefighter safety is that the incident commander (the firefighter commanding the fire attack) sometimes doesn't do a good size-up (looking at the conditions outside the building) before starting to fight the fire.

The top-level objective is that the incident commander will become able to do an adequate size-up on the next firefight. (Just for the record, a key to a good size-up is doing a complete walk-around before starting the firefight. The incident commander has to walk around the burning building before doing anything else. Although that might sound like the simplest thing in the world to do, keep in mind that personnel are requesting direction and the situation is often chaotic, too frequently resulting in a skipped or partial walk-around.)

Unfortunately, just saying that the incident commander should take a stroll doesn't really capture the entire objective. The incident commander needs to know what to look for and evaluate during the walk-around, and therein lies the subject of the task analysis.

Armed with a list of objectives, we sat down with experienced firefighters and found out the steps involved in doing a good size-up. We learned that it was critical to actually walk *all* the way around the building, even when it might seem superfluous to do so.

If the incident commander stops after checking the front and side of the house, he or she may miss a frightened child paralyzed at an upper window at the back of the house, may miss the telltale signs of smoke streaming from under the eaves on the far side of the building, or may miss the half-constructed swimming pool in the backyard (a real danger to firefighters who are charging around). Teasing out the right stuff from experienced performers is the black art of task analysis. People don't necessarily know how they do things, so you have to force them to walk through the process in the tiniest steps you think necessary.

We, the analysts, had to get experienced firefighters to tell us every step and task involved in doing a good size-up and walk-around. We asked them all their secrets. We looked for critical discriminations: What factors have to be recognized, compared, and understood? In the case of the walk-around, questions to ask included the following:

• Are there toys in the backyard that give the incident commander clues that small children are living in this house?

- What kind of exit is there from the building?

- What is the overall shape and structure of the house when seen from all sides?

- Are there any indications of remodeling that might be going on inside and might affect the way the fire will spread or should be fought?

These are critical discriminations, and we had to list every conceivable one that could be made in doing a walk-around. To find all of them, we had to talk to lots of experienced firefighters. The more firefighters we talked to, the more complete our list.

Often, you may uncover disagreements about approaches or best practices within a job sequence or event. Sometimes these disagreements may be about a matter of policy. Call your interviewees back if you have to. Have them work out the disagreements if possible. If not, go to your curriculum authority and have that person make the call. Or present the dichotomy in your analysis report, and use the report meeting as a way to get the client to resolve the issue—for example, the authority may conclude, "That's the way some of them say they do it, but *this* is the way the national organization wants them to do it."

In the case of *Fully Involved,* when we concluded researching and analyzing size-ups and walk-arounds, we had the related objective pretty well described. All we had to do after that was to methodically go through every other objective and subobjective and catalog the details of what the best firefighters would do to meet them. Table 12.1 shows the top line objectives for the serious game with subobjectives noted.

Note the point under the first objective, that knowledge about following procedures would be a prerequisite to using the learning game. This was a heavy-duty conclusion. It meant that the serious game did not have to attempt to deal with the basics of firefighting. There wouldn't have to be a learning module about Firefighting 101, because users of the game would be expected to know these procedures before they began play.

This bit of analysis was the professional judgment of an experienced instructional designer, and right here the person should have earned the client's respect, because the judgment would ultimately allow the developers to create a game focused on objectives more in tune with the needs of someone actually commanding a firefight.

The *Fully Involved* needs and task analyses ultimately formulated eight objectives with 49 subobjectives. A detailed task list matched every subobjective. But look at what we created for the game developers in the process of doing that analysis: a complete list of challenges for gameplay and a complete list of all the conditions, props and characters needed to successfully simulate a firefight. Figure 12.4 shows the summary frame of the objectives and sub objectives for a good walk-around (also called a size-up.)

Now our game developers knew that one part of the game would be to add different items to the backyard of the house so that when the walk-around was executed, the player would have to evaluate the meaning of different objects or events he or she discovered. These variables weren't just random items that were added. They were critical discriminations, each of which meant something very important.

TABLE **12.1** Objectives and subobjectives for the entire firefighter-safety training program as determined in the needs analysis (note objective 3: Doing Size-ups).

1 Following Procedures

State the correct steps to follow in fighting a single family dwelling fire.

Prerequisite

2 Establishing Authority

Establish and maintaining authority at all times.
8 sub-objectives

3 Doing Size-ups

Understand the value of a size-up and "walk-around" and do an effective size-up on a series of single-family dwelling fires.
11 subobjectives

4 Combating firefighting hazards

Recognize and counter hazards that are faced when fighting a fire

5 sub-objectives

5 Making Decision Under Stress

Demonstrate the ability to understand and deal with the effects of stress, determine situational awareness and make critical decisions in stressful firefighting situations.
8 sub-objectives

6 Clear Communications

Demonstrate the ability to maintain clear communications with subordinates
6 sub-objectives

7 Limiting Freelancing

Limit freelancing during a fire, and take preventive action before and after the incident.
6 sub-objectives

8 Maximize Fitness

Demonstrate the ability to enforce an effective physical fitness program and send sick firefighters home.
4 sub-objectives

And we had more good news for the game developers: not only a list of props, situations, and characters, but a ranked list of those items and their relative importance, and the associated performance criteria spelled out as well. We indicated which props or situations had to occur at which game levels.

The player's performance in encountering these elements eventually helped develop the game scoring and rewards system.

Establishing Performance Criteria

It's not enough to know what tasks must be accomplished to meet an objective. It is equally important to know how well the tasks have to be performed and if there are other constraints that have to be acknowledged in describing the tasks. It's what we call *mastery performance*—that is, it's the job done the way a master would do it. In most cases, this designation is done in collaboration with officials in the field. In education, there are curriculum and test designers who have to adhere to previously established standards, and serious games have to be just as strict.

In our interviews with firefighters for *Fully Involved*, we determined each of the steps that had to be performed to meet the objectives of the course, and we also took the time to note the constraints that determined the effectiveness of performance.

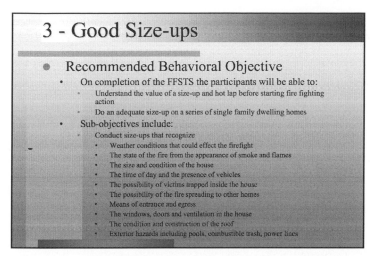

FIGURE
12.4

Objectives and subobjectives. These items are followed by a detailed task list of mastery performance in this activity. ©2007, Compelling Technologies, all rights reserved. Used with permission.

We found out how quickly each task had to be performed, how much time could be allowed before it had to be performed again, how much time each task should take, when a task was taking too long, and when it was being done too quickly.

We asked the firefighters to rank the tasks: which tasks were more critical than others, which could be minimized or omitted, which rules could be ignored and when. This was slow going because we were talking about firefighter safety, and when we asked which tasks were more important than others, the usual answer was that they were all equally important. Consequently, we had to push hard for some rankings, and we had to force rankings from several sources so that we could compare the results of our interviews and look for commonalities and strong disagreements.

At the end of the day, we had our list of answers, we had our measurements, and we could tell the game designers, for example, that doing a proper walk-around should be given more weight in scoring and evaluation than some other activities.

Case Study Examples

In addition to the massive job of describing mastery performance, including establishing the required criteria, a task analysis should also gather information about examples. What is the ultimate example of the best thing to do? The very worst? The most surprising?

Again, if game designers are not used to thinking in terms of instructional design, they should still be able to relate to this effort as good, old-fashioned research (but as we noted earlier, it's extremely organized and rigorous research).

It's important to find out the exact vocabulary people use in given situations and to establish what an event sounds like, because that should be part of the environment that shapes performance. Finding lots of exceptions to the rules helps make a training system extremely rich and deep. Also, the task analysis should have set the scope of the instructional effort. In the case of *Fully Involved,* we determined that we would not try to teach firefighter safety for every kind of fire in every kind of structure but would focus on fires in single-family dwellings. The task analysis then made sure that the classification was specific enough or whether it needed to be refined further.

Within the single-family dwelling scenario, the decision was then made to stage various kinds of fires in the same house, with different occupants and varied floor plans. The task analysis gave us the details that made this decision acceptable, but it also helped us understand that changing the time of day and the weather conditions could provide a great deal of variety for our participants.

Expectation Violations

One learning theory states that the lessons people remember most are those that they learn when they're surprised—because the right thing to do in a given situation turns out to be the exact opposite of what they expected it to be. It's like saying, "When I was inexperienced, I believed that something would be done this way. But when I really saw the way it worked, I was surprised to find out that it was just the opposite of what I expected."

We posed questions about expectations violations to firefighters and got some interesting answers. We always look for expectation violations, because they are a way of finding secrets known only to the old pros.

For example, one firefighter told us of seeing a home with three windows across the top of the back of the house. This led the firefighters to believe that they could enter the building through the middle window and it would enter onto the same floor as the two outer windows. But in fact the central window opened onto a two-story stairway with no floor beneath it (a very dangerous way to enter the building). The firefighter who tried to enter the building that way never forgot the lesson about possible interiors that did not match the outward appearance of the home. The lesson seems to contradict some features attributed to a good size-up, but in fact they reinforce the need to look carefully at the building for hints of the internal structure, and they very much corroborate objectives relating to clear communication and the need for firefighters working outside the building to coordinate actions and information with those operating inside the building. In this case, those interior firefighters would have seen the open stairway and could have told the outside firefighters about the danger.

Analysis

Sifting through the hundreds of pages of notes and hours of audiotapes gathered in a task analysis, making comparisons, and verifying decisions about the perfect way to perform a task is a time-consuming affair. But there is no reason not to involve others in the process. It ends up much like an editing job: comparing quotes, sifting through data, and calling for verification.

In the end, what instructional designers are doing is formulating a list of the steps that must be taken to perform the job correctly under all the circumstances described in the objectives (in our example case, fighting fires in a single family home in a variety of circumstances). But the instructional designers are doing something else within this process. The task analysis not only clarifies the steps to be taught, but it also describes the actions of the game in minute detail. It describes the situations to be simulated, all the variables that will have an effect on gameplay, and the relative degree of that effect.

Streamlining the Analysis Process

Projects with lower budgets may have a difficult time justifying a budget for two sequential analysis phases: the needs analysis completed in order to fully launch the task analysis.

For *Spark Island*, we combined the needs analysis and the task analysis into a single step and involved another analyst to help with the data crunching and report writing.

There is no doubt that the facts that (1) the needs analysis required flying around to remote Alaskan Native towns in late October and (2) a subsequent task analysis that would have required additional trips to the wilds of Alaska in mid-January might have made us more willing to deviate from standard procedures. In addition, a good level of trust had already been established between the client and us, making this shortcut a little more possible.

Nevertheless, you can see how this shortcut was a risky one and how it created an overlap in some of our work. Before the objectives were fully spelled out, we tried to define the tasks that met those objectives. To some degree, as the process went on, the objectives solidified. Still, some of the tasks that we defined were less important, and some were even irrelevant. Some tasks still needed additional investigation.

(Continued)

However, in this particular case, the benefit of combining the steps was that the interviews that allowed us to gather data about the project needs also provided us with people who were able to give us information about the details of the tasks involved. The interviews took longer, but in the end there was one interview with each person (usually with a follow-up phone call or two). Time was saved, travel costs reduced, and on *Spark Island* at least, where we were asked to conduct needs and task analyses in the wilds of Alaska in the dead of winter, we were able to cut down on the number of harrowing flights in single-engine planes that hopped here and there between Alaskan Native villages in subzero weather.

Speaking only for ourselves, we can say that we liked that a lot!

Summary

- Solid research into the content of a serious game can be broken down into two kinds of analyses: a needs analysis and a task analysis (these analyses can be broken down into even finer categories, and we refer you to current instructional design literature and study for a more thorough treatment).
- To conduct a needs analysis:
 1. Identify subject matter experts, master performers, and experienced practitioners (in other words, experts in doing the job and people who are doing the job right now).
 2. Formulate a hypothesis as to what performance problem the game is trying to solve.
 3. Conduct interviews and collect data to verify that hypothesis or adjust it as needed.
 4. In the same research effort, determine the demographics of your target learners.
 5. Report on your findings, and obtain approval to continue the analysis.
- To conduct a task analysis:
 1. Continue your interviews with master performers and experienced practitioners.
 2. Determine the detailed steps in each task of the desired behavior.
 3. Determine criteria for correct performance.
 4. Provide case studies.

5. Document your findings in a task list that will guide the writers and game designers.

- Sometimes these two analyses can be combined—and if you do so, you may save time and money. But the risks are high in this approach: you're defining tasks before fully defining objectives, and you may have to redo some of your research or, worse yet, you may jeopardize the validity of the instructional content in your game or simulation.

CHAPTER THIRTEEN

Instructional Design

Introduction

Well-done needs and task analyses can yield the basic material to determine the content of your game. At this point you know what everyone is supposed to learn, the priorities, many of the tricks of the trade, and the critical discriminations. You also have a clear picture of your target audience: your game players.

Now it's time to look at the content from an instructional (as opposed to a behavioral) point of view. What are you actually teaching, and how do you teach within the context of a game? After you teach, how do you test? And will the test generate a score or other feedback that's shared with the user?

Let's begin with the instruction itself. Are there rules that might affect the way content is presented in the game? You bet. A basic formula explains exactly how to teach something.

Demonstrate–Practice–Test

Traditionally, instructors have used the exercise model, which follows three critical steps in assembling a lesson plan or teaching program:

1. You demonstrate the skill (show the users how to do it).

2. You have them practice it (let them do it while you give them advice based on their performance).

3. You test them (check to see how well they can do it without any aid).

Without going into great detail about the distinction between cognitive tasks and motor skill tasks (like dancing or throwing a ball), we have to acknowledge that demonstrating and practicing cognitive tasks can sometimes be challenging. But you'll see that there are instructional strategies that work for them. That's what this chapter is all about.

Interestingly, this model fits right in with many of the principles of good game design. If you want someone to do something in a game, you typically have a tutorial level (or an introductory level that functions as a tutorial). Often, the tutorial

level has a mentor or coach (or a mechanism that functions as such) who steps in and makes suggestions about best practices. By the end of the level (or the beginning of the next level), the mentor has been removed, and the skill has to be performed in the most difficult of situations.

That last step is really a test and, if the test is good enough, it will allow the game to give a realistic score of the players' performance—and it even helps them transfer the skills back to the real world. That transference only happens when the final level is challenging enough and contains the most important distractions and complications of the real world.

Transfer is the Holy Grail of training, instruction, and serious games. It may be fine to develop a game that players like, and it's even better if they can pass a pre- and post-test on the content of the game. But to really be effective, players have to carry those skills with them. If the game's been persuasive, the ultimate transference is if the user goes out and acts based on the game's content. Users have to do the job better in the real world because of the training. The fact that the exercise model helps assure transference makes it especially valuable. It's not enough to remember the skill; the user has to perform it.

However, key parts of the model are often left out or minimized in serious games. Here are the most costly failures:

- Lack of adequately detailed instruction on how to perform the tasks in the tutorial level

- Not enough coaching responses to cover the variety of situations where coaching is needed

- A testing level that does not represent real-world behavior or have an effective scoring system

If the instructional designer pays close attention to those areas of the model and doesn't allow them to be minimized in the final game design because of budget, time constraints, or even the lack of creativity on the part of the design team, then a truly effective serious game is possible.

Step Size

In the tutorial level, or even during remediation by a coach within the game, you have to decide just how much information to present to the participants in a single step. You don't want to give the users so much that they can't remember it all, yet you don't want to give them so little that the whole process becomes tedious. The classic term for the amount if information that should be presented is *step size,* and the solution is as follows:

- Present as much information as you think can possibly be digested in a particular step.

- Test your tutorial with the target population (sample game players).

- See if they get it.
- If they don't, break the tutorial down into smaller steps.

This process assumes, of course, that the instructional designer is involved in the developmental testing of the game. We talk about that issue a little farther on.

Order of Presentation (Shaping)

In a game, order of presentation affects the way the content is introduced. Ideally it is best to go from simplest to most difficult. The process is called *shaping*, and it suggests that it is best to present an idea without all the distracting complications of real life. Then you add more complications as you go along until the final level of the simulation is as lifelike as possible. If there are a lot of variations in the process, start with the simplest form and move to the more complex. There is also an issue with distractions or noise in the environment. That can be physical noise, like traffic whizzing by as you are simulating a tire change, or conceptual noise, like knobs and buttons on a control panel that have nothing to do with the controls that really matter. Adding a clock to an event can provide a critical and very real distraction that also adds stress to the situation, so in that sense a ticking clock can be considered noise too.

Begin without the noise, and then add it as the game progresses.

The gaming technique of creating "games with levels" fits right in here. If you want multiple levels in a serious game, put the fewest distractions at the lower levels and add them as you go along. In the current vernacular of human factors, you are "increasing the cognitive load." If you want to present a complex decision or procedure, ask the player to do it in its simplest form at the lower levels, then add complexity. In *Fully Involved*, we had five levels and a tutorial level preceding them. The levels dealt with more and more complex house fires ranging from a simple garage fire that had not yet entered the house to a fire that had already spread to the second story and the basement. We trained the game players to deal with simple fires and then led them to extremely complex ones.

Procedures

Teaching procedures is tricky. Often procedures present instructional problems related to sequencing—that is, the key to performing a procedure correctly is performing it in the right order.

Sequencing

At the lowest game levels, procedures should be isolated so that there are no distractions or interruptions as the player works through the task. Then,

later on, add distractions that represent the way the real world would interrupt the performance of the procedure. Sometimes having to go through the whole procedure operates against the previously discussed principle of shaping, because it may be difficult to present a simple version of a long and complicated process. But if it is necessary to teach the whole procedure so that the user understands it in its entirety—rather than to teach it by breaking it into smaller pieces—then you have little choice.

In *Fully Involved*, the walk-around we were teaching firefighters to perform had a basic requirement, even at its most basic level. The incident commander had to walk all the way around the house. He or she could not (at the lowest level) just go to the back of the house and call it a walk-around. So even at the lowest level, we had to check for and not allow progress to those who didn't go all the way around. At later levels, of course, we added more complex items that could be found in a walk-around, but we had to require the complete procedure from the start.

Chaining

Another way to teach procedures is to teach them backward by starting with the last step, then moving to the last two steps, then the last three, then four, and so on. In such a method, the end is always reached successfully. Teaching someone how to tie his or her shoes is always given as an example of this kind of backward instruction or "chaining" (or "backward chaining").

In case you've never taught kids to tie their shoes, here's how it goes: do everything for them but tie the bow, and then just have them tie the bow. Then do everything but make the final loop of the laces and tie the bow. Have them do that. Then repeat the process over and over again, always adding one more previous step. Work backward through the entire procedure until the kids can do the whole procedure from start to finish. By the time they get through it all, they will have mastered the task.

Interestingly enough, the structure of games allows chaining more than other kinds of instruction. You can build out the game scenario so that all the player has to do is complete the act at the first level, then complete the last two steps of the act at the next level, and so on. It works very well. Think of a puzzle within a game. The first time through, almost the entire puzzle except the last step is completed; the next time through, all but the last two steps are completed, and so on. If you pay attention and structure the game right, you're teaching the players how to complete the puzzle (a complex and difficult task) through chaining. The objective, solution, and goal presented in Table 13.1 of this chapter form a great example of how we used chaining in *Fully Involved*.

Chaining is not the solution for all teaching, of course. There are some learning problems for which chaining would be a poor technique (e.g., any kind of problem other than a sequencing problem).

TABLE **13.1** A section of the final instructional design that shows how one objective was dealt with in *Fully Involved.*

Objective	Problem Type	Solution Type	Recommended Solution	Goal
6.1-6.5: Maintain clear communications	Sequencing	Chaining (teaching step-by-step processes backward)	Calls come in and are structured in such a way that the incident commander's responses are tailored to require the appropriate parts of the chaining process. The task is monitoring and participating in the flow of audio communication.	Teach the process of soliciting information, clarifying it, giving orders, and asking for restatement while limiting irrelevant data. Chaining allows the step-by-step teaching of this process in such a way that the first call only needs clarification at the end. The second call needs clarification and probing, the third call needs clarification, probing, and solicitation.

Discrimination Problems

These are cognitive tasks, the stuff of medical diagnoses. (Is it skin cancer or eczema?) It's also the stuff of hostage negotiations, cultural awareness, and other ill-defined domains (where the distinction between right and wrong answers is often fuzzy). The most important kind of discrimination problem to confront has to do with discriminations between things that are confusing because they're so similar.

Competition and Discrimination

In spite of the need to use the principles of shaping in moving the game from simple to complex, sometimes there are other considerations. As just noted, the need to teach a whole procedure in its entirety is one; another is when we deal with discrimination problems. (Remember we mentioned this principle when we were trying to differentiate between instructional design and game design.)

The way to deal with two confusing or competing concepts is to present them together. Show them side by side during the tutorial when you're demonstrating

skills and practices; show them together during the game when you're simulating the way people encounter them in the real world. Make it part of the game to tell the competing items apart. You will teach your serious game players to make critical discriminations that they might miss if this technique were not employed.

In the initial instructional design of *Spark Island*, our Alaska Kids fire safety game, we ran into the issue of different kinds of waste. Hazardous waste was a big concern. What is it? What isn't it? The task of sorting waste required the discrimination between hazardous waste and other kinds, and it was a competition problem. So we created a minigame called the *trash pickup game* (see Figure 13.1) where the players (Alaskan Native kids) had to get the right kind of trash into the right barrel.

Having players discriminate between competing items fits naturally into a game and is the stuff of myriad minigames. The trick is to recognize the discrimination task for what it is and take advantage of the instructional strategies that can teach it effectively.

FIGURE
13.1

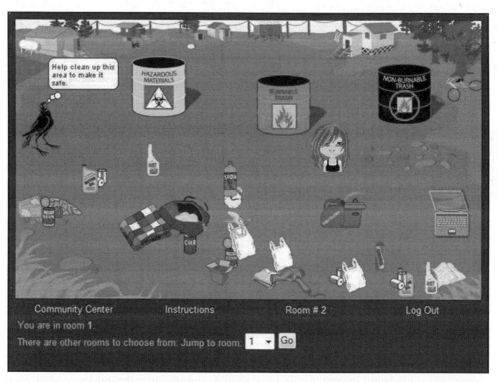

A sample of a competition problem as handled in the Alaska Kids fire safety learning game *Spark Island*. Kids have to identify various kinds of waste material. Presenting the different kinds of hazards and making the kids choose reinforce the distinction. ©2007, Compelling Technologies, all rights reserved. Used with permission.

Job Aids versus Instruction

Job aids are checklists or other notes that a performer can use to complete a task accurately. The classic example is the checklist that all commercial airline pilots follow at the start of a flight to make sure that the plane is ready for the trip. The idea is that there are so many things to do that it is easy to forget some. Also, there is no reason not to have a checklist because no one is watching who would think that the pilots were less professional because they couldn't do the whole preflight check from memory. So checklists are used, and they work well.

Job aids are generally far more dependable than unaided memory (requiring people to remember all the steps of a complex task) and if possible are the preferred way for people to get the job right. The problem is that there are a lot of reasons for *not* using job aids, such as if the task is time sensitive or if it would seem unprofessional to be looking things up as you go along.

The rule for the use of job aids is that it is beneficial to develop checklists or job aids whenever you can to help the performer. How do you do that in a game? If, in the real world, they're a critical part of the job you are simulating, then build the job aids into the game so that in the process of playing the game, the checklist is right there on the screen to help the player get things done. In this way, you're teaching the game players to use the job aid, and in the end, that's what you want them to do.

In game design, we have conventions for navigation and other parts of gameplay. When you create a table and put it into the booklet that comes with the game, you've created a job aid. When you create a screen that users can call up during gameplay, you've done the same thing. Now apply that same principle to creating a guide to the tasks within the game.

In real life, firefighters use a common incident command checklist, so we made it available to the players during *Fully Involved*. It was in a window that players could open or close as they wished. Even that device reflects real-world performance, because incident commanders carrying clipboards with checklists on them will not always be holding the clipboard right up in front of their faces during the firefight. They'll look at the checklists as they need them. Of course, in some cases, where the checklist has to be used constantly, it can be built into the game interface. The trick is to match the real world and facilitate the behavior that the game players have to learn to perform in the real world.

Fading

Think of this as a game version of training wheels. Fading is an instructional technique for removing support (scaffolding) from players (and trainees) so that they can stand on their own. If you build a checklist and don't want to make the game players dependent on it, remove it little by little throughout the course of the game. You could also have partial checklists at higher levels of the game and make them

available when players need them. (Separate minigames or side games could have players filling in the missing steps.) We determined that incident commanders should not be dependent on the incident command checklist, so we constructed our game so that the checklist gradually disappeared at the later levels of gameplay.

Coaching and Intelligent Tutoring

The raven in Figure 13.1 is coaching the kids, telling them what to do next. He could also tell them whether or not the items they are putting in each barrel are going into the correct ones. The statements the raven makes, the frequency with which he says them, and the fact that, after a time, the raven will stop coaching and make the kids figure it out for themselves are all elements of the instructional design; in this case, they are combined with the technique of fading to build toward a stronger transfer of knowledge after the game.

Is it enough that the raven only says one sentence no matter which hazardous item players put in the wrong barrel, or should his words be tailored to individual items and even to individual players who may be making the same kinds of mistakes over and over again? That's what the instructional design determines.

The latter system, by the way, where the game monitors each individual player's activity and comments accordingly, is called *intelligent tutoring* and requires that the game system know what each player is doing and then choose appropriate responses from a broad array of responses that it has available to it.

Intelligent tutoring may require more artificial intelligence (AI) horsepower than you have available for your serious game, but it can show excellent results if you're able to apply it. We developed an even more advanced system for the *Leaders* project that we did for the U.S. Army. In *Leaders*, the intelligent tutor monitored performance of each individual player across the game and offered tailored feedback for each incorrect response. At the second level of the game, the tutor went beyond simple performance advice and began giving detailed content feedback based on the misunderstanding that the player was showing. It's important to note that this kind of intelligent tutoring started at the second level of the game and was based on the performance of the particular player during the previous level.

In the case of *Leaders,* the intelligent tutor was presented as simple text that appeared across the bottom of the screen. In *Fully Involved,* the tutor/coach was given a personality and an appearance. A John Madden–type battalion chief (shown in Figure 13.2) ran the firehouse, advised the players, and had a gruff manner about him.

The design of the coach or tutor character in any serious game system is something of a creative decision, but it should also be a decision based on the needs analysis. When we talked to Alaskan Native kids and their elders, we learned that the raven was a respected creature in Alaskan Native lore and one that the students could respond to positively. The battalion chief in *Fully Involved* was also a character who was vetted with all the members of the target population, and they all responded affirmatively to this characterization of the coach.

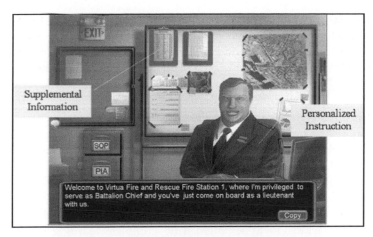

FIGURE
13.2

The battalion chief at the Virtua Fire Station. (Virtua is the name of the virtual town.) He acts as coach and tutor for the firefighter safety training simulation. ©2007, Compelling Technologies, all rights reserved. Used with permission.

Generalization Problems

Among the major kinds of learning problems, the ability to generalize is probably the most pervasive. You give a rule, and the learners have to figure out how to apply that rule to lots of situations. They have to generalize the rule. Our firefighter command trainees had to ask themselves, "Does this fire fit into the rules I learned for fighting that other fire?"

Inductive Reasoning

Part of the strength of simulation training is the ability it gives game designers to keep changing the variables in the situation, not only so that players can discriminate from one variable to the other but also so that they can see dozens of examples of the rules you are teaching them. But what if you didn't give them the rules? What if you gave them the situations and asked them to infer the rules from the specific situations (inductive reasoning)? The answer to that question actually helps answer the most important and most common question that serious game designers ask: "Is it necessary to have a separate lesson or tutorial for every individual skill to be taught?" You may have seen serious games that never demonstrate the skills involved in the job at all: they just throw the players into the game and let them figure things out for themselves. You ask, "Are these games instructionally sound?" The answer is: it depends.

 What these games are doing (consciously or unconsciously) is providing inductive training. That is, they put the players into the situation and have them figure out the solutions and from those experiences, the rules. They are generalizing from observations to the rules that need to be applied. Does it work? A lot of the time it

does. Success depends on a number of variables including the thoroughness of the experiences in representing the rules you want your players to infer. Success also depends on the kind of tutorial support provided.

Limitations of Inductive Gameplay

Generally speaking, it is not a good idea to expect to base an entire serious game (or course, or lesson) on inductive training. You're putting quite a burden on the game players. They have to figure out the rules you're trying to teach by generalizing to all of them. Even if you add a lot of tutoring, it probably won't be enough. The best mix is to provide a solid tutorial for the key elements of the game and let inductive training add excitement and variety to the gameplay.

However, because so many games are merely simulations of an experience without the necessary tutorial backing to make them truly complete learning experiences, the question becomes, "What kinds of learning experiences do these games present?" The answer is that they're either practice sessions or testing sessions, depending on the amount and quality of the coaching involved.

If you have developed a program without the necessary tutorial material and you want to make it a complete learning system, you are going to have to find some way to demonstrate the skills required in the game outside of the game environment. You can do this by referencing or providing the following:

- Classroom lectures
- Demonstration videos
- Hands-on demos
- Manuals

Make the successful completion of those materials a prerequisite to going through the game. If you really want to be solid, test the prerequisites before letting the players start the game. They may not want to do it, but it will greatly increase their ability to learn the correct performance, and it will make your learning system far more effective.

ADDIE

Training developers with instructional design or educational degrees will recognize that this book essentially walks through the ADDIE (analysis, design, development, implementation, and evaluation) model of instructional systems design. As discussed in Chapter 10, when we talked about philosophies of project management, we're not wedded to specific philosophies or models, just nuts-and-bolts processes that we find work.

One improvement to the ADDIE model is the use of rapid prototyping, which we hardily endorse and which we'll continue to discuss throughout the book.

Testing and Scoring

Testing and scoring systems within a game should be based on the results of the needs and task analyses, as well as the instructional design shaped by these analyses. Task lists should delineate the behaviors that will form the basis of your gameplay (further discussed in Chapter 16). They should help structure and provide content for the scaffolding (tutoring and help systems) that you build. In the same way, they should provide the content and organization of a testing and scoring system that will accurately evaluate the student's performance within the context of the game. The testing system can and should be constructed as the characters and their behaviors are being created and the tutoring and help systems developed, and they should dovetail with the evolution of these elements.

Scoring

Let's use *Fully Involved* as an example of a good way to set up a scoring system. Early in the design process, we determined that every level of the game (each of which was made up of an individual firefight) would have its own individual scoring. We created scoring categories to match each learning objective and then tagged each event, action, and interaction as part of one of the categories. We assigned those events and interactions to one category each. Overlapping categories and categorizations were ruled out. Even though we could argue that some actions impacted several categories, we could always find a priority to their application: generally, one category was paramount. We also added an additional category relating to the overall success of the firefight. Table 13.2 shows the broad categories for the game.

Within a category, we created a set of challenges that represent an opportunity for the player to meet a specific objective. Each challenge was given a weight: for

TABLE **13.2** Scoring categories matching top-level learning objectives in *Fully Involved.* An additional category is related to the successful conduct of the firefight (a more classic win-lose measurement).

Fully Involved Scoring Categories
Following basic procedures
Performing sizeups
Identifying hazards
Establishing authority
Maintaining clear communications
Maximizing fitness
Limiting freelancing
Dealing with stress
Conducting a successful firefight

example, spotting an unusual and dangerous fire hazard might get a weight of 5, whereas managing a panicky firefighter who is not immediately engaged in the fire-fight might get a weight of 2. Subject matter expert input determined the weighting of each challenge, as did the importance of the challenge within the context of the firefight. For example, SMEs determined that if a challenge was so critical that it could immediately cause firefighter injury, it deserved more weight than a proce-dural issue that would only tangentially affect the results of the fire.

Scoring System

The scoring system within *Fully Involved* was refined throughout production and further refined in beta testing. So that it would work effectively, all events, actions, and interactions had metadata attached to them. These metadata related to a challenge, the weight of the challenge, and the media elements associated with it. For example, a Freelance Limiting Challenge involving firefighters going off and breaking windows on their own (a negative practice called *freelancing*) had metadata that included firefighters' audio reports of the freelancing, various potential responses or actions that the player could take (including no action), and the scoring algorithm that calculated the points awarded or deducted for the choice.

Scoring Calculation

Players would begin with a certain base set of points, and points were added to or subtracted from that point total based on decisions made and actions taken. (Examples are given in the accompanying box on scoring criteria.) Additional points would be added, but not deleted, for meeting challenges within each of the scoring categories.

We established scoring criteria not only for correct performance in the face of each challenge but also for the overall success of the firefight. Table 13.3 shows early examples from the category "Following Basic Procedures."

Criteria were refined throughout game scripting, production, and testing phases of the project until all actions in each scenario had a set of associated criteria. Then through the beta testing, the weighting and point allocations in the scoring were further refined to provide a balanced sense of the player's performance in the simulation. (These phases are discussed in later chapters.)

Note that in the early draft shown in Table 13.3, some activities were assigned to other categories and objectives. Note too the references to the battalion chief (B.C.) who served as a mentor through the early part of the simulation and was faded from the game in later firefights. The interventions of the B.C. were developed in conjunction with the scenario and were cross-checked against the scoring for each action. Points were not deducted when an intervention occurred because they were already deducted for the action itself, which caused the intervention.

TABLE **13.3** Early draft of *Fully Involved* scoring criteria centered on the learning objective category "Following Basic Procedures."

Criteria Based on the Category "Following Basic Procedures"

- If the player identifies a victim in the size-up, then the player should initiate Rescue mode before initiating Search mode. (An error will trigger a battalion chief (B.C.) intervention in early levels.)
- All incidents should include a primary and secondary search before leaving the scene. The search group declares the primary search complete; the player declares the secondary search complete. (B.C. will intervene in early levels if the player doesn't follow protocol.)
- A secondary search should only be initiated after fire is under control and ventilation activities have been completed. (B.C. will intervene in early levels if the player doesn't follow protocol.)
- Search lines should be used any time a hose line is not being used during a search. (Failing to confirm this will be a scoring element under the Clear Communications learning objective.)
- Search should be terminated when fire attack goes to Defensive mode. (B.C. is likely to assume command in early levels if the player ignores this protocol.)
- If primary search is in progress, Attack mode must be offensive. (If in Defensive mode, search assignments will not be executed.)
- The first priority between victim and fire is to protect means of escape. The second priority is to knock down the fire. (If priorities are switched, the player is showing signs of tunnel vision and does not have clear situational awareness.)
- Firefighters must first contain the fire (i.e., stop it from spreading) before focusing on extinguishment. (Player commands to move to premature extinguishment will trigger a B.C. intervention in early levels and will cause the player to lose points because of a violation of basic procedures.)
- Player should mark all concealed spaces even if they are not close to the fire or the victim(s). (Failing to mark all concealed spaces will be scored against Recognizing Hazards learning objectives.)
- If the Abandon command has been given, Attack mode must already be defensive. (Otherwise, the Abandon command will not be executed, and there will be a point deduction in the area of basic procedures.)
- A player changes from Offensive to Defensive mode; the player should get a Personnel Accountability Report (PAR) and should communicate exposures. (This oversight will trigger a B.C. intervention in virtually all levels and will cause the player to lose points because of a violation of basic procedures.)

Score Reporting

According to our testing and scoring design, performers were given their score for each level and had to achieve a level of proficiency before they could move on to the next level. Score reports showed the areas where the performers did well and where they made mistakes.

FIGURE
13.3

Early concept art for the *Fully Involved* user interface (the final interface looked substantially different). The floor plan and the battalion chief (both examples of scaffolding) were removed from the simulation at the final exam level. ©2007, Compelling Technologies, all rights reserved. Used with permission.

The final level of the game we called a final exam level. Play at that most difficult level had no scaffolding (as shown in Figure 13.3), and tabulated results were sent to a database where the player's performance was recorded (and stored in XML).

After-Action Reviews

The after-action review (also called the AAR or hot wash) is a standard feedback approach often taken by the U.S. military and those who emulate its training systems. In the review, instructors who have been watching the simulation unfold or who may have even been controlling the simulation (the "man-in-the-loop," discussed in Chapter 27) now report their opinions about the participant's performance.

The instructors have taken notes. They have read the results of scores tabulated by the simulation system as the game has been played (the scoring in these systems is often carried out in ways that are similar to the firefighter safety simulation training example we just presented).

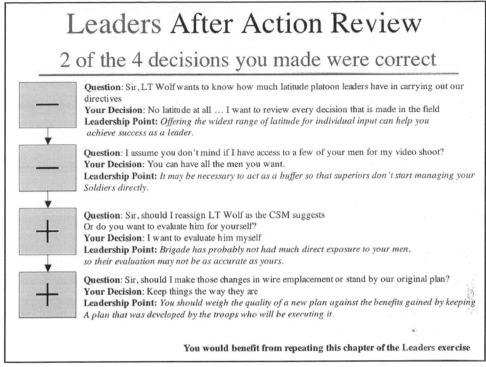

FIGURE
13.4

Automated AAR frame from *Leaders* summarizes the trainee's performance and offers prescriptive information based on the decisions the trainee made.

Now the instructors walk the players through the simulation step by step. They comment on what players did well and did poorly. The review takes on the personality of the instructors, and the players are reprimanded, shamed, excited, motivated, and finally rewarded for their good work.

AARs have proven to be an excellent way of presenting testing and scoring data and related feedback to performers in simulations. Sometimes automated AARs (see Figure 13.4) can be built into the serious game itself. In these presentations, scores and feedback are given, often with feedback frames and voiceover narrative that mimics the tone and style of a live, in-person military AAR. It is critical that the feedback be delivered point by point so that it provides the detailed corrective feedback that performers need to improve. Of course, players who fail to complete the game or simulation to a predetermined level of success almost always have to repeat the exercise.

Scoring for Professional Certification

The kind of accurate scoring we've been talking about allows serious games to be used for certification within various professions. One of our banking clients wanted

to upgrade the quality of its tellers and create another rung on the promotional ladder; to help the client take this step, we created the *Certified Teller Program.* Tellers who took the self-instructional course and passed the certification test were given the promotion and the raise.

One of the more dangerous aspects of certification, of course, is that it's often used to influence a person's salary and position. Whenever you're talking salaries and reasons why people do or do not get raises and promotions, you raise the ugly specter of lawsuits. People will sue you if they think someone else got a raise for reasons that seem unfair. Certification provides a testing mechanism that can often reduce the risk of lawsuits. For example, the employer can say, "Sorry Jennifer. Gloria got a raise because she took the certification instruction and passed the certification test. If you want a raise, go out, learn the material, take the test, pass it, and get certified."

Few people ever get to the point of using a lawsuit to challenge the scoring system within a certification test. When the scoring system has been crafted with the kind of painstaking analysis that we've been talking about, it is difficult to dispute. Just make sure that the client signs off on the criteria and the scoring, or you may be held accountable.

SCORM

One of the most quantifiable methods of immediately measuring serious game or simulation success is through the use of the Sharable Content Object Reference Model (SCORM) packaging and content. Sharable content objects may be reusable pages, modules, or tests that are part of the curricula.

Whether using a pre- and post-test model or more modular-based learning and testing, SCORM compliance in the game or simulation allows data retrieval and evaluation via connection to a learning management system (LMS) or learning content management system (LCMS). The latter include Blackboard and WebCT.

SCORM-compliant games and simulations are particularly useful in education and certification training and where there is agreed-upon, readily measurable knowledge (e.g., advanced algebra or Microsoft technician certification); in such situations, creating or acquiring SCORM packages that can be integrated with your application will be a critical component of your instructional design work. Your client will let you know upfront if SCORM compliance is a necessity.

SCORM deployment and compliance clearly simplifies assessments of user progress and advancement when the knowledge base to be transferred is easily measured. Unfortunately, the education, training, or persuasion we often wish to impart is less easily measured.

Summary

- The instructional design process can provide invaluable information that will help turn your serious game into an effective instructional tool. The converse, however, is also true: ignoring or bypassing the process will result in a far less effective product, one that could very well fail.

- Here are some of the most effective instructional design techniques:

 - *The exercise model.* Organizing a learning experience by demonstration, practice and testing.

 - *Procedural instruction.* Solving sequencing problems by focusing on the order in which tasks are performed.

 - *Backward chaining.* Solving sequencing problems by simulating the last step, then the last two steps, and so forth.

 - *Competition.* Solving discrimination problems by teaching things together when they are confusingly similar.

 - *Shaping.* Moving from a simplified version of an activity to those that are more complex until the final version has all the noise of the real world.

 - *Fading.* Providing support for performance and then gradually taking it away as the game goes on.

 - *Coaching and tutoring.* Supporting learning thru scaffolding that should be faded as games progress.

 - *Inductive instruction.* Allowing performers to generalize sets of rules.

 - *Scoring.* Using the detailed information gathered in the task analysis to rate the player's performance in the skill areas simulated in the game.

- The techniques listed here are just a sampling of instructional design techniques; they're also some of the most important and often used. Applying these techniques to the design of serious games will dramatically increase their effectiveness. These techniques can also have a dramatic impact on games used for advertising (advergames) and promotional games as well. We'll explore this aspect in the next chapter.

- Base testing and scoring systems on the needs and task analyses, and ensure that their development dovetails with the development of the behavior of the characters and the support, coaching, and help systems.

- Create scoring categories to match each of the top-level objectives, and then tag each action and event as a part of one of those categories.

- Create challenges within each category, and have subject matter experts assign relative values to the importance of each challenge.

- Give players a baseline score, and then add or subtract points from that score based on correct or incorrect decisions or actions within the simulation.

- Adjust the scoring mechanism through the various stages of testing and debugging. Adjust the score and the relative value of the actions and the position of each challenge within the set of objectives.

- Report scores with remediation at the end of each level. But at the final test level (if you have one), use that score to approve or certify the participant's pass or fail status and, if the latter, the need for the participant to repeat the material to improve performance.

- The after-action review (AAR) is a feedback system developed by the U.S. military that often uses live instructors to provide detailed, in-person feedback to game players when they have completed a military simulation. The key to the AAR is score–based performance remediation. (See more about AARs in our previous book, *Story and Simulations for Serious Games*.)

- AARs can be simulated with summary frames and voiceover narrative.

- SCORM-based testing for education and certifications provides quantifiable assessments and metrics. If the learning content is standardized and portable, then building a SCORM-compliant application is a must, and the payoff will be clear-cut data that are transferred to a learning management system.

FOURTEEN

Instructional Design for Advergames and Promotional Games

Introduction

Let's take a quick look at how the use of instructional design techniques (needs analysis, task analysis, and learning problem analysis) can have a dramatic impact on the effectiveness of games designed to promote or sell products, services, and brands.

Needs Analysis for Advergames

The parts of the needs analysis that lend themselves to games for advertising and promotional purposes are roughly analogous to basic market research. In market research, one of the first steps is always to identify target customers; get a demographic picture of them; and check out their location, their income, their lifestyle, and the kinds of computers they use. We follow similar steps in the instructional design needs analysis for serious games.

We mentioned that in instructional design, we also investigated user preferences for learning games and delivery systems and looked for specific instructional strategies that we thought would be most appropriate. We touched on the fact that the instructional designer needs to have a hand in developmental testing to find out if players can learn from the game and if specific instructional strategies are working or need further adjustment. All of this is much like the kinds of focus group testing that market researchers pursue.

This is not for a moment to suggest that instructional designers can replace market researchers or that good instructional design reduces the need for marketing

analysis. But it is possible to use instructional designers and analysts to gather market research data and to use needs analysis techniques to corroborate marketing assumptions. Just as we tested learning problem hypotheses in our needs analysis, so too an instructional designer can test and verify sales and marketing hypotheses.

Let's look at an example. While designing a massive instructional package (including some serious games) to teach bank account officers how to better serve their medium-sized business clients, we conducted a series of needs analysis interviews with account officers and their best customers. Because of the close relationship between the bankers and their clients, we never visited the customers unaccompanied. But we were given entrée to some of the bank's most successful customers, and we were even able to see some important noncustomers as well. The bankers often participated in these data-collection interviews.

Because our effort was well understood within the whole bank marketing operation, the market research group from bank headquarters asked us to "just ask a few specific questions" in the course of our more targeted interviews. Because these were in-depth interviews with some important clients, market research must have thought it was worth the effort. Our interviews went on for an entire summer. They were recorded and later edited into documentary training films about small business customer attitudes and used as part of that massive training effort we alluded to. The data we collected were qualified and fed into the market research pipeline. The bank's sweeping effort to achieve success in this market resulted in an increase in profitable business, and we like to think that the data we gathered influenced policies and even services offered to these customers and helped sustain the bank's record of achievement in the market.

The bottom line is that if an advergame contains instructional elements and there is a needs analysis required to deal with those elements, then the needs analysis can work hand in glove with the marketing effort to gather information that will add depth and insight to the marketing research.

Task Analysis for Advergames

It seems as though the connection between the needs analysis and marketing research is fairly obvious; the connection between the task analysis and the research needed for the creation of an advertising or promotional game seems less so. When would you ever need to do a task analysis as part of the development effort for an advergame? Consider this example of a serious game designed to advertise a new luxury car with very special new features.

The new car your game is promoting has an advanced breaking system (ABS) that makes it better than any other car on the road. The information about the braking system is a mix of marketing information and training. On the marketing side, your client will want to know how to best present all the features and benefits of the ABS braking system. On the training side, you will want to know what kind of

customer performance affects the use of the braking system and what critical discriminations apply to braking a car that will show off the new features.

If your game includes a simulated drive of the car with related braking experiences, you'll want to know how you can simulate the braking experiences in such a way that you challenge game players to test and appreciate the new features. A quick task analysis of exactly how the braking function can be used in the situations that show off the best of the new braking features will help your game designers create the most compelling advergame.

How do you do that quick task analysis? The easy answer is that you have the marketing person act as the experienced performer. Have him or her talk to the instructional designers. Have the designers employ the exact techniques they use to do a task analysis of any other kind of performance problem (describing the performance in tiny steps and looking for critical discriminations). If possible, have a *game* designer along as well, to look for insights and creative ideas that can be used in the development of the simulation game.

The task analysis will probably tell you that the simulation of the actual act of braking may be important, but the drivers' decisions during the braking action may be even more important. Showing the various outcomes of the braking decisions could have a dramatic effect on the power of the game and even on the sales of new cars.

Any time a product feature involves performance and the performance can be simulated to help demonstrate the benefits of the new feature, task analysis can help identify the parts of the performance that need to be stressed in the simulation.

Figure 14.1 shows a typical frame from a PowerPoint presentation for an advergame. Note that the text lists some of the typical kinds of advertising games

FIGURE
14.1

Frame from a promotional PowerPoint presentation for an advergame company (with some details genericized).

and simulations: shopping sprees, travel advertising, driving simulations, ads for banquets and casinos.

Learning Problem Analysis for Advergames

In Chapter 13, we talked about the analysis of learning problems and how it helped structure the presentation of information. In many ways the presentation of information about a product or service can be governed by the same principles. Here's a quick look at how that is done.

Order of Presentation

In the case of advertising or promotion, the general rule is go from the most important features to the least important. As in instructional design, present the features in isolation, and then add noise (and excitement) to the presentation as you move through it. After the features and benefits are presented separately, integrate them into a single example to give the full sense of the whole product and sell the package.

Competition

In serious games for instructional purposes, this principle refers to combining and contrasting concepts or actions that are confusing because they are similar. In the world of advertising the same technique can be applied to contrasting features of competing products. That is, you need to do head-to-head comparisons with the features of competitors' products. In the example of your new ABS, you don't want some slick salesperson to pretend that the braking system on the car he or she is selling is the same as the fabulous new one in yours, especially when it's not. So you have to differentiate! And if your corporate marketing strategy does not allow head-to-head comparisons, then compare your product to the generic version of the product. Compare the advanced braking system in the car in your game to braking systems in all other cars.

Inductive Training

Inductive training is enjoyable as well as powerful. And there is evidence to support the contention that learning generated by inductive training has a higher rate of recall for learners with higher cognitive abilities.[1] So why not use inductive training

[1] Maldegen, R., Statman, M., and Yadrick, R. "Analysis of Aptitude-Treatment Interactions from a Personnel Classification Perspective." *Proceedings of the 38th Annual Conference of the International Military Testing Association*, San Antonio: 1996.

in the most dramatic and effective way? Dramatize a situation in which the outcome, the thing to be learned, is how much the game player needs the new product. This can be a 3D game in which the player had an adventure leading up to a climax that portrays a dramatic need. Then the need is met because of the product.

For example, you're in a car chase, driving the hot new car you're promoting with your game. You're chased into a dangerous area where the need for special brakes is a matter of life and death. Suddenly, the moment of truth! Your car is headed for the precipice. You're going way too fast. If only you had that fabulous new braking system! Everything in the game forces you to think that. And guess what? You do! You're saved, and suddenly you want to go out and buy that new car with those wonderful brakes.

Inductive training can be a dramatic part of advergames. It can set up the presentation of feature/benefit statements that can invite further investigation. It works wonders.

Job Aids

As wonderful as the inductive training game and the memorable realization of the players' need for the new product are, it'd be nice if the players of the advergame could remember some of the product details. They have that image of driving toward the cliff and being saved by your new car's wonderful new brakes at the last minute. But just what were those new brakes all about, and how do they compare to the brakes in the other cars your customers were planning to buy before they played the game?

Build tables and checklists into your advergames. Make them printable so that the customer can stuff them into his or her pocket. Make sure that your potential customers can look at the features/benefits—and details about them—wherever they want to do it. Don't rely on recall.

Advertising recall (retention) is a big deal in the spot-advertising business, and it should be a major goal of any advergame. But when a gaming system has the ability to generate job aids to support recall, why not take advantage of it? After all, job aids are the most dependable way to influence performance.

Applying Instructional Design Processes to an Advergame

The best example of an advergame we ever saw was presented at a conference of instructional designers. A drug company created the game to sell medical products to doctors in a kiosk on a convention floor. The analysis had revealed

(Continued)

that doctors were very busy and didn't really want to give time to salespeople. The analysis also suggested that doctors have a tendency to think they're smarter than most other people, including the salespeople who have to deal with them.

The result of the analysis was a simple Jeopardy-style quiz game hosted by someone doctors could admire, someone they'd want to spend time with, and someone they were willing to accept criticism from because they had to admit that he was smarter than they were. Who was it? *God!*

That's right. God. But this was not some forgiving God, or the vengeful God of the Old Testament (not exactly, anyway). This was God as Mel Brooks and Carl Reiner might have conceived him: a tired God with a long, gray beard who was disillusioned with his creation, unhappy that he had to appear at a medical convention (though he did admit that it was important). He was pretty fed up with everyone, especially doctors, and he mumbled to himself a lot in Yiddish. This God could gain and keep the doctors' attention. He could call them *schlemiels*, and who would dare say he was wrong?

The amazingly creative feedback to the simple multiple-choice quiz game was so engaging that the doctors were never aware that every trick in the instructional design book was being thrown at them by God himself. The underlying techniques included many that we've been discussing here. The negative feedback made the doctors feel guilty as hell (literally). And the positive reinforcement! Boy, nobody can praise and reward someone like God, right? Okay, your mother—but that's another story.

Summary

- The underlying principles of instructional design can positively influence advergame and promotional game design.

- A needs analysis, coupled with market research, can help focus the direction of advergame design.

- The use of a good task analysis can help structure the body of any game that is based on real performance. By identifying the critical discriminations that make up the task to be performed, game designers can focus on the key moments affecting the action and the outcome of the game.

- Order of presentation, competition, inductive training, and job aids are all techniques that can be used to develop an effective promotional game.

SECTION THREE

GAME DESIGN

The Creative Side

In creating our serious games, we follow the rigors that we learned when designing educational material for Disney. The studio insisted we never even think creatively until we understood the content completely. One step before creativity took over was to study the project goals and look for the goal behaviors that we could simulate in our game. Is the core behavior finding objects, making decisions, recognizing situations or similarities? We identified that activity and placed it at the heart of the gameplay. Then it was time to focus on creative approaches.

In our chapter on game design, we enhanced our experience with input from some of the top game designers in the consumer games business. We wanted them to give us their creative secrets, and they did—even if they had to stay undercover for contractual reasons.

Once the initial brainstorming has been done—and a creative approach and concept have been defined and the documentation on those elements has begun—the concept should be field-tested. We offer some tips and techniques to maximize the value of this step.

Let there be no doubt: the creative part of development is clearly the most fun.

FIFTEEN

Determining Simulation Activity

Introduction

"I found that I could handle the job in the field because I had played the game beforehand."

This message is part of an email sent from a firefighter who had to serve for the first time as an incident commander. The benefit he had was that he had just finished playing the firefighter safety game *Fully Involved*. What the firefighter is describing is the goal of every serious simulation game: to transfer skills from the game itself back to the real world. It is a testimonial to the instructional design, to the needs and task analysis, to the playability of the game, and to the selection and creation of simulation activities that work. In this section, we'll look at the process for identifying those behaviors that need to be simulated in serious games, and then we'll explore how to devise game activities that train users on those behaviors.

The Whole Shooting Match

The U.S. Army asked us to design a simulation that would train teams in military command centers to manage operations in the field. In our simulated command center, a team of three soldiers, each a specialist, received different intelligence data through their computer systems, received radio communications from the field, were fed a steady stream of television images both from the national news media and various recon vehicles, and maintained constant phone contact with their chain of command.

The Advanced Leadership Training SIMulation (ALTSIM) was indeed massive. It used every kind of media imaginable from gigabytes of Intel data, to original audio recordings, to prerecorded video, to text messages that were generated in real time, to synthetic audio, to maps that were modified to accommodate the outcomes

of their decisions. The system even simulated the forms that members of such a tactical operations command team used to communicate from one shift to another. It was the total experience: a simulation of a working field command center facing a growing crisis, worked out to the most minute detail, and presented to soldier-game-players in real time, and it allowed the players to get an actual sense of a military operation.

Moreover, we structured the events that occurred during the simulation so that they unfolded in the form of a dramatic story. We were even able to simulate the tension that members of command centers feel during dangerous military operations. It was the ultimate example of a multimedia simulation.

We followed the ALTISM simulation with *Leaders,* a simulation that was carried on entirely in a 3D virtual world. There were no more video images of battlefield action, no actual news clips, and no mountains of computer text intel. This was an entirely different experience that occurred while a company commanding officer (C.O.) stood at his command post looking out over the action all around. The simulation dealt with issues that occurred during what was meant to be a peaceful food distribution operation. If the players made the wrong decisions, however, it would turn out to be anything but peaceful.

(Both of these projects are described in much more detail in our previous book, *Story and Simulations for Serious Games.*)

We mention these two examples because they reflect the image that most commonly occurs to people when they hear the words *simulation training.* They are picturing full-blown, integrated experiences that try to capture the sense of what it is like to be there: the look and feel of the place, the tools they have to work with, the mechanisms for delivering all the necessary information, all the distracting background noise, the ever-shrinking time frame, and the growing sense of tension. We simulated a combined set of tasks, each well defined and each integrated with an urgency expressed in the tone of the audio, video, and other media elements in the simulation. (Figure 15.1 illustrates these media elements.) In a sense, these games represent simulations that are as complex as they can be. But there is more than one kind of simulation, and there are different levels of simulation complexity.

Let's look at the decisions that game developers must make to find the most appropriate kind of serious game for any particular learning problem.

Isolated and Integrated Simulations

Every task analysis defines the steps and tasks in the desired performance. Every task that is defined should be considered a potential simulation activity. The tasks can be simulated in isolation, or they can be combined with other tasks into a larger simulation effort (as we did in ALTSIM). Often it is necessary to do both: simulate the individual tasks and then combine them with other tasks into an integrated exercise. As noted in Chapter 13, if there is a question about whether tasks should

FIGURE
15.1

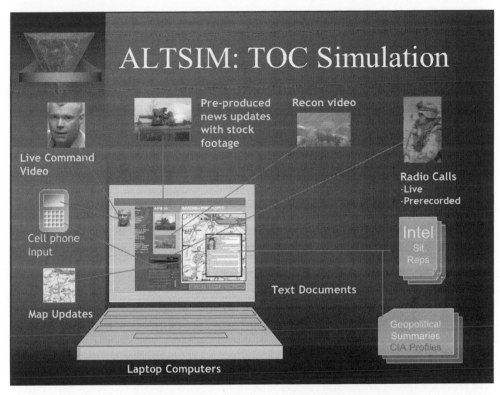

Diagram of the various kinds of media employed in the ALTSIM simulation. Even though we did not reconstruct the physical presence of an actual tactical operations center (TOC), we did push all the information streams into a single computer screen that resembled the computer screen that would be the main area of focus for the working members of a TOC. ©2004, University of Southern California Institute for Creative Technologies. Used with permission.

be taught in isolation or combined, the best thing to do is to try to combine them and test the design to see if players are getting it. If they aren't, then break the tasks up into smaller, isolated practices.

In ALTSIM one of the most critical tasks was for the intelligence (intel) officer to continually check incoming electronic news feeds and emails to spot clues to enemy activity indicated in these messages. In our tutorial, we had the officer-player use the interface to check these info feeds so that they would know how to use them. Once the simulation started, checking the mail became the first and simplest overt task performed by the intel officer, and we monitored just how often and much of the mail was checked. Finding clues was another task, putting several clues together was another, and determining a specific enemy activity based on these clues was yet another. These tasks have to be integrated. And to make it tougher, they are all cognitive. There is no overt behavior to measure as they're being performed.

177

How did we measure the intel officer's performance of these tasks? We had report forms that members of the TOC exchanged, and the information on those forms could be recognized. They were presented in fill-in-the-blank style, so the responses were structured. Also, we recorded the captain's overt commands (again issued on forms), which indicated an awareness of the situation presented as clues to the intel officer. The only way the captain could know to make those decisions was with information that was only presented to the intel officer.

Isolated simulations are the stuff of minigames. In *Spark Island* (the Alaska Kids fire safety game), we looked at the tasks that we were trying to teach, and then we found that each of them could be turned into an individual simulation minigame. For example, we identified the need for younger kids to warn older kids not to play with fire. (Children playing with fire is one of the greatest fire hazards in Alaska.)

Now, some precocious young children might speak right up if they saw their older siblings decide to start a little brushfire beside their home "just for the fun of it." But most little brothers or sisters would be too intimidated to speak up. Consequently, we invented a game where we simulated the situation in which a brushfire was about to be started, and then we asked the players to choose the response that they thought they should use to stop the action. (See Figure 15.2.) Although we were forcing the players to recognize the need to say something, we were also providing them with a litany of responses that they could employ when confronted with such a situation.

FIGURE
15.2

Boys and girls compete for the position of Junior Dragon Slayer as they learn how to make their homes and their villages fire safe. Includes Interactive Conversations with kids and adults.

Concept art for the simulation activity in which an Alaskan youth warns his older brother about playing with fire. ©2007, Compelling Technologies, all rights reserved. Used with permission.

We recognize this is not precisely the same as actually having the child speak words to a real older brother or sister who is holding a match. But it still contains many of the elements that are part of doing so, such as the following:

- Recognizing the danger situation
- Knowing what to say
- Knowing what not to say

Because this was a clever game with lots of fun responses from the non-player character (NPC) children, the game would be played over and over again, and the main message would be drilled into the players.

Finding the Core

The previous example suggests that almost all desired behaviors contain a core activity that can be simulated effectively. Part of the job of determining simulation activity is finding that core. In our example, although many possible elements were critical to that task, the core task that we decided to simulate was "finding the right thing to say." We addressed it through an instructional strategy called *scripting*. (This shouldn't be confused with either scripting code or scripting dialogue or scenarios.)

In scripting, you ask someone to learn the right set of words to employ in a given situation, and then you simulate the situation so that the person learns to use those words at the right time. You do it over and over again, and in the end, through repetition, the words have become embedded in the person's mind so that they are right there when the individual needs them. In this instance, the simulation minigame becomes repeated confrontations with fire starters, followed by choices of the right thing to say.

Scripting is a technique that has found ardent followers in other types of interpersonal training such as customer relations and sales. If you've ever found yourself in the middle of an angry confrontation with a customer representative in a bank or a store and he or she keeps repeating the words, "I hear what you're saying," or "I can certainly see your point of view," you'll know that you have run into someone who has taken a customer relations training course that uses scripting as an instructional strategy. The person, in a sense, has been programmed to respond to the situation with those words.

Repetition is also an instructional strategy related to learning problems that require instant recall. In some cases, it is the quickness of the decision that prompts the use of this strategy. You have to plant the idea in the learners' minds so deeply that it becomes second nature for them to respond in the prescribed way. When they find themselves in the appropriate situation, they automatically do it.

In another minigame for *Spark Island*, we wanted kids to immediately recognize which fires they could put out and which they should stay away from.

FIGURE
15.3

Concept art for the "Put Out the Fire" flashcard game. ©2007, Compelling Technologies, all rights reserved. Used with permission.

Consequently, we used the classic concept of a flashcard game, which presents the problem and asks for a quick response. (See Figure 15.3.) Any minigame concept that involves quick responses is usually a lot of fun as players try to make quick choices and beat the clock. See the accompanying box for the preliminary design for that minigame.

Minigame Design 5: "Put Out the Fire" Flashcard Game

Brief Description

At the fire pits the fire safety counselor will show flashcards of fire situations and ask kids if they think they should try to put out the fire or not.

Game Dynamic Breakdown

At the easy levels of the game, a closeup focuses on the counselor's hand showing the flashcard. The counselor describes the fire situation, and players must indicate whether or not they think they should try and put the fire out by clicking on the words yes or no on the card. On later levels of the game, there are multiple cards on the screen, each representing a different fire situation. Players click on the cards representing fires that they can put out themselves, and they leave cards in place that represent fires that should only be handled by adults. When only adult cards are left, players click on an image of an

(Continued)

adult on the side of the screen, and the adult runs from card to card putting out the hazards on the card. If the adult comes to a card representing a fire that players could have put out, she grabs the card and explains why players could have put the fire out.

Game Variables

Most of the items will be small fires that kids can put out. Cards will also show the appropriate tool to put out the fire. Most important cards will be fires that kids should not try to put out. The table provides a small sample of possibilities taken from the task analysis. A much larger list will be created with subject matter experts (SMEs) during game development.

Event	Action
Smoldering campfire with bucket of water next to it	Put it out
Couch on fire blocking a doorway	Don't put it out
Flaming socket with a toaster plugged into it	Don't put it out
Flaming matches on a cement floor with a bucket of sand nearby	Put it out
Heater igniting a nearby chair	Don't put it out
Small grass fire in the corner of lawn with a bucket of water nearby	Put it out
Sparks jumped onto small piece of paper in front of fireplace with a shovel nearby	Put it out
Smoldering cigarette on kitchen linoleum floor	Put it out
Candle placed directly on a stack of newspapers with no candleholder	Put it out
Lampshade on fire from a candle placed too close to it	Don't put it out

Player Actions

Players can use the mouse to click on yes or no buttons at the bottom of the card, or they can use left or right arrows or Y and N keys. In later levels, the mouse and arrow keys will indicate which cards represent fires that players think that they can put out.

Scoring

Decisions are timed, and later decisions must be made more quickly. The game goes in levels, six cards to a level. The decisions move from clear yes/no to judgment calls. Later decisions given less time are those that must be made quickly because of imminent fire danger. Raven comments on how and why. Players get 10 points for each correct yes answer and 20 points for each correct no answer. Points double at each succeeding level, but maintain the ration of 2/1 for adult versus player fire put outs.

Now it could be argued that a flashcard game is not a simulation: it's a learning exercise, and it bears little resemblance to the real-world experience of seeing a home fire danger. This observation is both right and wrong. The game is not a complete simulation of the experience, but it does simulate the core activity. The core activity is immediate discrimination as to whether or not you as a kid should try to put out a home fire. As such, it is a perfect simulation of the decision-making process. In this case, the game device (the flashcards) will not distract from the basic decision-making activity. In another vernacular, the skills being taught are cognitive (not overt performance). We are not teaching kids *how to put out a fire*. We are teaching them to recognize fires that they should not try to put out.

A more highly integrated simulation in which players go from room to room and spot fire dangers embedded in the environment adds noise and distraction and thus is a higher level of simulation that increases the probability of transfer to the real world. (See Figure 15.4.) But this activity will not achieve the same level of exact recall that can occur with the more isolated practice of a flashcard game. In the end, the best instructional strategy is to use both approaches. Start with the isolated practice of the flashcard exercise, and then move on to the integrated practice of moving through a virtual world where fire dangers are present. Move from the low-level (abstract) simulation to the highest (most realistic, noisiest) level.


FIGURE
15.4


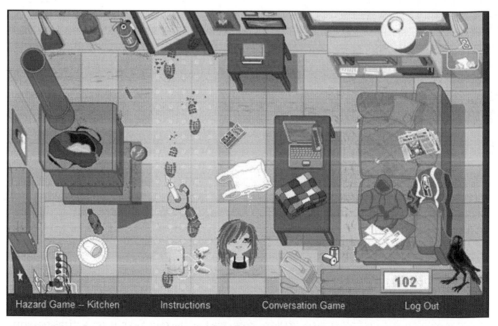

A Hazard Quest minigame from *Spark Island*. Note that the mission here is to find the hazards. Note also the complexity of the environment, which makes this a higher-level simulation than the flashcard game. ©2007, Compelling Technologies, all rights reserved. Used with permission.

A final illustration of finding core activities: at Hewlett Packard, we created a game called *Know Your Product*. The learning problem we addressed: salespeople who did not know the most important features and benefits of their brand new products.

The game approach was that salespeople would be presented with questions about their product in a game show format; in turn, they'd have to use their product knowledge to identify the correct responses. The game was, in fact, a fancy, multiple-choice product knowledge quiz, and it was extremely popular with salespeople and with clients in other departments who often used it to introduce new products.

Was it a simulation or not?

Certainly it was a simulation of a television game show. But it can also be argued that it simulated the linking of features and benefits that salespeople have to do on the job. It forced salespeople to make the critical discriminations that are needed to match features and benefits and differentiate their product from that of the competition. We considered this kind of learning exercise a simulation, though you'd be right in asserting that we stretched the concept.

The question is one of *simulation fidelity*. Surprisingly, low-fidelity simulations are often at least as effective as high-fidelity simulations in facilitating transference of knowledge or skills. High-fidelity simulations always cost you more money to create, so a key question is how much would high-fidelity simulation further benefit your application? (If the task is visual object recognition for tank commanders, then the answer is plenty!)

This is a critical debate in serious game theory, with no easy resolution. But to summarize here, once you isolate core behaviors, there are creative ways to present them in minigames before integrating them into a single integrated exercise. In the broadest and arguably most effective serious games, both kinds of simulations (abstract and realistic) are present.

First-Person Simulations

To some degree, the notion of simulation implies that the player is seeing through the eyes of the player-character. But as popular games are evolving, this is happening less. Many of the most popular game designs are built around seeing your own character (your avatar). Then you can have the added fun of customizing your avatar. The device of the avatar has become such a convention that we feel it is no longer any kind of barrier to the design of a first-person simulation game. (Some will refer to this as a second-person simulation.)

In the *Leaders* simulation, the player avatar (Captain Young) was on-screen, and players could see him even though they controlled his choice of words and his actions. In *Spark Island,* we were faced with the objective of showing players how to escape from a burning house. Again, this was a perfect place for a first-person simulation in which the player avatar could be on screen. In this game, as shown in Figure 15.5, players manipulated their characters from their bedroom through a burning home, avoiding the fire and getting to a predetermined meeting point

FIGURE
15.5

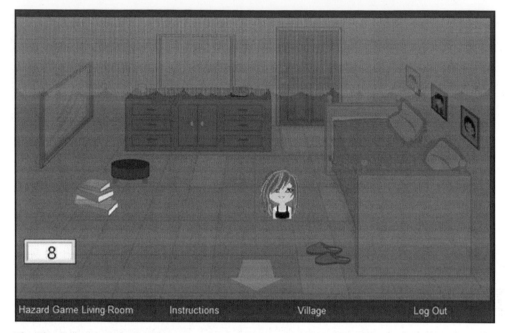

The Fire Escape minigame from *Spark Island*. **Note the player-character who is manipulated by the player so that she successfully escapes from the room.** ©2007, **Compelling Technologies, all rights reserved. Used with permission.**

outside the house. At later levels, they had to retrieve their little brother and save him as well.

In further support of this objective and also to help meet subobjectives identified in the needs analysis, we added a second minigame designed to help families establish a family escape plan. This game presented the general concept of good escape routes and the need for each player's family to set up such a plan.

In the Family Escape Plan game, players have to run from their burning house to a designated meeting point by connecting dots overlaid on a home floor plan. They had to do this while staying as far away from the fire as possible. Points are given or taken away based on how quickly they escape, how far they stay from the fire during escape, and other factors. At higher levels, more furniture and larger fires complicated the escape, as did the need to rescue the little brother.

Total Integration

The firefighter safety simulation *Fully Involved* is a classic example of a totally integrated simulation. Although it starts with an effective tutorial and walk-through that presents each skill one at a time, it moves onto a series of fires that each represent a higher level of difficulty. In the lower levels, some of the major firefighter challenges

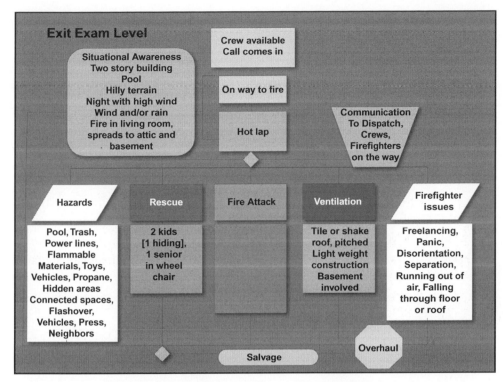

FIGURE
15.6

Flowchart for a high level of the firefighter safety simulation _Fully Involved_. (Don't read too much into the shapes; they're only meant to differentiate various actions.) ©2007, **Compelling Technologies, all rights reserved. Used with permission.**

are omitted entirely so that the players can focus on the more basic skills, like doing a complete walk-around or finding a single child in the upstairs of the house when that child is out in the open and not hiding in any way.

Later, the complexity builds. As previously mentioned, a coach (the battalion chief) steps in to give advice, but at higher levels the coach disappears. In the end, the players are working entirely on their own. The final level is actually an exam that could be used as part of a certification process. Simulating the experience of an incident commander who is commanding a fire from outside the building, the major input is direct radio communication with the firefighters inside and around the house and whatever parts of the fire are visible from that command post. The truth is that sometimes there is little to see. So the simulation, as _Fully Involved_ portrays it, is in fact very real because incident commanders don't pick up a hose and go in and start spraying water on the fire. They stand back and command the firefighters who do so.

Figure 15.6 shows the flowchart for the highest level of simulation in _Fully Involved_. Notice all the variables that are thrown at the incident commanders.

The good news is that players have been led to this level through far less complex activities that help build these skills along the way.

Summary

- Developing simulation activities to translate instructional design into gameplay involves breaking down (1) tasks that are going to be simulated and (2) core activity within each task.

- With core activity in hand, the next step is determining which activity best gets the users to simulate what it is they have to do to execute the activity:

 1. If it's a physical activity, is there a way to simulate the action?

 2. If it involves decision making, is there a way to isolate the decision so that it can be dealt with directly?

 3. Does the core activity involve a response to a statement? If so, can scripting help?

 4. Does the core activity involve quick choices that must be remembered? If so, can repetition help teach it?

 5. If the core activity involves remembering ideas or concepts, can memory aids (like rhymes or songs) be built into the activity or the background music to constantly remind players what those concepts are?

- Simulation activities can be low level (abstract) or high level (realistic). The best serious games or simulations will integrate low-level and high-level simulation activities to achieve the best transference of knowledge, training, or persuasive points.

Gameplay Design

Introduction

Determining gameplay is a key component of creative design. But before you undertake this task, the goals and objectives of the serious game (whether a simulation, a persuasive game, a training game, or a promotional game) need to be very clear-cut. If creative solutions to problems are considered prematurely, you may overlook some key elements of the behavior you're trying to teach in favor of those that are more fun to deal with. You may get locked into creative solutions that don't even address your objectives. But once the goals of the game are clear, then the fun begins.

Designing gameplay is an art and a science. It's a science because there are sets of well-known game activities that players can perform in certain stories and environments, and it's important to know them and how they can be used to make your game more fun. It's an art because it is really something like choreography. You have to determine how player-characters move around in the game space and how they react when they encounter elements within the space. You need to figure out the timing of the actions, the related sound and visual effects, and other appropriate game elements. Then you have to polish the game until the interaction between the player, the interface, the player-character/avatar, and other elements in the environment all work together in a smooth and enjoyable way.

The goal is to make it all interesting (and fun) if you can: realistic for a serious game, but also unusual and unexpected. That assures replayability, which contributes to retention.

For example, if your serious game has a learning objective requiring your player to recognize the difference between toxic and nontoxic waste (as ours did in *Spark Island*), then you're into a discrimination (choosing) game. With the gameplay revolving around choosing, how can you make it especially enjoyable while it's under way?

This chapter focuses on selecting kinds of gameplay that match your goals and then talks about how you can tweak them so that your players will get the most fun out of the experience. We're assuming that the instructional designer's job has largely been completed. You know the kind of activities you need. Now it's just a matter of making a great game out of them.

TABLE **16.3** Sample objectives and instructional solutions for the *Spark Island* game.

Objective (after completing FS4K, students will be able to do the following)	Problem Type	Solution Type	Recommended Solution	Comment	Minigame
1.1: Know the consequences of fire. 1.2: State examples of fire disasters on homes and villages.	Generalization	Demonstration and prompted exercise	Players need to experience a simulation of a small fire that eventually grows large enough to consume part of the town and possibly their own home.	These objectives are addressed in the first fire lessons with the Dragon Slayer at the fire pits, specifically in the *Sparks* minigame. Also in the *Fire Escape Plan* minigame	*Sparks* Game
1.3: Describe the action of a fire as it spreads. 1.4: Know the effects of smoke, wind, and weather.	Generalization	Demonstration and prompt	Provide several examples of fire as it spreads.	Additional versions of the *Sparks* minigame add wind and a weather component.	*Sparks* Game *Family Escape Plan* Game

Making Games Fun: A Proven Process

In the course of creating serious and entertainment games, we've been fortunate to work with some wonderful creative directors who have added their own spin on the creative process. It is this spin that makes their games different and unusual. Phil Campbell has served as creative director on Electronic Art's *Godfather* and *007* franchises and designed several Lara Croft games. He shared his creative process with us, and we'll see how we can apply this to serious games and simulations.

Research and Saturation

Campbell's tongue-in-cheek first step is complete immersion in the material. He reads everything he can about the game's subject matter, plays the game, watches videos, and reads the fan blogs and websites. In a serious game, he would become totally familiar with the results of the needs and task analyses. Then he takes a couple of days off, takes his dog to the beach, and lets the information sink in. And then he's ready to start his design.

Creative Brainstorming

Campbell goes to the first creative meeting and brainstorms with the team. He prefers to brainstorm with the client and key members who have creative ideas about the game. If he gets inspired, he may do his own riff on one or more of their ideas, but he wants key team members to contribute so that everyone will buy into the concepts as they're evolving. Because Campbell is both an architect and a graphic artist, he'll probably start drawing the ideas on the white board. He'll put up as much as he can, tweaking ideas as he goes along. Eventually he'll cover the entire board (see Figure 16.2 for an example). He says people will either be inspired or intimidated by this presentation, so it's better not to make the drawings too good or have too final a look. Everyone should know that the ideas will continue to evolve.

Metaphors That Give Structure

Campbell likes to think of the whole game at once. He wants to see the arc of the game story, especially the beginning and the end. Often he uses metaphors to structure his thinking. For example, he uses a golf course metaphor frequently. The game he's designing (no matter what it is about) can be thought of as a round of golf, he says. The players know the goal of the game: to get the ball from the tee, onto the green, and into the hole. Sometimes they can see the flag waving at them from the hole. Other times they can't; it's hidden, but they still know where they're going—the purpose of the game. Campbell can pepper the course with obstacles and hazards. He can hide the green or make it visible. But he sculpts the course,

FIGURE
16.2

Sample Phil Campbell brainstorming sketch. © Phil Campbell, used with permission.

building each hole differently, where every hole becomes a level in his game. (Not that he always has 18 levels to each game.)

Next, he gives the player a bag of golf clubs to play with, and those clubs are the mechanics of the game. In a fantasy game, they may be a variety of weapons and spells (invisibility, stealth) as well as tools for climbing and building.

Now the entirety of the game has emerged. Campbell sees the whole experience, and, like a golf course, he knows where the traps and hazards are, where things are easy, and where they get difficult.

Another metaphor Campbell likes to use is that of a large building (a nod to his architect training). The building is again a metaphor for the whole game, and the path through the building represents the players' path through the experience. (See Figure 16.3 for an example.) He sometimes conceptualizes this building to set the mood of the game, so he's always aware of the kind of atmosphere he wants to maintain. How do the players approach the building to get started? What do they see through the windows of the building? What tools do they employ to get in the door? Do they use some kind of stealth and sneak in, or do they pull out a rocket launcher and blow the doors away? This is the kind of wide-range thinking that Campbell uses to get a sense of the whole game, and be it a golf course or complex building serving as a metaphor for an entire world of action or adventure, he's seeking to understand the total player experience.

FIGURE
16.3

**Phil Campbell's early sketch of a building used as a metaphor for an entire
action/adventure game.** © **Phil Campbell, used with permission.**

Gameplay

Returning to the golf metaphor, Campbell suggests that players can choose their
path through the course. Some will choose to charge right down the fairway
and get to the hole in as few strokes as possible. That's the way golf is supposed to
be played, after all. But other players may want to take the scenic approach to the

green, stopping to check out the lake on their way. Still others may want all the challenges they can find, going from trap to bunker to hazard on their way to the hole.

Campbell's point here is that he wants to give the players a course that they can play any way they want to; he gives them different tools so that they can have a variety of experiences as they go along. But he still has them playing in a world that has a beginning, middle, and end; where the direction of the game is never in doubt; and where the players know where they're going at all times, no matter what kind of circuitous path they may take to get there.

Guided Paths versus Branching

Campbell's designs do not always require the kind of endless interactive structures and branching that people assume must exist in story-based entertainment games. There may *not* be vast worlds that players can roam around in for hundreds of hours. (Although his *Tomb Raider* games certainly feature such worlds.) But there is always a sense of mission or destiny to these designs. The destiny in the golf game is to get the ball in the hole. And he always tries to create great interactive experiences that can grab players and hold their attention. Players progress from beginning to end along a defined route, but there is still plenty of opportunity to stop and play.

"It's kind of sleight of hand," he says. "We give the illusion of freedom but maintain a grasp on the linear design; the interactivity quotient feels high."

The "guided path" approach doesn't require the building of vast 3D worlds or the creation of many paths through the material. As a result, they're well suited to serious games that have demanding numbers of objectives but limited budgets. It doesn't mean they can't be fun to play. Just that the gameplay is in the activities, not in endless branching.

The Clever Player

Campbell says that he likes to make the players of his games feel clever: to give them tools, show them how to use them, and then turn them loose. There may be a lot of ways to play the game, but Campbell is always thinking of what the clever player will do. What can he do to challenge and reward that player? He wants his games to be most exciting and rewarding for the players who make the cleverest choices.

He lets players see the end of the mission, know where it is all going, but on the way he opens all kinds of windows, opportunities, and options. He doesn't tell them how to play the game though, and in that way he gives them that incredible sense of freedom.

The Gaming Experience

This is where Campbell and his team get really creative. As he scopes out his terrain (his golf course or the inside of his complex building), he looks for opportunities for

traps, hazards, and puzzles, things that the game player has to solve to advance the game. This is where he and his team let their imaginations run wild. We have to build a slight rise in the terrain of our game space, he suggests. So why not add a giant waterfall? The question then becomes, how do players get to the top of the waterfall? Is there a flying horse that they can tame and ride up there? And how do they tame and then ride that beast?

When considering serious games, Campbell asks how game challenges can be used to strengthen skills that fit the objectives of the instructional design. If the challenges fail to strengthen skills, then the serious game won't be fulfilling its mandate.

How do you get through the sand traps? How do you ascend to the next floor of the building? How do you find the hidden gun (or hidden skill set) that will save your life? What are the most creative challenges and answers that you can think of? What would be the trick that would challenge the cleverest players and give them a sense of accomplishment when they solved it?

Figure 16.4 and Figure 16.5 show some of Campbell's early sketches for designing challenging gameplay.

Applying This Process to Serious Games

Let's take a look at how a few of Campbell's approaches apply to serious games:

- *Guided paths.* The *Leaders* game narrative takes place within one day and is a largely linear story with different "waypoints" that would launch the player toward distinctly new leadership challenges. The player's goal (to successfully complete a food distribution mission) remains the same throughout, but numerous concrete minigoals (e.g., to maintain good relationships with subordinates and superiors, to forge and maintain a good relationship with a local tribal leader) emerge and then must be reached to successfully move toward the primary goal.

- *The clever player.* Ian Bogost's and Persuasive Games' *Fatworld* (funded and published by the Corporation for Public Broadcasting) gradually introduces the rules of an economy to players. Players are rewarded as they figure out how to apply the rules and better their lot (earn more money, eat better food) throughout the game. Similarly, the Wilson Center's *Budget Hero* allows players to discover how the playing of certain federal budget cards (i.e., budget priorities and variables) may have either minor or major effects on long-term forecasting models.

- *The gaming experience. Fully Involved* continues to amp up the complexities of potential house fires through its levels, revealing new and unexpected challenges that require the use of knowledge gained in earlier firefights.

FIGURE
16.4

Early Phil Campbell sketches showing camera blocking for an action adventure game.
© **Phil Campbell, used with permission.**

FIGURE
16.5

Early Phil Campbell sketch showing an overhead view of blocking for an action adventure game. © Phil Campbell, used with permission.

Creative Questions That Lead to Better Gameplay

We talked to some of our other creative director friends who have their own slant on how to make gameplay more fun. Most of their games feature a player-character (an avatar), an environment he or she needs to navigate, objects, and nonplayer-characters (NPCs) that he or she can interact with. Using that basic list of game elements, they recommend getting more creative by asking yourself the following kinds of questions.

Player-Characters (Avatars)

What's fun about a given player-character? What can the avatar do? Does the avatar have powers or limitations? Can you customize what the avatar wears and its other visuals aspects? Does it sound a specific way? Is it a hero or a villain (in relation to the story)? What does the avatar carry? Also, think about the avatar's interactions in the environment. How does the player-character interact with NPCs? Does it have to lead them, convince them, hide from them, kill them, have them follow it some-where? Just thinking creatively about these basic questions can lead to interesting choices and outcomes.

Navigation

Ask yourself what's fun about the navigation in this game. Is speed an issue? Can the avatar go too fast? Do doors or gates block its way? Are there vehicles that the avatar can climb on or into, drive or fall out of? What's the terrain? How can you make it more exciting? Does the avatar have to wade through mud? Is the avatar traversing an icy slope that is challenging because of lack of traction? Think about ways that movement within the game world can be more interesting and more fun to understand and get through. The world you're building needs to be believable and tell a story that supports the goals of the game. To make the world make the most sense, pick forms of navigation that suit the story.

Objects

What's fun about interacting with objects in the environment? What's the most crea-tive form these objects can take? How do they relate to the player-character or the navigation of the environment? Do they help or harm the player-character? Do they affect the avatar's performance? Can the avatar carry the objects and move them? Are the objects expendable? Can they be combined into new and more powerful forms? Is the avatar rewarded for finding objects and building sets or collections of them? Are they prizes or symbols of success or symbols of danger and impending doom?

Game Mechanics

Game mechanics are all the things that your characters, environments, and objects are able to do within the game space. (Sometimes they're called the *rules of the world*.) Think of game mechanics as a toolbox (or, as Phil Campbell suggests, a set of golf clubs). Find the best ones for the job from an established set of pieces you've seen before, and repurpose them to fit the goals of your instructional design, story, and game.

Establish the story you're trying to tell, the goals of the story, and the world the character is in. Then define the things that these different elements do that provide choices with consequences, a heightened feeling of tension and danger, a sense of progress and reward. Create a sense of immersion to pull the players into the game world and make them feel a part of the game. Good designers can do this with very few common pieces, activities, and common rules. It's easy to get things so complicated that the game will either be hard for the player to learn or so hard for the developer to build that it can't be completed in time.

Another approach here is to take different types of game mechanics and mash them together. Pull the rules from game A and game B together and give them a twist to make something new. Most games are based on features that already exist, but every once in a while something new and revolutionary comes up that's never been done before. (Think of the first time you ever tried *Tetris* or *Guitar Hero*.) But don't mash together too many mechanics; your game will lose coherence and become difficult to design and produce.

Key Gameplay Concepts

Here are a few gameplay concepts that you should also consider to make your game memorable and rewarding.

Fun

That gameplay has to be fun goes without saying. What is critical is how you make it fun. See the sections that follow.

Choice

Players need to make decisions. They need to feel that they have the ability to make choices. Some will further their cause, and some will be mistakes. Players should see their choices clearly, be able to execute them intuitively, and then learn from what they did. If they make a mistake, don't punish them. Let them try again with their improved knowledge. Then they will feel they're getting better at making

decisions and at the game. The frequency of the choices and the cleverness of the related consequences contribute greatly to the fun of the game.

Choices should have real consequences. If either choice A or choice B leads to the same result, then these are pointless choices. In addition, the consequences should have some weight and meaning. If choice A or choice B leads to trivial or insignificant differences in performance or narrative path, the player will quickly grow frustrated. When choice counts, it's said that players have *agency*. Players prize agency.

Rewards/Progress

You've got to give the player rewards, whether it's to ascend to the next level, obtain new equipment or skill, or add points and progress on a leader board. Whether it's sirens and confetti or messages of congratulations, players have to feel that their decisions further their progress on a moment-to-moment basis. If they earn something tangible from an achievement in the game, they'll want to keep playing to get to the next achievement.

Risk versus Reward

Players like rewards, but the rewards are more meaningful when risks are attached to them. The higher the risks taken, the better value will be placed on the reward. Don't be afraid to set up challenges that have real risk (in the context of the game) attached—but if a player fails, be sure the player has opportunities to remedy the failure and learn from the mistake or poor execution.

Immersion

How into the game are the players? Do they feel they *are* the character in the world? Are they pulled into the environment? Do they have an emotional involvement in their decisions and the outcome? Do they feel the tension? We don't necessarily need the emotional pull of *Titanic* or *Gladiator*, but players need investment in the reality of the game world, a feeling they can make a difference, a feeling that it'll be a better (game) world through their experience.

Immersion is easy to break. If you put something suddenly out of context into the game world, it makes the game unrealistic and breaks immersion. The worst example of breaking immersion is a crash bug. Players are ripped out of the experience and feel cheated. But sometimes designers end up breaking immersion themselves by doing something silly, out of context, or punishing in the game. Good games need to pull the player in and keep them there from decision to decision for

(ideally) as long as is physically possible for the player, until they have to sleep, eat, or run screaming to the bathroom.

Pillars

Pillars are tools to keep the game design under control. You're building a game, and it's an epic project. Ask yourself, what pillars or "tenets" are going to support the project. Identify them, and then use them to measure every decision the team makes. If the decision doesn't support a pillar, it doesn't support the project and it shouldn't be pursued.

There are usually three pillars to a project: never fewer than two and never more than four. For example, a game about fishing could have three pillars: (1) realistic rod-and-reel technique, (2) larger-than-life fish (both in the visual representation and in the timescale in which the player catches them), and (3) a worldwide online fishing competition. With these as the pillars, you could have a constructive discussion about the value of including lots of different types of boats, engines, trucks, and trailers. The game designer should come in at this point and say, "Only those things that further the pillar of realistic rod-and-reel technique should be supported!" As a result, the team would then promptly cut trucks and trailers and some of the boats that don't impact that form of gameplay.

Certainly in serious games, the instructional goals of the project are the tenets. Thus, in a game that didn't just want to simulate a fishing experience but actually wanted to teach fishing, the pillars could include the choice of bait or lure as well as the action of casting and where to cast.

Further Studies in Gameplay Design

The complexities of designing gameplay can't possibly be covered in a single chapter in a book, when an entire field of study (ludology) and academic degree programs have grown up around the topic. In addition, dozens of books have been written about gameplay design. Two we can recommend are Tracy Fullerton's *Game Design Workshop* (published by Morgan Kauffman) and Jesse Schell's *The Art of Game Design* (published by Focal Press).

Take these steps to further improve your grasp of effective gameplay:

- Keep up with the latest developments in gameplay (play a lot of games).
- Understand key components of game mechanics.
- Broaden your study of gameplay to reach beyond videogames (the "prehistory" that includes sideshows, Coney Island–style parks, haunted houses, dioramas, amusement arcades, and much more).

Summary

- For serious games of all stripes, designing gameplay should take place (as much as possible) after instructional design has been completed—to avoid the premature lock-in of gameplay that fails to support your application's objectives.

- Metaphors for the entirety of the game can help conceptualize gameplay design. We might consider the game as a golf course or as a multilevel building. The ultimate player goal in each instance is clear-cut. But between the tee and the hole, the game designer can add all kinds of obstacles, hazards, and traps so that the cleverest players will enjoy the challenge of figuring them out.

- Navigation, interaction, and game mechanics are some of the tools (or to extend the golf metaphor, the clubs) in which to assemble gameplay.

- Key elements of effective gameplay include player choice (agency), risk versus reward tradeoffs, immersion, and game pillars.

- Ludology is the study of games from social science, humanities, and engineering perspectives, and the more you study both the theory and practice of gameplay, the better you can contribute to designing unique (and fun!) game experiences.

The Concept Document

Introduction

We'll talk about an ideal concept document approach first, before acknowledging that the real world is usually a lot messier and that there is no simple, one-size-fits-all approach for developing concept documents. In the process, we'll also discuss how our analyses and instructional design will intersect with the concept document, and how the concept document can operate as a sales tool for the project.

Defining the Concept Document

The *concept document* (sometimes known as the *proposal*, the *creative treatment*, or the *preliminary design document*) will be the first true capture of what the game or simulation concept will be, along with the broad strokes of the following:

- The user demographic
- The delivery platform
- Example(s) of functionality and user interactivity
- Some suggestions of distribution, marketing, and assessments

Concept sketches, storyboards or mockups of environments, the interface, characters, and key interactivity can certainly help a concept document, but they may not be essential, especially in the early stages or drafts of a concept document. Early visualizations of concepts can sometimes lock in ideas and approaches too early in the process. At this point, the full flow of conceptual creativity should be encouraged.

Traditionally, concept documents were developed as linear documents, delivered in print. Now, it's possible for us to use content management systems, wikis, and other tools to build and distribute the concept document. Obviously, there is no right

way or wrong way to deliver the concept document. However, its relative brevity and focus on the Big Picture may argue that we shouldn't decentralize (or "chunk") the experience of the concept document too much. Later on, the chunking of design specifications will become more useful.

Here are the twin goals of a concept document:

- To get everyone on your core development team—and as the concept document progresses, anyone who might have a say in getting the project funded—excited about the project

- To begin to help everyone visualize some of the design, the production, and even the finished product

If the concept document is successful enough, it'll eventually serve as a jumping-off point for a design document, but we're getting ahead of ourselves.

An Approach

A concept document, like all documents we'll be discussing, should be expanded, revised, and iterated multiple times. It should be considered a working document that will evolve and grow over time.

The first draft may run just a page (nothing wrong with this!) and may be either:

- The starting point for meetings and brainstorming about the proposed project

- The result of an initial round of meetings and brainstorming

At this stage, some people will label this a vision statement more than a concept document, and that's fine. This one-pager might be a breathless visualization of core gameplay, with some suggestions of how teaching points will be deployed during this experience. It might be a compelling proposal for a unique user experience or look and feel, built around some of the teaching points you've already developed. Game concepts are not born fully formed; inspiration, risk-taking, and creative thinking are great places to start a project.

You may generate several different concepts and need a one-page concept document for each. Compare-and-contrast was a good exercise back in high school, and generating multiple concepts may be a way to sift through different approaches and arrive at the best one.

But eventually, you're going to need to choose. Then your one-page concept document will begin to need some expanding in order for its value to grow and for you to begin to do the real work of conceptualizing a game or simulation. No optimum length exists for a finished or final concept document. We've seen successful projects launch from concept documents that run just a few pages, whereas other projects may require concept documents that run 20 to 30 pages.

As the concept document expands (out of an iterative process of brainstorming, writing/illustrating/flowcharting, and feedback), you'll begin to capture the key

elements necessary to design and produce any game. They may include overviews of the following:

- The project thumbnail (what's the three-sentence overview?)
- Target users
- Delivery platform(s) and justification(s)
- Learning objectives and teaching/persuasion points, and user goals in the comprehension and deployment of these teaching/persuasion points
- The user interface and environment
- Interactivity: How much input and what type will the user have? What will be the core gameplay? How does the interactivity intersect with the teaching points?
- Gameflow/narrative synopsis: a user's *critical path* or *sweet path* should be mapped out, along with key narrative events and turning points
- Examples of how gameplay will integrate with (and advance) instructional design
- Intellectual property licensing and licensed or purchased media acquisition (if needed)
- Possible assessments of user progress, advancement, or social behavior
- Technology, tools, and media used to build and deliver the project
- Evaluation and assessment tools to be used
- Project testing and iteration
- Budget, personnel, and production/delivery timeline estimates
- Distribution and marketing strategies
- Risk versus reward in advancing the organization, its mission, and its image

Clearly, the more detail and accuracy the concept document can accumulate, the better the chances are for successful design, production, and completion of the project. In the early stages of developing a concept document, creativity and thinking outside the box should be encouraged. Sketchiness and a "reach for the stars" approach are okay, too.

But as the concept document advances in iteration, a harder and more skeptical eye should begin to be applied to the proposed design and production. In addition, some or all members of the team should be experienced game players. This may seem more obvious than it actually is.

One project we became involved with (very late in the process) contained elements of *Grand Theft Auto*, *Guitar Hero*, and *The Sims*, despite a shoestring budget. It was as if the creators had read about the top five videogames, looked over the shoulders of their teenaged offspring, and decided to just throw them all into the stew—without any regard for the difficulties involved in creating just one of these environments, let alone combining them all into some unwieldy, unproduceable mix.

Amazingly, this vision survived the concept document phase and moved into the final versions of design documents (to be discussed later in this chapter), with no one putting the brakes on this unrealistic goal (as you might guess, project management also fell short here).

Integrating Analyses and Instructional Design into the Concept Document

We've placed this chapter after a lot of work has already been done to translate instructional design into simulation activities and after we've conceptualized solid gameplay. However, it's possible that the composition of preliminary concept documents may precede or parallel the initial gameplay design.

Regardless, it'll be useful to incorporate the progress you've made on gameplay and instructional design into the concept document. Ideally, gameplay and instruction will clearly infuse the totality of the gameflow, but you may decide to devote an entire section to describing how the conceptualized gameplay and instructional design will influence the gameflow.

If little instructional design has been done, you're really spitballing as you write concept documents. Without clear objectives, it becomes difficult to successfully evaluate a concept.

Working out a concept for gameflow—incorporating narrative and gameplay into a coherent whole—is a mysterious and bumpy process. Don't be afraid of trial and error. When possible, good creative meetings can help, as a lot of ideas can be thrown around, critiqued, and refined. (Bad creative meetings are when everyone looks at each other, unprepared and with no ideas. Avoid these.)

With *Fully Involved*, a much longer and more detailed story narrative was originally one of the potential concepts that the development group explored. However, the needs of the gameplay, and of the users (who would typically use the application in short bursts of time rather than spending hours with the game), eventually dictated a light narrative framework and more of a pure simulation approach. We didn't know this when we started. Both approaches had to be explored in order to find a winner.

Including flowcharts that demonstrate user progression through key teaching points or levels or user progression toward an action item (volunteering for a cause or supplying information that can be used for a sales call or other data mining) can help illustrate gameflow and user experience.

Figure 17.1 shows a typical document flow for most interactive applications. The concept document may lead to prototyping or proof of concept (to be discussed in the next chapter). It will also lead to the iteration of a design document and numerous subsequent documents (to be discussed in Chapter 21).

FIGURE
17.1

Typical document flow for most interactive applications.

Concept Document Dos and Don'ts

Dos

- Gather all the hard data and specificity you can—sooner rather than later. You may not deploy it all in the concept document, but the more you know sooner, the more solid your conceptualizing will be, and the faster you can get a design document on its feet.

- Gather feedback and iterate. Your readers will spot confusing elements and concepts that may deserve skepticism.

- Keep as much enthusiasm and creative appeal as you can. This is the time to inspire and to see the forest rather than the trees.

- Focus on the problem you're solving with the serious game or simulation. You may weave this throughout the sections in your concept document, or you might reserve a specific section for this step. But you want to start selling the return on investment (improved employee performance, heightened awareness of a political situation or brand name, etc.) right away.

- Insert preliminary storyboards or flowcharts if they successfully convey key concepts, but don't feel you have to include these in early versions of your concept document. You're conveying "feel" more than nuts and bolts, and sometimes a brisk narrative will do better at conveying gameflow and user experience.

- Identify key members of your team as soon as they're secured. However, early versions of a concept document may be recruitment tools for those key

members—and that's okay! (But don't roll out a preliminary draft of the concept document too early; you usually get one shot with a majority of readers.)

- Have champions and subject matter experts (SMEs) sign off on key concept document drafts. Create an approval paper trail.

Don'ts

- Don't overwhelm your reader with details and specificity. It's good to have a lot of ammo left in your gun. But stay with the Big Picture in the concept document. Make the reading as compelling you can, so you can sell both the reality and the vision of your project.

- Don't gloss over the unknowns, hoping no one will notice where things get blurry and uncertain. It's better to identify the unknowns at this juncture, while setting goals for discovery of the information.

- Don't begin building the project without a clear understanding of the central learning objectives and the user base. As discussed in earlier chapters, these items are central to your brainstorming gameplay, delivery platform, and other key elements. You don't need to have every teaching or persuasion point worked out, but you should know what most of them are before conceptualizing a game that will advance them.

- Don't create a mish-mash of genres and interactivity, hoping this will make the project more exciting. Nothing succeeds like coherence and elegance. Know what you want to accomplish, and keep the project focused and executable.

- Don't get bogged down in endless refinements of a concept document. At a certain point, you should be ready to move from concept document to design document. If the concept document isn't convincing others to buy in to the idea, then tweaking descriptions and adding a new storyboard probably isn't going to solve the central problem.

Concept Document as a Sales Tool

A concept document can be a successful sales tool for attracting investment, gaining in-house or upper management buy-in (especially if SMEs have signed off on the concept), or recruiting development talent (either in-house or outsourced).

You might even generate a *selling* concept document and an *in-house* concept document (which will be the one that evolves into the design document).

The selling concept document should be written to emphasize the excitement and uniqueness of the application and how it's going to succeed in promoting, persuading, or training. You'll need to think about who your readers are and address their specific interests. If your readers are upper-level corporate management,

it might be return on investment (ROI) (application sales, improved employee performance, a decrease in defective goods, etc.) or ways the application will reflect well on the organization. If your readers are development talent, you might stress the application's uniqueness while simultaneously suggesting that the vision can be successfully realized (rather than turning into a bog no one can escape from).

If you're circulating a concept document outside of your organization, we strongly recommend the use of a nondisclosure agreement (discussed in Chapter 7).

Grant Proposal to Concept Document (and Vice Versa)

Serious games and simulations often rely on grants to get off the ground and even be built. Your concept document may be the underlying document that can translate to a successful grant proposal; alternatively, a grant proposal can lead to a concept document.

In the case of *Fully Involved*, Compelling Technologies (CTI) secured a grant to launch the full project. "We partnered with the Western Fire Chiefs' Association to facilitate their interest in developing a technologically advanced training product to teach cognitive decision-making skills," Michelle Harden, one of CTI's principles, recounted. "Live fires are a much less common scenario [in the 21st century], and incident commanders have little live experience. Classroom study and tabletop simulations—the most prevalent tools used—don't provide real-world positive and negative consequences and feedback. We wanted to simulate that experience: the variables, the speed, and the heat on the back of the neck."

CTI navigated a complex grant application and was eventually awarded federal money to develop the project. But the clock immediately started ticking. "The period of performance during which the grant funds had to be expended was 12 months," Harden said. This is typical, as grant budgets are usually funded annually. The ticking clock of grant funding emphasizes the importance of good project planning and effective team building (all discussed in Section 1).

Can There Be More Than One Concept Document?

Of course, particularly if your development group has clearly defined roles, with some people doing the creative and some people doing the technical. One subgroup may be catching up to the other subgroup(s), or one aspect of the project may be farther along than another.

With *Fully Involved*, instructional design was far along (as it should have been; this was ideal), and technical design was already well under way (a game engine had been selected, and there were pretty good ideas about needed assets). But how

would the user experience work, and what would be the gameflow and mechanics for the user?

After a couple of all-day meetings with the working development group, a creative treatment emerged. While still an extremely *early* representation of the game, it's amazing how much of this survived to the finished product. Figure 17.2 displays a sample from the creative treatment.

FIGURE
17.2

Game Narrative (from user perspective)

(Throughout this section, we'll refer to the user as *You*.)

Tutorial Level

(Introduction)

You'll enter the game via a fast-paced, slightly irreverent "You Don't Know Jack" style mini-game, which will demonstrate whether you have sufficient knowledge prerequisites to play the game. (This will be bypassed in future playthroughs of the game.)

(Firehouse/Roster)

Passing the quiz will bring you to a firehouse and an encounter with your Battalion Chief (B.C.), who will serve as your mentor throughout the game. B.C. will let you know that you've been selected as a Company Officer and that you should be prepared to assume the Incident Commander (IC) assignment on every roll-out. B.C. is going to monitor your training.

You'll have available a map of your city sector. (Topographic? Or like Google Maps?)

You'll be presented with a roster that includes fellow COs for your company (Company A), as well as a second company (Company B) that typically rolls out of the same firehouse. (In later levels, roster can be expanded to show personnel for companies C and D. Roster may be a feature available at all times.)

This roster will work a little bit like the pre-game NFL player spotlights, i.e., click on an NPC and he/she will fill you in on experience, strengths, etc.

(Control Burn [game control tutorial])

B.C. will mentor you on pre-call prep (weather check, equipment check, personnel check, etc.) and then have you undertake a Control Burn assignment, where you will be IC and lead your company in handling a small structure fire. Here you'll learn about navigation, job aid and dialogue game controls. Specifically, you'll see how to execute a

Pages 2 to 5 of an early creative treatment for *Fully Involved.*

FIGURE
17.2
(Continued)

size-up, command crew, get updates and revise size-ups and crew assignments.

Tutorial Completion

When you successfully complete the Control Burn, B.C. will tutor you on stress and other issues. (Not yet determined if this material is interactive, or how it is interactive.)

Tutorial could include weblinks, case studies of fires and command issues, or other material.

When tutorial is completed, B.C. indicates you're ready to go out on calls. B.C. also indicates that your company has a long history of excellent service: it's up to you to carry on the tradition. B.C. will be coaching you when needed.

[NOTE: Tutorial can be skipped in future game playthroughs.]

Level 1

Core Simulation

Fire site is a 2500 sq. foot, 2-story house with attached garage: terrain is relatively flat. Fire will have started and will be burning in the garage. A child is up on the second floor in a known location. (NOTE: If fire has not entered house, why hasn't parent gone up to the 2nd floor to evacuate child?)

Before the Call

As demonstrated in the Tutorial level, a pre-call "walkaround" of the fire house is necessary. You should check your roster, check the weather, check your equipment. A job aid/checklist will be available to you. If necessary, you can get coaching from B.C.

When you indicate you have completed your "walkaround", the call will come in.

On the Way

You'll see a map screen, with the fire's location highlighted (in essence, a loading screen.) Audio chatter

FIGURE
17.2
(Continued)

will inform you about current weather, color and direction
of the smoke, and other approach factors. Your own
company, and a second company, are on the way. You may be
able to consult today's roster during this time.

Arrival on Site/Size-up/Incident Report

You'll be in your truck (your Command & Control Center),
able to see the ongoing fire through your windshield. You
should immediately conduct a size-up by leaving the truck
and navigating around the entire fire site.

One of the key elements in Level 1 is the discovery of a
child in an upstairs window in the back side of the house.
A skipped or incomplete size-up will mean you'll miss the
potential victim.

Before you can begin assignments, you must file an Initial
Incident Report. (Is this a checklist you fill out, or
dialogue that is menu-driven?)

If the completed Incident Report shows you missed the
child, the B.C. will step in and notify you of the
oversight. The B.C. will coach you on other errors made in
the Incident Report.

Commanding the Firefight

Here are some of the assignments and decisions to make:

- Fire attack
- Rescue efforts
- Ventilation
- Victim search
- Overhaul and salvage
- Crowd control/Police management/Press management

Variables and Complications

- Wrong placement of hoses, ladders, etc.
- Roof
- A CO in your company becomes physically sick
 (stomach flu?)
- Toxic materials in garage
- Automobile(s) in garage?

FIGURE
17.2
(Continued)

- Automobiles blocking garage?
- Leadership challenge: "We know how to do it" is the attitude, rather than waiting for you to do size-up. Also, random audio chatter may challenge authority.
- Freelancing challenge: Company B CO starts child rescue, before being assigned.
- Other hazards

<u>Success</u>

The fire is put out, the family is safe and intact.

Level 2

<u>Core Simulation</u>

Fire site is a 2500 sq. foot, 2-story house with attached garage: terrain may pose some difficulties. Fire has started in the garage and entered the first floor of the house. Several people are on the 2nd floor (all in known locations?).

<u>Before the Call</u>

You'll need to decide whether to send the sick firefighter home (from Level 1). He'll make the case that he can still do the job.

<u>On the Way</u>

Your company and company B arrive nearly simultaneously. Companies C & D arrive shortly afterwards.

<u>Variables and Complications on Scene</u>

To be determined. All objectives should be tested.

<u>Success</u>

The fire is put out, the family is safe and intact.

The document walks through the game's short segments, from the user perspective. The "You Don't Know Jack" concept was removed fairly quickly, as it ultimately wasn't seen as one of the project's pillars (discussed in Chapter 16). Where possible, details about user actions and variables and complications challenging the user are indicated; the instructional design helped to populate these details. However, the concept treatment isn't afraid to ask questions where there are uncertainties.

The concept treatment, iterated through several drafts, created the necessary gameflow so that a feel for the entire game was possible.

A separate preliminary technical design document was also under way. Feedback between the technical and creative ends shaped development of each. Design moved forward rapidly.

Finalizing the Concept Document

Ideally, the third or tenth or twentieth revision and expansion of your concept document will achieve consensus buy-in. If you haven't already, you're now beginning to assemble a development team.

But before you commit 100% to the concept, you should take it out for a test drive. There are a variety of ways to do this, which we'll discuss in the next chapter. It's a lot easier (and cheaper) to validate the concept now than to build your application and then find out the concept is neat in theory but unworkable in practice.

Summary

- Concept documents are a first textual capture of the game and simulation concept, trying, in broad strokes, to convey both the game experience (from the user perspective) of the game as well as some of the key development features and expected ROI from the application.

- Early drafts of a concept document can be as short as a page, and different concepts might each get their own document, so all concepts can be evaluated and compared. As the concept document moves through a revision process, it should continue to gain more detail and specifics.

- Ideally, the concept document will serve as a vehicle for the merger of gameplay and game narrative, resulting in a coherent user experience that will transform the user upon completion (the user will have greater knowledge of a job function, a brand, product, or cause).

- Concept documents are useful tools for selling the project to investors, upper management, and potential development team members. You may find that you need to maintain a couple of different versions of concept documents to appeal to different kinds of readers.

- Before the concept gets a production green light, some testing is advised. The next chapter discusses concept testing methods.

Concept Testing and Refinement

Introduction

You've developed a strong instructional design, a solid game design and game narrative, and an overall concept and vision for the game. A concept document or preliminary design document has captured these elements. The next step is usually to gain final approval for that design and permission to move on to the next phase. This usually requires presentation to your clients. Clients, on the other hand, may ask you to test the concept on the target audience and bring proof of audience approval to your concept presentation.

There are a number of ways to present your concept, and they range all the way from a sit-down storytelling session, to sketches, to storyboards, to demos and prototypes.

In the case of military training simulations, we've seen people use video they shot at the National Training Center where the Army has a complete fictional Iraqi village. They role-play situations and in some sense do a dry run of the virtual simulation in the real world.

What are the differences in types of concept presentations, what are the benefits, and can you use these same techniques after concept testing and refinement in the game development process?

Concept Testing

In the following examples, we'll talk about presenting concepts to decision makers who can approve or kill your project. That situation is certainly the ultimate concept test. But the same steps are followed when testing the concept with members of the target audience or with focus groups that represent various demographics whose input is important to the success of your serious game (educators, subject matter experts, corporate executives, parents of the target audience, etc.).

We'll look at five types of concept tests, each of which has benefits and drawbacks. They range from the simple pitch to the development of a full-blown prototype. The costs vary widely, as do the talents of the people needed to make them work.

The Pitch

The pitch is a Hollywood movie technique that relies on the talents of the presenter to get the point across. A good storyteller is, after all, the most exciting of all presentation media. In Hollywood, one or more studio executives meet with the presenter or presenters in an office or conference room and listen to them tell the story of the game or movie (i.e., pitch the idea). The pitch person presents the concept as dramatically and as engagingly as possible without any graphics or other support media.

Rick Berman, one of the producers of the *Star Trek* series, presented the best pitch we ever saw. He was trying to sell us an entertainment website based on an entirely original concept. He began slowly, sitting at the table speaking in the soft, almost distracted voice of a great storyteller. As he spun his tale, his tone changed to one of concern, almost desperation. He played the parts of some of the characters. His descriptions of people and places and events were riveting. At the most dramatic moment, he jumped up and began to pace the floor, increasing the sense of urgency in what had become the description of an earth-shaking disaster. What a presentation!

It is the skill of the presenter that makes or breaks the pitch. The Hollywood pitch approach has spread outside the movie business, and today authors pitch books to publishers and game designers and producers pitch game ideas to executives. Of course, you have to know your audience and tailor the pitch to them. But if you have a charismatic team member who can dramatize the game without any support material and a corporate culture that is fascinated by personalities, as is Hollywood, you might consider this approach. Otherwise, you'll need to spend a little time and money on graphics.

Concept Boards

In this approach, used often by advertising agencies, the presentation is not actually storyboarded. That is, there isn't a single frame of art created for each key moment in the story; the presentation isn't laid out like a comic book.

Instead the most important moments of all, no more than four or five, are drawn up in elaborate art pieces that are presented by the same kind of talented presenter who did the pitch. But now it's the skill of the graphic artist that is also on display. This is an effective technique for presenting a concept to clients, and it works well with members of the target audience. (The television series *Mad Men* has dramatized this presentation technique several times.)

There is a question as to whether or not the boards have to reflect the art style of the final product. Current thinking is that they may not. The goal is to get across the concept—if the design of the characters and the background changes later, that's less important.

Our creative design contract on the *Spark Island* game required that we get concept approval from our target audience of Alaskan Native American children, leading us to fly up to Fairbanks, Alaska, the first week of February and present our work in the local school. Then we drove another hundred miles north to the native village of Minto, just below the Arctic Circle.

We used the concept pieces to describe the concept to the children (see an example of one such concept piece in Figure 18.1), and then we discussed it with them. One member of the team took notes on their reactions, while another presented the ideas. At the end of the sessions, we gave questionnaires to the students asking them their opinion of the ideas. We pinpointed some specific concerns we had and tried to clarify some expectations (e.g., we wanted to know whether or not the children liked games that featured kids their own age or animal characters who might represent them). The children loved the presentation and our concept boards. They gave us good feedback and expanded our ideas. To the surprise of some of the members of the team, they preferred games featuring kids their own age.

Paper-and-Pencil Concept Testing

Never underestimate the value of paper-and-pencil design and testing. It's cheap and flexible. In fact, 51% of surveyed commercial game developers still prefer paper-and-pencil prototyping tools, according to the May 2009 issue of *Game Developer* magazine. University of Southern California professor and game designer Tracy Fullerton (author of *Game Design Workshop*) argues that if you can't draw the game on a piece of paper, you're already in trouble.

One of the applications we developed for LeapFrog was a game package consisting of a series of minigames. We concept-tested a couple of dozen minigames using paper-and-pencil versions. This allowed us to give executives and marketers a means to have a direct influence on the design before we made our final decisions and began coding.

One bonus in paper-and-pencil testing is that no matter how clever and appropriate a design, executives and clients will always want to make changes in order to exercise input. Their involvement in these early stages allows them to contribute before code is written and changes become costly.

Demos

We recently produced a pair of demos for Virtual Mindworks, a company that produced interactive assessment systems that could be applied to dating or corporate

FIGURE
18.1

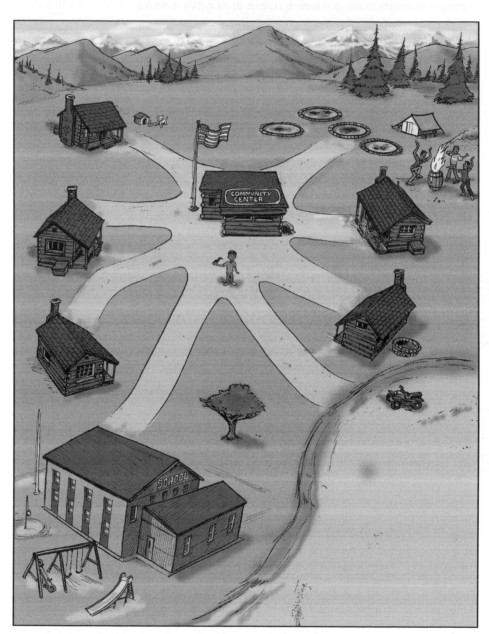

One concept board used to present the initial *Spark Island* concept to Alaskan Native grade-school students. ©2007, Compelling Technologies, all rights reserved. Used with permission.

FIGURE
18.2

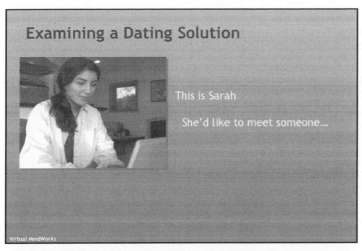

Frame from a demo version of the Virtual MindWork's Dating System prepared in PowerPoint with embedded audio, animation, and special effects. ©2008, Virtual Mindworks Corporation. Used with permission.

personnel applications. We faced some serious questions as to whether we should develop a full-blown working prototype or a demo. (See our discussion of this issue in Chapter 4.)

Virtual Mindworks wanted a highly workable demo, one that a presenter could take into a client or investor and use as a proof of concept and that would actually show most of a fully working module. (See the example in Figure 18.2.) Even though we were only producing a proof of concept, they wanted it to have a fully functional interface, Internet streaming video, and an audio help system that worked at all the appropriate places. The proof of concept had to have simulated exercises that took participant input and stored it. You could say that it was a full-blown prototype. But it wasn't. It had holes in it (paths and places that went nowhere). An experienced presenter had to operate the demo or some strange things would start to happen. There were exercises but no scoring and no tabulation. There were extra navigational features that would not be in the final product but in this case would allow demonstrators to shortcut certain segments if they wanted to. The demo had no functional back end that applied the science and physics that Virtual Mindworks was promoting. It was beautiful, and it worked on the surface, but it was really smoke and mirrors.

Nevertheless, it's important to know that smoke and mirrors are okay in demos when you're testing *concepts*. Our demo was never intended to represent the fully working system.

The demo can rely on smoke and mirrors because it doesn't have to work in the hands of a novice user. Consequently, you can build a demo in PowerPoint and take advantage of that software's animation and video/audio presentation

features. Alternatively, you can build your demo in Adobe Flex or Flash—Microsoft Silverlight—and stream content from the Internet. You can even build your demo with a game engine and have it approximate all the features that the game will have.

The line between demo and proof of concept is sometimes blurry (like the line between concept documents and design documents). Demos are intended to show more of the totality of the game and the game experience, while giving just a glimpse of functionality. Proofs of concept typically focus on core game technologies and may be pretty rough around the edges when it comes to the interface and look and feel. Ideally, the proof of concept should be a starting point for the full version, and the underlying software architecture should be close to finalized (pending approval). Anything less and we're probably peddling a demo more than a true proof of concept.

Neither a demo nor a proof of concept can be considered a prototype. As noted, prototypes cost much more than demos to develop and produce. In our experience, prototypes generally don't make the concept much clearer to the client and the target audience; consequently, they rarely justify the escalations of cost they entail. For initial concept testing, demos generally do the job well enough.

Prototypes

A prototype will bring the game to a working phase. It may be a complete level of the game, or it may be a miniversion of the game with all core technologies and the user interface in place.

Naturally, prototypes go a long way toward getting you to the actual application. But they're high risk: if the project dies at the finance stage, someone will have spent a lot of money and/or energy for nothing.

Despite our cautions, some situations require the production of a prototype:

- When you actually have to show the game working

- When your clients *insist* on actually playing part of the game

- When grant funding or venture captial funding requires prototype delivery (see the box)

- When you want to illustrate a feature that no one can grasp unless he or she can actually see it working

- When developmental testing is required (because of contractual obligations or cutting-edge technology uses)

Developmental Testing and Refinement

Developmental testing refers to the process of testing the game as it's being developed: finding out which aspects of it work and which ones don't; figuring out how

to make every little thing better; and, of course, finding bugs that crash the system, make the user's avatar bump into an invisible wall, or take him or her to some totally undesired outcome. In most established game companies, developmental testing is part of a lengthy process that begins once the concept is approved. It leads to the much more rigorous alpha and beta tests and the whole process of quality assurance, which is often done by a whole separate department or team (all to be discussed in Chapter 25).

Our developmental testing almost always begins with the building of a prototype, once there's agreement on the project goals and concepts (and assuming adequate time is found in the schedule). This can often be one level of the game or one chapter of a story simulation. In the *Leaders* application, we built out the second chapter of the simulation as a prototype. Next we tested it on clients and select members of the target population. We then refined it and then redid it completely in the final version.

As you usually hope with a prototype, a great deal of programming code could be reused. We also got a clear picture of the game mechanics, the look of the virtual world we were building, and the performance of the avatar and nonplayer-characters (NPCs).

Sometimes developers build an *interaction prototype*. This type of prototype tests if the interface and interaction styles are satisfactory. Ideally, the interaction prototype will save substantial development time later on. In games, this is where a designer figures out how many mouse clicks are optimum to achieve a certain goal, whether the navigation tools are adequate, and so on.

Paving the Way to Completion and Distribution

Sometimes prototypes are funded by grants or other funding mechanisms with the hope that the prototype will attract further funding so that the game may be completed and then distributed.

Such is the case with *Budget Hero*, developed by the Woodrow Wilson International Center for Scholars, under the direction of David Rejeski (then the center's director of the Foresight and Governance Project). *Budget Hero* aims to educate players about the U.S. federal budget, involving them in setting budget priorities and pursuing policies that will raise revenues, cut taxes, and change fiscal policies. (See our brief discussion in Chapter 11.)

In 2006, the Wilson Center secured an initial grant of $60,000 for development of a working game prototype. After initial conceptualization, game developers 360Kids were brought on board to collaborate on design and build the

(*Continued*)

221

prototype for a browser-based game. Development took four to five months, resulting in a solid prototype that could be shown to potential distribution channel representatives.

Fortuitously, Minnesota Public Radio (who produces the popular American Radio Network show about economics and finance called *Marketplace*) was looking for new forms of journalism to fill out its online content. A serious game educating users about the U.S. federal budget fit the bill, and more than a year after the prototype was built, it paved the way for further fundraising, project completion, and distribution. *Budget Hero* went on to become a successful application, as described further in Chapter 26.

Prototypes are hardly guaranteed to attract distribution and funding, but if it's possible to secure initial funding for a prototype, this can beat working on spec to build demos and proofs of concept.

Prototype Testing

The best way to get a clear picture of the developmental testing process is to consider how it is done in a major game company. The strict quality assurance (QA) processes of a national brand that feels a great responsibility to the public can serve as an excellent model for the way that serious game developers large and small should conduct their testing.

In the projects we did for one of our major clients, we built prototypes of many game ideas and then play-tested the prototypes ourselves to see how much fun they were. For a game package that would be a bundle of minigames, we wanted to compare the playability of each proposed minigame within the package. We also wanted to explore the degree of difficulty of the engineering behind each concept. The package had a tight deadline, and most of the concepts were new and untried, so it was important to see if our engineers thought that they could develop the games within the available time frame.

Games were eliminated for poor gameplay, lack of concept clarity, because our target group testers did not especially care for them, or because engineering thought that it would take too long to develop them. As we play-tested the prototypes, we also uncovered new and better features for the games that we wanted to keep. In the end, we planned to enhance the basic engines that we developed for the prototypes and use them to create the final versions of the games.

Our prototype testers consisted first of the members of the development team and management; we also brought in and paid freelance testers to help with the developmental testing, and on several occasions we carted prototypes of the game to the local junior high school where we found a class whose teacher was willing to give us a series of study hall sessions over a period of weeks so that we could test

our prototypes as they evolved. The students, of course, really enjoyed being part of the creative process.

For those games that required the involvement of subject matter experts (SMEs) for content development, we went back to the SMEs periodically to verify that they felt their experience and knowledge had been expressed in the prototype.

The creation of the prototype is often a milestone point in the development of a game and a buyoff point for the client. It is then that the client can decide whether or not to continue funding the project. For this reason, there are many kinds of prototypes that serve different purposes:

- Rapid prototypes are used for early developmental testing, and if someone insists that a prototype be used in concept testing, it is almost always a rapid prototype.

- Later, as the testing continues, more polished prototypes are developed.

- Late-stage prototypes are the ones you want to submit for client approval.

From this point on, you stop building prototypes and start creating the product itself. Developmental testing continues. Game developers continue to look for ideas and features that do not work and so can be eliminated from the application to save time and money and perhaps be traded for more desirable features identified during the prototype testing.

Summary

- Concepts are tested with members of the target population. They're also tested on executives and decision makers, whether from within your organization or from the client's organization, often in presentations that determine whether your concepts will be included in the game. But concepts can be tested in a variety of ways.

- *The pitch* is a tried-and-true approach and can be most effective if you have someone who is an exciting and enthusiastic presenter. (In fact, the best medium for any concept test is often a talented presenter.)

- *Concept boards* can be a great method for presenting the concept to members of the target population and decision makers, particularly when your audience may be more attuned to visual appeals or when your visuals are the strongest aspect of your concept.

- *Demos* are mockups of the application that give some sense of the gameplay and may even show some working parts of the game, but they're generally not meant to be played by the target audience or by decision makers. Demos are driven by a presenter who is aware of both the limitations of the demo and the ways to show off the application at its best. A *proof of concept* is a related form of demo that may be somewhat less polished visually but will contain a true buildout of core technologies.

223

- *Prototypes* are working versions of part of the game, and users can play them. They contain not only the interface and other parts of the front end of the game, but they include some of the back-end software as well. Generally, prototypes are not needed for concept testing. They are, however, needed for developmental testing.

- As the game is developed, people play it, determine how playable it is, determine how hard it will be to build, and check out features that may or may not be worth inclusion in the final product. Ideally the prototype begins to turn into the actual game build, and some of the code that has been created in the prototype may be used in the actual game.

SECTION FOUR

GAME DESIGN

The Technical Side

With the concept ratified by testing, we can now finalize selection of our delivery platform (the operating system and device combination we'll be publishing on) and our development tools and development platform (the operating system and device combination we'll be using while authoring our application). Because of the multiplicity of potential delivery platforms, we should make a careful study of our target users, as well as the demands of the application itself.

Once the delivery and development platforms and game engine and middleware have been selected, a detailed design document should be authored and continually iterated. The design document will be the road map for the upcoming marathon that's production and authoring.

CHAPTER NINETEEN

Development and Delivery Platforms

Introduction

A platform is the device-and-operating system combination that our application will run on. Often, devices will be married to specific operating systems: consoles and cell phones are two examples. Other times, a device may host one of several different operating systems: non-Mac desktop PCs are the best example.

Delivering to multiple platforms is often difficult and, at the very least, is more work (and cost) than delivering to a single platform.

Applications may be developed on one platform for delivery on another. This is typically the case for mobile applications, if for no other reason than it's easier on the eyes. (Desktop/laptop platforms will also be far more robust and responsive when coding, authoring, and testing applications.)

Why Are We Waiting So Long to Choose a Platform?

Proposals for trade industry books (like this one) usually receive peer review. One of the game industry professionals reviewing this book's proposal stated, "I'm shocked that the authors would advocate document generation before determining the game platform and tools. That determination *always* comes beforehand." Sadly, this *is* a common belief—and a completely wrong-headed one.

All too often, the development and delivery platform(s), game engine, and even authoring tools are selected before the game's producers and designers know what type of project they're trying to create.

Seat-of-the-pants decisions are often made ("everyone's got a personal computer, so we'll put the game on the computer"), with no examination of the available options or what might be best for the user.

You may be in this situation right now. Your CEO may be saying, "We need a training game that looks like *Grand Theft Auto*." Or your client may have seen

The Sims or *Second Life* and decided this is the look and feel she wants for a promotional game. Or the game designer you've hired may be telling you to produce the project in Flash. The desire to make a serious game or simulation "sexy" or "easy to make" will often outweigh the actual goals of the project.

Environments emphasizing navigation or elaborate terrain may be selected, and yet the finished project will scarcely allow the user to move around. A game engine more suitable for designing a role-playing game is selected, but few of the role-playing features are used in the finished project. Online delivery is chosen, only to discover halfway through development that the targeted users won't have reliable broadband access or that security restrictions and content blockers sabotage the Internet connection. A game engine may only accept animations in a restricted set of formats, limiting the tools that artists can use.

Instructional (or market/promotional) analysis, design, and appropriate gameplay activities all need to precede the selection of platform and tools. Obviously, teaching/persuasion points, gameplay, and game design can (and will) continue to evolve after these crucial decisions are made. But the premature selection of delivery platform and design and programming tools can create several problems:

- *Content restriction.* If we select a real-time 3D environment (such as in *Halo* or *Half-Life*), we'll begin to focus activities and teaching points around navigation and reflex control. But we may find that the points we want to teach or the behaviors we want to modify have little to do with either of these. Similarly, a real-time strategy engine may force more of a top-down terrain view for our content and teaching points, which may be entirely inappropriate to the learning content we wish to impart (careful navigation and trigger reflexes may be what we need). As an old cliché goes: to a carpenter with a hammer, everything looks like a nail (even if it might be a lightbulb).

- *Budget busting and schedule issues.* Sophisticated 3D animation and 3D game design require highly skilled contract personnel and substantial development time. Licensing or purchase fees for software tools and software development kits (SDKs) can also be expensive. Other platforms and tools may actually be more appropriate (reducing development time and salaries), and open source software can further reduce costs. Conversely, choosing the wrong platform and cheaper tools may be decisions to backtrack on partway through development, creating cost overruns and schedule delays. Yes, we can kill a fly with a sledgehammer— but the sledgehammer might cost $60 and create collateral damage, whereas a $2 fly swatter will do the job even better.

- *Inefficient use of personnel.* You may have either in-house personnel or contract personnel with experience using certain software, yet the impulsive choice of the wrong platform or engine may require additional training, and a ramp-up time for getting comfortable with the new tools. Cost overruns and schedule delays will again result.

- *Ineffective or incomplete assessments.* The game engine may make it difficult to hook into custom statistics tools, backend analytics tools may do a poor job collecting or evaluating user actions, or the platform may fail in transmitting user performance or trends to the game's clients. Any one of these issues may negate much of the project's purpose.

- *Derailment in distribution.* You may build for online delivery, only to find out that your target organization has just installed new content blockers that will prevent your application from running. (The organization may have assured you that Internet access was "no problem.")

Key Questions

But if you've (1) followed the general approach that this book has put forth and (2) developed the needed learning objectives and general game activities that will model the teaching/persuasive points and assess progress, then you should be ready to begin making decisions about development and delivery platforms, which in turn will lead to decisions about essential game development tools.

The delivery platform will control the types of user environments, interfaces, delivery expectations, and assessment data collection in your project. Delivery platforms have different user demographics and will have an impact on your budget when it comes to (1) development and production and (2) distribution.

So what are some of the key questions you need to ask at this point?

How important is realistic 3D user navigation and visualization to the training or persuasion you want to impart? If it's really important, then you're probably going to need a real-time 3D environment (and a real-time 3D game engine). But be sure the 3D navigation is critical and not merely window dressing. Real-time 3D environments and the 3D assets they require are relatively expensive to create and can add weeks or months to your schedule; in addition, the distribution of content requires that users either receive a disk or download substantial data to store on their local systems.

How important is situational awareness to the training or persuasion you want to impart? If situational awareness is a critical component of your learning objectives, you're probably going to need a real-time 3D environment. But don't assume this. Analyze what you've identified as "situational awareness." It may be that the situational awareness you're modeling is based primarily on incoming audio, Google Maps, and a constant stream of short messaging service (SMS) text messages. In this instance, a 3D environment will be superfluous.

Are you focusing on strategic decision making, or are tactical decisions more important? Strategic decision making may focus on quick assimilation of audio, text (blogs, wikis, emails, etc.), satellite imagery, and survey data—all forms of 2D information that can be delivered by Web 2.0 technologies and sent to an iPhone.

Tactical decision making will tend to argue for 3D environments, but this should be analyzed rather than assumed.

Should your training environment include nonplayer characters (NPCs)? How many do you typically need within (1) an interactive sequence and (2) a linear "cut scene"? How realistic do they need to be? Game engines vary in how robustly they can handle NPCs, and even if a cut scene (a non-interactive cinematic sequence; see chapter 22) is being created, there may be a limit to how many NPCs can be placed within a scene. If you do need NPCs, you'll have to decide how much realism they'll require, as this decision could make the difference between your using a 2D or 3D environment.

What assessment tools will you need? How frequently will assessments be made? Is persistent or periodic Internet access necessary for assessing user progress and success? Your assessment needs may easily drive your choice of platform, game engine, middleware, and other game authoring tools. If your assessment and evaluations require Internet access (for anything from lookup tables to transmission of results), you'll need to factor this into your decisions about platforms and tools.

How important is Internet access for gameplay or modeling? How much bandwidth do you need? Do you need persistent (i.e., always on) Internet access, or is occasional Internet access all you need? Delivery platforms all have their strengths and weaknesses in connecting with and rendering Internet data and in the robustness of their upload and download speeds. Some game engines do well in incorporating Internet data; others don't. Some are now built from the ground up to work within a browser or media player, and if Internet delivery to the user is critical, this may dictate your selection of tools.

What kind of Internet access will your typical user have? Having sifted through the preceding questions, you may have decided that Internet access is critical for your game. But we are still a few years out from ubiquitous "cloud computing" (wireless Internet available everywhere). Therefore, you can't assume your typical user will have Internet access while using your game or simulation. In addition, even if you know your user has persistent Internet access, you shouldn't make assumptions about access and ease of use. Military and educational sites, for example, frequently employ content blockers and content filters, creating a virtual moat around their computer systems.

What kind of digital equipment will your typical user have? Similarly, you'll need to be certain of the digital technology your typical user will have. For example, you may wish to build a game designed for iPhones, but if the majority of your users use BlackBerries, you're going to have a problem. Although your client may tell you that user systems have certain minimum specifications, you may find out that the reality falls far short. Consequently, you may need to conduct a survey to evaluate or verify available user technology and then make platform and tool determinations based at least partially on these data.

Do you have a preferred distribution channel? Will it work well for your typical user? Physical media (CD-ROMs, DVDs, or flash drives) can be expensive to distribute, and users often lose or damage media. If using physical media, you'll have to decide if mail is the best delivery method or if distribution at trade shows or site visits makes more sense. Distribution via website, FTP site, or online app store is clearly cheaper but may restrict the platforms you can select and the environments you can build. Organizations frequently frown on Internet downloads, and no-download browser-based environments further narrow what you can build. Content blockers and lack of administrative privileges can hamper users when they try to interact with online apps. In sum, you'll need to make sure that your distribution channel works for your users. If you're distributing a CD-ROM to mobile users who don't have a CD-ROM drive in their netbooks or handhelds, you've got a problem. And if you're distributing an online, browser-based game, you'd better make sure your users have always-on Internet access.

Where is your user? Will he or she be using the product at the workplace? In the home? On the road? Will he or she need access in multiple locations (both the workplace and the home, or in different cities)? Will there be use internationally or just domestically?

What is your user profile? The age, gender, income level, and hierarchical position of the typical user should influence your decision about a platform, as well as how you expect the game to be used. Is the typical user familiar with the device and platform? Is the user OK with downloading large installation files or installing browser plug-ins? Will the user feel comfortable learning the game? Will your user be eager to embrace the game, or will you have a reluctant user who may be lured by the physical packaging and may respect the application more when it's tangible (i.e., a CD-ROM)?

How do you envision the game experience for your users? If it's to be a single-user game, will the user be isolated from other users when using the game, or will the user be in a room with other users? If it's the latter, is there a concern that the user could appear "stupid" or "clumsy" in front of other users, and how big a problem is this? (Upper management, in particular, is not likely to be comfortable in this sort of situation; older users may also feel uncomfortable.)

If you're undertaking the development in-house, what is your current development "shop" platform? If you select the Xbox as your distribution platform, you'll have problems developing for it if you're a Mac shop. If you select the iPhone for your project, you'll need Macs, not Windows PCs.

What is your budget? Having decided on a highly sophisticated 3D virtual world environment that will offer many hours of gameplay (probably meaning huge numbers of assets, animations, and levels to build), you may find that your budget is completely inadequate to the task. Although budgets are usually somewhat malleable, you need to make sure that your platform and tool determinations match up with the realities of your budget. You don't want to run out of money

231

halfway through your project (this won't impress your CEO). You may discover that your vision is *Halo*, while your budget is a 2D browser-based Flash game.

Platform Pros and Cons

We could easily write a book discussing the benefits and drawbacks of game and simulation platforms. But let's take a quick look at some of the currently available delivery platforms, as well as some of their pros and cons. As noted, we may be able to develop on one platform for delivery and distribution on another platform. We'll note these instances.

Personal Computers

Personal computers—Macs, Linux systems, and Windows PCs, desktops, and laptops—are widely found both in the workplace and in the home. They offer an expansive palette of development platforms and environments, and their ubiquity results in (1) a substantial pool of programmers, artists, and other production personnel and (2) greater budget latitude, which means we can more easily scale projects to the platform.

This is not to say that there aren't specific disadvantages to developing for personal computers. Often these platforms require user interaction in installing applications. Users may need to make decisions about software drivers, browser plug-ins, system files, and even connected devices. Most users would prefer not to make those decisions, and some users will make bad decisions. The freedom provided by personal computers comes with a price: operating systems crash, become infected by viruses, and their administrative privileges and security settings are unpredictable.

In addition, the graphics capabilities of laptops and desktops are very different. Desktop computer graphic systems can usually be upgraded. CPUs are faster and graphics accelerators are easy to install. Consequently, high-end 3D simulations may run differently on laptops and desktops. So selecting a personal computer platform is not the no-brainer it might first appear to be.

Let's take a closer look at the major personal computer platforms, as well as their pros and cons for application development.

Windows-Based PCs

Pros

- As of mid-2009, Hitslink reported that more than 85% of personal computers around the world run Windows. In addition, approximately 75% of Americans have used Windows.[1] Not surprisingly, Windows is the most popular operating

[1] Extrapolated from Parks Associates' 2008 study of Americans' email and application usage.

system in the world; thus, the odds are good that a targeted user is familiar with the platform.

- PCs have nearly limitless program and file storage, and the graphics hardware and software subsystems allow for delivery of every kind of visual environment (2D, 3D, full-motion video, high-resolution text, etc.).

- Various user input devices are available, increasing the ways we can have the user interact with the system. Aside from the usual pointing and keyboard devices, the user can touch, speak, scan, or send video.

- Development software is usually relatively inexpensive (and can even be free, when open source software is used).

- Windows' long market domination and massive deployment means that skilled programmers, artists, and other production professionals are usually available, and you won't need to pay a scarcity surcharge for their services.

- Distribution can be either physical (CD-ROM, flash drive, etc.) or virtual (via Internet download).

- Windows can serve as the foundation for a browser-based platform (discussed later).

- Even if it's not the distribution platform, Windows can serve as a development platform for many game console and mobile devices.

Cons

- Media software often has to be installed. These installations can create memory and program conflicts, discouraging users from deploying your project. In addition, software and plug-in installation often requires administrative privileges, which users in large organizations usually don't have.

- The open nature of Windows PC systems can make project design difficult, because user systems (both hardware and software) can vary so radically. Programming for one system (e.g., Xbox or PlayStation) is difficult enough; programming for a hundred different "flavors" is even harder.

- Handheld portability is a significant problem, despite the existence for a number of years of handheld Windows personal digital assistants (PDAs) (which have achieved relatively little penetration either at home or in the workplace and which have now been superseded by smart phones).

Platform Summary

Clearly, the availability and familiarity of Windows-based PCs makes this a hard platform to ignore when conceptualizing a project. But we shouldn't merely assume that this is the right platform for our project. If mobility is critical, if children are our primary user demographic, if our demographic is a workforce used to using

233

Macs, or if we are envisioning a casual user demographic who doesn't want to (or can't) fuss with installations or physical media, then the Windows-based PC platform may well be the wrong choice. The bottom line is that we should know why we're choosing the Windows platform rather than assuming we must choose it.

Macs

Pros

- The platform is easy to use. When software installations are necessary, they usually are done without user intervention.

- Macs have nearly limitless program and file storage, and the graphics hardware and software subsystems allow for delivery of every kind of visual environment (2D, 3D, full-motion video, high-resolution text, etc.).

- Various user input devices are available, increasing the ways we can have the user interact with the system. Aside from the usual pointing and keyboard devices, the user can touch, speak, scan, or send video.

- Distribution can be either physical (CD-ROM, flash drive, etc.) or virtual (via Internet download).

- The Mac operating system (OS) can serve as the foundation for a browser-based platform (discussed later).

- The Mac OS can host a Windows emulator if necessary for development.

Cons

- Though slowly changing, the installed base for Macs is still relatively small. According to Hitslink, only 9% to 10% of personal computers are Macs; the percentage of Macs in the workplace would be even less. Only specific user demographics can be relied on to have access to a Mac.

- Software development tools can be expensive. Relatively few open source tools are available.

- Although Windows emulation is possible on the Mac, heavy-duty Windows development applications may still resist usage in an emulation mode (either crashing or running sluggishly). Relatively few Mac users also run Windows emulation.

- Programming talent will tend to be more expensive, because the market skews so heavily toward Windows.

Platform Summary

The Mac is certainly an exciting platform to launch a project for, because of its ease of use for every demographic. However, without a specific targeting of the user

demographic, the chances are too great that the Mac will be the wrong platform for a majority of users. A way around this is through the development of a browser-based project, which makes the computer OS irrelevant. Porting a Mac app to Windows is often challenging; in some instances, a better approach may be developing a Windows application that could then be run on a Mac running Windows emulation (but as noted, few users have this option).

Linux-Based PCs

Pros

- The software is almost all open source, and most of it is free to license.
- Linux can usually be booted from external media, somewhat increasing its availability to users (e.g., a user could have a Windows system but be given a flash drive to run a Linux-based serious game).

Cons

- As an installed base, the platform is too small and specialized. According to Hitslink, only 1% of personal computers use a Linux OS. Except in rare circumstances (developing a project for an all-Linux organization), this probably excludes a project for this platform.
- There are relatively few Linux-proficient programmers, compared to Windows-proficient programmers.

Platform Summary

Except in rare circumstances, Linux is not a likely platform for a serious game or simulation. However, Linux systems can certainly host browser-based applications, and as we'll discuss further in Chapter 20, Linux may work well as a development platform even if it's not the distribution platform.

Game Consoles

Clearly, the wide availability of game consoles makes these attractive platforms to develop for. Nearly 50% of U.S. homes hosts one or more consoles, and a majority of the population under 50 has used a console controller and is at least casually familiar with the platform. Approximately 5 million to 7 million consoles are now connected online in the United States, and this number is growing quickly.

In addition, game consoles negate the need for any kind of software, file, or driver installation, a huge advantage in getting users to start up the game and feel positive about the experience. The large user base comfortable with the platform further increases the chances for success.

But there are potential drawbacks to consider:

- Most game consoles reside in the home rather than in the workplace. Exceptions exist, of course: there could be some workplaces where game consoles are typically found (perhaps environments where on-call users both live and work for awhile, like firehouses, hospitals, offshore oil operations, remote research sites, military bases, etc.). But the general lack of game consoles in the workplace may prevent them from being selected as platforms.

- We can't realistically consider these platforms to be portable. So if mobility is part of our user profile, the game console will need to be ruled out. (Handheld game console platforms exist, and we'll discuss them later this chapter.)

- Though the average age of the game console user continues to rise (according to a 2008 Nielsen Media study, 15% of Wii and PlayStation male users were over 35, and 30% of female users were over 35), older users are usually less familiar with console interface and screen grammar (they may have briefly used a game console while playing with a child or grandchild, but they aren't comfortable with usage in the way they are with Microsoft Word, Excel, or Windows Solitaire).

- Game console programming is difficult, and highly skilled artists and designers are required to create good 3D graphics. Consequently, development and production are expensive because of (1) the high demand for relatively scarce high-caliber personnel and (2) the timelines needed to create, refine, and debug the game. In addition, console game development generally requires purchase of software development kits (SDKs) and other costly software packages.

- Game console media can easily be misplaced, especially in a home environment.

- Although digital distribution is becoming increasingly prevalent for consoles, many consoles remain unconnected to the Internet and developer networks.

Let's take a closer look at the pros and cons of the major game consoles' platforms.

PlayStation

Pros

- According to Sony, more than 50 million PlayStation 2s and some 7 million PlayStation 3s were sold in North America through mid-2009. That's quite an installed base and quite a lot of users who are comfortable with the platform.

- Tremendous 3D graphics, enabling realistic environments and actions. The PlayStation can easily deliver 2D and 3D graphics, along with full-motion video.

- There is no need for software, file, or driver installation.

- Internet connectivity is available via the PlayStation Network and the PlayStation Store. This means a serious game or simulation can be distributed digitally and updated with additional content, and user assessment data can be sent back to the developer.

- Wireless connectivity is possible with the PlayStation Portable (PSP) (PlayStation 3 only).

- The platform is good with multiplayer and local network applications.

- Development can be done on Windows, Linux, and Mac systems, with integrated development environments (IDEs) available on all three platforms.

- Sony has released a graphics engine, PhyreEngine, for free, and a debug PS3 can be purchased for only $1200.

Cons

- Most PlayStations are found in the home, rather than the workplace.

- Many PlayStations lack Internet connectivity.

- A majority of North American households don't have a PlayStation.

- Projects containing many text, spreadsheet, or form elements are probably inappropriate for the PlayStation, which has been optimized for graphics delivery rather than portable document format (PDF)–like resolution.

- Development software is expensive. Sony's PlayStation 3 SDK runs $10,000. The PlayStation 2 SDK isn't a whole lot less. Physics packages as well as graphics and game engines can also have significant costs.

- Art and programming development (i.e., skilled labor costs) can be expensive, given the complexity of building 3D objects, environments, and interactions.

- Distribution is likely to require physical media, although an Internet download is possible (the problem is that Internet-connected PlayStations remain a minority of the user base).

- As of mid-2009, there was still a relatively small track record of serious games being developed for either the PlayStation 2 or 3.

Platform Summary

Although the PlayStation is attractive because of the sophistication of its console platform, few projects are likely to be suitable for it. Our project would need to be for home use only, and we'd still need to determine that the vast majority of our targeted users had access to the console. This might make the most sense for projects intended for home use by children or teenagers.

Xbox

Pros

- More than 15 million Xboxes were sold in the United States through mid-2009.[2] As with the PlayStation, that's quite an installed base and quite a lot of users who are comfortable with the platform.
- The platform offers tremendous 3D graphics, enabling realistic environments and actions. The Xbox can easily deliver 2D and 3D graphics, along with full-motion video.
- There is no need for software, file, or driver installation.
- Internet connectivity is available, thanks to Xbox Live Arcade (XBLA) and Xbox Live Indie Games. This makes it possible to digitally distribute and update content and relay user assessment data back to the developer.
- It is good with multiplayer and local network applications.
- Xbox development can be done virtually exclusively on Windows-based PCs, and programming environments like Microsoft's XNA make porting between the Xbox and Windows trivial. This can reduce software development costs and fees substantially, making the Xbox a cost-effective platform to develop for. In addition, Microsoft has extremely favorable terms on its development tools for educational institutions.

Cons

- The vast majority of Xboxes are found in the home rather than the workplace.
- A majority of North American households don't have an Xbox.
- Many North American Xbox owners don't use the Internet connectivity features. Consequently, distribution may require physical media.
- Xbox development is limited on Linux and Mac systems.
- As of mid-2009, there was still relatively little track record of serious games being developed for the Xbox.

Platform Summary

Although it shares many of the PlayStation's negatives, the Xbox may be a more attractive platform to develop for. In particular, the Xbox may be a good *second* platform to target, as Windows PC development can often be ported to the Xbox relatively easily. Good planning may allow you to target Windows and Xbox development simultaneously (for relatively little extra cost and human resources), further expanding your potential distribution and user demographic.

[2] All U.S. sales figures for game consoles in this chapter are based on the NPD Group's 2008 U.S. console sales data report, with mid-2009 unit sales extrapolated from the 2008 report.

Nintendo Wii

Pros

- Approximately 20 million Wiis have been sold in the United States as of mid-2009, and the installed Wii base continues to be the most rapidly growing in the market. (In 2007, Merrill Lynch forecast that one-third of U.S. homes would have a Wii by 2011.) Again, that's quite an installed base and quite a lot of users who are comfortable with the platform.

- The Wii offers a unique user input system, allowing for much greater physical interaction between the user and the software.

- There is no need for software, file, or driver installation.

- Internet connectivity is available, thanks to the WiiConnect24 service and Nintendo Wi-Fi.

- It can connect wirelessly to the Nintendo DS, a handheld game console.

- The Wii SDK is less expensive than the PlayStation SDK.

- Wii games can be developed on both Windows and Mac.

- Paradoxically, the graphics and memory limitations the Wii possesses (relative to the PlayStation and Xbox) may be a plus, because users don't necessarily have the same high expectations for quality graphics that they do for the other major game consoles.

- The Wii excels at multiplayer interaction and is solidly established as a platform for more casual gamers. Nielsen Media found that women over 35 comprised a third of the Wii's female users and that men over 35 were far more likely to play the Wii than the Xbox.

Cons

- The vast majority of Wiis are found in the home rather than the workplace.

- Despite the rapid market penetration, the majority of North American homes do not contain a Wii.

- Projects containing many text, spreadsheet, or form elements are probably inappropriate for the Wii, which has been optimized for graphics delivery rather than PDF-like resolution.

- Distribution through WiiWare requires that Nintendo accept you as a developer; the Wii SDK will cost around $2000, and other development hardware costs may be necessary.

- As of mid-2009, there was still relatively little track record of serious games being developed for the Wii.

239

FIGURE
19.1

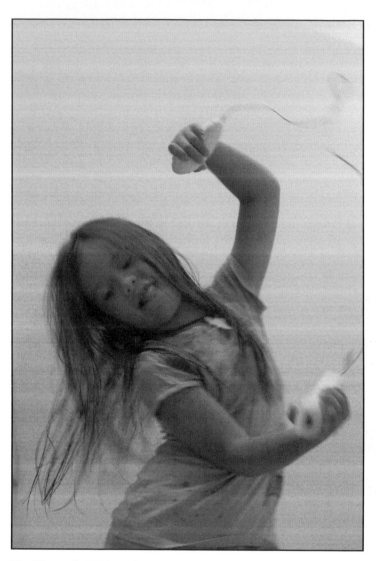

The Nintendo Wii in action, with its unique controller. ©2009, Photos by Tony, used with permission.

Platform Summary

Because of its innovations in user input and its somewhat lower programming costs relative to other game consoles, the Wii opens up the possibility of some interesting applications, including simulations and exergames/fitness games. (See Figure 19.1.) However, the Wii (like other game consoles) is probably still limited to home-based projects.

Handheld Game Consoles

The two significant portable game consoles in North America and Europe are the Nintendo DS and the Sony PSP (PlayStation Portable). Let's take a closer look at the pros and cons of these two handheld consoles.

Nintendo DS

Pros

- Approximately 30 million DS units have been sold in the United States. That's quite an installed base and quite a lot of users who are comfortable with the platform.
- The device is portable.
- It has stylus-driven user input. This can be useful for certain kinds of cognitive trainers, as well as any application requiring ongoing mobile user input (a game or simulation designed to train delivery truck drivers, e.g.).
- There is no need for software, file, or driver installation.
- Internet connectivity is available via the Nintendo Wi-Fi service, which enables digital distribution, content updates, and the return of user assessment data.
- Connectivity with other external devices like pedometers is possible.
- Wireless connectivity with the Wii is possible.
- Users don't have the expectations for high-quality graphics that they do for nonportable game consoles, and this is likely to reduce development costs.

Cons

- At the end of 2007, 80% of DS owners were under 16, according to market analysts Wedbush Morgan. Although the percentage of adult DS owners has undoubtedly increased, adults are still unlikely to personally own a DS.
- The small screen real estate limits visuals.
- Some applications resist stylus-driven input.
- DS media cards (for application distribution) are easily lost because of their small size.

Platform Summary

The DS opens up the possibility for some interesting applications, especially in simulating user input in more proprietary portable data collection devices. In addition, the DS has already seen success with commercial edutainment titles like *Personal Trainer: Math* and *English Trainer*, along with an entire subgenre known as

brain games. Applications for patient rehabilitation, diet and medical support, and fitness have all been developed. However, it's unlikely that most adult users in your demographic can be counted on to own the DS (although the device is inexpensive enough that it could be distributed to desired users).

Sony PlayStation Portable (PSP)

Pros

- As of mid-2009, more than 16 million PSPs have been sold in the United States. That's quite an installed base and quite a lot of users who are comfortable with the platform.

- The device is portable.

- It easily displays full-motion video and real-time 3D graphics.

- Internet connectivity is available. The PSP has access to the PlayStation Store and the PlayStation Network. This enables digital distribution and updates to content, and user assessment data can be relayed back to the developer.

- It offers wireless connectivity with the PlayStation 3.

- PSP features continue to be added. The PSP can now function as a global positioning system (GPS) device and can wirelessly pick up displays from any Sony media system.

- Users don't have the expectations for high-quality graphics that they do for nonportable game consoles, and this is likely to reduce development costs.

- PlayStation games can be ported to the PSP more easily than to other consoles.

- In mid-2009, Sony cut the cost of PSP development tools to $1500 in order to further applications for the system.

- Development for the PSP can be done most effectively on Linux and Windows. Mac development tools lag behind.

Cons

- Sony originally targeted young professionals (riding subways, trains, etc.) with the PSP, but the user demographic has continually trended younger (though not as young as for the DS). The sweet spot for PSP owners is 16- to 24-year-old males.

- The small screen real estate limits our visuals.

- The PSP's proprietary universal media disk (UMD) can be misplaced, and not all users are connected to the Internet for digital distribution.

Platform Summary

The PSP is an excellent handheld game console, capable of almost any onscreen environment we wish to create. However, the user demographic is limited (though less so than the DS), meaning that we may need to supply PSPs to our potential users. Hilton Garden Inn has done just that, with a serious game that trains its employees in customer service. Plato Learning has been developing e-learning applications on the platform, and the potential for more ambitious serious games applications looms large.

Televisions (DVDs, Set-Top Devices)

DVDs

Pros

- Most television viewers have access to a DVD player. In addition, DVDs can also be played on almost any personal computer. As a consequence, DVDs are probably equally accessible both at home and in the workplace and even on the road.

- Users are comfortable with DVD player remote controls. Typically, no training is needed for the hardware.

- DVD authoring tools are usually low cost, and development talent is widely available and affordable (most university media arts students study DVD authoring, and they may be available for internships).

Cons

- Interactivity and navigation on a standard DVD player (whether hardware or software) are restricted to menu-driven decision trees. This is likely to exclude most simulations, removes 3D navigation and real-time engagement, keeps the user more at a distance from the virtual world (resulting in a "lean back" rather than "lean forward" experience), and largely removes stress and ticking clocks from the experience (although timers can be set up within a menu-driven format, creating some stress and urgency).

- Products restricted to physical media (rather than installed on a local system or resident on the Internet) are often lost or misplaced.

- The distribution of physical media can be costly (mailouts, trade shows, etc.).

- Content can't be updated or amended without replacement of the physical media.

Platform Summary

The DVD is an attractive platform because of the near universality of its availability and its comfort level with users. Fairly complex branching narratives can be created with DVD authoring tools, and authoring costs can be kept low. However, DVD

functionality drastically reduces the types of engagement and interactivity we can offer a user. As a result, only specific and targeted serious games and simulations make sense to develop on this platform. Low-interactivity advergames and persuasive games may be better suited to the DVD format.

Set-Top Devices/Interactive TV

Pros

- TiVo and TiVo-like digital video recorder (DVR) penetration has gradually increased, so a number of users are familiar with the functionality and interface. Similarly, video-on-demand and other limited interactive/enhanced TV functionality is becoming more widely available.

- Content can be updated and amended, and no type of physical media is necessary.

Cons

- Most of these systems are found in the home; they're not commonly found in the workplace.

- Interactive functionality is only marginally better than what we find on DVD.

- Most of these systems are closed (because they're made available by cable and satellite TV companies). Video-on-demand and DVR downloads can be purchased, but the costs are likely to be prohibitive.

- There is little to no track record of serious games being developed for this platform.

Platform Summary

Although there is some attraction to avoiding physical media and having an application that can be updated, the drawbacks to developing for TiVo/DVR delivery undoubtedly outweigh the benefits, at least at this juncture.

Mobile Devices

The rapid penetration of ever more powerful smart phones and PDAs into the marketplace begins to make this a viable platform for the development of serious games and simulations. Let's stipulate that the portability of these devices is a massive plus: they're available in the home, in the workplace, and on the road. Users tend to be comfortable using these devices, and Internet access is usually available. The functionality of these devices is improving rapidly.

In short, if portability and 24/7 access are urgent needs for your project—or if the simulation actually fits a mobile device—then this is now a viable platform for development. Whether the goal is to promote a healthy lifestyle or to train on a sales simulation, the ubiquity and intimacy of mobile devices are pluses for development.

In addition, many developing countries have more or less bypassed a personal computer era and are heading straight to mobile devices as their primary conduit to the Internet.

Although most mobile devices are in the smart phone (i.e., iPhones, BlackBerries, etc.) category, other mobile devices (like the Chumby, PSP Go, and LiveScribe) are emerging and are likely to become more prevalent in the next few years.

However, before we completely embrace developing applications on mobile platforms, a few complications exist:

- Mobile devices employ a plethora of operating systems.

- Screen size and relatively primitive user input are two key limitations in creating interactive content.

Let's take a look at the major cell phone OSs and their advantages and disadvantages.

iPhones

The iPhone/iPod Touch product line offers virtually all the graphic power and interactive capabilities that we've come to expect on laptops and desktops. The applications we're discussing here are *not* browser-based apps but are applications built specifically for the iPhone operating system.

Pros

- The IDC Worldwide Quarterly Mobile Phone Tracker pegged the U.S. iPhone market share at 22% of smart phone users (as of February 2009); AdMob metrics peg worldwide iPhone mobile Web usage at 43% as of June 2009. Add to this the much smaller number of iPod Touch users, and we see that millions of users are familiar with the form factor and gestural interface.

- The iPhone offers larger screen size than virtually any other mobile device.

- It delivers real-time, computer graphic, 3D environments; full-motion video; and 2D environments.

- The gestural interface and accelerometer open the door for innovative new applications.

- Because of its handheld nature, certain serious games and simulations can seem even more immersive.

Cons

- It would require that the user demographic be using iPhones. Approximately half of iPhone users are under 30 years old; 15% are students.[3] (Though as the

[3] Rubicon Consulting whitepaper, 2008.

FIGURE
19.2

The iPhone in the hands of a young user. ©2009, Photos by Tony, used with permission.

iPhone becomes more mainstream, its user base will age.) Targeting iPhone users tends to reach a young, politically liberal, college-educated demographic, which may be why the platform has already become a favorite of persuasive and social change games.

- The screen size is still relatively limited (compared to desktop and laptop PCs).

- iPhone applications are built using Objective C, a variant of the C language that even experienced C developers find challenging.

- Only one third-party application can run at a time.

- Applications must be distributed via the iTunes app store, after going through Apple's review process.

Platform Summary

We're reaching a specific user demographic with an iPhone application, but if the demographic makes sense, this is an attractive platform because of its mobility, crisp graphics, gestural interface, and other unique interface elements. (See Figure 19.2.) The iPhone has quickly become a prime platform for advergames and persuasive games, and more robust serious games and simulations are being developed for it.

BlackBerry OS Cell Phones

The proprietary BlackBerry OS was designed initially to synchronize with corporate email servers, but it has been upgraded to deliver full-motion video and 3D graphics and in essence to compete with the iPhone. The IDC Worldwide Quarterly Mobile Phone Tracker for February 2009 pegged the BlackBerry OS (all versions) as having a 47% share of the U.S. smart phone market, still the clear leader in the space.

The BlackBerry is nicknamed the "CrackBerry" for good reason: its users, including President Obama, are devoted to the device. Users tend to be a little older and more upscale than iPhone users; as a demographic, this could be either a pro or a con.

Pros

- It excels at incorporating text-heavy output, e-mail, and GPS services and enhancing user input via the thumbwheel.
- Synchronization with corporate servers is the bread and butter of the BlackBerry, which means that real-time data might be easily incorporated into a serious game or simulation.
- Multiple third-party applications can run simultaneously.
- Development can be done easily on Windows (using many standard development tools, thus reducing potential acquisition costs for these products), and developers report that the BlackBerry simulator running on Windows is better than almost any other mobile simulator or emulator.
- Distribution options are plentiful; there are no handset carrier hoops to jump through.

Cons

- BlackBerry application programming interfaces (APIs) taking fuller advantage of device functionality are available to developers, but their use will restrict an application to BlackBerry distribution only.
- Development on Mac and Linux systems requires extensive work-arounds and are still likely to be less than 100% reliable.
- Graphics won't be as robust as on the iPhone and Windows Mobile. The BlackBerry OS doesn't include the OpenGL codec; animated scalable vector graphics will need to substitute.

Platform Summary

Distributing to the BlackBerry platform will make sense if you're targeting a BlackBerry-specific user demographic. In addition, the serious game or simulation application should be exploiting the BlackBerry's strengths, with hooks to corporate server data.

Windows Mobile Portable Devices

In many ways, Windows Mobile is just a smaller version of desktop Windows. Most of the advantages and drawbacks derive from Windows Mobile's parentage.

Pros

- According to market researcher Strategic Analytics, approximately 25% of business smart phones were deploying Windows Mobile in 2009, making it the second most popular operating system in the space (the BlackBerry OS leads the way, with iPhones moving up quickly). According to Microsoft, Windows Mobile phones were being distributed in 99 countries by the beginning of 2009.[4]

- Often, a preexisting Windows applications can be ported over or repurposed to Windows Mobile. Conversely, development on a Windows Mobile can be done with an eye to later distribution on Windows or even the Xbox.

- Graphics power and interactive functionality is robust. The operating system can handle 2D and 3D graphics, along with full-motion video.

- Most potential users will already be familiar with using the basic operating system.

- A huge percentage of development talent will already be familiar with the basic platform.

- Because the Win32 API is used, development can be done using Windows-friendly tools (e.g., Visual Studio) on personal computers (dramatically lowering the potential acquisition costs of tools).

- Distribution options are plentiful; there are no handset carrier hoops to jump through.

Cons

- About 75% of business smart phones are *not* deploying Windows Mobile (i.e., we should distribute on Windows Mobile only if the client and users have standardized on Windows Mobile or if we're prepared to develop for two or three different mobile operating systems, as Windows Mobile applications are not likely to be portable to non-Windows platforms).

- Experienced desktop Windows developers may have more trouble tailoring applications to the small screen real estate and more limited user input options, as opposed to developers who specialize in mobile devices.

- Development for Windows Mobile must be done on desktop Windows. You can forget Mac and Linux.

Platform Summary

Windows Mobile is very attractive because of users' comfort with the platform, the wide availability of development talent that can create applications for it, and the possibility that a Windows Mobile application can be ported later to desktop

[4] *Infoworld*, January 20, 2009.

Windows or the Xbox. In addition, numerous cell phones and PDAs use Windows Mobile (according to Microsoft, some 56 handset makers distribute Windows Mobile phones). The chances that an organization has standardized on the use of Windows Mobile are good.

Symbian OS Cell Phones

Back in 2007, Nokia trumpeted the fact that 100 million mobile devices using the Symbian OS had been shipped. That said, the Symbian OS has a relatively low profile in North America: less than 4% of mobile devices use the operating system.[5] Virtually all Nokia and Ericsson cell phones use the OS, and consequently, Symbian has a vastly higher profile and market penetration in Europe (8+%), Asia (21%), and Africa (17%). Gartner Research pegged Symbian's worldwide smart phone market share at 52% in 2008.

Pros

- It offers availability on millions of cell phones. If you are outside of North or South America, a large percentage of your desired user demographic may have access to this OS.

- It is an open operating system with mature open source development tools available. This can drastically reduce development costs. Development tools run from Visual Studio to Java ME to Python and Adobe Flash Lite.

- The durability and longevity of the OS means that experienced development talent should be available and affordable. (This is less true in North America, however.)

- Distribution options are plentiful; there are no handset carrier hoops to jump through.

Cons

- In North America, Symbian is a minor OS, and it's difficult to make a case for developing on the platform unless the client is an all Nokia or Ericsson shop.

- There is a wide variance in hardware capabilities and OS versions. For the most part, graphics capabilities are extremely restricted, with no full-motion video or 3D environments possible. This is not true with the newest version of the Symbian OS, when available on state-of-the-art handsets, but this is a small slice of the Symbian OS pie.

- Only one application can run at a time.

- The Symbian emulator runs only on Windows, and work-arounds to enable Mac or Linux development are arguably clunky and complex.

[5] From GetJar.com's May 2009 aggregated traffic analysis.

Platform Summary

The Symbian OS is likely to greatly restrict the type of serious or simulation application you can develop because of to its limited capabilities on many older or less expensive handsets. In addition, the Symbian OS is not widely available in the Americas. There is sparse evidence of serious game development for the platform, but if you're developing applications in Asia or Africa, and if your application is appropriate for less advanced cell phones (user interaction chunked in small text and graphic deliverables, such as data collection simulations, puzzle games, and so on), then this OS is worth looking at.

Google Android OS Cell Phones

Released in 2008, Android has had a tough time grabbing market share either in North America or in the rest of the world through 2009. Therefore, 2010 will probably be the year that determines whether the OS has a significant future competing with the iPhone, BlackBerry, and Windows Mobile. Let's look at a few pros and cons.

Pros

- It shares much of the iPhone's user interface and functionality (accelerometer, GPS, gestural interface, etc.). Graphics capabilities are also extremely similar.

- Multiple third-party applications can run simultaneously.

- Development can be done on Windows, Mac, and Linux systems, because of Android's Java foundation.

- A number of open source development tools are available, meaning there should be little cost in terms of development software acquisition.

- Distribution can be done through Google's Android Market for a nominal fee; Google does not review applications.

Cons

- As of late 2009, the installed base remains fairly small, and some industry observers are doubtful about Android's long-term viability.

- The use of specific Java classes may tie an application exclusively to Android.

Platform Summary

Android shows a lot of promise, but unless you know your user base is using a handset deploying Android, developing for the platform seems premature. Far more people will be reached on the iPhone or BlackBerry platforms.

Palm Web OS

The archaic Palm OS has been replaced in the new Palm Pre by the Palm Web OS. The phone was just coming to market as this book was going to publication, and whether the new platform gains market acceptance is still an open question. Anticipating that the Palm Pre might gain a significant portion of the North American smart phone market (say, 5% or more), here are a few quick pros and cons:

Pros

- It shares many of the strengths of other current-generation mobile device platforms: gestural interface, multitasking applications, current generation browser, 3G speed, and GPS capability.
- Development can be done on Windows, Mac, and Linux (the Palm OS is built on Linux).
- This would be an excellent choice for legacy Palm application users (legacy Palm apps can be ported to the new platform).

Cons

- The Palm Mojo SDK is still unproven (as this book went to publication).
- Acceptance and success of the new Palm platform are uncertain (as this book went to publication).

Platform Summary

The new Palm Web OS holds promise for the development of serious games and simulations, but there is no track record for success here.

SMS/MMS

The short messaging service (SMS) enables text messaging on cell phones and other devices. Limited to 160 characters per message, it enjoys nearly universal access. The multimedia messaging service (MMS) is for the transmission of graphics, typically photos taken from cell phone cameras. Because SMS has been used for simple turn-based games, it's clear that it has the potential for simple serious or persuasive games.

Pros

- It offers nearly universal user access.
- Most users are comfortable with how to use text messaging and how to send cell phone photos.

Cons

- Transmitted content is media-poor. Only applications that can operate solely using short unformatted asynchronous text or image transmissions would make sense for this platform.

- Backend automation, management of SMS streams, and user assessment data collection are likely to be much more complex than the application development itself, a case of the tail wagging the dog.

Platform Summary

SMS/MMS is an intriguing platform to develop for, because of its ubiquity. However, only very specific serious games or simulations could be developed for SMS/MMS, given the extremely limited functionality the platform enables.

The Web Browser (Internet Explorer, Firefox, Safari, Chrome, Opera)

Back in 1995, Bill Gates realized the threat that Netscape's Navigator Web browser posed to Microsoft Windows. Although years away from realization, he could already see that the browser could evolve into a platform of its own. With the maturation of Web 2.0 technologies, this has now come to pass. We can now disregard whether we're running on a Windows or Mac or Linux system and develop dedicated interactive environments exclusively within the browser (and in a further extension, outside the browser as a desktop application).

Current generation browsers are nearly identical in terms of their de facto operating system functionality. So let's quickly look at a few pros and cons.

Pros

- The browser platform is found on a wide variety of devices, including game consoles, mobile devices, and personal computers. (See Figure 19.3.)

- It eliminates the need for physical media.

- Users don't need to download permanent files to store on their local system or install any applications. This prevents many firewall or administrative privilege issues on a workplace or home-based personal computer.

- If built to scale, an application should be able to function on both a desktop/laptop system and on a mobile device.

- User input is generally derived from mouse movement or keyboard activity; users know how to function within a browser.

FIGURE
19.3

Screenshot from *FloodSim*, a serious game developed by PlayGen that puts the player in control of flood policy in the UK for three years. PlayGen chose the browser as the delivery platform because of its wide availability and ease of use.

- Many development tools are open source; other commercial development tools are inexpensive, and it is likely that your development shop already owns them.
- Many IDEs and programming languages (Flash, Java, etc.) are mature applications, and developers should be readily available. If you are on the hunt for ultra-cheap development talent, your local college or vocational school is probably graduating experienced programmers and artists.

Cons

- Not all potential users have persistent Internet access.
- The lack of a needed browser plug-in can frustrate users (probably solved if we stay with IDEs like Flash and Java, although Java's long initialization and lack of a preloader creates other frustrations).
- Content filters, content blockers, and content scanners can circumvent application delivery on a browser. Users may also lack the administrative privileges needed for plug-in or other necessary installations.

- Environments can't achieve the richness, depth, and expansiveness that we can achieve on personal computers or game consoles, because browser delivery necessitates smaller amounts of application data. (In other words, a Flash game is never going to look like *God of War* or *Halo 3*.)

- Overall, the application data package will be much smaller than a data package delivered via local installation or physical media. This may cut down the number of levels and cut scenes, characters, and interactions we'd like to have.

- 3D support is spotty.

- Returning user assessment data to the developer can be a problem, especially when browser cookies can be disabled or cleared by the user at any time.

Second Life/Virtual Worlds

Second Life and other virtual worlds such as ProtoSphere, Active Worlds, and Multiverse have recently become an exciting platform for the development of serious games and simulations. Persuasive simulations like *Gone Gitmo* and promotional simulations like Mexico *Ruta Maya* (both available on Second Life) begin to show the power of what can be done using a virtual world platform.

Pros

- This is a unique immersive environment, particularly attractive if your user demographic is already using this platform.

- Users familiar with the platform won't need to download or install additional files.

- It is excellent for multiuser applications.

- It is excellent when navigation is a primary component of the user experience you're creating.

- Default avatars and the existing Second Life environment may decrease development costs and time.

- As a side benefit, linear machinima videos can be extracted from user navigations of these simulations, transmitting some of the experience even to nonusers of the virtual world.

Cons

- It is available on personal computers only: Windows, Mac, and Linux. It is not available on game consoles or mobile devices.

- Second Life and other virtual worlds require the download of installation files in order to run on a user's personal computer. (However, next-generation virtual

worlds are running completely within the browser and require only lightweight browser plug-ins. See Chapter 20.)

- Virtual 3D worlds usually offer a steeper learning curve to users unfamiliar with the platform.

- Game physics may be too lightweight for more robust and precise simulation applications.

- It is probably inappropriate for single-user applications. (Because this platform is optimized for massively multiplayer user interaction, it may feel too austere or lonely for a solo user.)

Platform Summary

This platform offers an exciting environment, particularly good where navigation and multiuser experiences and interactions are needed. But the choice should be weighed carefully if users are unfamiliar with the platform, as navigation and functionality have a fairly steep learning curve.

Before a Platform Is Locked

As our review of project platforms suggests, we shouldn't make any assumptions about the right or best platform for our product until we've thoroughly surveyed our target user demographic. In particular, we shouldn't be seduced by a platform perceived to be "sexy" or "state of the art." Instead, we should select the best platform for our project and our users based on data we've collected.

Compelling Technologies, who developed *Fully Involved*, visited numerous firehouses and also conducted a questionnaire survey before arriving at a base system for its target users. Michelle Harden, one of Compelling Technologies' principals, noted that "On a previous project, we learned that the technology bar was relatively low in the fire service. A product that required high-end capabilities would not be successful; and we made a decision early on to sacrifice higher-end graphics for greater content."

Although there was some initial exploration of console availability in firehouses, the survey results clearly showed that Windows systems were far more likely to be available to target users. An advantage to Windows development was that code could someday be ported to an Xbox application if demand warranted.

Summary

- Platforms are often selected before project goals, learning objectives, and user demographics have been established. The wrong platform can increase the budget and staffing unnecessarily and may jeopardize the success of the project. The selection of the appropriate platform for delivery of your product is one of the most crucial decisions you'll make. Replacing a bad hire is a problem, but usually one you can recover from. Changing a platform in midproduction can be disastrous and may derail your entire project.

- Some platforms are best for home delivery, others are best for workplace delivery, and still others are best for mobile delivery. Some are better for novice users, others are better for sophisticated users. Some platforms are best for complex user interactivity and logging of user input and decision making, and others can handle basic user interactivity only. The selection of the right platform is a complicated weighing of features, needs, and assessments. Platform selection will be a primary driver toward the hiring of production talent and plans for distribution and marketing.

- The targeted user demographic should be surveyed to discover typical user systems, user needs, and user patterns of use. Don't assume that users are using the hardware designated by your organization's information technology department: they often aren't! Find out the truth behind the hardware and software your users rely on, and weigh the pros and cons of a platform choice against this information.

- Match the platform to your learning objective needs. If you don't need 3D navigation, don't build on a platform that tilts toward 3D navigation. Choose the right platform, not the most glamorous platform.

- Check in with **endtoendgamedevelopment.com** for the latest developments in platforms and their serious games track record.

CHAPTER TWENTY

Selecting Development Tools

Introduction

The selection of development and delivery platforms, along with your project goals, will be driving the selection of development tools to realize your vision. Of course, nothing is ever this simple: the selection of development tools should also influence your development platform, particularly when you're developing on a different platform from the one you're delivering on.

Dozens of books have been written about asset building, level design, and programming, and this book will not pretend to thoroughly cover vast topic areas such as these in a single chapter. Instead, for readers new to game and simulation development, consider this a brief overview of some of what you need to consider in selecting the most critical component of your project: the game engine, which may be part of a larger middleware suite.

If there is a unique aspect to this chapter, it'll be our discussion of game engines and development software with an eye to their application in the arena of serious game and simulation development. Here are some key questions you should consider about a game engine you're going to use:

- What does the engine cost?

- When will the next version be released, and will it make your previous code obsolete?

- Has the engine been designed with e-learning or simulations in mind?

- Is it SCORM[1] compliant?

[1] Sharable Content Object Reference Model (SCORM) is a collection of standards and specifications for web-based e-learning. Many public and private agencies—and certifications—now require SCORM compliance.

- What kinds of user assessment metrics are there?
- What kind of ramp-up time is needed to get acquainted with a particular engine, and how challenging is it to work with?

In sum, this chapter's goal is to serve as a handy reference for (1) all our professional readers who are new to game development and (2) experienced game developers, even if it's just to discourage a client from making a bad decision.

This chapter will exist in two versions:

1. A brief print version which will cover a couple of the most popular game engines used in serious games and simulations
2. A much more complete online version, covering numerous game engines and other important development tools, with updated information on all these tools. You'll be able to download and print the chapter, and join the conversation about these tools, at **endtoendgamedevelopment.com**.

We'll get a glimpse of these tools put to use in Chapter 24, where we'll discuss the production pipeline, as your project accelerates into full production mode.

Game Engines

The term *game engine* is both accurate and misleading as a metaphor; although it will indeed be the motor behind our game, the engine will also be the enabler of game development itself. Its core features will almost always include a 2D or 3D rendering engine, collision detection and response, networking, streaming, memory management, code scripting, and threading—as well as the management of animations, audio, levels, and artificial intelligence. Typically, game engines will provide some kind of integrated development environment, but they are then often supplemented by—or packaged as part of—middleware.

Given this definition, we'll be including browser-based game engines and mobile device game engines.

Devmaster.net catalogs hundreds of game engines, and we would have to devote several volumes to fully discuss all available game engines. Instead, we'll offer a broad overview of some popular game engines in use at the time of this book's writing, with an eye to the following elements:

- Particular features that may favor their use for a serious game or simulation (e.g., rapid prototyping or the capture of user assessment data)
- Cost (game engines like idTech and Steamworks can cost hundreds of thousands of dollars to license or purchase; the game engines we discuss will all be available for under $10,000, and many will be free or nearly free to license or buy)

Even given our parameters, the following will still be a *sampling* of potential low-cost game engine candidates, not a comprehensive roundup. (We should note that fees and licensing/sales conditions are highly changeable.)

But if you're relatively unfamiliar with game engines, then familiarity with these development environments will provide a good starting point for further evaluations of other candidates.

Traditional Game Engines

For lack of a better term, we'll classify these game engines as *traditional,* because their lineage is for the design of standalone games distributed on physical media. All of these can now deliver downloadable executables, and some of them even have a runtime web player component, for delivery within or concurrent with the browser. All of these engines can develop either single- or multiplayer applications, and as we noted earlier, they'll be affordable on an Indie budget.

Torque

Torque, developed by Garage Games, now has a long history as the 2D and 3D engine of choice for independent game developers, because of its low cost. The engine has been used to build FPSs, racing games, and real-time strategy games.

Several flavors of Torque exist: Torque Game Builder (TGB) is intended for 2D games; Torque Game Engine Advanced (TGEA) is intended for 3D games; and T for Wii, Torque X, Torque 360, and iTorque handle publishing to specific platforms. Developing for the iPhone can be done within the Windows or Mac environments.

Torque includes an integrated graphical environment; a mission editor and terrain editor; shading, lighting, and asset importing tools; Torquescript for scripting code; (somewhat sparse) documentation and scripting examples.

Publishes to: Windows, Mac, Xbox, Wii, iPhone, and the Web.

Serious games track record: Torque was used for building the serious game *Fully Involved* (discussed elsewhere in this book) and has been used to create math-teaching games, forest simulations, and other serious games.

Cost: Torque's most attractive feature is probably its inexpensive licensing pricing. Independent game developers can license TGB for $150 and TGEA for $295 per seat. The user community is vast, and a number of books have been published exploring the world of Torque programming. Garage Games has also been aggressive in disseminating Torque to college and university game design students, possibly opening the door to your recruiting talented programmers directly out of your local college.

Bottom line: Torque's low cost can't be beat, especially given its capabilities across platforms and the availability of relatively low-cost programmers.

For more information, visit http://www.garagegames.com.

Choosing Torque

Justin Mette of 21–6 Productions has been "using the Torque Game Engine (and its variants) from GarageGames for almost eight years. The source code comes with the engine, allowing us to develop pretty much any kind of application you can think of. We've built casual games, serious games, government simulations, and even data entry applications using the engine."

Mette goes on to extol Torque's multiplatform publishing and its ability to go 2D, 3D, single player, or multiplayer. "Some say the art pipeline is challenging, but once you learn how it works, it's pretty straightforward. Some of the newer variants of the engine, like Torque3D, continue to make this process easier."

He adds, "Over the years we have evaluated other game engines but found none match the flexibility and power of Torque, especially for the price."

Adrian Wright of Max Gaming Technologies also argues Torque's benefits, "since most serious games tend to need to run on low- to mid-end systems and generally need us to be able to write custom code." He points to its long track record and community of developers as two additional strengths.

Browser-Based Engines

With the ubiquity of broadband access, the attractiveness of delivering a project via the browser is obvious: it eliminates the need for any physical distribution of media, thus reducing or eliminating packaging and distribution costs.

Increasingly, because of improved broadband speeds and software compression algorithms, even 3D content can be streamed online. However, rendering full-screen 3D environments with the richness of game engines like Unreal or a Gamebryo is still difficult without a significant upfront data download (which, as previously discussed, is usually less than preferable). Often, the browser-delivered 3D is more eye candy than a truly interactive and fully navigable 3D environment.

These engines work by using a downloadable runtime player—normally a browser plug-in that can be quickly downloaded and doesn't need to be permanently resident on a local hard drive (thus solving the problem of corporate firewalls that prevent permanent saving of data).

As we've seen, downloadable runtime players are becoming more prevalent even with traditional game engines originally designed to produce standalone applications: Unity 3D and Director are two mentioned earlier. So the line between these two categories of engines (the traditional and the browser based) is now blurring.

Nevertheless, the engines and development environments discussed in the following sections are almost exclusively designed for browser delivery (i.e., they will "publish" to any modern browser; exceptions will be noted).

Flash

Arguably, the grandfather of browser-based game engines would be Adobe Flash (although Sun's Java should probably share this title). Flash has been the premier delivery vehicle for online 2D interactivity, and for more than a decade, Adobe Flash has now added 3D capabilities to its feature list—but these features have more to do with moving 2D objects through 3D space rather than creating lush Unreal-like environments. (Some sophisticated third-party Flash toolkits are now delivering truer browser-based 3D, but these are usually for Windows systems only.)

Figure 20.1 shows a serious game developed in Flash. Flash is an attractive development environment for several reasons:

- Its initial learning curve is probably kinder than most others: almost any user can begin to create simple animations within an hour. Flash's programming language, ActionScript, allows professional programmers to wring the maximum out of the platform.

- Partly because of Flash's relative ease of use and partly because working in 2D is easier than working in 3D, development time is typically much shorter than in most game engines.

- Shorter development time means lower costs, and 2D assets will tend to lower costs even further.

FIGURE
20.1

PlayGen selected Flash as the development environment for *Climate Health Impact* (an educational game about global warming), due to its wide availability on personal computers.

- Nearly every Internet user has the Flash player installed for the browser, meaning that almost every user is potentially within reach.

- Flash programming talent is widely available, as academic game design programs almost always train students on Flash.

Key features include object-based animation, 3D transformations, inverse kinematics, a plethora of video tools (allowing developers to easily combine animations with video content), interactive storyboarding, and the aforementioned ActionScript. In addition, Adobe Flex can be used to complement development with its own IDE, making some coding and debugging easier. A drawback to Flash is its unavailability on the iPhone (as of Fall 2009).

Adobe has expanded the Flash development platform in two ways:

- Adobe Integrated Runtime (AIR) allows developers to package up their Flash applications and deliver them as an offline desktop executable (which could be downloaded or distributed via disk or flash drive).

- Flash Lite makes it possible to extend the application to mobile devices. (See the Flash Lite discussion presented later in this chapter.)

Although we don't normally associate Flash with the building of massively multiplayer applications, a tool called SmartFoxServer can work in conjunction with Flash to build massively multiplayer online (MMO) serious games or simulations. We'll look at SmartFoxServer later on in the extended online chapter.

Serious games track record: Applications like *Fatworld*, *Budget Hero*, *Darfur Is Dying*, *FloodSim*, and a McDonald's training game for customer service are just a few examples of Flash-based serious games. Flash advergames have been created for Pepsi, Doritos, EconoLodge, and Paramount Pictures, to name just a few clients.

Cost: $249 purchase price.

Bottom line: The low cost, wide availability of development talent and easy deployment make Flash an attractive platform for serious game development. Adobe AIR means that we no longer have to think of Flash as a browser-only vehicle. But if we're looking for realistic simulation environments, deployment on consoles or the iPhone or BlackBerry, or high-end interactivity, we may need to look elsewhere.

For further information, visit http://www.adobe.com/products/flash.

Choosing Flash

PlayGen has used Flash in several of its games. "My favorite delivery platform is Flash," says CEO Kam Star. "It's something I've resisted, but with our development tools, we've figured out how to move Flash more into a game world. Flash is ubiquitous. It runs on any computer practically anywhere, and for flexibility, there is no better platform."

(Continued)

He pointed out that "most of our clients want applications to run on any computer. Their systems don't have graphics accelerators. Because of that, graphics effects have to be software based, rather than relying on the hardware."

Flash is certainly not PlayGen's only preferred game engine, but for non-mobile, nonspecialized applications, it's one of the first tools the company reaches for.

Summary

- Game engines can be licensed for hundreds of thousands of dollars. But game engines are also available for free or for just a few hundred dollars. Clearly, this is preferable for serious games and simulations being produced on Indie budgets.

- Some game engines are best for desktop PC or console development; other engines will deliver applications to the browser; still other engines have been built to deliver applications to mobile devices.

- Certain specialty engines and development environments offer particularly attractive features to serious game and simulation designers and should be looked at closely before final decisions are made about development environments. Some application toolsets are being bundled with developer services, which may be attractive to the organization or entity that lacks its own game development expertise.

- The selection of a game engine will come down to a variety of factors: distribution decisions, capabilities to deliver content, development time, inclusion of middleware tools and a development environment, availability of development talent that can work with the engine, and whether user assessment metrics or SCORM compliance is built in.

- Many software packages will complement your game engine and middleware solution, either expanding the capabilities of the engine or making authoring easier. In this print version we've reviewed just a brief sampling of available game engines. In the extended online version of this chapter, we'll cover many other game engines and development tools, including tools intended for (1) massively multiplayer online environments and (2) and mobile device delivery. Don't forget to visit **endtoendgamedevelopment.com** for the extended chapter discussing tool selection, along with many more references and updates on this topic.

CHAPTER

TWENTY-ONE

The Design Document

Introduction

The concept document should secure the team's commitment to and understanding of the project, and often it will secure the funding for design and production.

At the point where design and production get the green light, a design document will need to take shape, usually springboarding from the concept document.

The design document is the bible defining all aspects of the game's creative and technical design, design specifications, programming, asset building and management, delivery milestones, user testing, scope, and completion.

Frequently, design documents are assembled from separate creative design and technical design (or design specification) documents, and sometimes the segments or documents are kept completely separate.

The traditional design document is, indeed, a print-oriented "bible," but organizations are now using content management systems (CMSs)—which might include intranet websites, wikis, blogs, revision control systems, and other tools—to create a more fluid and up-to-date design/production bible. (See our mention of MediaWiki and Subversion in the online version of Chapter 20.) With the plethora of collaborative Web 2.0 tools now available, design documents are arguably much easier to create and iterate, and the idea of the "document" can be greatly expanded and enhanced. A necessary component of this distributed approach, however, would be a central portal that directs traffic.

The Design Document Paradox

The December 2008 issue of *Game Developer* magazine offered a classic illustration of divergent opinions regarding what goes into a design document. A featured column argued that most design documents were way too dense and complicated and that they should be simplified to a number of bullet lists targeted specifically at programmers building the project. However, the cover story spotlighted a lack of detail and specificity in design documents as one of the single greatest roadblocks to successful game development.

Both viewpoints are correct, in their own ways. Design documents are meant to evolve and iterate, and all too frequently they can become difficult to maintain and present navigation issues to users (i.e., What information do I need? Why do I have to read all this other stuff?). But at the same time, design documents are often kept too high-level and vague, leaving artists and programmers to either (1) work in opposition, rather than in tandem, or (2) work in a vacuum, because little or no task guidance seems to exist.

We encourage all the detail and specificity a team can manage in ongoing assemblage and maintenance of the design document. Text, graphics, flowcharts, wire frames, sketches, and storyboards should all be part of the document, and electronic versions of the design document can certainly include audio and video files.

Different team members should be contributing to the document's content, but someone on the team—a producer, designer, or writer—should be charged with shepherding the design document from start to finish. These documents will not write themselves! Conversely, if ownership of the design document is shared, the potential exists for multiple, competing versions of the document, obviously a disastrous situation (if part of the team is following the John version and part of the team is following the Sally version, you've got big trouble).

As content accumulates, the key to a successful design document will be its information hierarchy. As mentioned, some organizations maintain separate documents for creative design, design specs, marketing, and so on. This is one way to enforce an information hierarchy, but it can still sometimes create confusion as to which document content will be in, particularly during meetings and work collaborations when reference is made to the content.

That said, a single, integrated document should be easily detachable into its parts. If the design document is maintained through an electronic CMS, thought should be given to maintaining easily generated print segments or compilations, especially for clients. In addition, the CMS should be behind a firewall and secure.

Clients like design documents. The process of game development and production is frequently messy, and early versions of environments, characters, and animations can actually be disconcerting for clients inexperienced in the process. A good design document (like a good architectural blueprint) suggests a steady hand and a clear vision behind the construction work.

A good design document will also combat the tunnel vision that creeps into the long months of development.

So What Goes into a Design Document?

No two design documents are going to be written in the same way. There is no right way or wrong way. The document serves the team and the project, not the other way around. And the design document is meant to evolve through the course of the project.

With those caveats, here is a brief overview of some of what a serious game or simulation design document should contain:

- Game/simulation overview (including delivery platform and genre)
- Project scope and milestones
- Scenario and narrative
- Levels (from user perspective)
- Scoring and evaluation
- Tutoring and remediation system (if any)
- Game mechanics
- Technology and tools
- System design
- Interface and commands
- Environments and levels (from assembly perspective)
- Characters, assets, and animations
- Audio
- Lighting
- User data collection
- Testing and QA
- Marketing and distribution

What does a real-world example look like? Table 21.1 displays the table of contents for *Fully Involved*'s design document, which demonstrates much of our model but reflects sections specific to the project:

Examples of Design Document Content

Let's look at different kinds of content found in design documents. We'll find a broad range of content, and that's lesson 1 in design document content: *anything* that will further an understanding of the design for others is useful.

Narrative

Figure 21.1 illustrates the opening two pages of an early story narrative treatment for *Leaders*. The goal here was to create a movie-like feel in the simulation opening.

TABLE **21.1** Sample design document table of contents from *Fully Involved*.

Section #	Section Title
1	Creative Design
2	Game Overview
3	Game Levels
4	Rescue and Risk
5	Game Scenario/Narrative (from user perspective)
6	Scenarios and Events Based on Learning Objectives
7	Tutoring and Interventions
8	Scoring, Evaluation and Remediation
9	Casting, Set Design, Sound Design
10	Technical Design
11	Design Goals
12	Platform/Genre
13	Interface and Commands
14	Assignment SOPs, Rules, and Behaviors
15	Fire Simulation
16	Smoke Simulation
17	Venting
18	Firefighter Injury
19	Event Driven System Design
20	Environment, Actors, and Sounds
21	Lighting
22	Scoring and Report Card
Appendix A	Game Levels and Elements
Appendix B	Event Manager System
Appendix C	Usability and UI Questions
Appendix D	Potential Future Enhancements

Technical Design

Figure 21.2 illustrates the opening two pages of an early technical design document for *Fully Involved*. Notice that user interface and commands are now being spelled out in great detail. Although some specifics changed, this was a good early capture of menu commands.

Gameflow Process

Figure 21.3 illustrates the use of flowcharts to give an overview of the gameflow. Narrative-heavy games tend to have gameflow that is closely tied to the narrative script flow; in the case of "sandbox" games or pure 3D simulations, gameflow will be more closely tied to the world map and its locations.

Don't Listen When Someone Tells You That You Don't Need a Design Document

You may hear stories of game development teams who simply met to discuss objectives, went to their computers to crank out code and design levels, met to iterate their progress, and never needed a design document.

FIGURE
21.1

LEADERS DEMO

Story Treatment by

Terry Borst

A Word On The Mechanics Of Game Play

The story will be told via actions and events depicted in a real-time 3D graphical environment, and through natural-language dialogues that the user — assuming the role of company commander Captain Young — will have with his direct subordinates, as well as an officer outside the company.

The mission-critical decisions the Captain will have to make will often depend on how much he can trust, motivate and lead these men. This primary effort will continually be interrupted by the kind of personnel issues that are the day-to-day essence of military command. These issues will not only challenge his ability to balance priorities but also to maintain focus on the mission itself.

Results of the Captain's decisions will be visible in the virtual world around him where the consequences of his actions may be seen from his point-of-view and from a dramatic third-person perspective that allows the game user to see beyond the Captain's limited perspective.

The Story

As our story begins, Captain Young is just now joining the company, as the previous CO had to be airlifted out due to appendicitis.

Captain Young's OpOrd for the day can come via an email or IM screen. (The text could be V.O.'d as well.) An NGO food distribution operation in southern Afghanistan is to

First pages from version 1.0 of the *Leaders* treatment.

269

FIGURE
21.1
(*Continued*)

take place at 1400 hours. The Captain's company will be providing logistical and tactical support:

- prepping the site to facilitate distribution and prevent disruptions
- overseeing local security
- managing traffic and access, etc.

This OpOrd could have extremely detailed specifications: complete site containment by 1100 hours, inspect local security at 1130, etc.

We may begin with an establishing shot from a ridge, overlooking the small valley where the food-op is to take place. (We won't know, until the very end of the demo, that this was the POV of someone uninvited, watching activities.)

The establishing shot would include soldiers stringing concertina wire, perhaps some canopies being set up, vehicles strategically placed, soldiers moving about (to suggest various other activities they'd be undertaking: everything from clearing brush to setting up porta-potties). In addition, there should be another Army unit a little ways off the main operation: their immediate purpose unclear.

[The OpOrd mentioned previously could be V.O.'d in conjunction with this establishing shot.]

The establishing shot concludes as a Humvee pulls away: Captain YOUNG has just arrived on site.

[There may be some emotional punch in establishing Young in a 3rd person POV shot, while we enter his head for just a moment, listening to a V.O. of his thoughts (to the effect that this is the first time he's captained this sort of operation). This would probably be the only time we would encounter the Captain's private thoughts ... but it may achieve real audience identification/immersion, because the game player should be thinking the same thing...]

We don't doubt that this has happened—with very small teams (three or four people) who had all known each other for years, who all worked under the same roof in a small space, and who didn't have to answer to a client or high-level management.

Often, however, serious game and simulation development team members wind up being scattered across the country and may never have worked together before. The size of the team is likely to grow, and turnover within the team becomes increasingly likely the longer the project is. Clients want to see what they're paying for, and in-house executives want to make sure their butts are covered.

FIGURE
21.2

Fire Fighter Safety v 1.0 Design Document

Design Goals

Fire Fighter Safety is a interactive training simulation. This document is to specify all the different aspects of the design of the simulation including interface, sounds, reporting, and game play. This document is a living document and can and will be edited and amended as needed during the prototype phase.

Platform/Genre

Fire Fighter Safety is a real time strategy simulation designed for the fire fighting community to allow those advancing to Company Commander to get experience on the fire scene. The simulation will run on Windows based PC's with minimum specifications determined my Compelling Technologies.

Interface and Commands

This section of the document will cover each different interface element and the commands related to the different elements.

Main Menu (Reference Flowchart 1)

- Play Game (greyed out til profile logged in) – This button takes the user to the scenario selection screen.

 o Login – This is will prompt the user for their user name and password which will be used to save their simulation scoring.

- Profile – Used to login and review your profile history, create new profiles, and make changes to the users profile (password change)

 o Review Profile – Brings up the users personal information, play reports and awards.

 ▪ Edit profile – allows user to edit their password and any other information except user name stored in the profiles personal information section.

 o Create New profile – allows a user to create a new game profile.

 ▪ User name

 ▪ Departments

First pages from an early version of the technical design document for _Fully Involved_.

FIGURE
21.2
(*Continued*)

- password

- Options
 - Video options
 - Audio options
 - Control options
 - Internet tests

- Exit

Scenario Selection Screen (reference Flowchart 2)

This screen will allow users to select the available scenarios which to run. Scenarios not yet unlocked by completion of the previous scenario will be greyed out. In addition, the players high score on played scenarios will be displayed.

Selectable scenarios are :

- Tutorial

- Easy

- Medium

- Hard

After Selecting which scenario they wish to run, the user will be taken to the Firehouse interface.

A return to main menu button also need to be placed on the screen to allow the user ease of exit.

Firehouse Screen (reference Flowchart 3)

The Firehouse will be the staging are between each training exercise containing:

- Desk
 - Battalion Commander dialog. The B.C. will be the players couch throughout the simulation. In the Firehouse in the tutorial level and easy level the B.C. will appear and help the user get his company ready. The first 2 exercises

In sum, you need a design document. The time and money spent on its creation and iterations will be amply rewarded. A solid design document will generate production documents such as programming task lists, audio lists, art lists, voiceover scripts, budgets, and schedules. In addition, it will keep the development and production team on track, focused, and adhering to the same overarching vision. It's easy to get lost in the middle of production, but if you're able to rely on the design document for direction and mission, then you should never veer too far off course.

FIGURE
21.3

Flowchart from early version of the creative design document for *Fully Involved*.

Design Document Version History

The design document version history needs its own documenting (within the design document). Significant changes and deletions in the design should be explained so that history doesn't repeat itself (i.e., somebody asking, "Why don't we do this?" when the idea had been discarded with good reason months earlier). These changes or deletions may be contained in a separate appendix or as part of the original sections (some design documents will actually contain text with strikethroughs).

If printing the design document, the version history should be indicated on the cover page or on the first page after it. If the design document is electronic, the version history should always be obviously available through a link.

Interestingly, printed film or television screenplays have a long-established history of indicating version changes via page colors: a blue page signals one revision, a yellow page signals a different revision, and so on (each color is also pegged to a specific revision date). The new color pages are distributed to swap out with the previous version.

Given that game production is different from on-set film production, this system may not always translate well to design documents, although adopting it may provide a nice feeling of tradition for your team!

Regardless of whether you're distributing electronically or by print, make sure your version numbers are attached to specific dates. That'll make it obvious as to whether the reader has a current version.

In both cases, offer a brief precis for version changes, so the reader will know if design specifications or core gameplay has changed or if there have been minor editorial changes throughout or sweeping changes to just one section.

Design Document Distribution

If the design document is being distributed on paper, give it the respect it deserves. The document should probably be bound (or at least held together with brads, like a script) and have a cardstock cover. If possible, old versions of the printed design document should be collected and shredded to reduce any possibility for confusion (and to protect your intellectual property).

If the design document is electronic, be sure to publish (on the entry page or the top level of the wiki or CMS) news of the release and revisions. Redundant emails or feed announcements to notify your team of electronic distributions are also advisable. The email or feed announcement can briefly summarize the most recent revisions.

Production Documents

Production is likely to start while the design document is still evolving. At a certain point, the game's feature set needs to be locked so no new features or directions are added to the project. The design document's iterations should begin winding down, mostly reflecting the deletion of features.

But a steady stream of production documents should start being generated, including the following:

- Programming task lists
- Audio lists
- Art lists
- Budgets
- Delivery schedules
- Game scripts, which we'll devote a separate section to

Lists

Programming, audio, and art lists may be directly pulled from the design document or design spec. However, these documents are likely to be expanded to indicate issues, delivery dates, and so on. Figure 21.4 illustrates a typical audio list.

Game Scripts

As discussed in our earlier book, *Story and Simulations for Serious Games*, simulations and games are, in a sense, theatrical productions presented on a stage (usually an electronic screen), with actors, props, and progression. Consequently, games need scripts, just like theatrical plays, films, and television episodes do.

We should be sure to differentiate narrative scripts from code scripts. Programmers often say they are "scripting," and indeed, they're correct. If we think about it, theatrical and film scripts served as programming code for the makers of these projects. The code had to be interpreted in order for the experience to be created.

Here, we'll be referring to scripts that are designed for human interpretation rather than for machine interpretation. Not surprisingly, these game or simulation scripts can look very different from any theater or film script, and different projects can require different kinds of scripts.

We may have a game that is gameplay intensive with little narrative. We may have a game with no audio voicings or textual character dialogues. So we may think we don't need any sort of script.

FIGURE
21.4

Audio Dialogs

Audio dialogs will be documented in a separate document. In general, we want to use a minimum # of voices to minimize asset management and cost. While it's OK to use multiple voices if necessary to manage actor fatigue, it's not necessary for realism or to achieve learning objectives. Distinct voices will need to be used, or can be re-used, as follows

Sex	Age	Use For	Communicate Via
Male #1	40-50	BC	Open air
Female #1	40	Dispatch Neighbor	Radio Open Air
Male #2	40	Dad, neighbor	Open air
Female #2	30	Mom	Open air
Male #3	20-30	Firefighter	Radio
Female #3	20-30	Firefighter	Radio
Male #4	15	Victim, neighbor	Open air
Female #4	12	Victim, neighbor	Open air

Ambient Sound

Background sound will be necessary for creating a sense of realism:

- Fire
- Explosions
- Sirens
- Water (from hoses)
- Extinguishers
- Burning of materials
- Footsteps
- Equipment clanks
- Collapsing structural elements (e.g., roof, wall, floor)
- Dogs barking

Final audio elements will be determined by game production and budget, along with game testing.

Audio list for Compelling Technologies' *Fully Involved*.

However, even a simple "sandbox" serious game is likely to require extensive title cards (the equivalent of interstitial silent movie title cards) and help screens to explain locations, rules, interactions, and the like. Collectively, that material needs to be scripted.

More complex serious games and simulations often have extensive narratives and often rely on character dialogues (whether audio or text only).

Though an oversimplification, we might categorize game scripts in this way:

- *Voiceover scripts.* These scripts are most familiar, as they are similar to voiceover scripts in other media (e.g., radio or television).

- *Narrative scripts.* These scripts describe the gameflow and game narrative, and they may combine mission descriptions and waypoints, nonplayer-character (NPC)/player interactions, and transitions between cut scenes and interactive sequences.

- *Scenario scripts.* These scripts try to capture specific actions and interactions on a more "molecular" level.

Examples from—and discussion about—these different kinds of scripts can be found in the online version of this chapter (found at **endtoendgamedevelopment .com**). Aside from an extended version of this chapter, you'll find even more extensive samples to view and download and a continuing discussion and interaction about how to script voiceovers, gameflow, and other game narrative materials.

Marketing Document

Finally, it's never too early to begin thinking about how to market the project. Marketing should begin months before the project's completion and continue through the life span of the product (ideally, even extending that life into secondary markets).

If the project is funded by a grant or if you've got a "prebuilt" customer, you might think you don't need to market the product. This is shortsighted. Often, the people who gave the green light to a project will be gone by the time the project is completed. In addition, the prebuilt customer may not be as enthusiastic about the project as you are.

Nobody should ever take an audience or customer for granted! Your goal is to grow the customer base and create enough enthusiasm so that you'll get a shot at version 2.0 (which we'll discuss in an exclusive bonus chapter to be found at **endtoendgamedevelopment.com**).

The marketing document should walk through the following phases:

- Marketing and communication in the months before the product is released (online, print, and trade show). What materials will specifically address customers' needs? Is the messaging for the product consistent and accurate? Is the story of the product being told?

- Marketing during the project's pilot and initial release. This should include all the ways that marketing can improve and accelerate product distribution, reach the target audience, and secure good reviews.

- Marketing that will extend the product's life cycle.

Marketing preparation and planning cannot wait until the application's completion, beta, or pilot testing. We'll discuss marketing further in a later chapter. But Figure 21.5 shows a PowerPoint slide excerpted from the marketing section of the design

FIGURE
21.5

Sample information about consumer advertising lifted from the marketing section of the SHOPGame design document.

document for an advergame. The content was repeated and then expanded in the company's business plan.

Summary

- The design document should evolve out of the concept document as soon as a green light is given to production. (Preliminary design documents may precede the production green light; this gets into semantics as to whether we're still in a "concept" phase or "preliminary design" phase.) The design document will serve as the bible for production of the serious game or simulation.

- The design document may be split into creative design documents and technical design documents. Although it is print oriented in its origins, electronic distribution across wikis, blogs, and intranets may make more sense for your team, providing a central portal is used.

- The design document should always serve the team and project first, but it should get into details and specifics about gameflow and mechanics, game narrative, system design, technology and tools, asset and level production, characters, scoring systems, capture of user assessment data, and other critical components of the application's production.

- The design document should evolve throughout the course of production. At a certain point, the design needs to be "locked," and the only further changes to the design document should reflect midcourse corrections, deletions, and amendments.

- A complete and thorough version history should be maintained, and this needs to be available to all key members of the development team.

- One person on the team needs to supervise design document revisions and claim ownership of the design document. This becomes even more important if the design document is distributed across a content management system, because parallel (but different) versions of the design document might potentially exist, threatening a unified vision and direction for the project.

- Lists, schedules, and scripts are just some of the documents that will be used during production. Version histories remain critical to these documents. A marketing design document should emerge sooner rather than later, because effective marketing needs months of preparation and lead time to fully exploit the distribution of a finished application.

- For a thorough discussion and review of game scripting, more samples of document flow throughout game production, and a discussion of document and scripting tools, visit **endtoendgamedevelopment.com**. There, you'll be able to print and download an extended version of this chapter.

SECTION FIVE

PRODUCTION AND AUTHORING

Building the Game

You have the full "green light" for production and a comprehensive (but still evolving) design document to guide that production.

Media assets need to be created or acquired. You may need full-motion video assets; you may need audio assets; you'll definitely need 2D or 3D computer-generated assets. We'll look at audio and video production first. Our chapter on graphics production includes input from both commercial and serious game graphic artists. We'll look at the production pipeline and consider the entire authoring and coding processes.

Finally, we'll discuss testing and refining, as well as the steps needed to gain final approval and, if necessary, certification for the finished game.

CHAPTER TWENTY-TWO

Graphics Development

Introduction

In this chapter, we'll look at the creation of computer-generated art elements for serious games and simulations. We're indebted to Lance Alameda for his extended consultation on the subject. Lance is an experienced art director and veteran of both serious games for the military and commercial games for Electronic Arts.

To give the broadest overview of the subject, we'll look at the construction of serious games that involve 3D virtual worlds and then scale back to simpler graphic representations. Though smaller game development houses combine a variety of art positions into a few key roles, we'll describe the functions as though they each exist independently. That way the functions and tasks involved in art creation will be clearer. Our goal is to provide an overview of the process so that game producers and project managers will have some sense of the steps involved.

Preliminary Design

The purpose of preliminary design is to lay out each of the game levels and block out the physical flow of the whole game. It's also an opportunity to figure out how many graphics a preexisting budget will buy, or just how much to budget for graphics development. During this process, the art director also begins to define the style and look of the characters, objects, and environment.

As soon as the delivery platform is selected, it becomes critical to dial into the target hardware: to understand its capabilities and performance limitations. Often, either artists or clients will want to create a detailed look for objects that are just too complicated to play efficiently on the required hardware, and as a result the game begins to move as though it were being played in slow motion. As a consequence, producers and programmers need a firm understanding of the hardware and its capabilities. The development team can then match the complexity of the graphics

FIGURE
22.1

art by Richard Almodovar

Original rough character sketches created for _Leaders_. Note the faces on the top right for the character Lieutenant Perez. ©2004, University of Southern California Institute for Creative Technologies. Used with permission.

to the performance requirements of the hardware. Following that, a preliminary game design that suits the performance of the delivery system(s) can be created.

The preliminary design should also set standards that are cost effective. Artists often get caught up in creating objects and characters with lots of flourish that are lost in actual gameplay. The key to success is to review the instructional goals and determine which tasks are most critical and will have an impact on the behavior of objects and characters within the game. If the goal of part of the gameplay is to be able to recognize a certain kind of tank, for example, then your objectives require that that tank be rendered at a level that will make that discrimination possible. If that recognition is not critical, then creating highly detailed tanks will be a waste of time, energy, and money and will cost a great deal in game performance.

Figure 22.1 shows character sketches from the _Leaders_ project that we developed for Paramount Pictures and the Institute for Creative Technology (ICT) under contract to the U.S. Army. In this design, our artists chose a slightly cartoony style of character to make it easier for players to differentiate between characters so that they could focus more clearly on the complex leadership issues. We also developed a consensus that this would be appealing to today's soldiers. Clients within the military, Paramount, and the ICT approved the design.

Creating Characters and Objects

Many software programs can be used to create characters and objects in a 3D virtual world. Maya and 3ds Max are two of the most popular; both are from Autodesk.

FIGURE
22.2

A 3D model of Lieutenant Perez, an important character in the *Leaders* simulation. Note that Perez has cartoon proportions with large legs and feet that are out of proportion for his head. ©2004, University of Southern California Institute for Creative Technologies. Used with permission.

Open source 3D modeling tools like Google SketchUp do exist (to keep software acquisition costs lower), but they have more limited features.

Here is a quick outline of the creative process. The characters, which are created as illustrations during the preliminary design phase, are translated into the 3D models that are used in the game. Figure 22.2 shows the 3D creation of one of the characters from *Leaders*.

Many 3D modeling programs start with a set of basic shapes called primitives: a box, a sphere, and so on. The artist grabs part of the shape with the cursor and scales and shapes it to the desired form. A pull-down menu allows the artist to extrude the shape and create areas for the hips, the waist, the arms, legs, and the rest of the character's body. In actuality, the character and the objects—as well as the primitive shapes—are all made up of polygons (a flat surface with three or more sides). The number of polygons needed to make up the object multiply as detail is added to the character.

Consideration should be given to how much detail a character needs to be believable. Remember that too detailed an object (one made up of too many polygons) can slow down game performance. Is the benefit worth the cost? Here's an example: How many fingers do figures need? It might seem pretty obvious. Five, of course! But do they really need five? Or can they get by with "mitten hands," which differentiate the thumbs but nothing else? The extra polygons needed to create the fingers add to the data needed to represent an object—and with too much data to process, the game slows down.

Texture mapping refers to the process of applying texture to the shape that has been created. Textures sometimes come packaged with game development

software, and others can be copied from images of real items or drawn by the artists themselves. (There are also procedural textures, which allow game programs to generate textures themselves using math. These textures take up almost no memory but are not as believable as graphic textures.)

Using programs like Photoshop, artists take the texture and build something akin to a dissembled version of the character or object (the skin). Then the artist applies this texture map to the various shapes that make up the character or object. The process has to be done carefully so that the texture applies to the appropriate area of the object. Sometimes objects need multiple textures to be believable and accurate.

Environments and Game Engines

The game engine provides the code that runs the game. But it often also offers tools for graphics creation. (See Chapter 20 for our discussion of game engines and other development tools.)

Most of the environment in which the game will be played (the background) has to be built in the level editor of the game engine. But some of the terrain can be created in Photoshop as elevation levels. Basically, you draw high points and low points in an image as gradient areas. Then the game interprets that as high terrain and low terrain.

Objects within the environment (as shown in Figure 22.3) have to be built using character creation software and imported into the environment and the game engine.

Environmental artists are often specialists who are expert at creating great expanses. They understand light and shadow and perspective. The activity is usually done in parallel with other activities in the graphics creation process starting soon after approval of the preliminary design.

The environmental artist follows the work of the level designers who do the layout for each level during the preliminary design phase. The level designers indicate where the buildings are located, which way they will face, if there are any bridges or other objects. Level designers are part artist and part engineer. Graphics positions are increasingly becoming more specialized. For example, one of the key designers on the *Leaders* team only does lighting for games now. The same goes for other specialties including game engine programming.

Animation

In addition to creating the character, artists have to create animations of that character in motion (see Figure 22.4). That is, they have to create the skeleton of the character and then follow an animation list of the various moves that the characters have to make. In a sense, they have to move that skeleton into all the required positions needed to create that action and record those actions as though they were

FIGURE
22.3

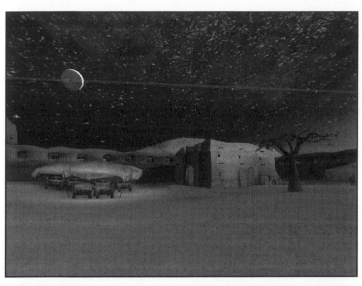

Background for scene from the *Leaders* project. Note the building, tree, vehicles, and covering, all of which are objects, not part of the background environment. ©2004, University of Southern California Institute for Creative Technologies. Used with permission.

FIGURE
22.4

A series of images from the animation of Lieutenant Perez as he looks up and sees the warlord and his troops converging on the hill. ©2004, University of Southern California Institute for Creative Technologies. Used with permission.

frames in an animated film. Some development programs like 3ds Max have procedural skeletons that are standard figures with fingers, toes, and segments, and they move in certain ways. These procedural skeletons may provide all the action you need. But for unique characters that move in unique ways, they have to be rigged.

The rigger is the artist who builds the skeleton and then links the vertices of the model to the program in such a way that there are 3, 5, 8, 10, or more individual frames of action, thus providing a walk cycle, a run cycle, kneeling down, standing up, and so forth. Once you have each of the individual action sequences you need for your character, then it is necessary to blend the motions in and out of the action to bridge between the last frame of a walk, for example, and the first frame of a run.

Motion capture is another way to create animated sequences. In motion capture, actors wearing glass-bead-covered Styrofoam balls operate in a zone flanked by dozens of infrared cameras. The cameras plot the position of the balls within the finite area of the capture studio and give a strong indication how the skeleton moves throughout the action. Motion capture seems to cost less than standard animation but usually requires extensive cleanup before the animations can be finalized. (Messy data, for example, sometimes result in unusual movements like fluttery hands or other distracting actions.)

Lip Sync

A unique feature of character animation has to do with the ability to show the synchronization of lips to speech during animated conversations. In film projection, it was always possible to thread a projector poorly, and this poor threading would result in unsynchronized lip movement. Audiences have been known to detect poor lip synch to within a 12th of a second, and the effect has always been distracting.

Cartoon animation has perfected a series of lip positions that make lip sync virtually perfect. Now better game engines include a lip sync component. Still, lesser game engines do not deliver the best lip sync, and the distraction in games that rely heavily on interactive conversations (as opposed to action sequences) is still an issue. In the *Leaders* project, we spent an inordinate amount of time and energy working to achieve believable lip synch with less-than-perfect results (see Figure 22.5). If interactive conversations are at the core of your simulation or learning game, then it is important to consider the problem and choose a game engine that delivers a strong lip-sync feature. In the end, our studies showed that random lip movements were preferred to attempts at lip sync that failed.

Special Effects

Games use two major kinds of effects: 2D emulation effects (a 2D effect that is trying to look like 3D) and volumetric or particle effects. In the former, a simple fire

FIGURE
22.5

Lip-sync test from the *Leaders* project. In this test, mouth positions for various letters in the text are synched to the narrative. ©2004, University of Southern California Institute for Creative Technologies. Used with permission.

effect, for example, can be generated onto a set of polygons so that, if you drove through that fire, it would look great from the front and from the rear, but as you passed through it there would be no fire at all. It only looks like 3D.

If you drove through a fire generated with volumetric effects, you would see the fire all the way through it. It would be true 3D. Game engines often come with standard sets of effects, and there are libraries of effects that can also be purchased. But if you need unique effects, your graphics team will have to build them. Good game designers will tell you that nothing ruins the sense of realism in a game more than poor effects.

Cut Scenes/Cinematics

A *cut scene* or *cinematic* is the name given to a movie-like 3D animated scene created within the virtual world with virtual world components. That is, when a specific action or scene is unique enough to stand on its own and it is not involved with actions by or with the player-characters, the art team can stage and build the cut scene as a standalone, prerendered piece that the game engine plays at the appropriate time within the game.

For example, in *Leaders*, a local warlord and his entourage walk up to the food distribution site that is the heart of the *Leaders* story. The walkup of the warlord and his troops was staged in the Unreal Engine and created as a separate linear entity (machinima). Then, whenever that point in the simulation was reached, the game engine would play that prerendered cut scene. Figure 22.6 shows a frame from the extended cut scene that we used at the start of the *Leaders* simulation.

FIGURE
22.6

Opening cut scene from *Leaders*. The helicopter flies over the food distribution site showing the activity of the soldiers on the ground and passing the command post where the camera settles on Lieutenant Perez and Captain Young. ©2004, University of Southern California Institute for Creative Technologies. Used with permission.

Engineering

The role of the engineer is to write the code that links everything together, defines the borders of all objects in the virtual world, drives the movement of the nonplayer-characters (NPCs) through the environment, maps all actions down to the controller, applies the functions of the controller and the game engine to the action of the player-character, tabulates the score, runs the puzzles, and so much more.

Usually there is one lead engineer who is responsible for the game engine itself. You also have animation engineers, infrastructure engineers (they do network, etc.), and artificial intelligence (AI) engineers who create the automatic behaviors that the animated characters perform. In *Leaders,* we had soldier NPCs whose only AI behavior was to string barbed wire for crowd control of other AI characters whose only AI behavior was to mill around.

3D Models—For Free

Today, 3D model libraries—many of them free—are available in order to speed art development. For low-budget projects, stock 3D models may be all you need.

(*Continued*)

The Google 3D Warehouse is one such library, a free, online repository where you can find, share, store, and collaborate on 3D models. Many of the models have been built to use in conjunction with Google Earth, and certain serious game applications may be able to incorporate usage of Google Earth for learning topics ranging from geography to architecture to public policy. However, the models can be used for other applications as well.

The 3D Warehouse, in combination with Google SketchUp, may substantially cut the cost and time needed to develop 3D assets.

Summary

- Art design and production are complex processes, particularly when 3D worlds are being built. The strengths and limitations of the delivery platform must set the boundaries for the kinds of art being used; the same rich detail we expect on a PlayStation 3 will only be detrimental for a game delivered via the browser or a smart phone.

- The graphics development flow moves from the initial preliminary design through character and object design, construction, and animation, typically using programs like Maya or 3ds Max. Environments are then created within game engines or world-building middleware. Effects animating and cut scenes are specialized art features.

- Engineering and programming then marries the art to the desired gameflow and interactivity.

CHAPTER TWENTY-THREE

Media Production

Introduction

In late 2008, startup company Virtual Mindworks became interested in using serious games to evaluate interpersonal relationship skills for purposes of job recruitment. The company contacted one of the premiere graphic artists and designers of multiplayer games in the country and asked his advice on creating a game to match its goals.

To the surprise of the sales force and most of the psychologists involved, the game designer recommended against their game featuring conventional avatars moving through a 3D virtual world; instead he recommended the use of interactive video. In spite of the fact that artists creating graphic characters and avatars have come a long way in constructing the likeness of human features, the designer felt it was still hard to create avatars that could present the full range of emotions needed to portray all the interpersonal interactions that Virtual Mindworks required. In essence, the designer was talking about the theory of the "uncanny valley" (see the box for a brief discussion).

As a result we, the contract producers of the system, turned from our original design for an avatar-based game to a game that used interviews with video characters to present and then test their concepts. We hired a professional video production group and went through a process that is much the same as film or television production and came up with an effective demonstration of the clients' system. Figure 23.1 shows the basic interface that was used in the demo.

In the previous year, in creating the firefighter safety simulation *Fully Involved*, we went through a similar process. We were building a computer graphics (CG)-based computer game, but in spite of the fact that the representation of all the characters was done in CG, the soundtrack relied heavily on prerecorded audio performed by actors. This is because audio performed by synthetic voices is still far from acceptable (the uncanny valley again in action). The synthetic voices are distracting, unbelievable, and guaranteed to break the immersive feel of the simulation. For the immediate future, assume that if you're going to use spoken audio in your games, it needs to be performed by live actors.

FIGURE
23.1

Sample screen from the demo for an interactive video simulation used to assess interpersonal skills. © 2009, Virtual Mindworks Corporation. Used with permission.

Consequently, whether you want to produce interactive video to teach interpersonal skills, linear video for cut scenes or other interpolations, or audio tracks for your 3D virtual world, you'll need to understand the process of media production to get the job done.

The Uncanny Valley

The first wave of sophisticated narrative-rich videogames in the 1990s used full-motion live-action video—often plenty of it. The downside of this video was its replayability factor: players got bored seeing the same video multiple times. When CG 3D environments and characters that could be rendered in real time became possible, full-motion video was largely abandoned.

However, a curious paradox exists when we see and interact with synthetic human characters, one that is beginning to seem fixed (rather than an artifact of a particular generation's discomfort with technology).

Cartoony humans (like *The Simpsons*) are synthetic humans we actually embrace: we recognize their humanity and similarity to ourselves. But as CG humans approximate real-life humans (such as in the film *Polar Express*), most people find them disquieting and a little disturbing. Rather than identify

(Continued)

more closely with these characters, the players' reactions turn negative and distanced. This phenomenon is known as the *uncanny valley.*[1]

For certain applications (particularly those in the "soft skills" arena), we may find that full-motion video will better suit our needs. Interestingly, we have noted a turn back toward interactive video in games. CG video is hardly going away; however, developers are now realizing that they can embrace every tool in their toolbox, and sometimes the use of full-motion live-action video is the best solution for transference of teaching points.

Asset Management

Having spent months in total confusion early in our careers as we tried to sort out the various media assets that we'd created for interactive games, we can tell you that one of the first and most important jobs in the process of media production is to come up with an identification and numbering scheme to use on the project before cameras ever shoot or audio ever records. Your writer may be adept at creating a script that accurately portrays the dialogue, sound effects, music, visual elements, and everything else needed to create your game, but if the assets aren't numbered clearly (with as much metadata attached to each asset as possible), your programmers are going to be faced with an almost insurmountable task in sorting them all out.

The best way we know to make sure that things go well is to hire an asset manager for the duration of the project. (Your budget may force your art director or audio-video director to also serve as asset manager, but this isn't ideal.) Our ace asset manager takes the script once it is approved and goes through it, numbering each shot, each piece of audio, each sound effect by the scene number, the character, and the shot. Consider these examples:

- If the first scene starts with a narrator named Tim offering a welcome and it all consists of one shot, it might be identified as TIM_001_001 (welcome).

- When the video is shot, the director identifies and slates the shot with that number (calls out the number or writes it on a slate that is placed in front of the camera before the camera begins to roll).

- The editor (who may be the same as the director on a low-budget project) gives the video clip that number (TIM_001_001.mov) when it is saved, and the software developer uses that same asset number in the code that plays the scene.

If the assets are clearly identified, the entire process becomes easier. It is not something you can do after the video is shot or the audio has been recorded. The proper

[1] First promulgated by Japanese roboticist Masahiro Mori in 1970, the uncanny "valley" describes the dip in a visual graph mapping the positivity of human reaction to near-human robots and animations.

time for the act is after the script is finalized (so all the assets are known) and before the media is produced (so the asset number is on the slate that identifies each scene).

Don't overlook this step. If you do, your life will be miserable, the project will almost surely miss its deadline, and everyone on your staff will want to kill you.

As we mentioned in Chapter 21, scripts can export character, dialogue, and action metadata in an XML format. This metadata can then be attached to each asset and extracted as necessary by the game's underlying code.

Subversion can be used to track project assets, but Excel or Google spreadsheets can also handle the job. (Many other asset tracking and database tools can also handle the task.)

Finding a Production Company

There are a lot of criteria that you can apply in your search for a competent production house to create your media. Sure, the quality of the company's work is important. Its resume, list of credits, and referrals from colleagues all help. But in addition to all those things, it is probably important to understand the tasks you will need a production house to perform so that you can find a company that can give you all of those services.

What should you expect from a media production company? Well, every company worth its salt can get a crew to a production site and record video and audio. But a good production partner needs to be with you through all the steps. As we walk through them now, make sure that the company you're interested in hiring can give you all the support you need, in casting, scouting the scene, lighting to assure good production values, directing the talent, and postproduction. You'll probably have specific audio needs as well. Can the company you plan to hire provide all of them?

Do-It-Yourself Production

You might be tempted to say, "Wait a minute, I've mastered iMovie and have gotten pretty good with my digital camera. I've posted quite a few quality scenes on YouTube. Why can't *I* provide the media elements for a successful serious game?"

Maybe you can. The rest of the chapter describes the tasks that are needed. Read through them and ask yourself if you can do the job. Would you hire *you* if all things were equal? The savings in cost may be worth it. But remember, today's audience has zero tolerance for poor media production. Raised on the unbelievably high production standards of blockbuster movies, television ads, and commercial games, they won't tolerate audio that is too low or has noise in the background, shots that are poorly lit or out of focus, camera moves that are bumpy, or actors who are amateurish and not believable.

You won't want to sacrifice the effectiveness of your game just to save a few bucks. If you're confident, give it a try. But don't forget that you're in charge of game development. You're the producer, and a producer's job is to hire people who are competent and fire those who aren't. Good production houses can provide amazing quality with fast turnover. Can you? If not, you may end up having to fire yourself to assure that your game is a success, and that will probably occur after quite a bit of money has been wasted.

Casting

Let's say you have a game that employs a 3D virtual world but needs human-voiced audio. You need an actor who can deliver that voice in a believable way. Let's make it more complex. You're making a game for a nongovernment agency (NGO) that is involved in a peacekeeping effort in Afghanistan. Now things are doubly complicated. You need an actor who can deliver a believable voice with a believable Afghan accent. Let's kick it up another notch. It's video, so you need an actor who looks and sounds like an Afghan villager. Where do you get a person like that?

Here's the ideal approach. You go to a production company that has experience with casting. The company may have its own stable of actors standing by, or it may have close ties to a casting agency. When you hire the production house, you make casting part of the deal. On the predetermined day, the company calls you in, has a camera ready, and has arranged for actors to read for all the roles in your game. Each actor then reads an important scene from your script (known as a *side*) under the direction of the company's director. After you've seen a few, you and the director pick the actors who can do the job. The company hires them, pays them (probably union scale), and gets them to sign a release that allows you to own the use of their image in the game any way. That's how it should be done.

Here's an alternate, low-budget approach. You go to your local college or community theater and get the names of some actors who can do the job. You still tape them under the guidance of a director (who may be you); you still call in at least three or four for each part. You have a harder time deciding who is best, but eventually you make up your mind. You create some kind of release, and you have them sign it. You pay them something just to make it legal.

Here's what you *don't* do—ask your friends to play all the parts and have them show up on the day of the shoot, where you give them the script (for the first time). Because they're your friends, you decide you don't need the release, so you just let it slide. After all, your friends won't come back and ask for more money if the game becomes a big success, right?

Approach 1 is always our recommendation, but it may require you to travel to a major metropolitan area to find a good production house and a good casting pool. In addition, we've found that there is quite a gap in talent and professionalism

between Screen Actors Guild (SAG) and American Federation of Television and Radio Artists (AFTRA) members and non-SAG/non-AFTRA members even when you're reaching into the college theatrical pool of actors.

Audio Recording

Let's go back to our hypothetical 3D virtual world game that is using human-voiced audio. You've got your cast, and it's time to record. If this is audio only, you stay with your production company, which sets up a time when everyone is available and calls you in at that time. The company gives you a comfortable chair, puts the actors (one at a time) into a soundproof booth, and records their lines under the supervision of the director. The director picks the best takes—with your approval—and even asks if there are any considerations you have that need to be attended to. Speak up! If something is bugging you, say so. If you want to change something later, you'll have to call the actors back, rebook the studio, and pay as much as you paid for the original recording session all over again.

You give the actors advice through the director so the actors don't get confused over who is in charge. A script supervisor or your asset manager is there to make sure that the takes (individual recordings of the bits of dialogue being recorded) are all slated verbally with the appropriate asset name (when the actor playing Tim reads the welcome scene, he begins by saying "Scene: Tim zero zero one zero zero one—take one"). The audio engineer reads out the time code numbers of each take so that the director knows which take matches each time code number of the audio. (Time code numbers are assigned to each 30th of a second of audio by the record system.) The director will say, "That's the best take; circle it" (or "Put a star next to it" or something similar) so he or she won't have to listen to everything all over again to find the best performance. When the recording session is finished, the director has all the audio recorded and a complete asset list with takes and time code numbers identified. The script supervisor also has a signed release from each actor, and the actors (probably) have all been paid on the spot. That's how the actors' union (SAG or AFTRA) wants it.

That's how it should work. Of course, you can also go into the conference room in your office, turn on your digital movie camera, and record every one of your friends, along with all the room noise and everything else that is going on (try to avoid the planes flying overhead or the trucks going down the street). But for your own sanity, you'd still better have the actors read off the scene numbers, have the asset manager take notes, and somehow get frame numbers or some reference so you won't have to listen to all the takes again.

If you're not using professionals, don't be surprised if you need dozens of takes for a good line reading (professionals, on the other hand, can usually nail a line in a couple of takes). Interestingly, in our experience professionals usually only get better as they read. Nonprofessionals almost always get worse.

Location Scouting

Let's assume you have a game needing video. The scriptwriter has identified the scenes and described the settings. Someone has to go out and find the location needed to represent those settings—that is, the places to shoot. You and your colleagues may have some ideas: conference rooms, parks, exteriors of office buildings, and the like. If you set up the shoot, you'll have to get permission to use the space, so that you don't get arrested or chased away by security or the police. In many cities, you need a formal permit to set up a camera and begin shooting. As noted, *you* can do it, with perhaps some difficulty, but if you've hired a production company, your producer will handle the scouting.

Once locations have been narrowed down, your director will need to scout, making sure he or she has the following:

- Enough electrical power to run the cameras and equipment
- Room for all the lighting gear
- A good sense of necessary and appropriate props

The amateur will decide not to scout and instead will just show up somewhere and pray that the space and the power will be OK and that no one will be bothered by all the commotion that starts when shooting begins.

Green Screen

A popular alternative to location shooting is "green screen" shooting, where you go to a video stage, set up a green background of a special shade, and then shoot your actors in front of it. Using a process called *chroma-key*, you can then put graphics, photographs, or video anywhere that the green screen appears behind your talent. (Your local weathercaster uses green screen.) Your professional production company probably has deals with studios that offer green screen setups, so the process can be quicker and easier than location shooting. It's easier on the actors, the crew, and just about everyone but the video editor who has to pop those backgrounds in behind the actors. Actually, it's generally easy for the editor too, as long as he or she knows how to handle it.

If your mastery of iMovie hasn't progressed to the green screen editing stage yet, then you may need to have the production company do the editing, or shoot on location. Green screen can look sloppy too. Ever see those ads where the attractive spokesperson is standing in front of the local Dodge dealership and somehow there's an electric outline all around her? Sloppy green screen editing does that (and so does bad lighting).

Preproduction

Casting and location scouting are part of preproduction. But there are other issues as well: hiring the production crew, making sure you have all the lighting equipment necessary, getting together the releases, generating the log sheets so that you can keep track of the shots, and getting copies of the script. If there is a lot of narration to be delivered (as in a host making 120 seconds worth of opening remarks—ugh!), you might need a teleprompter. If so, then the script content has to be entered into the teleprompter system (or ported via XML or other file format). That means you may need a teleprompter operator (although mobile teleprompters are increasingly run as part of the camera operation).

A simple production usually requires at least three people: a lighting person, a script/continuity person, and the director/camera operator. You can then add on to that list a makeup artist and at least one gofer (sometimes called a *production assistant*). Good production houses also have an engineer to attend to the quality of the picture; they might also have a separate person for audio and, as noted, a teleprompter operator. If you're working with a production house, you'll probably have a producer assigned to you. She'll be in charge of everything and will get all the people signed up and ready to be at the location on time for the shoot. She'll also manage your budget and will be able to give you clear knowledge of what everything will cost when it's over.

She should also arrange for food *craft services* for the crew. Make sure you have an understanding about food requirements before the shoot. Otherwise you could get stuck with the job of driving around looking for a place that serves food out in the middle of nowhere. Union actors have strict rules about when they should eat. The upside is that it means that you and your crew will be required to have meals at the proper time as well.

Preproduction is also about wardrobe and makeup. Discuss the clothing required by your production with the actors. The producer should tell them what to wear during the shoot. If possible, have them bring a selection of their own clothes. Then you and the director can pick out the outfits appropriate for the scene when the actors show up for production. Makeup might seem like a luxury, but it isn't, and you'll need a makeup person for both men and women. Otherwise you'll see everyone at his or her worst, and the shiny pates and dark circles under the eyes will make your production just that much more unprofessional.

Preproduction, it turns out, is just as hard as production, and it's important to note that if any of these tasks isn't performed, they may delay or even cancel your shoot. If you're planning on operating on your own, *you* have to do all these things. It should make you think twice before you get a few friends together, grab your Sony digital video camera, and head out to the park to shoot the video elements of the game you're making.

Production

Now let's move to the location and get things rolling. What has to happen when production begins?

Lighting

An awful lot of production is about lighting. That's why, when you start your production day at 8 a.m., the crew has been at the location since 6 a.m. getting the lighting ready and setting up the cameras and sound equipment. You get there at 8 a.m., and then you learn that the first actor won't arrive until 8:30 a.m. and then will spend half an hour getting made up and into the right outfit. That at least allows more time for setup and lighting.

A *setup* is the term for getting the camera in place and getting the lighting right. A shoot day is usually broken down into setups. A good producer or director will ask you (and then double-check the script to find out) just how many setups there are. They estimate the number of hours or days required to produce a video by the number of setups. Once the camera and lights are set, you can go through a lot of script, with lots of different actors, but you have to spend another couple of hours to do another setup. Three setups a day are about right—if there aren't too many actors and scenes per setup.

We won't try to explain why lighting is so important. Let's just say it is (along with the actor's delivery) one of the most obvious elements that make a production professional. That's why the director and crew will spend so much time worrying about shadows, bad reflections, empty areas in the shot, and so on. Performers don't look good with dark shadows across the corner of their faces. The task of lighting seems endless, but you'd better learn to live with it because it is crucial.

Let's say you decide to ignore everything we've said so far. You plan to head out with your digital camera and shoot. Here are some proven lighting tips:

- Use available light so that you don't have to play with lights all day long.

- Don't shoot into the sunlight; turn your subjects so that sunlight is shining *on* them.

- If you're shooting outside, try to shoot on an overcast day so that the actors don't have to contend with bright sunlight shining into their eyes and the lighting looks even (no bright spots and dark shadows).

- If you have to shoot inside, choose a room with a lot of windows so that the light from the windows illuminates the subjects.

- If there are heavy shadows on the subject's face, use a piece of white cardboard to reflect light into the shadowy area to even out the lighting.

- Choose a neutral background that won't distract from the actor.

- If you're using props, don't put too many behind the actor. This will allow you to use the background for a variety of situations—and there won't be issues with something in the background disappearing because you've done a retake and forgotten to put the item back in the shot.

- Pay attention to the way the light is changing throughout the day. You may need to intercut shots, and if the shots are taken hours apart and the light has shifted, the change in lighting will be noticeable and distracting.

Directing the Shoot

Your director is in charge of the shoot, and your job (and the producer's, and everyone else's) is to be quiet and let him or her work. Not long ago we were out on the set with George Lang (pictured in Figure 23.2) and his Marin County production company. Let's use George as a model for the way things should be done.

When we arrived on the set, in this case a large office, the entire far side of the room was filled with a camera, a viewing monitor, and a place where we could sit with the asset manager. After half an hour of lighting refinement, the first actor came in, and George ran her through her lines half a dozen times before he decided she was ready to be recorded. George did the first take and asked if we were satisfied.

FIGURE
23.2

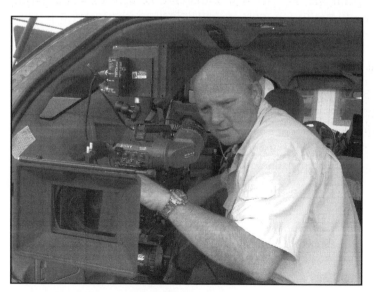

Director George Lang, from The Big Picture, framing the shot. The production company performed all the preproduction and production activities we described in this chapter— from casting to location scouting to handling the preproduction and running the shoot. © The Big Picture Film & Video Arts, used with permission.

There are some things you should always tell a director; other things are a judgment call. *Always* tell the director:

- If the actor is not doing all the things that you need for the game (action, expression, etc.)
- If the actor is mispronouncing important names, words, or phrases
- If the actor is not getting the point across because of bad delivery
- If the actor ad-libs a line and changes the meaning of the dialogue
- If the scene isn't slated properly
- If the framing of the shot won't work in the interface you've designed for the game
- If the action the director is calling for conflicts with action or staging of the scene in the game itself
- If any props are inappropriate
- If you agree that the take was good
- Anything else that has to do with the *content* of the scene

Maybe tell the director:

- If you feel that the take could be better (but after about 20 takes, when George felt that the actor had done as well as she could, we decided the better part of valor was to trust his judgment)
- If you think the framing of the shot could be better
- If you feel that the action in the scene could be better

As we've already mentioned, you shouldn't be giving your own direction to the actor. Tell the director and then let the director convey the instruction to the actor. Disregard this practice, and you'll have a confused actor and an unhappy director on your hands.

But let's say you have your camera, and you're the director. It's suddenly your job to do all the tasks we previously ascribed to George, and during production that means the following:

- Rehearsing the talent and getting the best possible performance
- Making sure that the actor's delivery is the way you wanted it
- Confirming that the shot is framed correctly
- Confirming that the action is as needed by the game
- Checking that the shot is slated correctly
- Making sure you call out the best takes when you get them
- Keeping tabs on your digital storage capacity

- Making sure you have plenty of batteries

- Making sure you're using a tripod and that your camera has a power zoom (because if anything gives video a nonprofessional look, it's a shaky camera or zooms that are jerky)

- Getting the audio right (a good level, not background noises, no popping of certain words and letters by the talent)

If you don't have that checklist completely nailed, you're probably going to need another day of shooting—and suddenly your costs (even for a do-it-yourself production) are going to skyrocket.

Incredibly, there are still further considerations on location. A small yet important matter is to avoid pulling the general public into your shoot. If anyone wanders into frame clearly enough to be recognized, you'll need to get a release from the person that allows the person's image to be used in your video content, and getting such releases isn't always easy. Even license plates that might be visible in the shot need to be covered up.

Music and Sound Effects

Many serious games and simulations will require a music soundtrack. The soundtrack may simply provide an ambient backdrop (an Indian flute for a simulation set at Chaco Canyon, for example, or Middle Eastern instrumental music for a training simulation set in Afghanistan) or cue segments and enhance emotional responses (an advergame or social change game).

You have three options for creating a soundtrack:

- Make your own.

- Hire a composer.

- License preexisting music.

Make Your Own Music

ProTools is the industry standard audio production suite for creating and editing digital music. Sound Forge is another premiere commercial suite, and numerous open source packages also exist for the creation of rhythm tracks or full-blown music tracks.

The creation of rhythm tracks is easy for the amateur music producer, but whether the rhythm track really complements your project is a difficult call to make for most amateurs. Your audio engineer can cue and blend your music in a mix with the remainder of your audio assets, but he or she can't make the music good if it isn't. Unless you have some previous background as a musician or composer, we recommend finding a professional. Bad or cheesy music is incredibly distracting and can sabotage an application.

Original Composition

An original music composition can add a layer of polish to your application. It's certainly not necessary for all applications, but if you feel like music may enhance mood, immersion, or overall game understanding (e.g., cues to represent new levels or chapters)—and if you have a little room in your audio budget—then you should explore adding an original music soundtrack.

So where do you find composers? The American Federation of Musicians local is one source, and the union has special contracts for videogame composition and performance, which can keep costs to a minimum.

The music program at your local college or university is another good source for potential composers. Contact one of the music professors; you may find that he or she would be willing to offer compositional and performance services at a low cost (the professor may be looking to build up a portfolio and also show professional advancement for future tenure reviews), or you may find that the professor can recommend a promising student who can intern as a composer and musician.

Videogame music composition is different from any other form of composition, of course, so having your composer learn on the job may be more risk than you wish to take. (It might work, or it might be a disaster. Most likely it's going to be a little bumpy.)

Past videogame compositional experience is a key factor in hiring, along with whether the composer is the right person for the job. Any professional composer will have a demo CD of past projects and works. Listen to a few demos from potential candidates, see whose work you like, and then discuss your application, its needs, and its deadlines with your final candidates. Find out what the candidate's process is like and what the candidate's vision for the project is. Does it mesh with your own, or will the candidate go in a completely different direction?

Typically, you will need to contract for all publishing rights to the compositions (the composition is a work-for-hire), although composers typically retain performance rights.

Licensing Music

Rather than commission original music, you may decide to license preexisting music. This can often be cheaper than paying for original composition. It all depends on what you license.

Licensing full-length commercial popular music tracks is expensive (costing multiple thousands to multiple millions of dollars, depending on the song and artist) and probably far out of the realm of virtually all serious games and simulations.

Licensing music drops (short snippets of recorded music tracks) is a cheaper alternative, and for some applications, music drops may be a great way to add interest and cue content. Costs will vary. Licensing a music drop from a Beyonce or U2 song is going to be enormously expensive (even a few seconds of it). However,

stock music operations will license instrumental music in a variety of genres—all of which has been specifically composed for the purpose of music drops. Whether it's world music, reggae, or heavy metal, you'll have no trouble finding the right mood and right accompaniment.

Your audio engineer may be able to recommend a favorite music drop source, and many recording and sound editing studios have libraries of music available for their clients. The engineer can then work with you to select drops and blend them with the rest of your audio soundtrack (dialogue and sound effects).

Tips for Your Music Soundtrack

- If you think your application will need a music soundtrack (even if it's just a few seconds of running time), plan for its production as early as possible (see Chapter 9 on project planning). Wait until you're in beta testing, and you'll find you don't have the budget and don't have the time. Locating and culling composer candidates, listening to demos, and hiring your composer all take time: obviously, composing and performing also have a timeline. If you're licensing music, you're going to need to listen to a lot of music drops to make your selections (or your audio engineer is going to need to do this).

- Original music is intellectual property, and a work-for-hire contract for original composition needs to cover all rights and parcel them out, either to standard industry practices or to what you can negotiate. You already have that lawyer, right? (See Chapter 7.) Don't write up a contract on the back of a napkin that will be "worked out later."

- The wrong music soundtrack will undermine your application. Test the soundtrack (as a standalone, and then integrated into your game) as early as possible. Studios sometimes misjudge composers and soundtracks and find they have to scrap soundtrack A and work on soundtrack B. If $250 million projects can go astray, so can $250,000 projects.

Sound Effects

Even more basic than music is the need for sound effects. There's nothing like the emptiness that exists when a player sees a soldier running toward a wall and clambering over it but doesn't hear the soldier's footsteps or the sound of feet coming down in the dust on the other side of the wall. Where do you get those sounds?

Sound effects libraries are even more plentiful than stock music libraries and often come as part of sound editing packages or even on your computer itself. We populated the soundtrack of our Virtual Mindworks Simulation with phone rings and other effects from the basic Apple sound folder.

But sound editing is an art, and the more realistic your simulation or game, the more important the sounds become. They have to be mixed with the rest of the

background. If there is no basic level of background noise in the soundtrack, there is a noticeable and unprofessional drop-off that all sound editors will feel that they are required to fill. If they don't do it, your players will be distracted and it could affect their learning experience.

Audio/Video Postproduction

Somehow, you've managed to get all the video shot and the audio recorded, and it's all been captured in digital files that can be edited. There are three steps left, and, amazingly enough, you probably *can* do some of these yourself.

The Rough Cut

The act of sifting though video and putting the shots together into a rough order takes a lot of time and may be the kind of thing that the video producer can do. The rough cut doesn't require that green screen backgrounds are inserted. It doesn't require that the sound be mixed or the audio levels balanced. What it does require is that the takes are assembled in a rough order so they can be looked at and judgments made about them. An editor in the production house can pull out the best takes from the shot log and send them to you so you can make the final decisions. Or you can do it yourself. iMovie is fine for this (Final Cut Pro, as shown in Figure 23.3, is even better, of course). Allow a couple of weeks (at least) for the task.

The Final Cut

This is a much tougher proposition. The final cut has all the shots trimmed to the appropriate length. If any creative editing has to be done (matching action and solving coverage problems), they're done in the final cut. Transitional effects are added (fades dissolves, etc.). Green screen backgrounds (often known as *plates*) are inserted. The audio has to be balanced. And the entirety of video and audio has to flow. If you have enough experience with your editing tools, you may be able to do this job as well. If not, pack up your rough cut and take it to the production house, where an experienced editor can do all the things we have just described and can do them rapidly.

At this point in the process, we come back to things that have to be done when you don't have to deal with the picture, just the sound. Though it's the last stage of the final cut, we have broken it out into a separate task called *sound editing*.

Sound Editing

No matter how good your sound recording people are, and no matter how good your director is, the sound somehow is just never perfect. There are always external

FIGURE
22.3

Editing screen from Final Cut Pro showing the browser (list of clips), Canvas (viewing screen), Audio Viewer, and the Timeline (where clips are assembled and effects—in this case dissolves—are added).

noises; there are always differences between the volume of one scene and that of another; there are always sound effects that need to be added because the sound that happened during the shoot either wasn't there or didn't work. This is sound editing. If you aren't proficient at it, your idea of doing the final cut may not be a good one. An experienced sound editor can *work* that soundtrack, equalize the volume, add the effects, fill in all those unexpected moments of dead silence with room noise, and even blend in a little music. This step has to happen even if there is no video.

Some game engines allow developers to mix the sound as part of software development. You get the pieces, and your software developers put the soundtrack together as they are building the game. But more sophisticated game soundtracks mean that the soundtrack is mixed outside the game and delivered in larger pieces to the engineers. If you're dealing with that sort of sophistication, we suggest again that you go to a professional sound editor to get your soundtrack assembled. The same sound editor can also pull from his or her sound libraries and find and deliver the isolated sound effects that your engineers call for.

Once the audio elements are labeled with the asset numbers identified by the asset manager—or your video segments (with a well-mixed soundtrack) are delivered in the same way—your media production days are behind you, and you can get back to game development.

Summary

- Although synthetic voice audio is certainly possible, the makers of most serious games and simulations requiring dialogue still turn to human beings to voice the audio. Some applications require the production of live action video, instead of (or in addition to) computer-generated animation and screen interaction. (This may be because of the uncanny valley, where synthetic onscreen humans fall short in their interactions with the player.)

- Although do-it-yourself production of live-action media is possible, professional-quality video production is still desirable, as users are rarely forgiving of amateurish video or audio.

- Video production can be divided into preproduction, production, and postproduction. Each phase of production requires that multiple tasks be completed.

- Good asset management is a critical component of live-action media production. You can be Steven Spielberg and it won't matter if you can't find the asset you're looking for when you need it.

- Music and sound effects are two other components of game audio. Good planning can vastly reduce the costs of music acquisition.

CHAPTER TWENTY-FOUR

The Production Pipeline

Introduction

Production and game assemblage may take a matter of weeks or may take a year or more, depending on the size of your project. You've put together a team, analyzed your needs, translated teaching content into effective gameplay design, created the necessary road map documents, chosen your software tools, and are now in the process of developing your media assets. Now it's up to your coders and artists to play nice together and build the project to specification.

How can we make sure that everything flows through the pipeline, avoiding bottlenecks and bad handoffs? What is a typical production process? While drawing from our own experience, we also talked to several small shop game developers to get their perspective on how production works.

The overview in this chapter will be just a taste of game production. Many books are devoted solely to programming flow within game production, and we refer you to those works for a more thorough treatment of the topic, as matters like the comparisons between programming languages like C#, Lua, or Python are beyond the scope of this book.

Milestones

Milestones are game deliverables intended for client review and demonstration of production progress. In the commercial game development space, payment is usually triggered by milestone deliveries and acceptance. In serious games and simulations, milestones help keep projects on time and (one hopes) prove that production is headed in the right direction.

We should note that milestones often have strict legal definitions within contracts. But we're not hewing to legal definitions in this brief overview. We'll instead look at milestones from the developer/programmer/art director standpoint.

FIGURE
24.1

Production phases and key activities.

Milestones largely delineate production phases. Figure 24.1 walks through these phases, and we'll quickly tour each.

From Concept Phase to Alpha Phase

Experienced game developers tend to focus on the development of core technologies first. According to Justin Mette (founder of 21.6 Productions), core technologies "might include new game modes where we try to establish fun factor, scale, and general level layout."

Some games or simulations may require extensive prototyping to be sure they're going to work. Eitan Glinert (founder of Fire Hose Games) says that "For our first game we [initially] made three prototypes in one week to try out general ideas. After testing them and analyzing the results, we made a larger prototype in a month to [fully] test out if the idea was viable."

"We're looking for the 30,000-foot view," says Kam Star, the CEO of PlayGen. "Functionality and deployment issues. A little demo is something we do quite quickly. We want to make sure we get the client onboard with what we're thinking. That's key."

Often, programmers prefer not to work with finished art at this stage. Dummy art ("crappy programmer art," according to Glinert) will sometimes work just fine for testing out core features and concepts.

In *Fully Involved*, one of the key early issues was figuring out whether the timing and physics of a house fire—and its advancement through stages—could be juggled simultaneously with firefighter animations, character paths, and user interactions (within the preferred game engine). Once the programming team could get this kind of sequence crudely running, they could have confidence in the overall design and begin building out fire sequences and developing an entire level.

Although some developers and programmers may refer to these early stages as the first alpha milestones in game production, it's probably more common to consider this a prototyping, first playable, or core technology phase.

During this time, custom authoring tools (if necessary) should also be built. (See Figure 24.2 for a custom tool that is now being marketed to other developers.) These might include graphical user interface (GUI) builders or art or programming pipeline middleware. Typically, these tools may be needed when higher-end game engines are used on higher-end projects—a simulation or training game using Gamebryo or Unreal, for example. An ambitious authoring tool set may actually require more code writing than the game itself, as it can include game code, GUI code, validation code, and meta-code, which will aid later user assessments.

Glinert believes it's critical to invest ample time in this early production phase. "Every day you spend upfront trying out different ideas will save you weeks down the line when it becomes much harder to change things and try out new features."

"One of the biggest production challenges is getting the design right," says Star. "The user interaction, the way to get feedback, the functionality. You can find out it's not very easy to play or it's not easy to get into, and that can be a problem."

FIGURE
24.2

PlayGen's proprietary authoring tool set *SG Creator*, which the company also markets to outside developers. The authoring tool set makes it easier for artists and game designers to build levels without having to worry about programming requirements. It also simplifies publishing to a variety of platforms. ©2009, Playgen Ltd. Used with permission.

Alpha Phase

With essential core technology programming out of the way, one or more alpha milestones begin to be met. Traditionally, serious games might have had a single alpha milestone, usually defined as the point where all key features were integrated into a playable game and the learning objectives became fixed. For some smaller games, a single alpha milestone may still be sufficient.

But with lengthier projects, several key alpha milestones are usually set. If we think about it, this is largely time driven. As Mette points out, "We plan milestones to be anywhere from 6 to 10 weeks in duration, with 8 weeks being the sweet spot. Anything less than 6 weeks and there really isn't enough time to develop a cohesive deliverable for the client. Anything more than 10 weeks and there is too much content to bring together easily into a stable release."

A typical alpha milestone might be as follows:

- A vertical slice of the game that shows key gameplay mechanics or full implementation of the instructional design

- A key simulation sequence

- A walkthrough or flythrough of a first level with integration of the user interface (but not yet fully populated with animations and triggered interactions)

- A significant demonstration of in-game multiplayer interaction

These milestones may be driven by the need for a demo at a trade show or conference or a key meeting with investors midway through a project. But they should also serve as critical necessary steps toward production completion.

During this phase, custom authoring tools (if any) should be getting polished and finalized. Middleware tools (custom or off the shelf) should be fully integrated into the pipeline.

When media assets are ready to be integrated into the workflow, it's fine to bring them onboard, but the use of placeholder media assets is still more than acceptable at this stage. Scratch audio and scratch video are likely to be used until the final rounds of production; simple animations are often preferable to complete animations that are trickier to time and place.

One caution in the use of scratch assets is that the real, finalized assets are often much larger than the scratch assets that are used. This can create memory issues, timing problems, and so on. As much as possible once levels start being built, scratch assets should try to approximate the size of the real assets.

Your authoring tools and content pipeline should be set up so that scratch assets can be directly replaced with the final versions. If this swapout hasn't been planned for, coding may need significant revision and unanticipated glitches and bugs may result.

Ideally (particularly if they're under the same roof), artists and coders should be able test out new content in the game immediately (in a real-time preview), rather than having to wait for a lengthy build of all code and assets to compile. This rapid

iteration capability should be a key feature of the game engine being used. That said, it's typical to then compile a full content build nightly (or at least two to three nights a week), so the latest and greatest version is available to the team on a regular basis.

During this phase, you may find out that the user interface specified in the design document isn't the right one; you may discover that a "fun" minigame isn't fun until a new user interaction is added; you may realize that inventory features are being wasted and should be removed.

PlayGen's CEO Star tells of one project that artists and programmers thought was meeting all design document requirements. But the client thought otherwise. "The good thing was that we'd separated the user interface from the underlying algorithms and data sets. We could redesign the user interface and completely redesign the game in 10 days." Star indicates that PlayGen tries to maintain a separation of design and code as much as possible through production: their proprietary authoring tools help considerably in this regard.

As these discoveries suggest, testing is crucial throughout the process of production. At this stage, the testing focus is first and foremost on functionality and playability, although stability remains a top priority.

Fire Hose Games founder Glinert sets up weekly deadlines to help with progress toward larger milestones. "Small deadlines happen every week when we bring in external testers, as our game must be stable and have new features in for us to test. I would say these deadlines are critical as they help us make those small, incremental changes as we race toward getting large feature sets implemented for our milestones."

Star echoes Glinert's point about external testers. "The problem with in-house testers is that they get used to a project very quickly. They stop noticing that the interface isn't friendly or the gameplay isn't fun. You need a fresh set of eyes. You think you've got the project right, but you haven't."

A final alpha milestone will indeed be when all required features have been integrated into the game. They may not all work smoothly yet, but nevertheless, they've been implemented—and any critical gameplay or game mechanics flaws have been eradicated. At this point, the feature set should be locked, as well as the learning objectives and the implementation of the instructional design.

Beta Phase: Part 1

By this stage, media assets should be getting finalized. Animations should be getting last-minute tweaks, objects and environments should be getting polished, and audio and video (if any) production should be getting scheduled and produced.

The beta milestone phase begins when the feature set is locked. From there, the full game will be assembled and polished. "The focus of beta is typically to bring together all of the core features into a cohesive experience and integrate assets," says Mette. Scratch or dummy assets are no longer acceptable; neither is gameplay

that still isn't working correctly. Tools for the collection of user assessment data need integration. Splash screens, cut scenes, leader boards, and transitions between game levels need insertion. If real-time data are being pulled into the application, then the feature needs to be made fully functional. Gameplay should be balanced (made easier or made more challenging based on testing). The beta phase should also eliminate all known bugs.

The classic definition of a final beta milestone reached is that the game should be considered shippable. "We'll fix things after the beta" is not an acceptable stance. Of course, more will have to be done after the beta milestone delivery, as we'll explain shortly. It's become a cliché in the game development business that crunch time is inevitable during the beta milestone phase (and possibly earlier milestones as well), with team members working 70- to 90-hour weeks to meet deadlines.

We've seen it, and we'd just as soon avoid it. If your project management has been first rate, then you may be able to ratchet crunch time down to "little crunch time." Everyone will be much happier if you can do that!

The Daily Grind

One approach, from Eitan Glinert: "Each day we sit down in the morning and have a quick, scrum-like meeting where we quickly go through announcements, say what each person is going to do for the day, and rate how successful we were at doing our tasks yesterday. We also quickly point out any dependencies that our work relies on (i.e., I'm blocking your work, or I can't do X until you do Y). At the beginning of each week, we have a design meeting for what we're going to try to do for the week, which we then use as our 'big picture' of features we want to implement. At the end of the week, we almost always do user testing, which is great for many reasons, not the least of which is that it ensures that we have a stable build and that we've made real progress. The testing session is then a springboard for the next week's design meeting."

Potential Bottlenecks

Project planning is the best way to avoid the potential bottleneck of programmers waiting for assets, especially during the beta production phase. (As already noted, placeholder assets should work during the alpha phase.)

Often, debilitating bottlenecks derive from dependencies that were never fully acknowledged during the project planning phase. (See Chapter 9.) The integration of custom authoring tools or middleware can be one potential bottleneck: often, insufficient resources are assigned to this aspect of game programming, and

suddenly too much time is being spent debugging and rebuilding tools rather than coding for the game.

Fire Hose Games' Glinert cites lack of communication as the biggest bottleneck in the production pipeline. "If people aren't clear on what they should be doing or aren't making sure their work is compatible, they will end up making assets which need to be redone once others realize they're flawed. Redoing assets that could have been done correctly the first time with a bit more communication is a huge time-sink."

Attack of the Feature Creep

Feature creep is the term for an ever-expanding application, as clients, designers, and programmers continue adding feature after feature. It's a bit like adding Christmas tree ornament after Christmas tree ornament. The tree will start looking terrible; it may even topple over. Decorating becomes a never-ending process, because, let's face it, no one wants to "undecorate" a Christmas tree. (We first mentioned feature creep in Chapter 9.)

During the game design process, your application will benefit as team members brainstorm features and extensions to the game. During the initial phase of production, new features may have to step in for features that didn't work in the initial prototyping or that are discovered to have significant value to the finished application.

But by the time alpha milestones are looming, the game should really be locked in terms of features.

Feature creep will delay delivery, increase your budget, and, in a worst-case scenario, derail a coherent game experience, thereby damaging or destroying the game's value. So how do we stop feature creep?

"We shoot people that say, 'What if ...' past a certain date. It's amazing how quickly people learn after a few gunshot wounds!" Glinert says, tongue-in-cheek.

He continues:

> Prioritize wish list features so that at any given point you are working on the highest priority new features. It's also important to be vicious about cutting out any noncritical elements of your game that don't support the central drive of what you're trying to do. Try to identify especially costly features with little payoff (online multiplayer, dynamic difficulty adjustment, several different language options) and cut those out early if they aren't critical.

But Glinert admits it's "much easier said than done." Mette concurs: "Feature creep is really challenging to manage on game development projects because they are so experience driven."

As hard as it is to control feature creep within your own development team, it is even harder to manage in your clients and subject matter experts (SMEs). It may come from a general lack of confidence that almost everyone feels toward the end

of a project before the final version is reached, but it is common for clients to suddenly start asking about an entirely different set of features that no one has ever thought about or discussed before.

On a recent prototyping project, we created a series of virtual discussions in which responses were generated in text in comic book–style word balloons. Two days before the prototype was due, the client decided that we should drop the word balloons and add synthetic audio instead—*a whole new feature set!* One critical technique for dealing with feature creep is to make sure that *change in scope* is defined in whatever contract you have with your client, and then remind your client that any major new feature is a change in scope.

Beta Phase: Part 2

You've reached the beta milestone—a stable build of your game exists. But now testers are going to need to try to break the game and otherwise stretch it all out of shape. Can they eradicate every bug? If they think the can, then you'll reach a quality assurance (QA) phase of production.

These bug-testing phases are often given short shrift in scheduling and budget for low-cost serious games and simulations. Yet the beta-testing and QA-testing phases are critical, even more so for serious games that teach or train. The next chapter explains why—and how you can squeeze a lot of testing into a low-budget project.

Summary

- Game production is typically segmented into milestones. This is where programming will breathe interactive life into all the concept art, design documentation, character design, terrain building and populating, and animations—as the game slowly (and sometimes painfully) emerges.

- While there is no fixed set of milestones, developers and programmers usually expect a design/prototyping phase (where core technologies are worked out), an alpha phase (where gameflow and game mechanics are built out), and a beta phase (where finished assets are integrated with program functionality and the game is debugged).

- Developers employ a variety of techniques to keep production on track and keep to schedules and deadlines. These techniques include an emphasis on team and client communication, the use of placeholder assets to keep programming moving forward, an extremely iterative approach that often is structured around weekly deadlines and build deliverables, and an early working out of the most difficult core features and technology.

- Production concludes with beta testing and QA phases, to be discussed in the next chapter.

CHAPTER TWENTY-FIVE
Final Product Testing

Introduction

What happens as the end of the game development process approaches? The madness of these final days, weeks, and months, especially in large commercial game companies, is almost unbearable. Yet having that experience is extremely valuable. People who have lived through it understand the pressure and can somehow deal with it better. In fact, most large game development companies prefer to hire senior programmers or producers who can show that they've survived the endless, horrific, and cataclysmic end time development.

The pages that follow describe the details of the end times as they typically occur in commercial game development companies. There is no standard set of procedures, so there are countless variations. Serious game developers may not always face the same kinds of rigors, but they'll get close enough. As a result, this horror story can be beneficial not only in preparing you for the final push at the end of your own game but in making your game better if you're willing to apply some of these practices. Consequently, at the end of the chapter we'll translate some of the lessons from commercial final testing to the testing you should apply to your own serious games.

Alpha and Beta Testing

When the actual development of the game is under way, the effort is to achieve an alpha version that can be circulated beyond the limited number of internal testers on your team. Once you get a complete build of the entire game (usually with stand-in art and other media), you've created that alpha version. Now, not only your internal testers but representatives from the game's publishers (if a publishing deal is in place) begin to get involved as well. As we learned in the previous chapter, you may also want to expand your team by bringing in additional testers who have not been involved in the developmental tests and can look at the product with new eyes.

In large commercial game development companies, the developers create a test plan for how the game will be tested. The publisher will also have a test plan, and there may be other plans as well. (We'll talk later on about certification testing.) The effort now is to make the game shiny and fine and polished, limit new features to those that provide major benefits, and, of course, find well-hidden bugs that may crash the game and the system completely. Once the game is as polished as the producers think it can be, it is declared beta.

The beta version is the first version of the game that you can consider for the golden master, from which the final replications will be made. There are usually different kinds of beta versions. There are internal beta versions that your internal test team works with, but there may also be private beta versions that you give to individuals who you want to test the system or whose opinions you value. (Sometimes you might build a beta version for the company president to take home and play with, depending on the disposition of your company and your president, of course.) Then there are public beta versions. Some game publishers create beta versions for enthusiasts to download, try out, and comment on. If a beta version is good enough, it might be offered to an even larger slice of the public at some kind of press event.

By now your team of testers may be expanded even more to make sure that you comb over every conceivable path through the material, check every possible interaction, and find any final bugs that are lurking within the software.

As we've alluded to, you should have a quality assurance (QA) group within your own organization, but the publisher will have its own QA team as well. This quality assurance team is supposed to be immune to the politics that might try and force it to overlook bugs or other flaws in order to meet a deadline.

The publisher's quality assurance group reviews the product, identifies and reports bugs, consolidates reported bugs from other testers, and sends them back to the producers who assign them to the appropriate developers for bug fixing. No one is looking for new features or any product changes at this point; it is all about making the game work flawlessly.

The game is played over and over again. Testers follow every conceivable path and check every conceivable decision point. It requires great skill to sit down and play a new and complex game from end to end in one or two tries and then do it over and over again. In some companies, highly effective and efficient testers become legendary.

Testing new features always claims first priority throughout testing, but in the beta testing phase, QA should also be carrying out regression testing to confirm that features working months ago still work today. Sometimes, the implementation of new features will break the old features. Crunch time during beta testing can sometimes overlook the reaffirmation that the tutorial or the first score-able level or interaction is still working cleanly.

The game's developers must address every bug on the bug report, fix it, and send an improved beta version back to QA for another review. The fact that QA may find additional bugs in the next review makes the final push to get the product

done that much more difficult. And here's where we enter a very scary place: the end time.

The End Time

Put yourself in the shoes of the development team at a large commercial game company for a few moments. The deadline is looming, QA is insistent on every bug being fixed, and you and the other engineers are trapped in your code, going back over it again and again, trying to figure out which combination of steps leads to the one bug that makes the whole game take the wrong turn and eventually implode.

At this point, there are no more mornings and evenings for you, there are no breaks between day and night, there is no going home or even going out for lunch. Everyone lives on pizza three meals a day and the most highly caffeinated beverages available. Being able to go to the bathroom becomes a luxury.

You get it all done. You make every fix the bug report demands, and you send it all back to QA for another go. Of course, they find more bugs and probably aren't satisfied with all your fixes.

The process starts again; the days run together. Your spouse, your friends, your kids, your parents don't even know who you are and certainly can't relate to that dark place in which you live—between the lines of code.

Producers are tearing their hair out. They're frustrated and, of course, they can't really do anything but be there for as many hours as you are, just to give moral support, just to prove that they're as dedicated as you are.

The client is going nuts and taking it out on the producers who do everything they can to shield you, the development team, from the wrath of the publisher, marketing, and the executives.

Everyone is trying to come up with new kinds of threats to make you understand the crucial nature of your mission, as though that would matter or make things any better at all. Everyone is trying to come up with new incentives to make you work harder and think more clearly, as if that weren't a contradiction in terms.

That's when you start fixating on that cruise to Tahiti; the one that you know will set you back $20,000. You realize that you're going to blow every cent of the overtime, bonus money, and whatever else you get for all this just to get as far away as you can from your office, your computer, and QA!

That's the end time, and maybe it's worth it. Because, at 3 a.m. on one endless Tuesday night, as you're eating the last piece of your cold pizza, drinking your fortieth cup of coffee, and wishing that they didn't turn the heat off in the building at midnight, you look at the code one last time. Maybe your eyes are twitching. Maybe you're squinting. Whatever it is, you look at it just a little differently, and suddenly there it is—something that isn't quite right. Why didn't you see it before? It's the bug you haven't been able to find for so many endless hours! The fix is easy. You do it; you run the code and #@#$%&GF$#! The thing doesn't crash anymore. The bug is gone.

At this point in the process, there may only be one QA specialist left on the project who is still screaming. But she is as passionate and vocal about making the product perfect as you are about trying to keep your marriage and your brain from turning into sludge. When the QA person gets the final build, runs it, and sees that the bug is gone, you can probably hear her cheering all the way from the QA office, which is 50 miles away. You thought she was your enemy. She was. But now she loves you a lot more than your spouse or significant other who has probably left you months ago anyway. Maybe the trip to Tahiti will help you put your family back together again—that is, until the end time of the next game.

But what if you can't fix that last bug? What if no one can? Reluctantly, this may be when everyone gets together and agrees to live with it. Such a decision evolves from a negotiation between QA, marketing, the game developers, and the game publisher, and it happens pretty close to the sixtieth minute of the twenty-fourth hour, if it happens at all.

In the end, you have a candidate for a golden master. Now, a whole new set of QA personnel enters the picture. These QA specialists are from the platform provider; they do certification testing.

They make sure that you're using their naming conventions properly, that you're meeting their technical requirements and usability standards, and that you're applying the correct trademarks and terminology. They look at quality one last time as well. If they approve, then you're done. If not, you have to make another golden master. But with that approval, the golden master goes to the replicator (even if that only happens to be your own PC), and it is shipped, posted on the Internet, or otherwise distributed. (Which we'll discuss in Chapter 26.)

Game over! You won.

Tahiti, here you come.

Applying Big-Time Practices to Small-Time Jobs

OK, so you're not going to Tahiti, you don't even work for a big-time game developer, and now that you've read that previous section, you are going to give up your dream of *ever* working for one. But you've got your own application to bring to the golden master. You just don't have the same kind of budget as the big guys. So how do you apply the painful processes we just described to your project? See Figure 25.1, which shows how the testing principles that the big game companies use can work for small serious game shops (whether independent or under the umbrella of larger nongame organizations).

You won't have the resources of a big game company at your disposal, but that doesn't mean that you can't test your alpha versions into perfection. Eitan Glinert, founder of Fire Hose Games, advises that developers "*Test all the time*! Really! At least every other week, and every week is even better. You don't need tons of people to come in each time: we find that four to eight people per build is just fine.

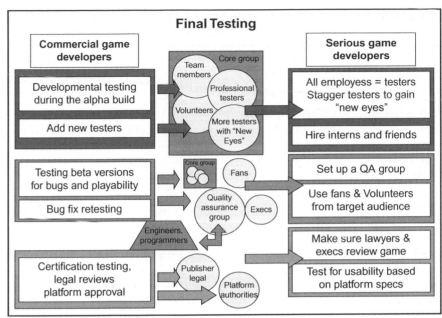

Diagram of final testing procedures that commercial developers use and how those procedures can work within a small serious game company.

FIGURE
25.1

Every single member of the team must test on occasion, not every time but at least once a month. That helps them to keep the end user in mind."

So draw on people you know are interested. Beta testing using a loyal unpaid audience is one way to reduce the cost of testing (your organization may have a devoted coterie of loyal customers, or you may have loyal fans because of previously successful YouTube or Facebook projects).

Another way to reduce testing costs is to have a game whose mission is considered important or attractive enough that interested parties will donate their time. One case was *Budget Hero*: its goal of educating the public about federal budget issues was compelling enough that numerous budget analysts and policy wonks donated their time to beta test the application. In the case of *Fully Involved*, the recruiting of firefighters to test out the game wasn't difficult, as firefighters realized the importance of the application's success.

Also, as Figure 25.1 shows, include your own employees. Hire interns from the local college. Tap all your resources. This is even a case when you can ignore our cautions about hiring your friends. Bring them onboard; get them involved. The danger of not enough testing is too great. Everybody can test. Just remember to hold some people in reserve so that they can look at the game with fresh eyes later on.

Testing in the Field

Your serious game or simulation may need testing out in the field, which makes controlling the test environment difficult. For educational games, "it's very hard to test with students in schools," reports Fire Hose Games' Glinert.

He continues:

> You need to worry about IRB [institutional review board] approval for testing with minors, (even if your game is designed to teach) and getting into schools can be tricky. Computers at schools are generally ancient—many don't even have the ability to show 3D graphics, and it's almost certain that something you develop in-house won't run on school computers. Getting consistent, comparable feedback from students is tricky as well, as many times students won't bother doing what you asked and will instead use the computer for other things like checking email or Facebook.

Glinert cautions, "If you're testing at schools, be prepared to spend lots of time and effort getting small amounts of feedback."

Our own experience has been much more positive. Of course, one of our clients (LeapFrog)had long established connections with numbers of schools and was able to set up lots of interviews with students for concept testing. Their input was extremely valuable. Our own connections with local schools put us in contact with a teacher who ran a study hall for junior high gifted students. She gave us a two-hour period every month to come into the classroom to demonstrate our ideas and discuss our concepts.

Additionally, in the needs analysis phase of *Spark Island* (discussed earlier in this book), the Alaska Fire Service set up interviews with students all over Alaska. In both cases, our clients were setting up a lot of the interviews (so we could focus on the game development). Because of their work (the Alaska Fire Service does a great deal of educational work with schools, e.g.) we were able to get the entrée we needed.

An additional issue with onsite school testing can be the content filters and blockers many school systems have installed on their Internet workstations. If your application is doing any kind of callout to the Web and you're planning for its use in schools, you need to test different safe Internet configurations.

QA and Certification

If you have a small operation, commit to having a QA group or at least a QA person. If you're the boss, have that person report directly to you or to the head of engineering. Get someone who pays great attention to detail, who is committed to quality, and who likes games. Then supplement the work of this QA specialist with testing from more volunteers, fans, and members of the target audience for the serious game. Their input about the gameplay will be invaluable. If you're still

short-handed, convert anyone left on the development team to in-house QA. (Just make sure that testers aren't testing their own code!)

There are two kinds of certification for serious games: content certification and platform certification. In the first case, certification is sought from organizations that specialize in the nature of the content and skills that the serious game is teaching. So, for example, a serious game to train nurses might need certification from various nursing organizations to make sure that the game complies with all necessary nursing protocols and procedures.

Representatives of the manufacturer of the platform on which your game will be played carry out platform certification. Platform certification testing does not happen on PC or Mac games, but it does on console games. Even if your serious game is headed for a PC, however, consider what a certification team would be looking for, such as meeting standard platform technical requirements, meeting usability standards, using correct trademarks, and terminology. Have your lawyer look at your game as well, with an eye to copyright protection and violations. (If you don't have a lawyer, we refer you to our cautions in Chapter 7.)

Minimizing the Pain

We've tried to convince you that you need to create a situation that will bring those deadly end times right into your small serious game development shop or department. Now that you've committed to all that testing and QA, the question is, can you possibly prevent the pain and suffering that comes with them? Some people say it can happen if you're very lucky. But as we discussed in an earlier chapter, you make your own luck. Early in project planning, allow as much time as possible for the QA and debugging process. Fight for this time: it'll always pay off for you.

You should also keep your executives aware of every event in the process so that they can adjust schedules throughout the project, manage resources, bring in new bodies, and retrain old bodies, if those bodies are there. You may be able to steal personnel from other projects or get those other projects put on hold. You can cut features, cut levels, and cut characters. Maximize every minute of everyone's time on the project (get them pizza and pick up their dry cleaning, if you have to).

If you have a small shop, of course, some of these options won't be available. That is why good planning is even more important when you've got a small budget and a small team.

Overall, just getting the game built is one thing (getting through beta). Finding those bugs is another. Sometimes that takes inspiration and having people who are good at doing it. And although we have been preaching against relying too heavily on luck, maybe a little luck is necessary. The bottom line is that you have to try everything you can think of in the end.

The best aid is having an internal road map because you and the key members of your team have been there before. But you and your development team may not

have that level of experience. If so, the best you can do (after good planning and management) is to hold on tight and start conjuring up pictures of your own low-budget version of Tahiti.

Advergame Testing

Interestingly, while it may seem like advergame testing should be done strictly under wraps (to minimize potential brand damage), some brands with an intensely loyal customer base can actually benefit by having enthusiastic customers beta test the application. These customers will feel even more special and rewarded by having the chance to beta test. They may be culled from opt-in emailing lists or site registrations and then invited to take a sneak peek at an early version of the app.

Advergame portals like England's MiniClip offer game makers an opportunity to upload an advergame beta and let MiniClip's loyal audience "bang" on the build for a while. This is really a two-for-one opportunity: expanding the tester base while simultaneously marketing both the brand and the in-progress app.

Summary

- Developmental testing goes on throughout the course of creating the game and becomes most rigorous when the alpha stage is reached. Then there is a full working version of the entire game. At this point there may be some work done in polishing the features of the game, but much of the effort is spent finding major bugs that crash or kill the game completely.

- Beta testing can sometimes be farmed out to users who are willing to use a less-than-perfect version of the product to find out how good it is. The effort at this point is largely to get the remaining bugs out. The publisher's QA department (and your own internal group) will test, test, and test again to find every hidden bug there is. This includes regression testing, which double-checks that the earliest implemented features continue to work, even as late features are added. Regardless of who finds bugs and where they're found, the developer will need to fix them and fix them again until the product plays perfectly and can be declared a golden master candidate.

- When necessary, next will come certification testing from the official content stakeholders and from the console platform provider; here the game is examined with new sets of eyes and new sets of criteria. Pass this test (or skip it because you're not publishing to console or mobile) and you have the golden master.

- In spite of the incredible pressures that it will create for you and your staff, all of this testing is really worth it. You should make sure that even a small shop or department has adequate testing and QA capability.

- Remember, the best defense against the painful end times of game development is good planning and an adequate time allocation up front.

SECTION SIX

THE FINISH LINE

Over the Hump

The final push, with its demanding hours and intense pressure, should be behind you now. The job of packaging, distribution, and marketing can be as easy as handing over a set of master materials to your client or as demanding as finding a package design company and getting through a selection process that is as complex as initial concept approval. The following chapter gives you our best advice on the subject.

We'll also discuss how and why, long after the application is published, you have to find a way to determine how effective it really is—and that means more than measuring its popularity. Serious games have a mission to accomplish: training, marketing, social persuasion. They're supposed to change behavior and help people do things differently. How do you find out if you've succeeded? We have some ideas.

Packaging, Distribution, and Marketing

Introduction

You've just gone to the golden master with your application, or you're ready to call it a beta and do a soft launch online. Either way, you're going to need to package the application (i.e., ready it for deployment) and distribute it.

Package an online application? Well, yes, and we'll tell you what that means. Even though you may have the greatest application in the world, it doesn't mean anything unless you can get it out into the world. We'll discuss various strategies for effective distribution.

Often, in small Indie game companies, planning for packaging and distribution doesn't start until the project nears the finish line. But plans for packaging and distribution should begin, as they do with large game publishers, before the project even enters production. In companies like LeapFrog, for example, experienced graphic design houses are brought on board to take the game materials and mold them into a package that's a full-on sales piece, touting the benefits of the game and the platform and presenting the most exciting possible image from the game to the would-be game buyer.

Even on the low-budget serious game side, the time-sensitive nature of much of the material means that you don't have any time to waste once production concludes, and nothing is less cost-effective than a project sitting on the shelf, waiting for packaging and distribution to be completed.

In this chapter we focus on packaging, distribution, and marketing for serious games produced by smaller companies who don't have the luxury of outsourcing the package design and production to an award-winning graphics house and an expensive packager.

Packaging

You already know your distribution platform. (If not, you're in big trouble at this point. As discussed in Chapter 19, you'll need to make this decision before you go to production.) But knowing your distribution platform doesn't tell you how to package up the application.

We can choose to distribute via a physical package or via a digital (i.e., virtual) package. But first, let's review some packaging considerations.

Packaging Cautions and Considerations

These issues should have been considered back when the decision was made about your application's delivery platform. (See Chapter 19 for a discussion of platform pros and cons.) But they're worth one final review:

- Does the person installing the game need to have administrator privileges?

- Is a network connection required to *install* the game?

- Is a network connection needed to *run* the game?

- Does the target platform support the media on which the game is distributed (e.g., the game is delivered on DVD-ROM and the computers on the military base only have CD-ROM)?

- Does the target organization permit certain applications to be run? (Government organizations, in particular, can have strict guidelines about allowable applications.)

- Have you made sure to secure rights to any additional software, resources, or other intellectual property (IP) needed for deployment?

Physical Packaging

Any application, regardless of distribution platform, can be packaged physically. But *should* you distribute a physical package? Here are some of the pros and cons.

Pros

- Your users may feel more comfortable with, and value, a physical package. This is especially true with somewhat reluctant users who don't work for your organization and don't feel in any way invested in using your product. The physical package can seem to add value. (More on that later.)

- Some older users and users who are less computer savvy may feel more comfortable installing your product from a physical disk or flash drive.

- You can address users who don't have consistent online access.
- A physical package may help promote your organization's or client's identity.

Cons

- Physical packaging costs money (for packaging itself, distribution, and sometimes even storage).
- Users have a tendency to lose physical media, and if the media presence is required for the application to run (e.g., an executable, data library, database, or graphics library may not be installed locally), you're bound to lose some users.
- Some users prefer digital applications, as physical media takes up space and can be lost.
- Netbooks generally don't have DVD drives, although they will accept USB flash drives (and, often, SD cards).
- Some mobile devices (e.g., cell phones) are unable to accept any physical media. Other mobile devices will accept SD cards, but a majority of users are unfamiliar with using an SD card in tandem with the device. Users generally aren't used to getting a physical package for a mobile application, and distributing a box with little in it but a link to a download site doesn't make much sense.

So What's the Package?

So you've decided on a physical package. And after all the expense of development and production, it may be tempting to simply slip the CD-ROM into a soft plastic sleeve, put a sticker on the sleeve, and distribute.

But users will respond to the respect you give your project. Package it like a freebie, and users are likely to give it little weight and merit. The package will inevitably reflect on your organization or the client's organization. Cheap looks cheap.

Professional packaging doesn't have to be expensive, however.

Some projects may require you to distribute only a few hundred copies of the product. If you're really on a shoestring budget, a do-it-yourself (DIY) approach may work. You may have access to a high-speed DVD burner (although disk duplication is probably still something you'll need to outsource); jewel cases can be bought in bulk; cover art can be mocked up in Photoshop and inserts can then be printed by FedEx Office, dotphoto, iPrint, and others; disk labels can be designed and printed in the same way.

But all this may be fairly labor intensive. Companies like DataDisc.com, ProActionMedia.com, MediaXpress.net, and many others can turn around even small packaging jobs (e.g., 100 disks) for several hundred dollars. CD-ROMs and DVDs can be packaged in sleeves, foldout wallets, regular and slim jewel cases, DVD amaray cases, and other combinations of packaging. Artwork templates and

labels are available to apply to the disks themselves, and inserts or imprinted cases will provide additional polish.

Although every dollar counts in production, the decision on whether or not to distribute via physical media should probably be driven more by marketing and promotional needs than cost.

Alternatives to CD-ROM and DVD-ROM Disks

- *Flash drives* are a more recent alternative to physical media distribution: 64-MB and 128-MB flash drives can be bought in bulk for pennies per drive, and even larger flash drives may be cost effective. Flash drives will work on netbooks, where disks will not. Flash drives can be imprinted with informational or promotional data, or inexpensive labels can be printed and affixed to them. They can also be attached to promotional key chains or packaged with booklets or other materials. A number of companies "logo" and duplicate flash drive content, so this can be either a DIY endeavor or an outsourced one. But there are a couple of cautions: (1) some flash drives can't be write-protected and (2) flash drives are often vulnerable to viruses and other data security threats.

- *Smaller-capacity SD cards* (1 GB or less) can be bought in bulk for less than a dollar apiece. They are ideal for netbooks and mobile devices. However, they are so small that they're easily lost. Typical packaging is a small plastic holder that can accept a very small label (the SD cards themselves can also carry labels).

- *Kiosks* may be an appropriate distribution system for certain kinds of applications: advergames and location-specific educational games in museums are two examples. The kiosk is capable of storing and accessing a wide variety of standalone media. For this reason, kiosk presentation of advergames and advertising material has been going on for a long time and actually has laid the groundwork for many of today's most successful serious games. (The design and development of kiosk advertising material were discussed extensively in our early book *Advanced Interactive Video Design: New Techniques and Applications,* Knowledge Industry Publications, Inc., 1988.) Suffice it to say that user engagement with kiosks is relatively brief, so the kiosk application needs to deliver a quick, rewarding experience with easy interactions.

Digital Packaging

It may seem counterintuitive to talk about digital packaging. If we distribute digitally, doesn't it mean no package? Well, there is no physical package, that's true. But we still need to package our application for distribution. In other words, what will users see when they attempt to access the application? What is the packaging around the digital app?

Before we explore this question further, let's look at whether we *should* package digitally. Naturally, in some situations, the choice is made for us. For example,

physical packaging is completely superfluous for applications delivered within the browser. But for other situations where we can choose how to package and distribute, here are a few pros and cons to digital packaging.

Pros

- Solves the problem of mobile applications: neither mobile devices nor netbooks have disk drives.

- Solves the problem when targeted users aren't allowed to install applications from physical media.

- Solves the problem of users misplacing or (accidentally or not) destroying media, as well as the occasional problem of defective media.

- Solves the problem of cross-platform compatibility of delivery media.

- Should be less expensive than physical packaging, although as we'll discuss, costs will be incurred in creating the digital packaging.

- Should be less expensive to store, transport, and distribute. (But don't labor under the illusion that digital distribution is free: the setup and maintenance of your distribution portals are factors you'll need to budget for.)

Cons

- Your organization or your client may not be promoted or branded as effectively as with a physical package.

- Target users may be more familiar and comfortable with software installations from a disk.

- Target users may not have access to an online connection.

- Target users may have an online connection, but they may have to deal with content blockers and scanners, or they may lack the necessary administrative privileges for use of the application.

So What Do We Mean by *Digital Packaging*?

Here are a few types of digital packaging. It'll be easy to view these concepts as marketing, but what is packaging but a type of marketing?

- Cover art. You may not have a physical package, but creating cover art, screenshots, and so on that you can make available at the application's digital home helps make the application feel more real and attractive, and it creates desire for the user to click on Start.

- A splash screen that conveys the organization or client name. If you're an independent game company, you might also love to sneak in your name—if the client's okay with it. Little touches like this will make the application seem more big budget.

- For Windows applications: a professional caliber installer program (InstallShield, or perhaps a custom installer built on Windows Installer or open source installers). If your application is being installed on a local drive, you'll find that users have a little more confidence when they see a professional caliber installer program at work. This touch is another way of making your project look like a big budget application.

Ratings and Certifications

Distribution via any developer network or retail outlet will require that your game be rated by a regional game rating board. In North America, that would be the Entertainment Software Rating Board (ESRB). Europe, Japan, Korea, Australia, and New Zealand all have their own regional ratings boards. ESRB certification costs run around $800 for low-budget games.

Distribution

Physical and digital distribution methods constitute different challenges. Of course, it's possible you may pursue both approaches—distributing your application via both physical media and downloads. Let's look at each approach.

Physical Distribution

Physical distribution of your application can happen in a variety of ways. We'll look at a few, knowing that you're likely to use more than one avenue for distribution.

- *Trade shows/trade conferences/trade organizations.* These will probably require an organizational booth or table in exhibition halls or exhibition rooms. More informal distributions (e.g., disks fanned out on a freebie table) can be done, but consider the relative effectiveness of this approach, since anonymous freebies are rarely invested with much value). One-to-one distributions (handouts during meetings or schmooze-fests) are yet another method, but this is clearly a small-scale approach.

- *Mass mailing.* The question is how targeted direct mail distribution will be, as well as who will handle the mailing (in-house or outsourced?).

- *Education channels.* Is it possible to partner with an educational institution, educational publisher, or nonprofit educational organization? Any one of these can be a powerful channel for distribution.

- *Online storefront.* You may create your own customized storefront or set up an Amazon or other "template" storefront, in order to distribute your application's physical media. But this suggests that you think your users will pay—at least for shipping and handling and perhaps a per-unit price for the application. There isn't much track record for this approach in the serious games and simulation arena.

- *Software publishers.* You may have an application you can sell or license to a software publisher linked to retail channels. But there isn't much track record for an independently developed serious game application that's completed and is then picked up by a retail channel (like, say, an independent film that is purchased at the Sundance Film Festival by a distributor). This avenue would need to be set up at the start of a project and may be possible if you've got a hot new "brain game" for the Playstation or Wii or a new twist on educational software for children. For most other applications, this is not a likely route.

Digital Distribution

Digital distribution of your application can happen in a variety of ways. We'll look at a few, knowing that you're likely to use more than one avenue for distribution.

Console Digital Distribution

- *Xbox LIVE Indie Games.* XNA developers submit their game to the community website. The game is peer reviewed, but only as to functionality (not to quality). Once the game is published, Microsoft will take a share of revenues.

- *Xbox LIVE Arcade (XBLA).* The bar for publishing is higher here: Microsoft will need to approve your game, and then will share revenues with you. If you'd like to publish here, you'll need to develop a relationship with Microsoft as you begin your design. One other doorway is Microsoft's annual competition DreamBuildPlay, where winning games are ushered into XBLA.

- *PlayStation Network.* You'll need to register as a developer with Sony and follow the company's process for submission and rollout of the game. Once your game is published, Sony will take a share of revenues.

- *WiiWare.* You'll need to register as a developer with Nintendo and follow the company's process for submission and rollout of the game. Once your game is published, Sony will take a share of revenues.

Desktop and Mobile Digital Distribution

- *Steam.* Valve's Steam publishing service is the premiere storefront for independent game publishers on personal computing platforms. Its development

and publishing suite, Steamworks, includes an API and other tools to make it easy to publish to the Steam service (note, however, that Steamworks only runs on Windows). Registration is free; you share revenues (if any) with Valve. Steamworks includes auto-updating services, real-time transaction data, player authentication, and numerous other features for tracking distribution.

- *App stores.* Virtually all key mobile platforms now have an "app store." Apple's iPhone truly pioneered this idea. BlackBerry has its App World, and Google has its Android Market; Nokia has launched its Ovi Store, while Microsoft has launched its Windows Marketplace for Mobile. Only Apple offers a significant approval process. Most of the other app stores require a small developer fee and share in the revenues (if there are any).

- *Online media portal.* Partnering with a media organization or channel is clearly a terrific way to distribute your application, and is most likely with advergames and persuasive games. *Darfur Is Dying*, for example, was made available on MTV's website, and the BBC, NPR, PBS, and the *New York Times* are just a few of the traditional media organizations publishing serious games online. For some time, Persuasive Games partnered with the *Times* to create and publish editorial "newsgames," vastly increasing the audience for these games.

- *Freeware/shareware game download sites.* If you want to make your application widely available, you should be distributing on the vast array of game download sites. Space prevents us from exploring all of these sites, but a quick Google search will open the doorway to many of the top sites.

- *Dedicated Internet website.* If you wish to reach a larger public, you should license a URL and set up a dedicated website for your application, even if you're publishing via Steam, an app store, or an online media portal. *Darfur Is Dying* was available both on MTV and on its own website. When you want to reach a wide audience, you should exploit as many distribution opportunities as possible. But the dedicated website raises infrastructure issues: Who will handle content and backend maintenance? Are there needs for player authentication? Will financial transactions be included in distribution, and how will these be handled? Website management is beyond the scope of this book, but it must be planned for if your project is going to have this dedicated presence.

- *Organization/client website.* Although you may be open to reaching a wider audience, the complexity of your application may argue against a simple downloadable executable. Cisco and IBM, for example, maintain training games only on their organizational websites. Interestingly, the public access to these games continues to promote the brand. The type of application you have may restrict how you distribute electronically.

- *Intranet website/broadcast.* Many serious games and simulations are proprietary and meant for internal organizational use only (and sometimes within a specific window of time), in which case pure digital distribution is likely to be done on a secure intranet or webcast.

Marketing

We may wish to change the world or improve first responder performance. Regardless of our intent, we need to aggressively market our application, not only to our intended audience but to our managers and the executives of our own companies to make sure that our projects continue on their path to completion. Members of this audience are bombarded with demands on their time every day. We need to sell the value of our application.

Marketing serious games and simulations seems much harder than marketing traditional commercial games, as almost every application is different and the goal is to reach different audiences where there is no simple exchange of entertainment for money.

In this arena, we need to broaden our definition of marketing, and look at a few examples of marketing with different kinds of applications.

Intraorganizational Training Research Application

Although the Advanced Leadership Training Simulation (ALTSIM) project was designated as a combined research effort carried out by the University of Southern California, the U.S. Army, and Paramount Pictures, it can still provide a good example of the kind of intraorganizational marketing activity that must go on in big projects to get them started and keep them going. ALTSIM received its initial funding at the creation of USC's Institute for Creative Technology, but then an entire year of formal presentations went into convincing Paramount, USC, and the Army of our approach and the budget needed to allow us to do the work.

Because the Institute for Creative Technologies (ICT) was set up as a showcase for new technology as well as a research facility, a presentation center was built for ALTSIM demonstrations, and ongoing presentations were made to a parade of visiting dignitaries from the military, academia, and Hollywood. In the earliest stages of the simulation, scripted actors performed the correct interactive gameplay, but, as the application was built out, visitors from various tour groups were asked to participate in fully functional versions of the simulations, and their enthusiasm for the game became one of our chief motivators.

Collateral print material was created to promote the game and its uses and the collaboration between a great university and a major motion picture studio. And national and local TV and news reporters were encouraged to cover ALTSIM and other ICT research projects.

During this same time period, we made related presentations to the heads of Viacom Productions (a part of Paramount), Paramount Home Video, and Paramount Licensing to discuss television shows and games that could grow out of the ALTSIM project.

Much of this effort can be considered sales and marketing, an attempt made to keep the participating entities informed and keep the project going.

Although your intraorganizational application may not merit outside press coverage (you might not even desire it, because you might not want to let competitors know what you're doing), promoting your application within your organization is highly desirable. Your company may have an intranet or internal blog that hails accomplishments and keeps staff current on departmental doings. Marketing your application within your organization may expand the reach of your department or your ad hoc game group. It could contribute to future budget increases and an easier green light for the next project you want to do.

Professional Training Application

Some training, education, and even persuasive serious games or simulations are intended for "the trade" (i.e., a specific industry or professional niche). So how can we market this kind of application?

Fully Involved—an application whose funding derived from the Department of Homeland Security and its grant programs for first responders—offers a case study for us.

Its originators, Compelling Technologies, partnered with the Western Fire Chiefs Association to secure the initial grant. The early relationship provided a sort of professional imprimatur for the project, and appearances at trade shows, along with professional networking, began to market the application while it was still in analysis and design phases. Early in production, a demo was created that was shown at trade shows and made available online to further show off the simulation to potential customers (primarily fire departments).

Michelle Harden, one of Compelling Technologies' principals, reports that the completed application has been marketed by "developing product sponsorship relationships, increasing awareness through participation at trade shows and conferences, and [the issuance of] press releases." In addition, "we've sold the product through the Western Fire Chiefs Association's online bookstore."

Early in the design phase, the decision was made to distribute the application via CD-ROM, given that many fire departments would not have a reliable Internet connection. (Note the CD-ROM packaging of the game in Figure 26.1.) However, a revised version was being funded as this book was going to print. Harden notes, "We plan to update the product and bring it online [prior to the end of 2009]. Our plans are to develop a community around this 'serious game' website and engage the fire service in an online marketing effort."

Trade publications and online trade organization sites are good outlets for advertising and for generating articles or other coverage for the application. If an angle can be found that will attract coverage from larger media outlets, this should further enhance awareness and interest in the app.

Some larger organizations (like universities or research facilities) may be able to host conferences or other events that can be used as a venue to market a serious

FIGURE
26.1

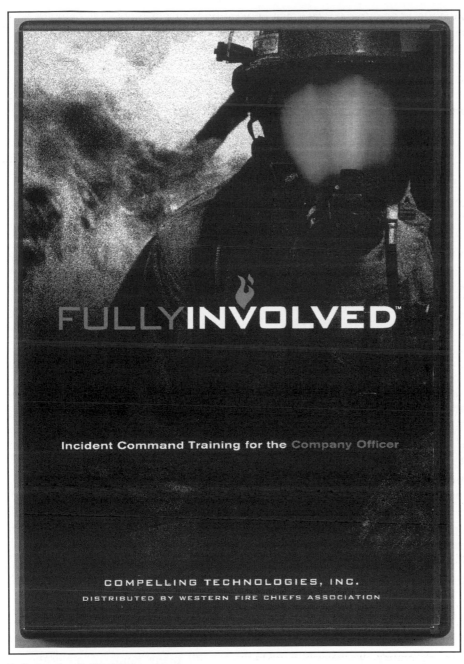

Fully Involved's **CD-ROM packaging.**

game or simulation project. Regional or local trade meetings can offer further marketing and promotional activities.

Finally, don't forget your subject matter experts (SMEs) and any early champions of your project. They can become evangelists, and because of their own involvement and investment in the application, they may serve as effective unpaid marketers on your behalf.

Advergame/Persuasive Game Marketing

Advergames lend themselves most successfully to traditional marketing approaches, although today's marketing toolset should include viral marketing techniques and a reach-out to community sites and social networks (MySpace, Facebook, Twitter, etc.). A clever advergame can quickly gain a following via Facebook or Twitter and then propagate virally.

Advergame portals have been around since Wrigley's Candystand started up in the 1990s and are another way to both distribute and market the application. It was inevitable that advergames.com itself would become an advergaming portal—and while frequent visitors to an advergaming portal represent a narrowly defined audience, as an opt-in customer, they represent gold.

A "cute" twist can sometimes break an advergame in the national media, escalating marketplace penetration. One example was an advergame developed for the National Christmas Tree Association to promote Christmas tree purchases, which wound up being covered by *USA Today* (Christmas trees in a game will attract even the nongamer).

Persuasive games can also reach into traditional national media when they're about a hot topic, and this can be an effective free marketing angle to move beyond the viral marketing that is possible to do online (for very little money). The Wilson Center's *Budget Hero* benefited from this idea: the game (which allows players to try to balance the federal budget) was distributed just as the Great Recession of 2008 got under way—and interest in the economy, the federal budget, and presidential election politics skyrocketed.

Summary

- Many factors play into the decision to distribute either physically or digitally (and, of course, it's possible to do both with many kinds of applications). Research the needs of your users, and consider as well how distribution reflects on the content provider and developer. The cheapest method of distribution is often not the best method of distribution.

- It's tempting to pay cursory attention to packaging because we've reached the end of production and we just want to get our application out there. But attention to detail and polish will help the success of our application, regardless of how we're distributing our project.

- A variety of channels exist for both physical and digital distribution. The more channels, the better, of course—but not every channel is appropriate for a given project, and more distribution channels inevitably mean more distribution management, which you'll need to factor into budgeting and hiring decisions.

- Marketing serious games and simulations is a tremendous challenge because of their heterogeneous nature, the lack of an obvious distribution and publicity pipeline, and the relatively low budgets usually available for effective marketing. Whether done virally or more traditionally, marketing will be necessary for any application that reaches outside your organization. Even intraorganizational training applications will need marketing in order to fully succeed.

CHAPTER TWENTY-SEVEN

Assessment

Introduction

Unlike concept, alpha, beta, or even certification testing, assessment testing is not used to determine if a serious game is marketable, interesting, fun to play, well designed, or bug free. In serious games, assessments are used to measure whether or not the product does the job, teaches the required skills, and changes behavior. More important than that, assessment testing should measure whether or not those skills and behaviors transfer to the real world and solve the performance problems that were identified in the analysis phase of the project. Assessment testing will tell the client whether or not the serious game was worth the cost of investment.

We should note that instructional designers typically use the term *summative evaluations* for these assessments. But we'll be going beyond the strict definition of a research-oriented summative evaluation, so as to incorporate the kinds of assessments we'd like to do for promotional and persuasive games as well.

This chapter outlines several kinds of assessment tests and the systems used to implement them. It also looks at those tests that are sometimes referred to as assessments but don't really do that job. Finally, it takes a brief look at the assessment of promotional and persuasive games.

But first, let us look at the easiest kind of serious game to assess. Doing so will help us understand what assessment systems are all about, why they are important, and how you determine their value.

Assessing the Value of a Serious Game

Your client should want to know (and deserves to be told) how you cost-justify your serious game—that is, what will be the return on investment, or ROI? To make it easier to do this, let's begin by looking at the one kind of serious game whose value is easy to understand.

By its nature, training for new product introductions fits that category. If a client were to rely solely on a serious game or simulation to teach new product knowledge and if that product never existed before, then your new product training game would almost certainly be assessed positively. After all, without your new

product knowledge serious game, the target population would know absolutely nothing about the product, so there wouldn't be any sales. You could argue (and some trainers do) that 100% of the income from the sale of that new product was a direct result of your game. The marketing and advertising teams that were involved in the new product launch might disagree, but then it would just be a matter of negotiating percentages. Be magnanimous! Take credit for only 10% of the profits. If your client is bringing out a multimillion-dollar product, it is probably easy enough to cost-justify the serious game.

But what if your game was not the only piece of new product knowledge training material in the package? What if there were all kinds of other elements? How would you isolate the value of the game itself? How would you assess the effectiveness of the game? How could you show that, of the billion dollars in sales generated by your $100,000 serious game, $1 billion, $1 million, or even $100,000 of that income was the result of your game? You might, as some trainers also do, just say that the game will pay for its costs 10 times over, and when sales are good and the product is successful, no one will probably challenge that assumption. But none of these arguments constitutes a real assessment, does it?

The real assessment is almost easier to pull off if the product doesn't do well. Then the performance problems may be glaring, and in that glare it may be clear that the salespeople couldn't really explain the new product or couldn't convince customers of its benefits, as the salesperson is shown doing in Figure 27.1. Your game may have been about a procedure associated with the new product and when that procedure was not followed, things in the processing center, for example, went terribly awry. You see, assessments are all about cause and effect. Did the serious

FIGURE
27.1

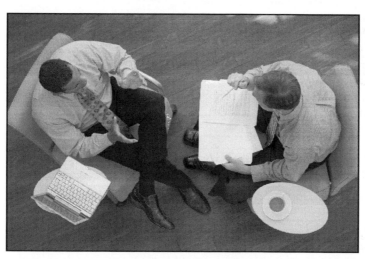

Real-world performance and assessment: Did the serious game application result in improved employee productivity 6-12 months later? Image courtesy of iStockphoto, © Monkey Business Images, Image # 5815174.

game cause the players to be able to describe the new product and close the sale? Did the serious game cause the players to be able to follow procedures correctly so that there were no processing problems?

How do you figure out if your game is the cause of the proper effect? Most of the time, it's not easy. For that reason, a number of assessment techniques have become popular that don't offer any real assessment at all, and we should warn you against them before we go any further.

Bogus Assessment Techniques

The assessment techniques that we present in this section are bogus in the sense that they aren't providing any useful metrics. They do not assess and validate your serious game's ability to teach your players the desired behavior so that they can use that behavior successfully in the real world. Let's look at these techniques and what they do and do not measure.

Attitudinal Measurements

We'll spend a little more time talking about this measurement and its benefits toward the end of the chapter. Attitudinal measurements (shown being implemented in Figure 27.2) assess whether or not the players liked the game. That may be a big deal in a commercial game, but it means much less in a game that is supposed to change behavior. Attitudinal surveys presented after the game is played basically ask the following questions:

FIGURE
27.2

Attitudinal measurement: Did participants enjoy the serious game application and find it challenging? Photo courtesy of iStockphoto © Monkey Business Images, Image #5815174

- Did you like the game?
- Was it challenging?
- What was your favorite level?
- Was the game fun?

The answers may make the game producers feel good and may indicate that the players will at least play the game, but they do not assess the behavioral change that takes place, and they do not tell you that the players have learned the skills.

Pre- and Post-tests

These tests actually do tell you that the players have learned. But what have they learned? A pretest about the specific subject matter in the game followed by a post-test on the same body of knowledge tells you that the players know and understand the content within the context of the game. That's better than nothing, and it is probably a good intermediate step in testing. But these tests do not tell you whether or not the players can use these skills outside of the context of the game. Can they transfer the knowledge back to the real world? Who knows?

Follow-up Questionnaires

Six months after the test is complete, you send out questionnaires to the players and ask them if they have applied the knowledge to the real world and if it helps them on the job. Even better, you send the questionnaires to their supervisors and ask them. What you'll get back will be opinions about behavioral change. That's better than nothing, but it doesn't truly quantify the advancement attributable to your serious game or simulation.

Genuine Assessment Techniques

So what techniques can you use to tell you when your players are actually doing things better because of your game? Let's go for the gold, the best of all possible worlds, and then try to come up with more realistic alternatives. The gold standard of all assessment systems, of course, is to find hard scientific data that prove that players who play your game are better at their jobs. Can you find clear-cut data, performer by performer, that show a positive behavioral change? Can you see a marked superiority in players over nonplayers? If so, you win the prize because you've proven the effectiveness of your game. Unfortunately, these kinds of specific hard data are hard to isolate and rarely exist. What are the alternatives?

Control Groups

The general increased sales data we discussed in our new product introduction training example do offer some information about effectiveness. The challenge is in

isolating the effects of the sales training game in the face of many other forces. But what if you could account for those forces?

That is what control group tests do. They find comparable demographic situations and then give the game to players (in our case at least) in one population and compare their performance to similar players who do not have the game. If there is a magnitude greater increase in performance in the players, you have, in fact, had a positive assessment of the game. In proposing your game, you can suggest just such an assessment; just make sure you have people within your client organization who know the various populations within the target group and can help you set up control groups. You'd better have a statistician on board as well.

Classroom Performance of the Real Skill

We just consulted on the design of an authoring game in which the players actually authored other games. There have always been projects that involved authoring systems, but imagine trying to create an authoring system that was learned while playing a game. Because the output of the authoring system was another game and that game could be played, all we had to do to validate learning was to check out the games that were produced. If they were games that met their objectives, our game authoring game was validated.

Game development is like any skill that can be performed in a classroom: typing, drawing, reading a foreign language (speaking one is a different story), and the like. If you can perform the skill in the classroom, you can validate it in the classroom by simply requiring the learners to perform the skill. However, you have to be careful because there may be mitigating factors in the outside world that influence performance and make your assessment less valid.

Speaking a language is one skill that can be affected by outside influences. You may have had the experience of learning a language using Rosetta Stone's software or an instructional audio package. But get into a foreign country and have a guy come up to you on the street and start speaking his native tongue in his native dialect at a mile a minute against the background noise of nearby traffic, and you'll see the problem. You can't assess the effectiveness of a language-speaking course without seeing it practiced in the real world, and that is not in the classroom.

Is there any way to get close? One solution may be to *simulate* the real world in the classroom. It isn't perfect, but it may be the best you can do.

Instructor-Led Role-Play Assessments

Here the instructor plays the role of another person and challenges that player who has just come out of the simulation game to demonstrate the skills he or she has learned. We recently proposed this technique to validate a cross-cultural interpersonal relations training game. If the players could stand up to the challenges presented by the role-play instructor, they might do well in the real world.

Of course, such a system depends on the skills and talents of the instructor. But if done right, this technique will show the player's ability to transfer skills away

from the game environment and demonstrate them when up against another living breathing person. What we have here is really a simulation role-play that follows a simulation game. To make the simulation role-play as real as possible, it might be necessary to use an instructor whom the players do not know, stage it in a room or other location that does not resemble the classroom, and stage it at an hour that matches the hour when the event would actually happen, especially if it is at night. Add just enough props to create some sense of realism. If tension is one of the mitigating factors in the outside world, then try to add that to the simulation as well.

Advanced Simulation Assessments within the Game

This is the exception to our cautions regarding the imperfections of pre- and post-tests. If the post-test is an accurate simulation of the real-world experience it may be as close as you can get to an in-classroom validation. How do you make the simulation as real as possible? You take out all the support structures that you build into the game, you add as much noise to the game environment as possible, you make the game-play in the assessment as challenging as possible, and you make it as realistic as possible.

Add an instructor to watch the players perform and give that instructor a checklist of what to look for: the critical behaviors that indicate mastery of the performance such as how long it takes for a player to respond to certain incidents, the order in which they perform certain tasks, etc. If you do that, you may be able to build an accurate assessment simulation into the game environment you've created. Your clients may want you to do it, because of potential assessment cost savings. But this kind of assessment is certainly not as reliable as hard data that supports performance improvement in control groups.

Advanced Simulation Assessments Outside of the Game

Here we are talking about simulations that are a little more rigorous than role-playing games with the instructor. The Army, for example, runs trainees through a series of computer simulation war games and then gets the trainees all suited up and has them carry out an assessment in real space with real gear. Several large military bases have built cutaway towns, and troops simulate close combat training in these mockup urban environments. Are such expensive assessment systems necessary? It depends on the skill being taught. If the players are learning a behavior that requires movement through a certain kind of environment and the consequences are life and death, then the answer is absolutely yes. The more real-world complications that are in the simulation, the better.

Survival schools practice another variation of this technique. Survival trainees go through weeks of basic study, and then they are suddenly dropped off on the side of a mountain somewhere to fend for themselves. To some degree, the mountain is a controlled environment because it is well known to the instructors and they are watching their charges. The challenges, the food supplies, and the presence of wild

animals are all understood (we hope). These simulations offer a good assessment of learners' ability to survive on their own by providing a testing environment that is almost but not totally hostile.

Psychometrics

Although the kinds of serious assessments we have been discussing involve hard evidence of actual measurable performance, the growing study of psychometrics can offer a new dimension to measurement. According to the advocates of psychometrics, those assessing the results of serious games will need more than knowledge of statistics and analytics. Knowledge of psychometrics will allow them to study the seemingly unquantifiable factors: cultural backgrounds, quality of life, personality, emotional baggage, and other high-level mental abstractions. Applied carefully, psychometric assessments broaden your ability to measure the full effectiveness on learning and reasons behind performance improvement.

Ideally, you should start applying psychometrics as you begin designing your serious game application. We encouraged detailed surveys of users in the needs analysis to find out more about their expectations, their behaviors, and their requirements. Once you add narrative content into the learning arena, you should also try to find out how comfortable users are with ambiguity and nuances. Can they see the underlying learning principles within the context of narrative? Are they going to need help navigating the narrative space?

As serious games get more ambitious in tackling soft skills and covert cognitive behavior, psychometrics-influenced long-term assessments will become more prevalent and will shed greater light on skill-knowledge transfer, retention, and performance improvement.

Marketers are particularly savvy about psychometrics, and we encourage you to read the latest literature and studies about marketing and advertising to gain an even better understanding of your application's users.

Promotional/Marketing Game Assessments

The ROI we're trying to measure in the arena of promotional and marketing games (advergames) is distinctly different. Through the use of control groups and precise tracking of sales patterns, we can quantifiably assess the success of our game.

Several marketing aspects can be measured through the use of control groups:

- *Brand establishment.* How is the consumer identifying the brand? How positive is the consumer about the brand, and what unique attributes about the brand is the consumer aware of (after playing the promotional game)?

351

- *Brand recall.* A week or a month after playing the game, what is the consumer's recall of the brand or product? How does it compare with a control group who never played the game?

- *Consumer outreach and sales demand.* Does the game suddenly drive or spike sales or licensing from previously underrepresented demographic groups or areas?

If distributed via the browser (the typical path for a majority of promotional and marketing games), the capture of demographic data via web bugs and other web analytic tools should provide boatloads of actionable market research. That capture alone may cost-justify your application.

Persuasive Game Assessments

Trying to assess the ROI for a persuasive game or social change game is often difficult. After all, global warming will not suddenly be halted (or likely even slowed) because you've made a game about it. If nationwide drunk-driving arrests decline a year after your don't-drink-and-drive game comes out, it'll still be difficult to claim credit for that drop.

The more clear-cut your persuasive games' actionable item, the better you can find some metrics for assessing its success. For example, if the goal of the persuasive game is to drive donations to particular organization, or to encourage users to register with a social change website, or to persuade them to volunteer for a specific event, the better you can evaluate its effect: if donations, registrations, or volunteer signups increase significantly (and if there are no other obvious reasons for the increase), your persuasive game did its job.

Because most of these games are distributed via one or more websites, the number of downloads or plays will also be a useful assessment metric. (The same would be true of any promotional or marketing game.)

On rare occasions, persuasive games or social change games may garner extensive media coverage, ideally raising the profile of the cause or action the game is about. Again, if this increased coverage triggers an increase in donations or volunteerism, the persuasive game can be declared successful. We can again do comparisons on "brand establishing" and "brand recall" via surveys and control groups—just as we would for a promotional game.

Usability Assessments

Evaluating employee performance progress or sales data over time is one way to assess ROI. But it's not the only assessment you should be doing. If you're planning to continue developing games or simulations (of any kind), then a long-term

assessment of your application's usability is worthwhile. How did the game or simulation work for the user? What could be improved (knowledge you can apply to future projects)?

Ideally, you tested for usability throughout development. But regardless of how large your tester pool was, the release of your application into the real world will stretch and test it in new ways.

If you're maintaining a message board, comment-enabled blog, Twitter feed, and other two-way venue with your users, you should be collecting data about the game's usability. Were doors hard to see? Were inventory features difficult to manipulate? Were objectives unclear? Ideally, if you're engaging with your users, you should be getting feedback from them—and they'll usually let you know what went wrong.

You might then bring in a selected sampling of users to let them discuss and demonstrate their usability issues. Usability labs can conduct these sessions for you, but obviously this will add cost to your usability assessment.

Document the usability issues you've discovered. Fix them if you can (most doable with digital distributions). Regardless, learn from them for your next effort in the space.

Attitudinal Assessments

Was the game fun or at least engaging? Did players enjoy playing it? Early in this chapter we pointed out that these factors don't indicate whether or not players have learned anything or that their behavior has been improved by the game. Still, clients almost always want these highly subjective assessments. At the least, these assessments will tell you whether or not users will start and continue playing the game, and you have to play the game to learn, right? Techniques for getting quality attitudinal data do exist.

"One of the hardest questions to ask is, 'Was the game fun?'" notes Eitan Glinert of Fire Hose Games. "Testers tend to want to tell you it was, since they don't want to hurt your feelings. We find a much better question is, 'Would you recommend this to a friend?' since, psychologically, it is the imaginary friend that is judging the [enjoyment of] the game, and not them."

Your development testing calibrated the "fun-o-meter," and your application's release into the wild shouldn't utterly diverge from your alpha- and beta-testing results. Nevertheless, it's worth doing some postmortem user assessment in the arena of user attitude and enjoyment. Surveys help (using some of the psychological tricks mentioned earlier). Sales figures, portal and download ratings, and message board/blog/Twitter chatter will further help you to make your assessments. Of course, if your client has in-house users who proclaim your game to be fun, then you've accomplished that goal!

Summary

- Clients and investors are going to look for hard data showing the ROI on serious game or simulation production. If you can give them the hard data they're looking for, you may have made it easier to launch your next project.

- Assessing the effectiveness of serious games is so difficult that a number of alternate systems have been advanced to do the job. But these don't really provide adequate results. Among these bogus assessment systems are attitudinal measurements, pre- and posttests, and follow-up questionnaires.

- If the application is providing training, the assessment system should offer hard scientific evidence that players have acquired the behaviors taught in the serious game and have carried them back to the real world and used them successfully. Among the systems that actually assess on-the-job performance that can be linked to serious game training are (1) reviews of performance data, (2) control group tests, and (3) classroom performance of skills that can be demonstrated to full effect in the classroom. Teacher-led role-play games and in-game simulations can also offer means of assessment, though they may not be as reliable. Out-of-game simulations are often expensive, but they are effective and worth investigating if they are worth the cost.

- Promotional and marketing games require a different kind of ROI assessment: Has the brand position been improved, or is there a demonstrable uptick in sales, website visits, or other similar metric? Web analytics will help provide these data, as will some of the techniques discussed with training-focused applications.

- Persuasive games also require a different kind of ROI assessment. Assessments will be easier if the persuasive or social change game has a clear-cut actionable item (as opposed to a game simply trying to persuade the user, for instance, that global warming is a fact).

- ROI is not the only feature that requires assessment. Although usability and game enjoyment should have been tested throughout development, it is worthwhile to try to assess real-world users' experiences with both. The data from each may be immediately applied to a new release of the application; the knowledge can also inform future projects.

Index

A

AARs. *See* after-action reviews
accuracy of estimates, 93–94
actors. *See* creative talent
ADDIE (analysis, design, development, implementation, and evaluation) model, 171–172
"Additional Special Thanks" credits, 83
Adobe Flash, 261f, 261–263, 262–263
Adobe Flash Lite, 262
Adobe Flex, 262
Advanced Leadership Training Simulation. *See* ALTSIM simulation
advergames
 assessment testing, 351–352
 instructional design of, **167**, 171–172
 learning problem analysis, 170–172
 needs analysis, 167–168, 169f
 task analysis, 168–170
 testing, 326
advertising. *See* marketing
after-action reviews (AARs), 162–163, 163f
Agile Manifesto, 114, 115, 116
agility as management philosophy, 114–115, 115
AI (artificial intelligence), 156, 290–291
AIR (Adobe Integrated Runtime), 262
Alameda, Lance, 283
alpha version, 92
 building, 314–315
 getting to alpha phase, 312–313
 testing, 319–321
alternate reality games (ARGs), 9
ALTSIM simulation, 6f, 177f, 175–176
 integration of, 177–178
 marketing, 339
Android OS cell phones, 250
animation, 287f, 286–288
 of characters, realism of, 294–295
 lip sync, 288, 289f
app stores, 338

appointments with potential clients, 41–42
ARGs. *See* alternate reality games
art. *See* graphics development
artificial intelligence (AI), 156, 290–291
assembling teams, 73f, 71–75. *See also* teams
 in concept document, 207–208
 whom to look for, 73–74
assessing delivery platforms, 229
assessment of students. *See* testing and scoring
assessment testing, 345
 attitudinal assessments, 347–348, 353
 of promotional games, 351–352
 psychometrics, 351
 of serious games, 347–348
 bogus techniques for, 347–348
 genuine techniques for, 348–351
 usability assessments, 352–353
asset management, 295–296
asset managers, 295
assuring customer satisfaction. *See* client management
attacking activities, typical, 188t
attending conferences, 31, 41
attitudinal assessments, 347–348, 353
audio, 307–308. *See also* media production
 casting, 297–298
 lip sync, 288, 289f
 music soundtrack. *See* music soundtrack
 postproduction, 307
 final cut, 307
 rough cut, 307
 recording, 298
 scratch assets, 314
 sound effects, 306–307
audio lists, 275, 276f
AudioOdyssey game, 12f
authoring. *See* creative talent; *entries at* production
authoring tools, custom, 313, 314
authority, 51
The Authority Dance (fable), 51

BALTIMORE COUNTY
PUBLIC LIBRARY